# pamella roland

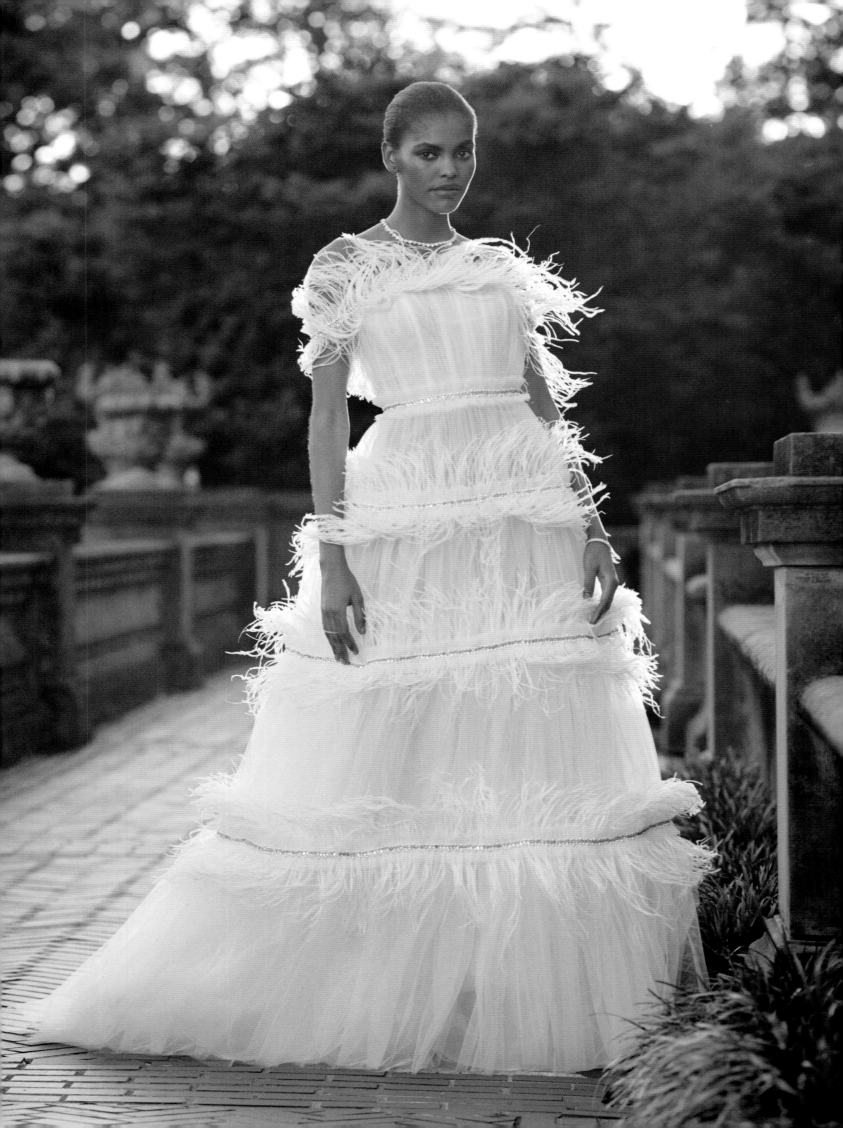

# pamella roland

dressing for the spotlight

by

## pamella roland

foreword and interview by

## vanessa williams

**RIZZOLI** NEW YORK

New York · Paris · London · Milan

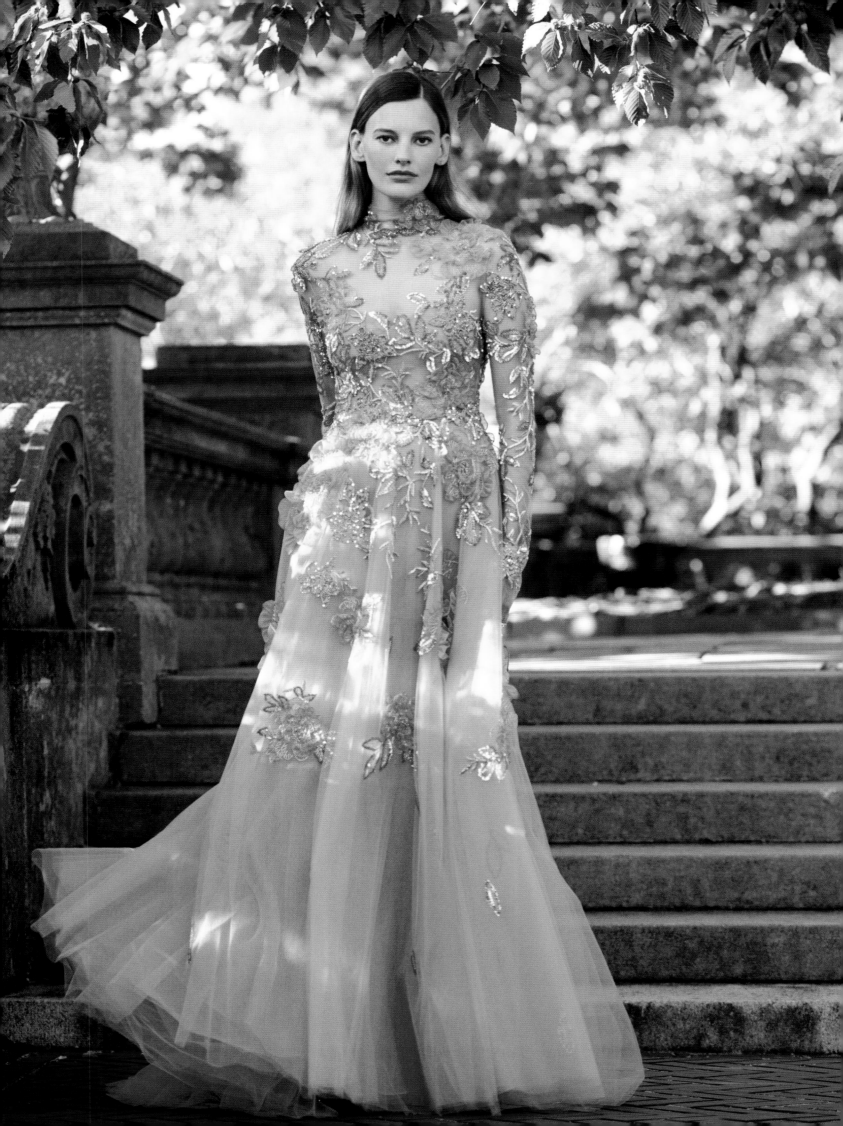

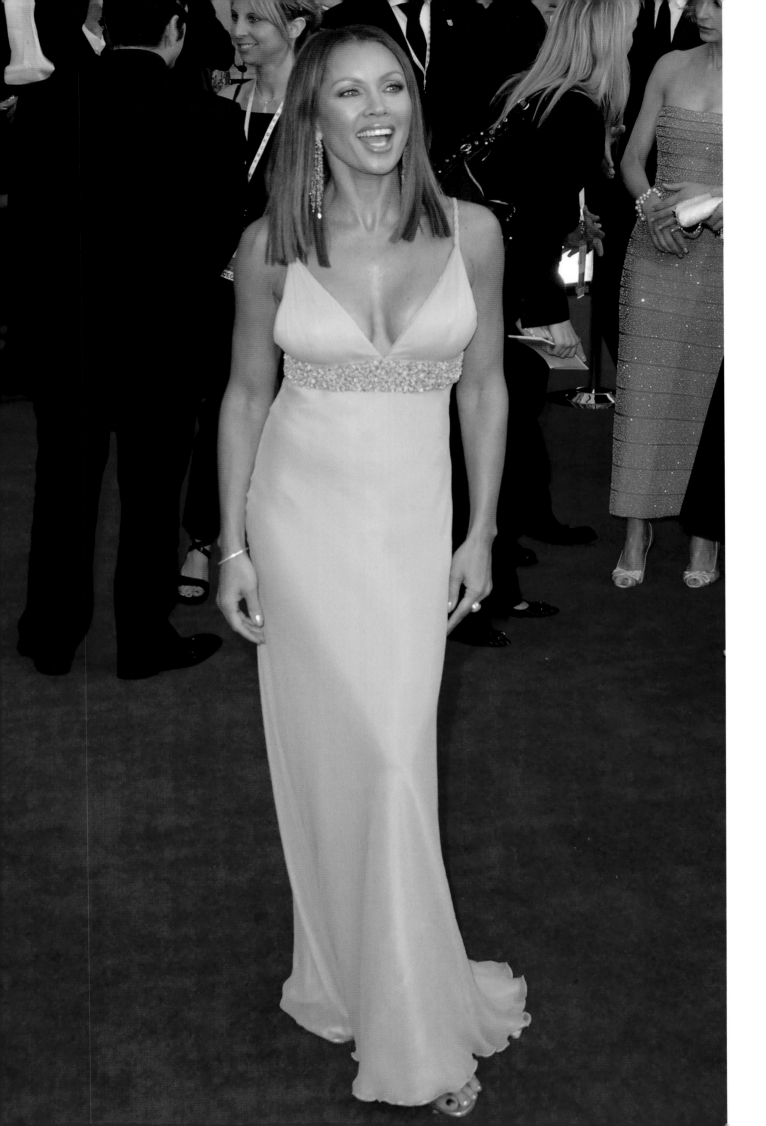

# foreword

# vanessa williams

I am lucky enough to have been there from almost the beginning. In 2007, I wore my first Pamella Roland piece to the Screen Actors Guild Awards. I remember it so clearly: a vibrant turquoise column gown with an empire waist and beautiful beading. It was organic, easy to wear, and so sophisticated. I knew I needed more from this designer.

And more I got. I have worn Pamella for so many occasions. After my SAG Awards gown choice, I selected a classic halter dress with an embroidered A-line skirt for my Hollywood Walk of Fame star ceremony. You have to sit down and stand up next to your star several times, which can be tricky, depending on the outfit. I did not have a single problem. In my years in the business, I have certainly spent plenty of time being pulled, tugged, and taped by wardrobe departments and stylists. Pamella's designs take into

*Opposite:* Vanessa Williams at the 13th Screen Actors Guild Awards, 2004.

account the fact that women want to look incredible *and* be comfortable, which is why I wear her for my symphony dates, cocktail parties, black tie events, and other special moments. If I am not wearing Pamella from head to toe, I am usually wearing a coat or cape of hers with something basic underneath.

From the vivid colors to the tailoring to the details, Pamella's pieces are absolutely fabulous and wonderfully well-made. Some designers make gorgeous garments so fragile that you are almost afraid to wear them—but not Pamella. I know a Pamella Roland dress or jumpsuit will last forever.

The woman behind the clothes is pretty special herself. I was sitting in the front row of one of Pamella's early shows chatting with her husband Dan, when she came out to say hello afterwards. We hit it right off. She told me how much my *Ugly Betty* character, the

*Opposite, clockwise from top left:* Vanessa Williams wearing a silver gown from the Resort 2018 collection at the 2018 Global Gift Gala; Vanessa at the 2019 Preakness Stakes; Vanessa at the New York City Ballet Fall Fashion Gala, 2016; Vanessa in a custom cocktail dress and me at the Whitney Museum of American Art's Gala and Studio Party, 2019.

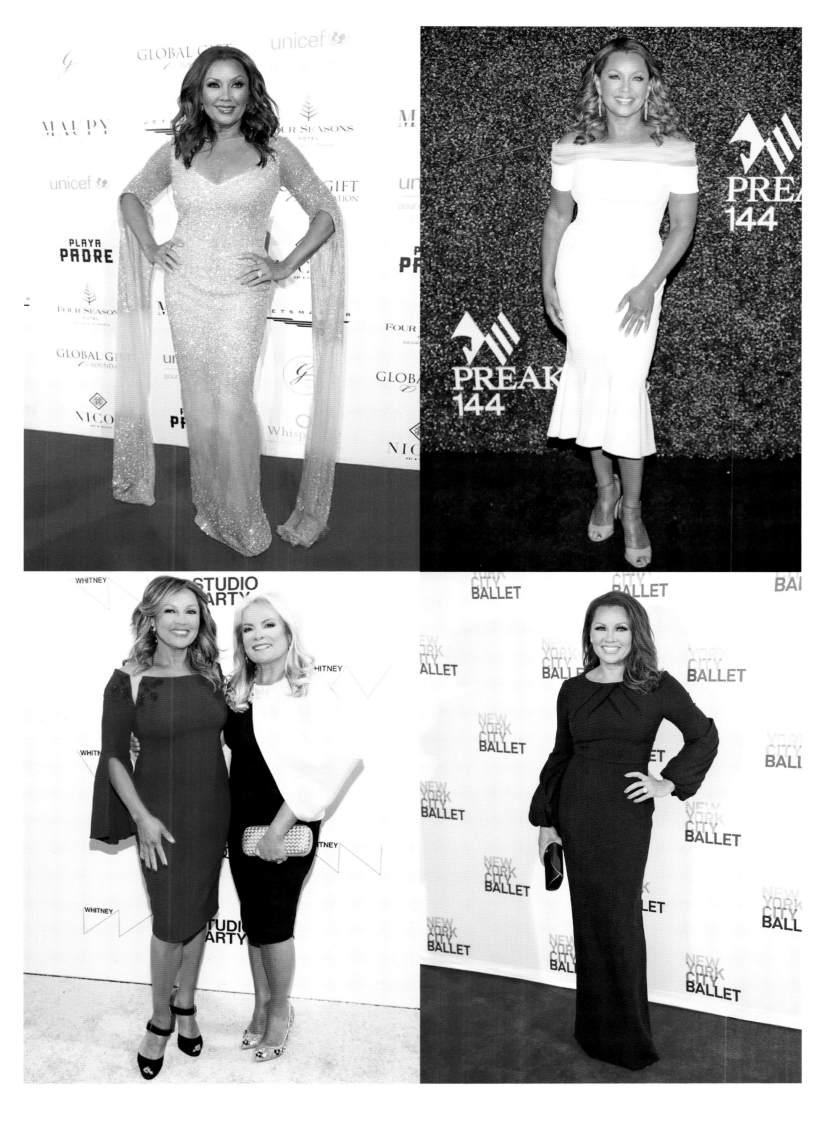

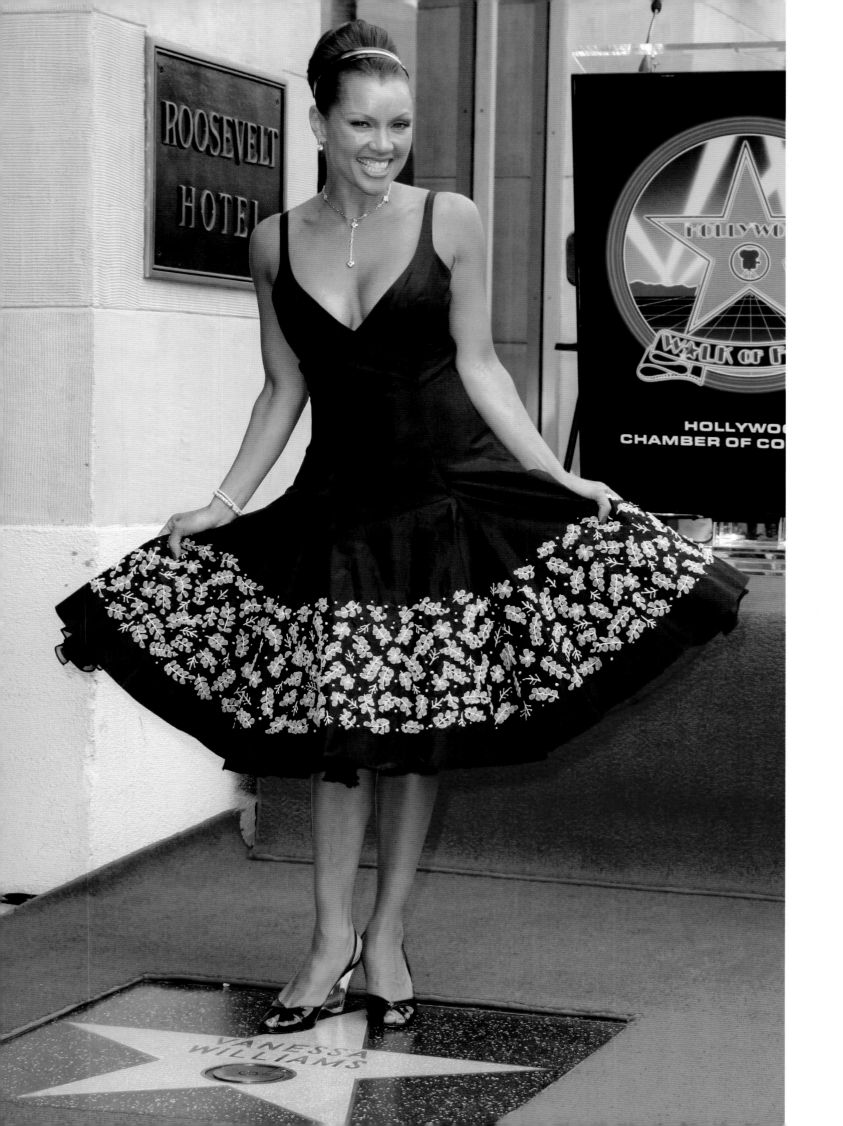

fashion magazine editor Wilhelmina Slater, made her laugh with her cutting one-liners. Although Pamella and Wilhelmina are both part of the same industry, Pamella is infinitely kinder than Wilhelmina.

Pamella and I have laughed and celebrated each other so much over the years. She even made my *Somewhere in Time* dream come true with a lovely visit to Mackinac Island and its Grand Hotel. Like me, Pamella knows what it is like to build a career in a competitive industry while raising a family. It has been a joy to watch her do both with such grace. She works incredibly hard, but she is also the life of the party. I am grateful that a few dinners here and there have evolved into a deep friendship.

Pamella has had a truly remarkable twenty years. Because of her drive and artistry, I know my friend will keep dazzling us all for many years to come.

*Opposite*: Wearing a cocktail dress from the Spring/Summer 2006 collection, Vanessa Williams receives her star on the Hollywood Walk of Fame.

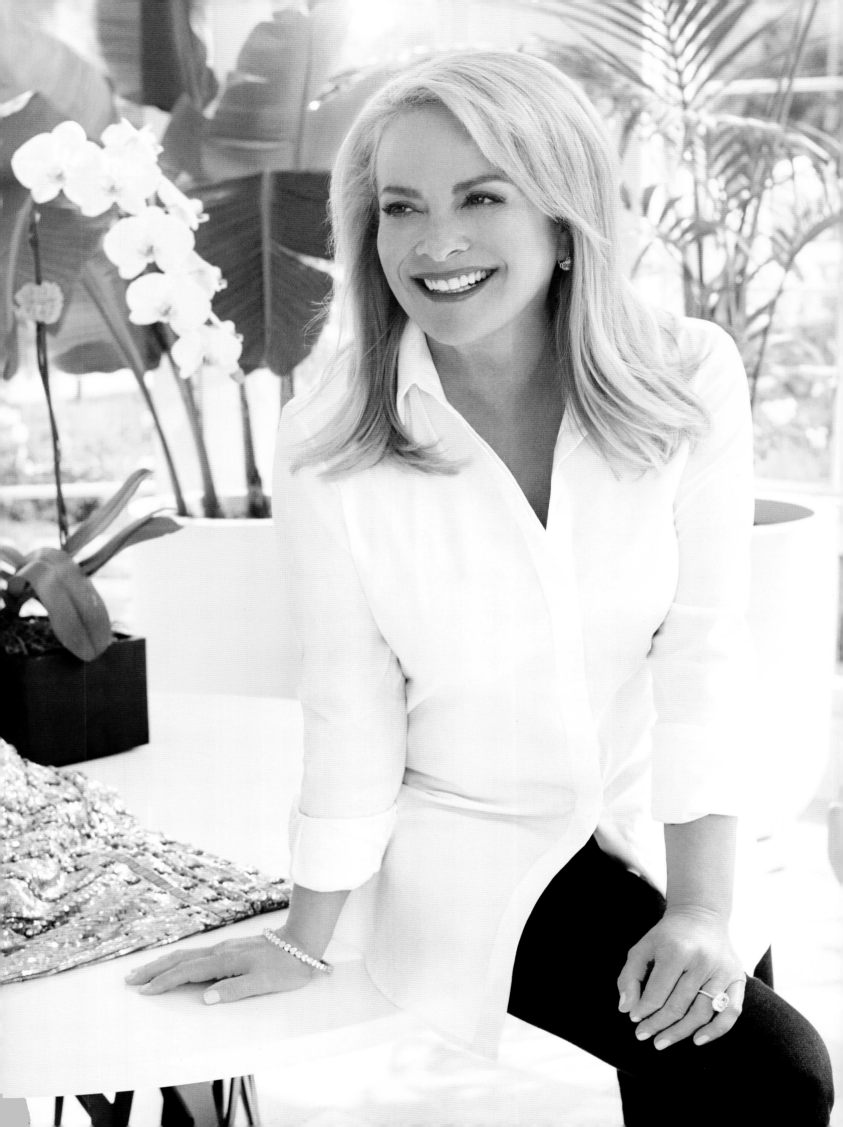

# pamella and vanessa

in conversation

pamella roland: It all started with my mother. As you know, most girls' first idol is their mother. I idolized mine. I remember, as a child, watching her get dressed in a glamorous red dress for a black-tie event. It was the first time I thought about what clothes can do for a woman.

Later, when I was fifteen years old, I started working in a local boutique in my hometown of Grand Rapids, Michigan. I worked there for seven years, all through high school and most of university. At school, I took many art classes, but my father insisted I get a business degree. So, I majored in business and minored in art history before building a career in public relations. Then, I got married and had three children. My passion for fashion, however, was always there. After my children were a little older and I felt like I had more time, I decided to pursue my dream. That was the beginning of Pamella Roland.

*Opposite:* Portrait of me in my Michigan home office by Miller Mobley.

vw: Where does your inspiration usually come from?

pr: Travel and art are my two main inspirations. I enjoy them both. The wedding dress I designed for you, Vanessa, was inspired by the art I saw when I lived with my family in Japan. I also am inspired by the fashion of old Hollywood. I love how the actresses dressed then.

vw: Do you have favorite old Hollywood style icons?

pr: Two of my favorite Hollywood style icons are Grace Kelly in *Rear Window* (1954) and Audrey Hepburn in both *Funny Face* (1957) and *Breakfast at Tiffany's* (1961). I also admire Katharine Hepburn, who was famous for wearing pants and suiting. I love suiting, and we almost always have a suiting element in our collection.

vw: What has been your favorite collection so far?

pr: It is difficult to narrow down my favorite collections, but three have been particularly special to me. I love Pre-fall 2023, which was inspired by old Hollywood glamour. Although we do not produce runway shows for our Pre-Fall or Resort collections, Pre-fall 2023 could have easily been a glamorous runway show, for sure.

*Opposite:* A red chiffon halter gown from the Spring/Summer 2008 collection.

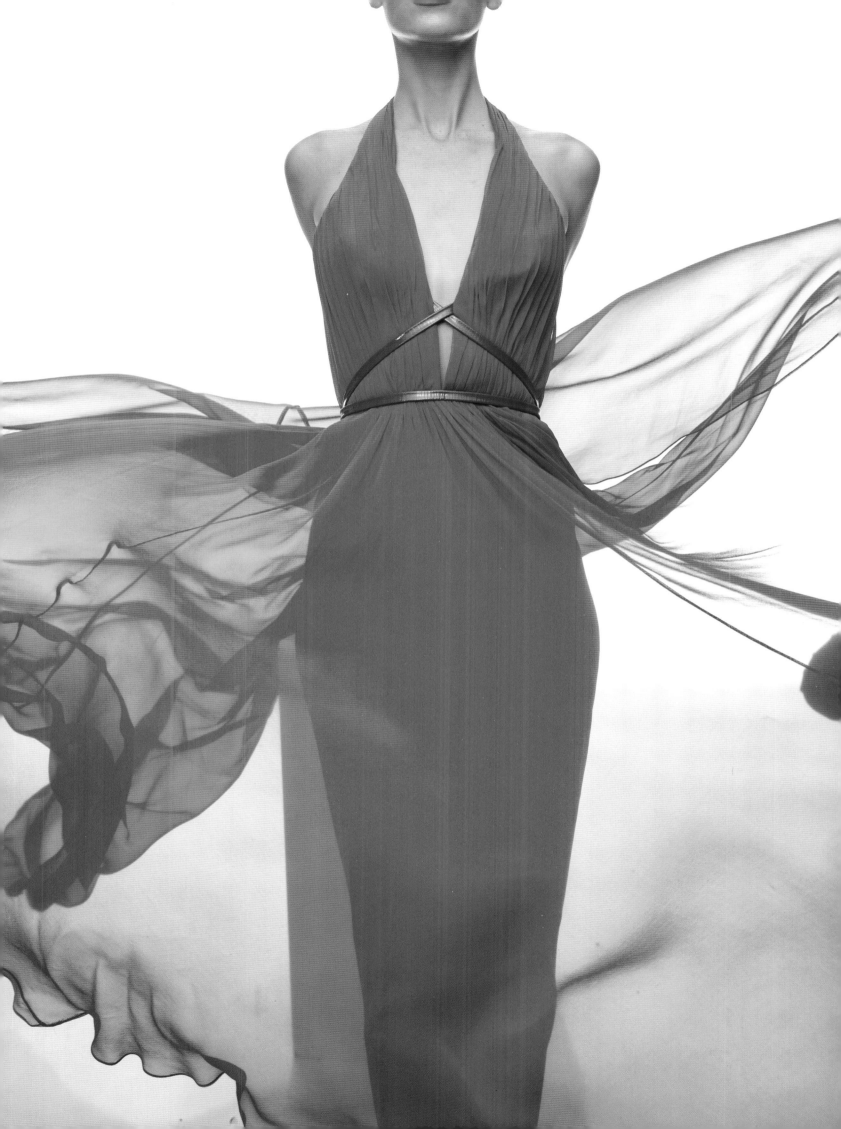

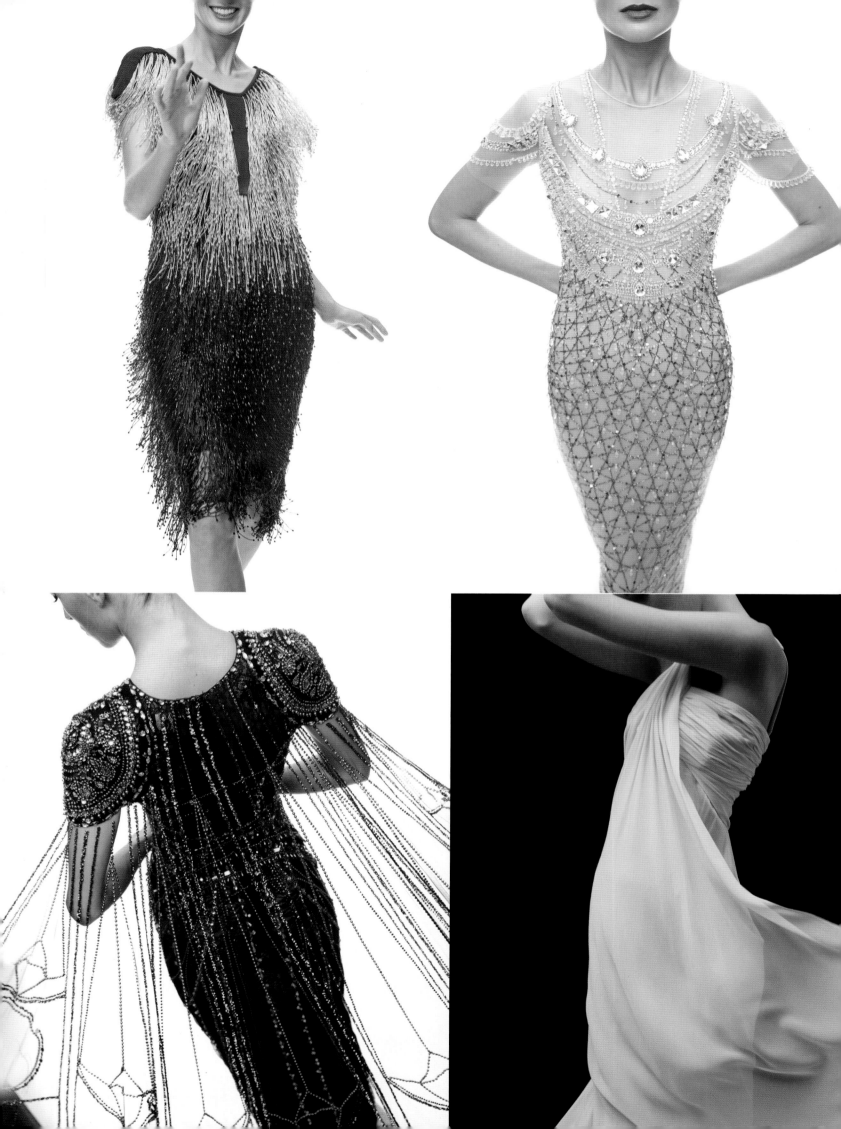

The second collection I love is the one we launched right before the pandemic but could not produce. It was inspired by Versailles.

And then, I love one of the very first collections—Spring 2003—which was picked up by Neiman Marcus. I look at it now and feel it is still a really beautiful collection, which is interesting because it's probably only twenty percent gowns. We had more cocktail dresses and suiting in the first collections because women were often wearing suits at that time.

vw: How did you begin your transition from day wear and separates to evening and red-carpet collections?

pr: We used to make the collections in Canada but then moved to New York. We found our gowns were really selling after we transitioned to New York. It happened organically. Customers were buying more and more of our gowns, and so we shifted our focus to making more gowns and cocktail dresses and making them well.

vw: Because of your background in retail and knowledge of the industry, you know how the average woman wants to feel in your clothing.

pr: I listen to what customers ask for. When I did trunk shows early on, I would hear customers say

Details of pieces from several collections. *Clockwise from top left:* Fall/Winter 2014; Fall/Winter 2020; Resort 2013; Fall/Winter 2019.

they were having a hard time finding gowns that weren't difficult to put on. I recognized there was a need to design comfortable clothing for special moments in people's lives.

vw: What were some of the biggest challenges and triumphs of the last twenty years?

pr: There are many ups and downs with employees, the economy, and everything.

Some of my biggest challenges have ended up being some of my biggest triumphs. For example, my team and I noticed many beaded dresses were too heavy, so we worked really hard to change that. Now, the dresses are pretty light, which makes our gowns very popular with customers.

My goal is always to make gowns that are comfortable and make women feel good. I remember being at an event where I wore an uncomfortable corset. It felt like it was cutting me in half. I had to leave the event early because I was in so much pain. I told my team, we needed to work on this. Corsets are difficult to construct, so it was a big triumph when we accomplished making one that was comfortable, which many of the important women in my

life can attest to, including actresses and customers, but also my daughters and friends.

vw: What lessons have you learned along the way?

pr: For one, I would say I've learned the importance of staying calm and focused. We often have fashion reporters come backstage at our runway shows and comment on how calm it is backstage. Although fashion can be challenging, I often joke it is much easier than raising teenage daughters. There are challenges with everything in life, and you must persevere as much as you can. I've learned how important it is to have a team that works well together.

vw: Is there any piece of advice that you would give to up-and-coming designers?

pr: Fashion is a difficult business that's competitive and requires working long hours. You also must love what you're doing. If you don't love your work, you've got to change careers.

Additionally, it's important to recognize what you're good at, know your craft, and expand on your knowledge and skills.

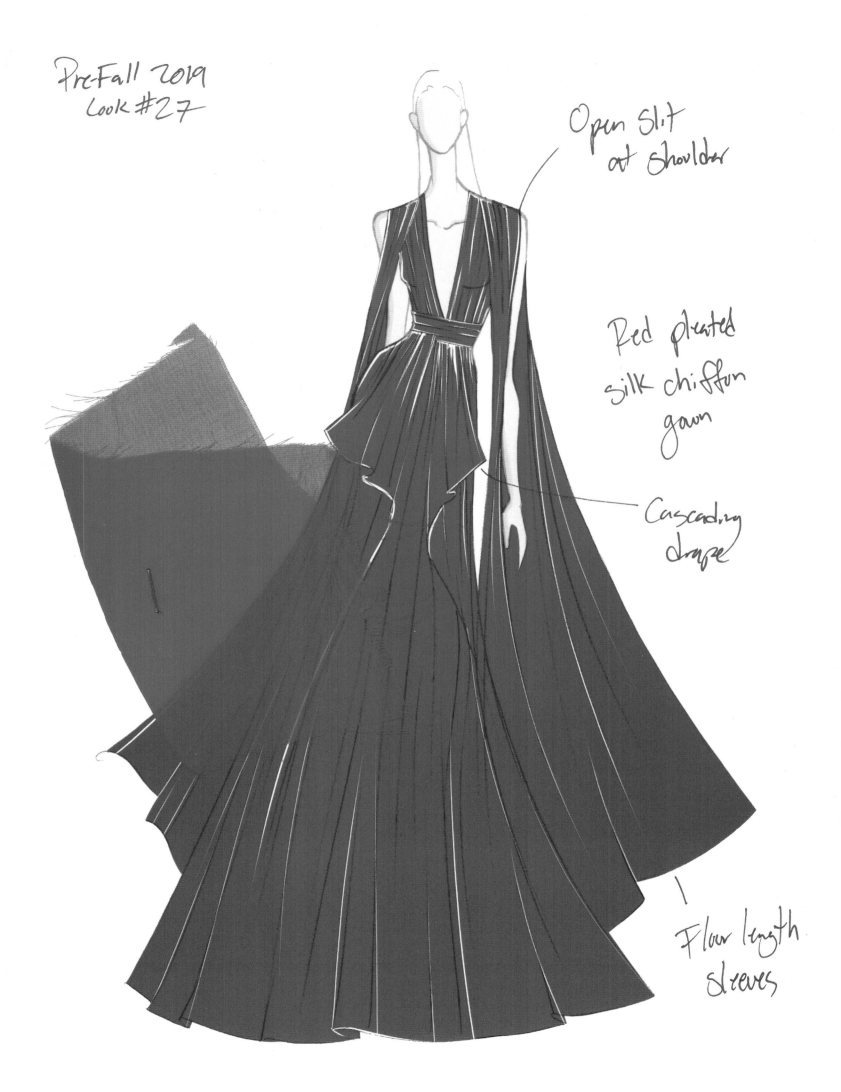

Pre-Fall 2019
Look #27

Open Slit
at Shoulder

Red pleated
silk chiffon
gown

Cascading
drape

Floor length
sleeves

# how to make a dress

It starts with my inspiration. I tell my team all about an artist, city, or historical site that fascinates me. Sometimes, I even send them photos as I am traveling! Once I am back in the studio, we collect references to make a mood board for the upcoming season. We then decide on the color story. Color is a big part of how we make the inspiration come to life.

The second step in the design process is to select the fabrics. I am lucky enough to work with some of the best fabric vendors and embroidery artisans in the industry. Once we have chosen them, the designers then sketch the garments we want to bring to life in that particular satin, tulle, or silk and decide what details would look best.

As much as I dream with the design team, it's up to the patternmakers in our Manhattan atelier to interpret the sketch and figure out how to make it fit a real body, starting with a muslin. They drape the fabrics on a mannequin, experimenting with their weight and movement. For our more heavily embellished styles, they make a paper pattern overlaid with sketches of where the sequins, beads, feathers, or other embellishments will go. That pattern goes to our partners in India, who create those lush sections. Depending on the complexity, they may need two weeks to a month to send a sample back to us in New

*Opposite:* A working illustration with a fabric swatch and design notes, which goes to the patternmakers. They are responsible for the first step in bringing my vision to life. Illustration by Andrew Cruz, design director.

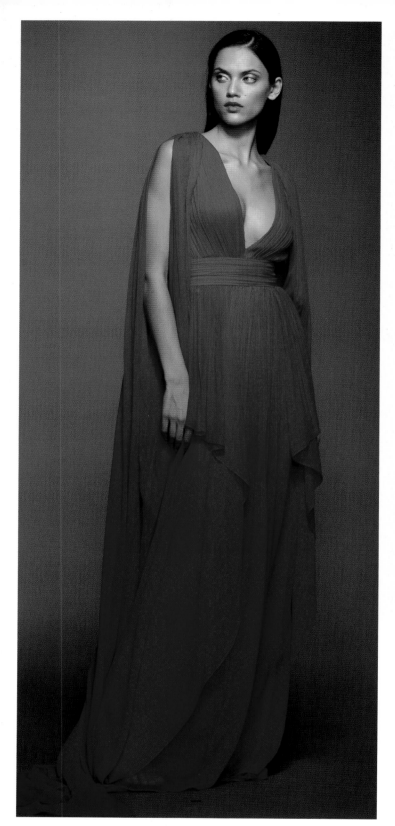

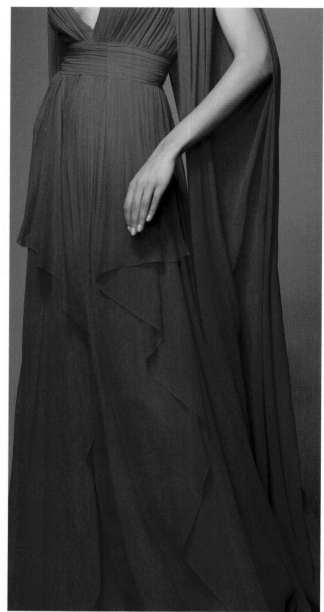

A dress like this one from the Pre-Fall 2019 collection requires 12 yards of fabric. My team in our New York City studio hand-drapes the chiffon to a base and sews the pleats in place.

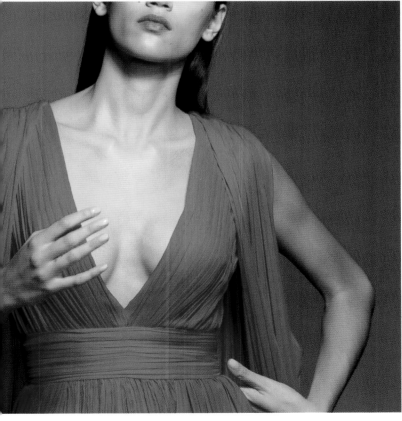

The gowns are gorgeous coming down the runway, but they are even better up close. The exquisite details and movement make the labor-intensive draping absolutely worth it. The dress is stunning from every angle.

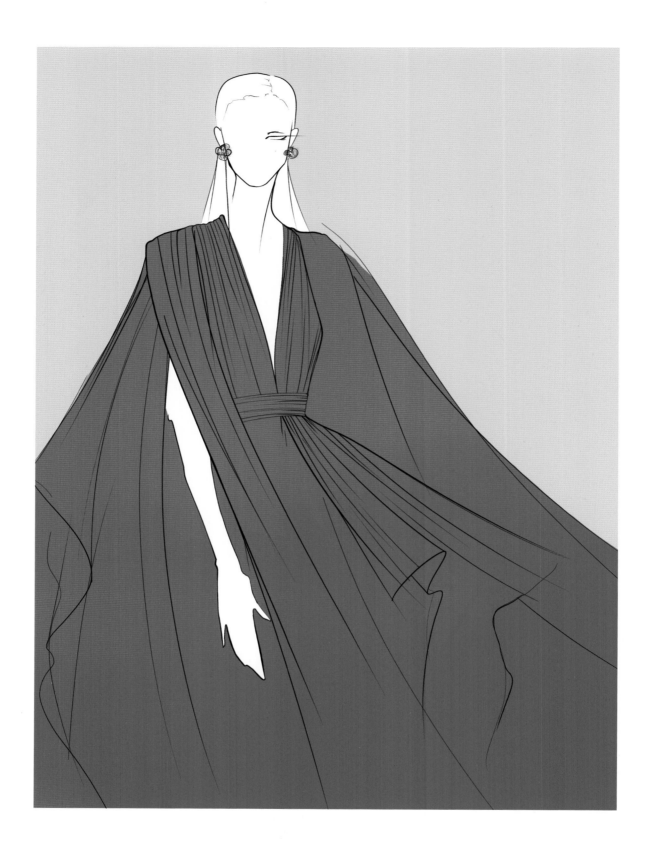

Voluminous gowns like this one are poetry in motion. *Above:* An illustration showcases the airy quality and graceful movement of the gown. Illustration by Andrew Cruz, design director.

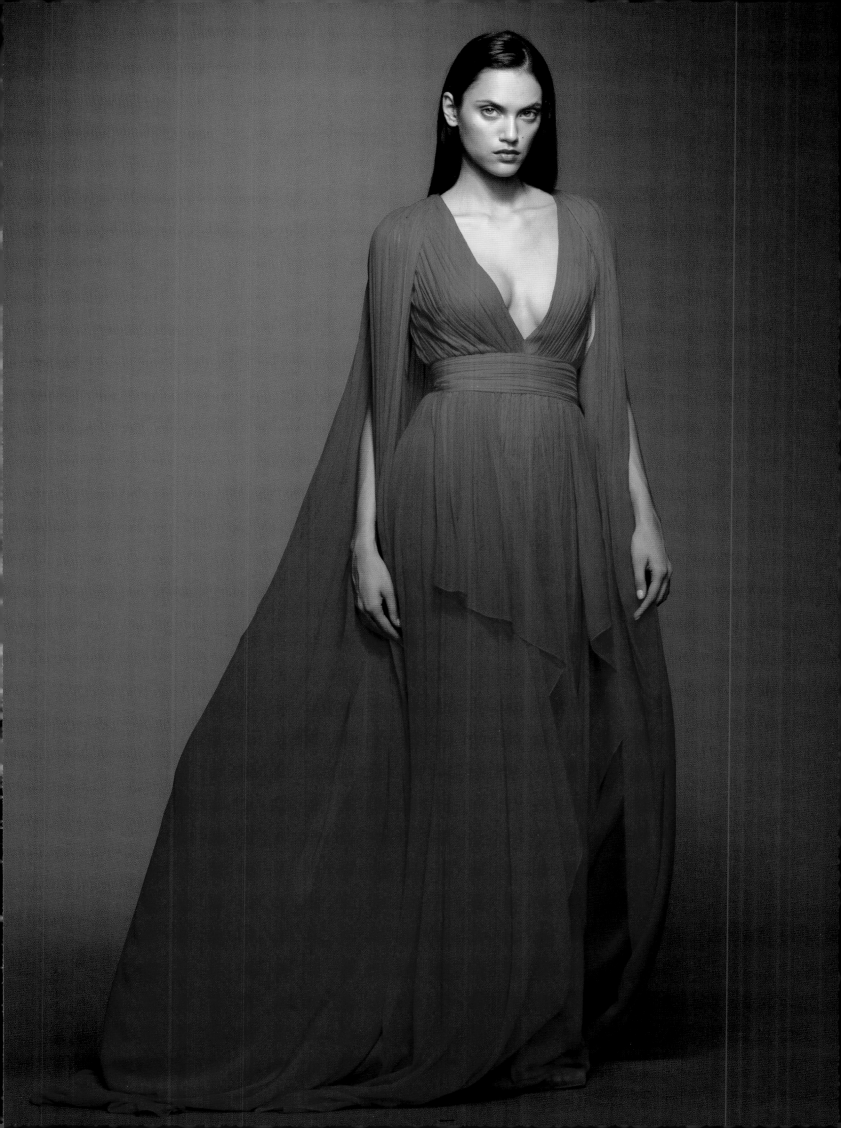

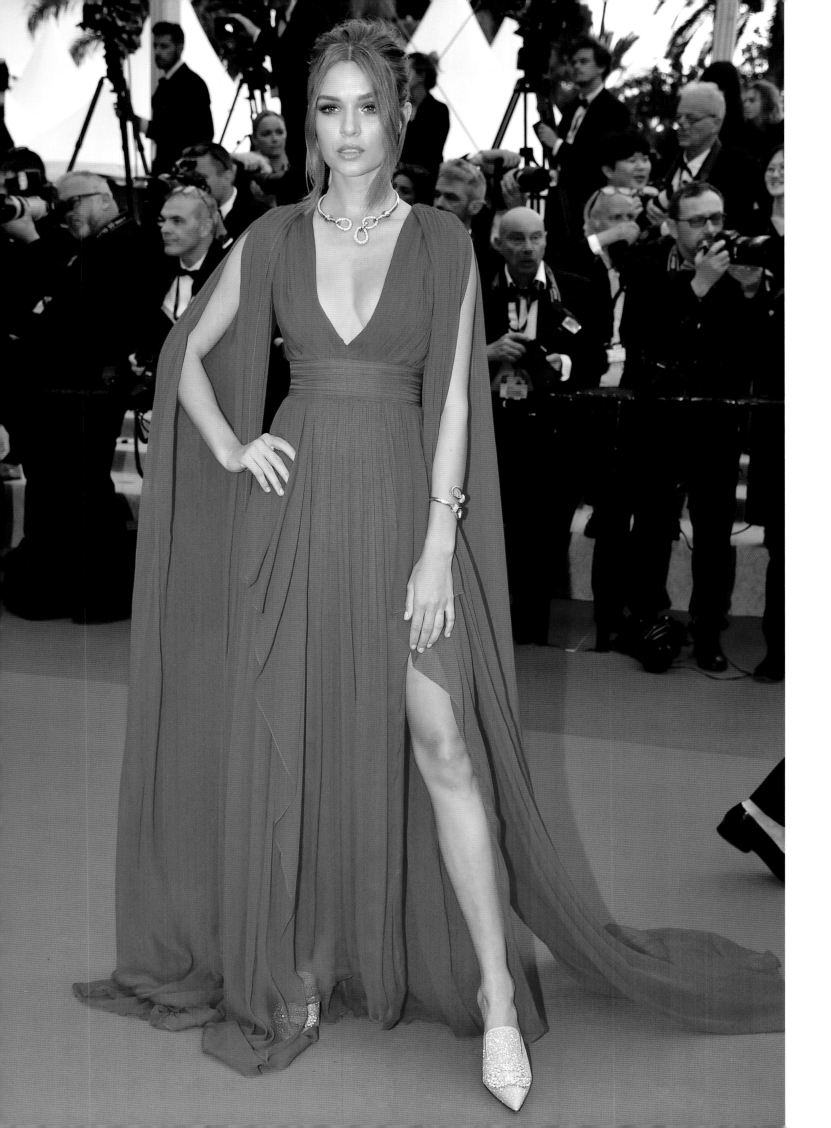

York. Our in-house collection sewers then incorporate them into a complete sample garment.

The sample allows us to get a sense of how this dress or suit will live off a mannequin. Sometimes, a sample is exactly as we envisioned it and is ready to hit the runway; other times, happy accidents make it even better.

Occasionally, we will get a sample and see the need to remove embroidery that is weighing it down or make other small adjustments before we are ready to share the garment with our clients or retail partners. This is our chance to adjust the fit, which has always been an incredibly important element to me. Even our most opulent designs need to be light and easy to wear. Our signature bustier is a big part of what makes our dresses fit so beautifully and comfortably. We design all our strapless silhouettes with one; however, sometimes, we get a sample of a different shape and see that it needs more structure. We then request a sample of the same dress with an added bustier.

There are so many people who work on a single garment, and I love the collaborative part of being a designer. I think I can speak for all of us when I say the best part of the design process is seeing the dress in its final form on a client. The garment comes to life and the client lights up.

*Opposite:* Model **Josephine Skriver** in the finished gown at the 72nd Annual Cannes Film Festival, 2019.

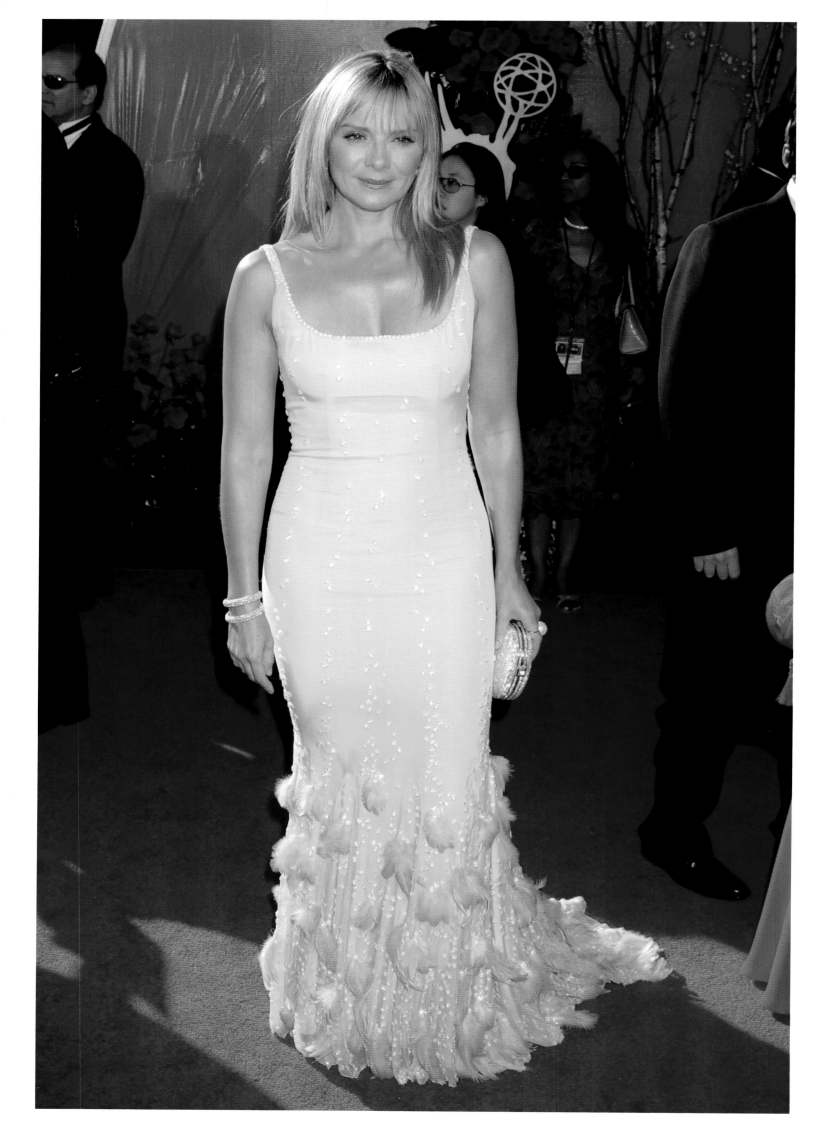

# on the red carpet

In 2004, *Sex and the City* star Kim Cattrall wore a gown from my Spring/Summer 2005 collection on the Emmys red carpet when she was nominated for an Emmy award. I had shown the gown from my collection at New York Fashion Week three days before the Emmys, and her stylist walked away with it and handed it straight to Kim. I remember being backstage at an event in a different part of the country and seeing her in my dress on television. I was screaming; it was like I had won an award.

Celebrities love our looks and it is truly an honor for me to help them celebrate some of the biggest moments of their careers. Awards season is a very busy and hectic time for designers and just about everyone in Hollywood. I like to think a Pamella Roland piece is the life of the party, and it is comfortable enough to wear into the wee hours of a special day.

One of the best compliments I have received is my dresses are easy to wear, even with all the complex, detailed embellishments. For me, fit comes first—from the custom stretch fabrics and ingenious cuts to the signature shaping inside the piece itself. My goal is to create pieces that look beautiful from every angle.

*Opposite:* Actress **Kim Cattrall** in a gown from the Spring/Summer 2005 collection at the 56th Primetime Emmy Awards, 2004.

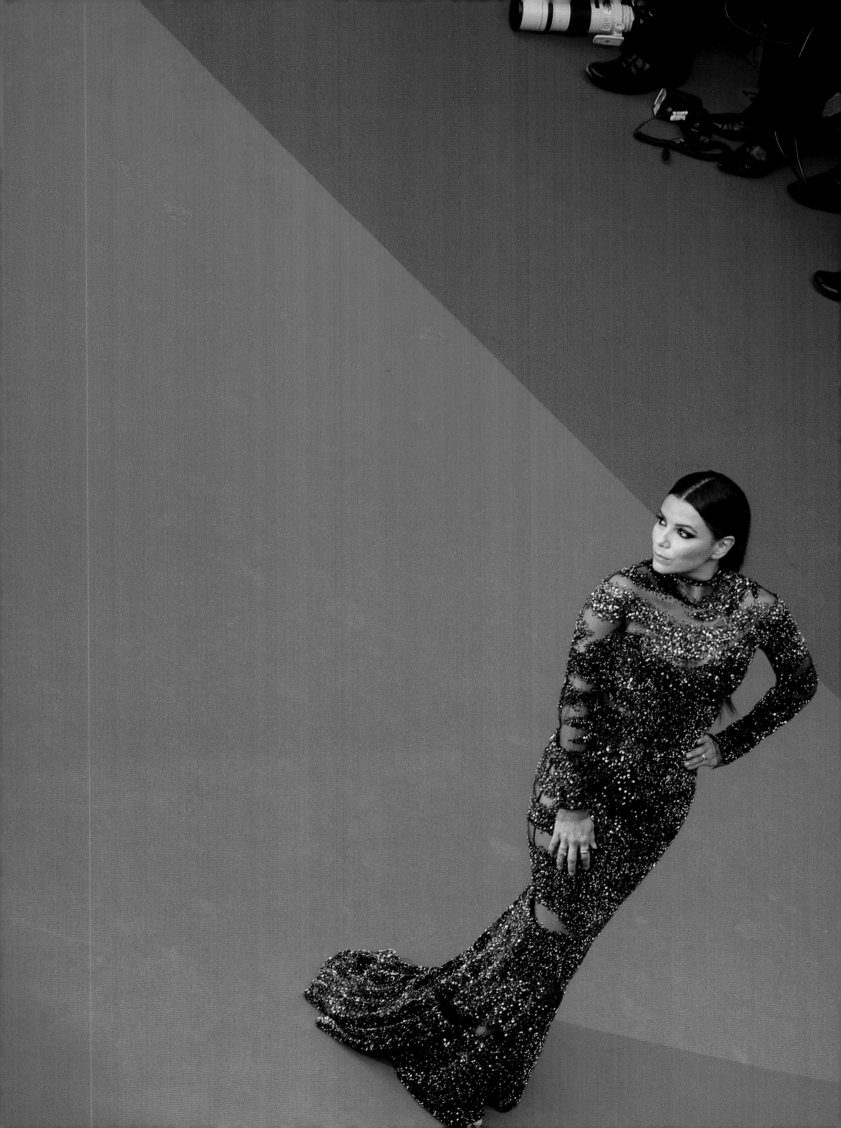

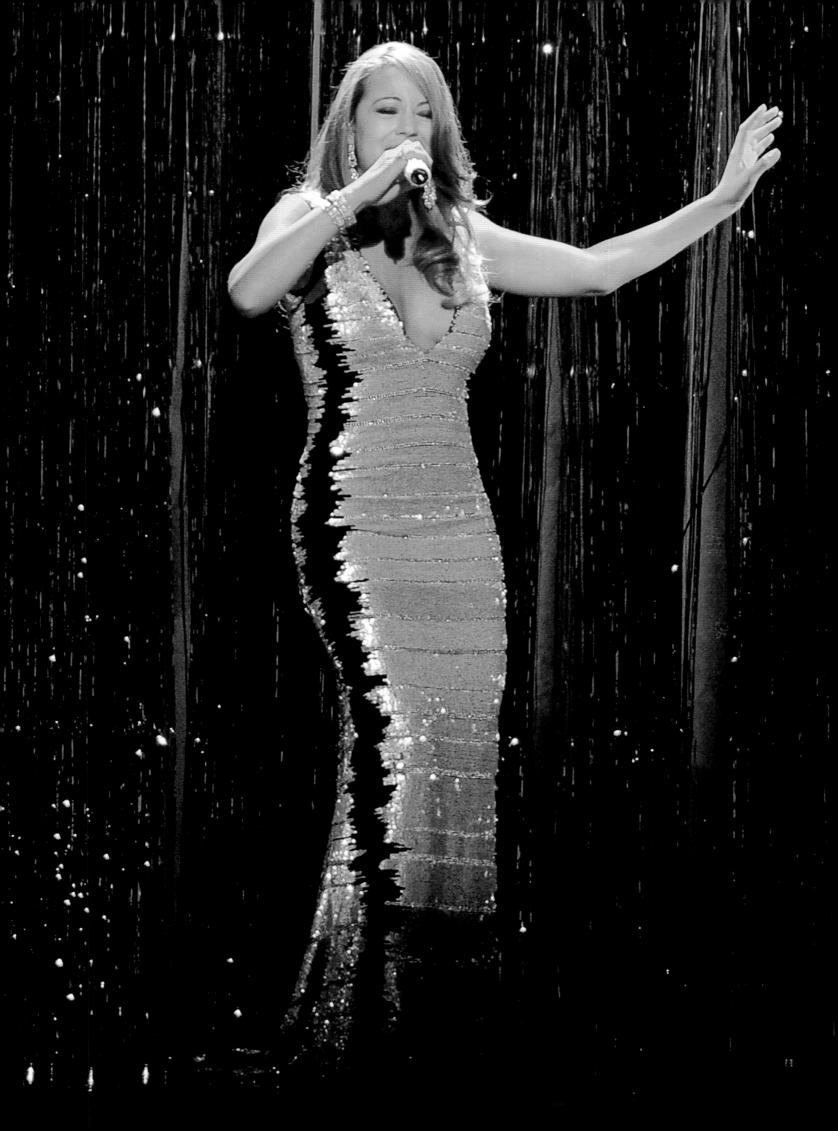

Previous spread: Actress **Eva Longoria** in a gown from the Fall/Winter 2017 collection at the 70th Annual Cannes Film Festival, 2017. *Opposite:* Designers dream of dressing singer **Mariah Carey**. I was honored she selected this sequin gown from the Fall/Winter 2008 collection to the Conde Nast Media Group's 5th Anniversary of Fashion Rocks.

*Opposite:* Actress **Leslie Mann** is the epitome of Hollywood glamour in this brilliant sequin gown with train. Perfect for the 2009 Oscars!

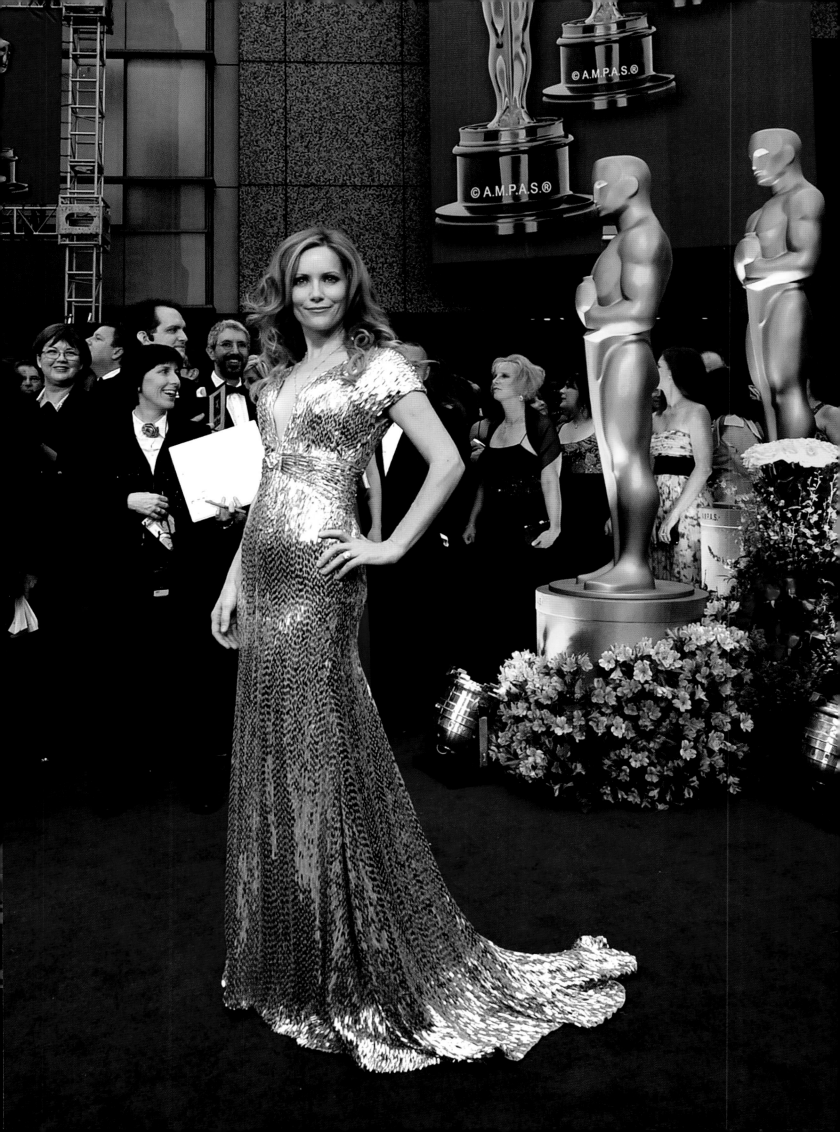

Actress **Zendaya** in a bustier from the Pre-Fall 2018 collection for a 2018 Lancôme lipstick campaign.

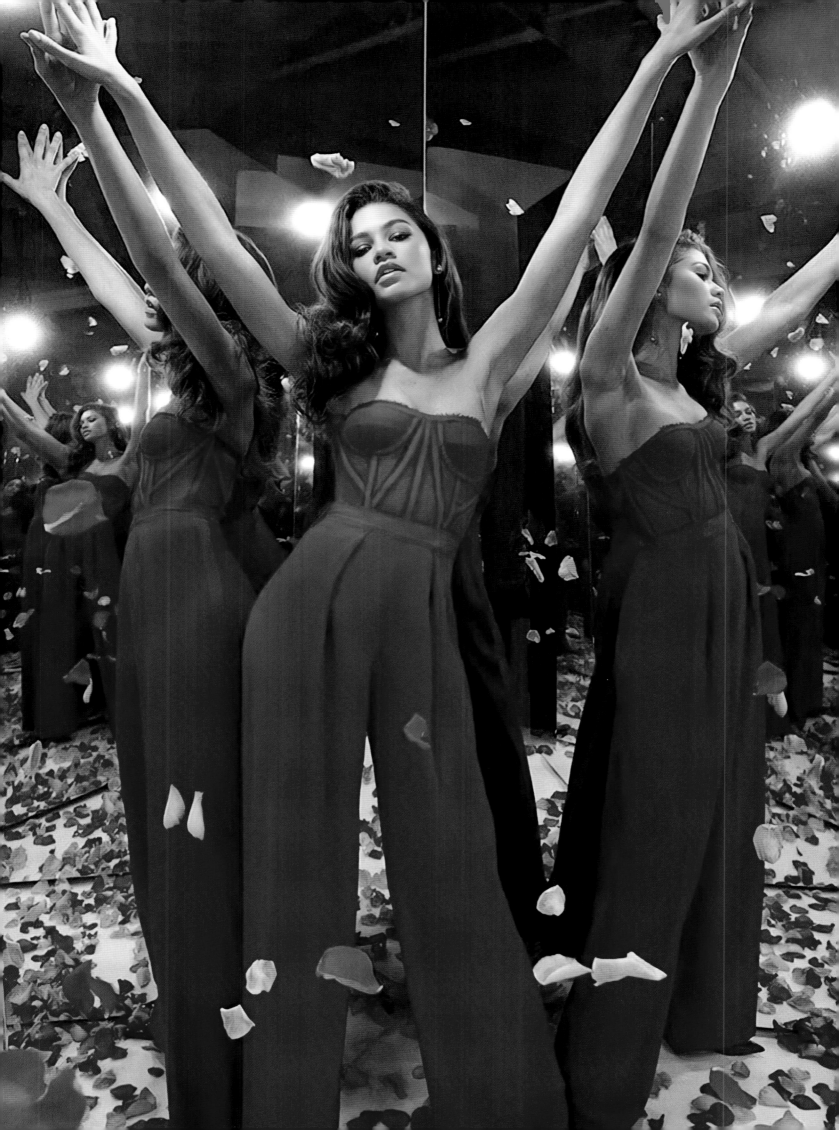

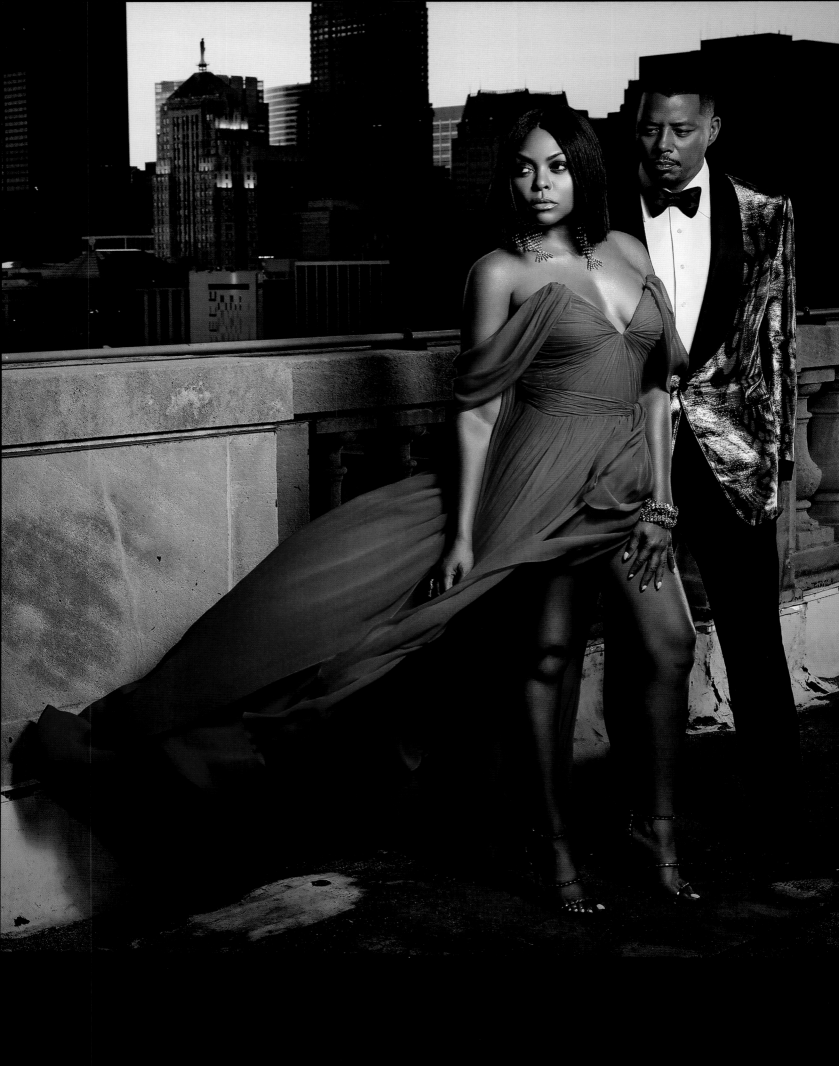

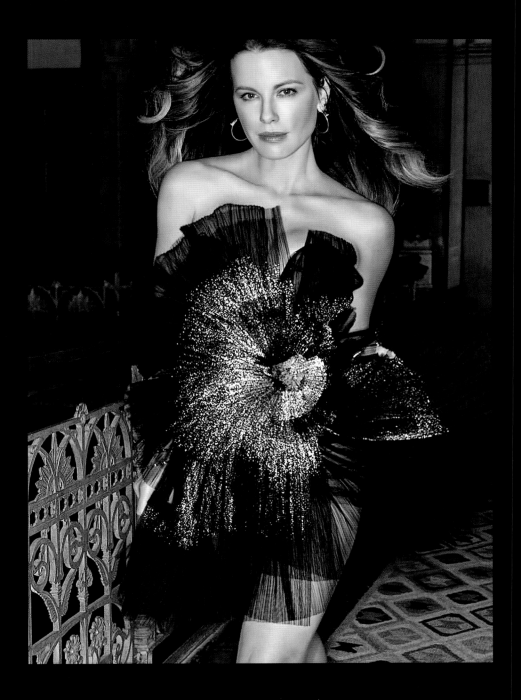

*Opposite:* Actress **Taraji P. Henson** in a gown from the Spring/Summer 2019 collection with her Empire costar **Terrence Howard** in a promo for *Empire* Season 6, 2019. *Above:* Actress **Kate Beckinsale** wears a cocktail dress from the Spring/Summer 2019 collection in *DuJour* magazine, 2019.

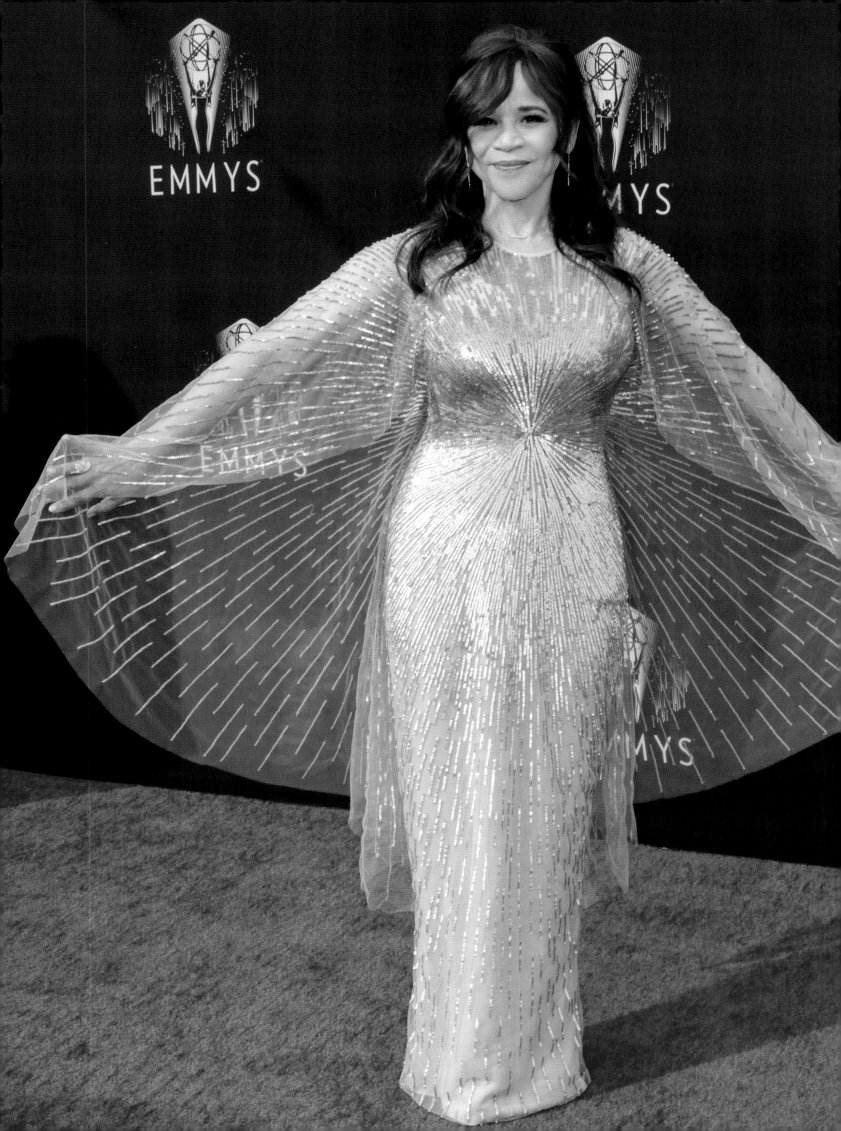

*Opposite:* Actress **Rosie Perez** gleams in gold at the 73rd Primetime Emmys, 2021. It was one of the first major awards shows after the COVID-19 lockdown. She fell in love with this gown and cape ensemble from the Spring/Summer 2022 collection.

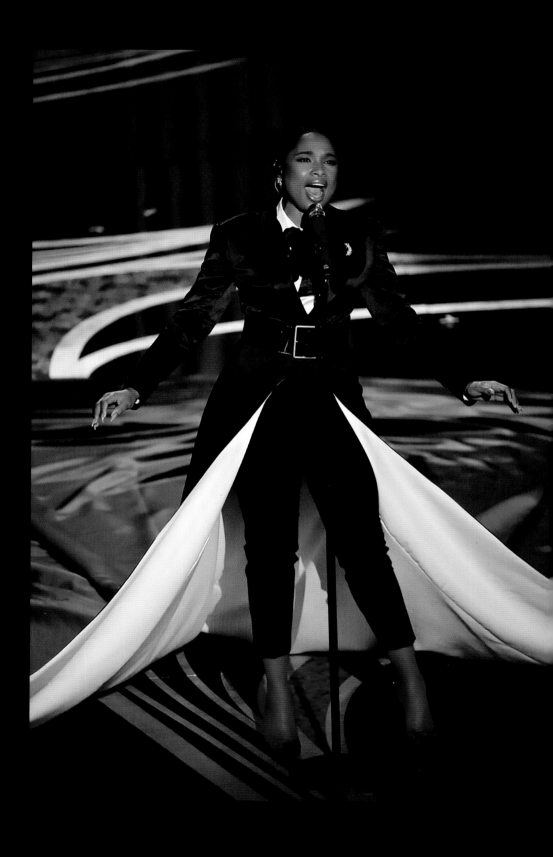

*Above:* Singer and actress **Jennifer Hudson** in a sweeping custom look at the 91st Academy Awards, 2019.

*Opposite:* Actress **Debra Messing** in a gown from the Pre-Fall 2019 collection at the 76th Golden Globe Awards, 2019.

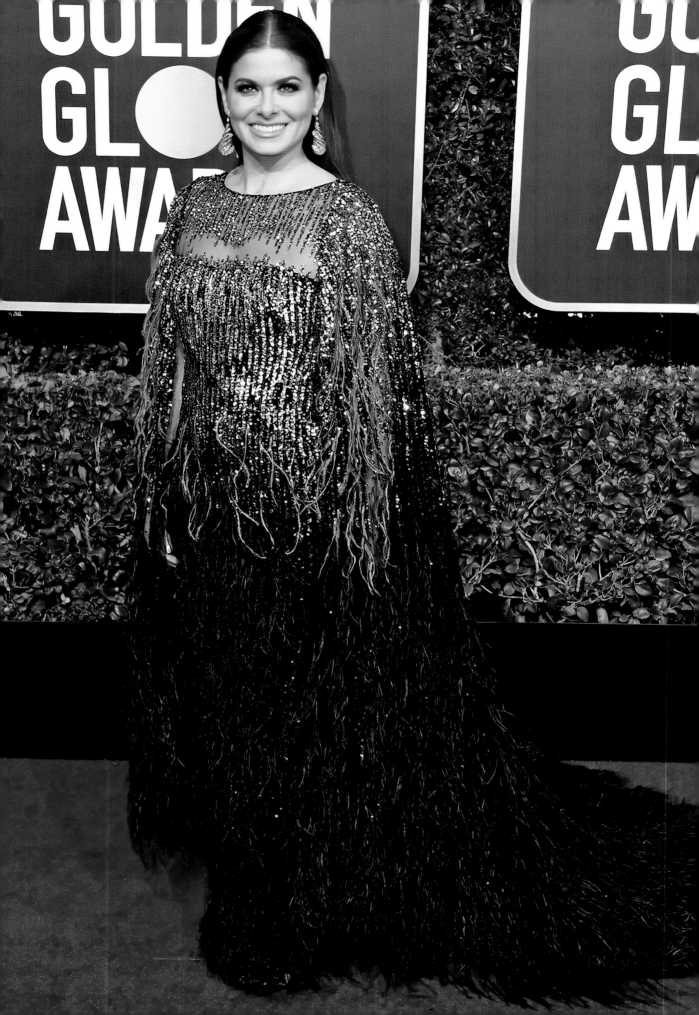

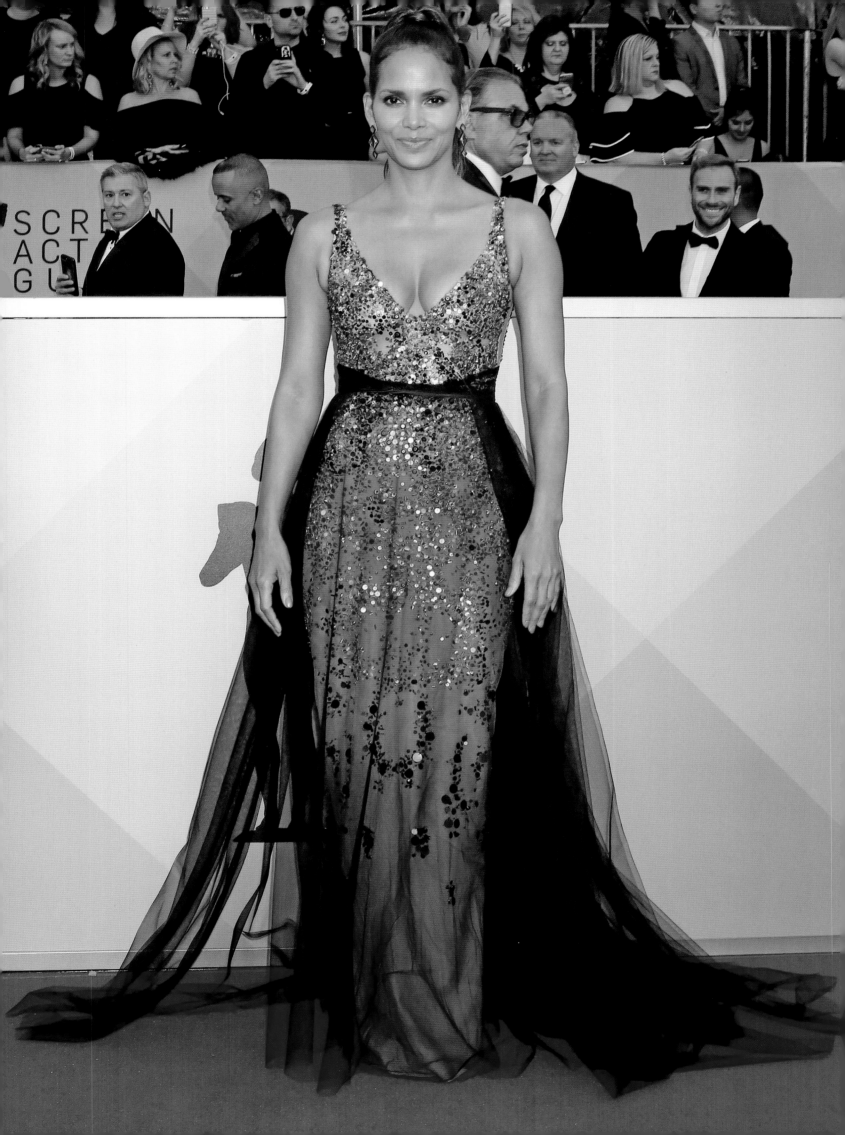

*Opposite:* Actress **Halle Berry** loved this gown from the Pre-Fall 2018 collection. Her customized version, however, was stuck in customs. My amazing team replaced the crystals on the runway sample and delivered it just in time for her to walk the red carpet. The gown she ordered arrived the day after the awards show. *Following spread left:* Actress **Kristin Chenoweth** in a gown from the Spring/Summer 2021 collection at the New York City Ballet Fall Fashion Gala, 2021. *"I love that Pamella designs for all shapes and sizes for women. She understands the structure and lightness of a body. In my case, I love pink, and I love a corset to give myself a longer torso. And the lightness of the feathers weren't too heavy for my frame. She's a true artist."* — **Kristin Chenoweth**. *Following spread right:* Rapper **Nicki Minaj** in a gown from the Fall/Winter 2018 collection at the Daily Front Row Fashion Media Awards, 2018.

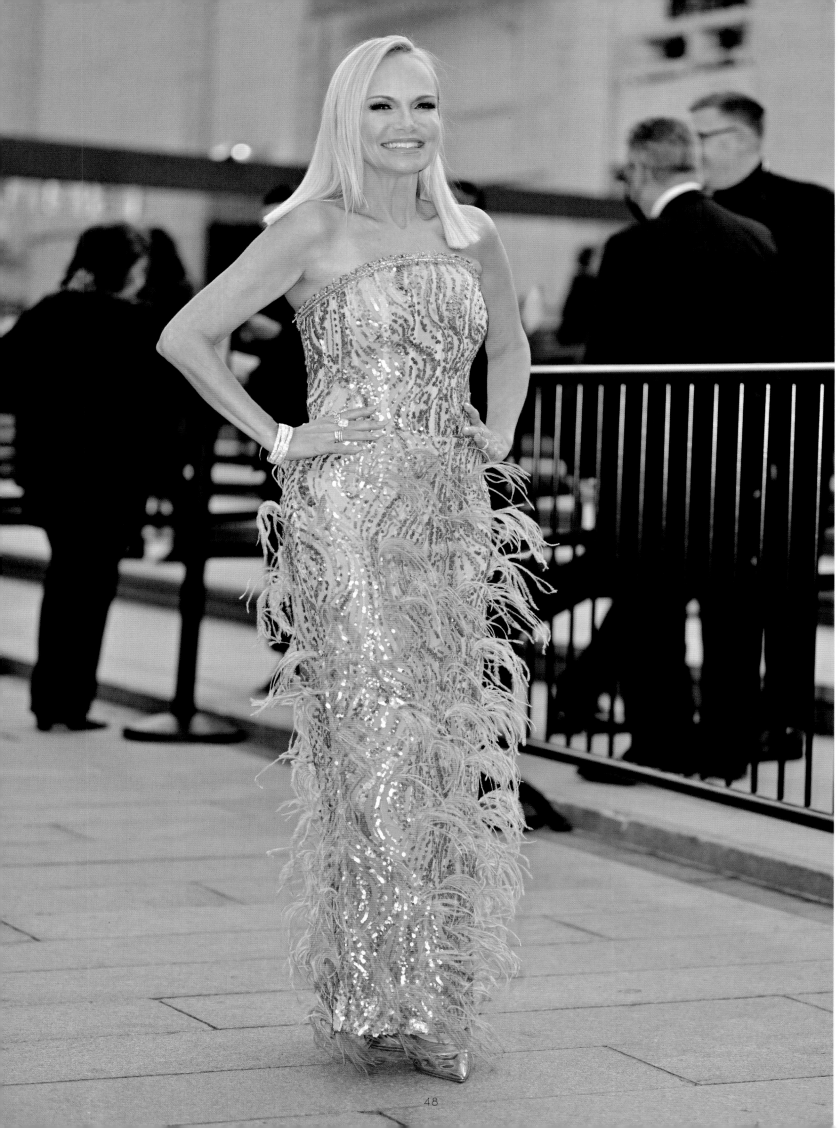

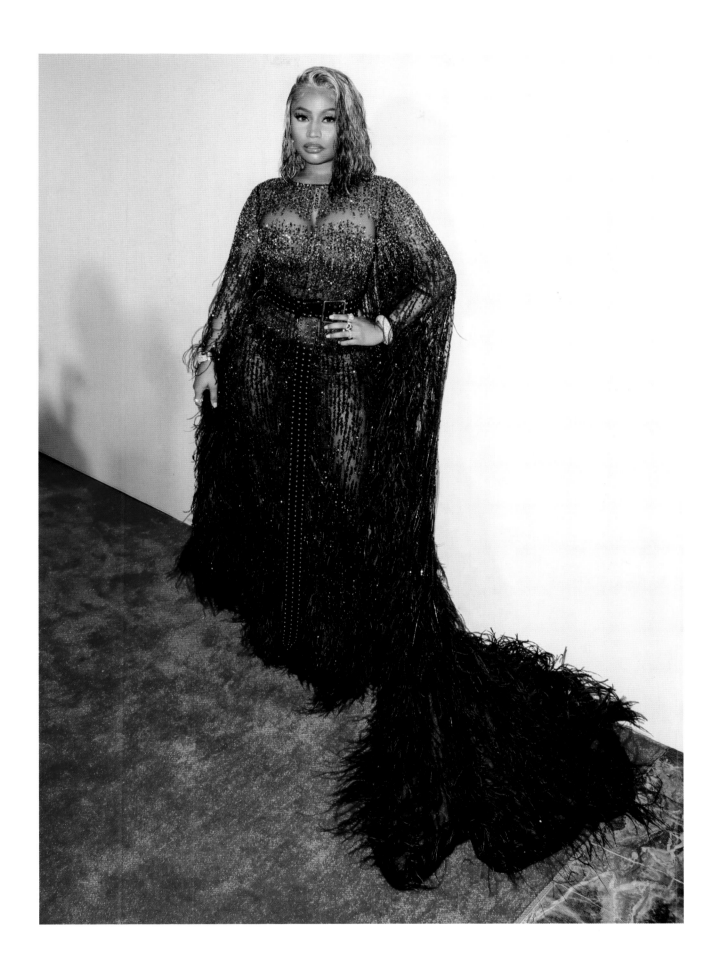

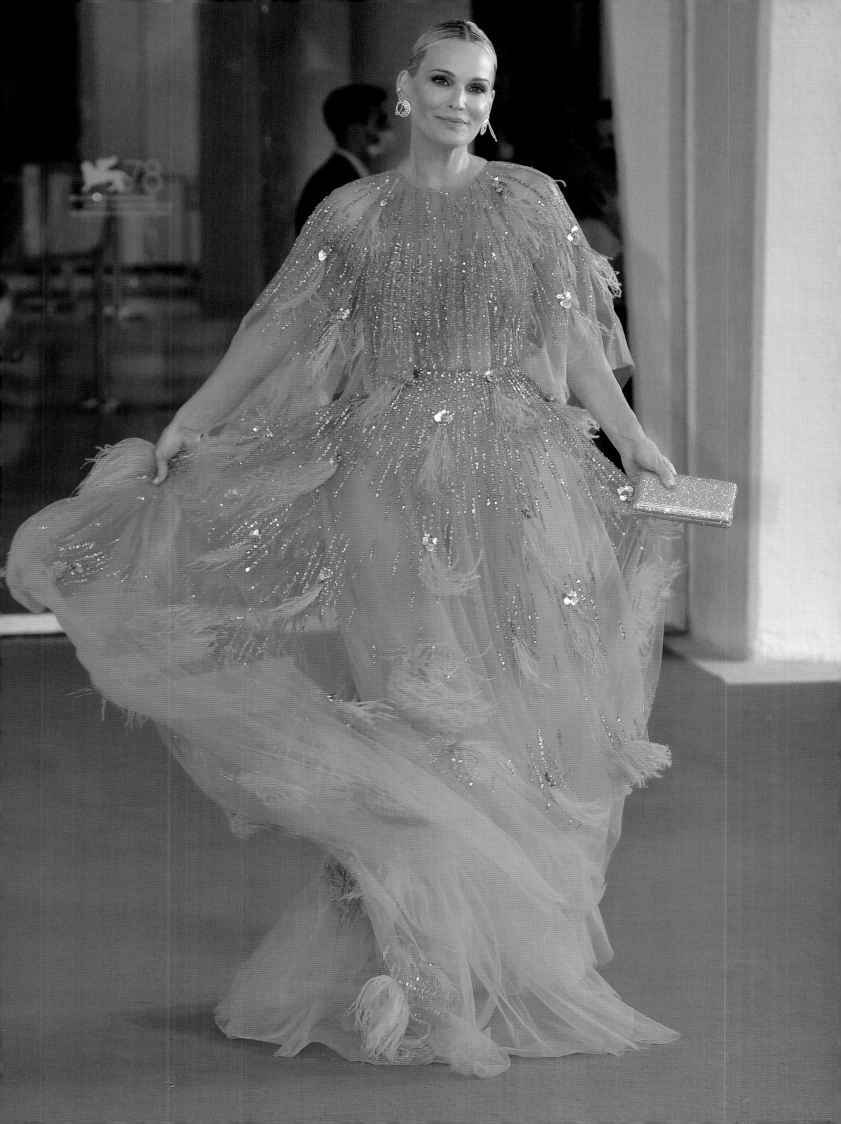

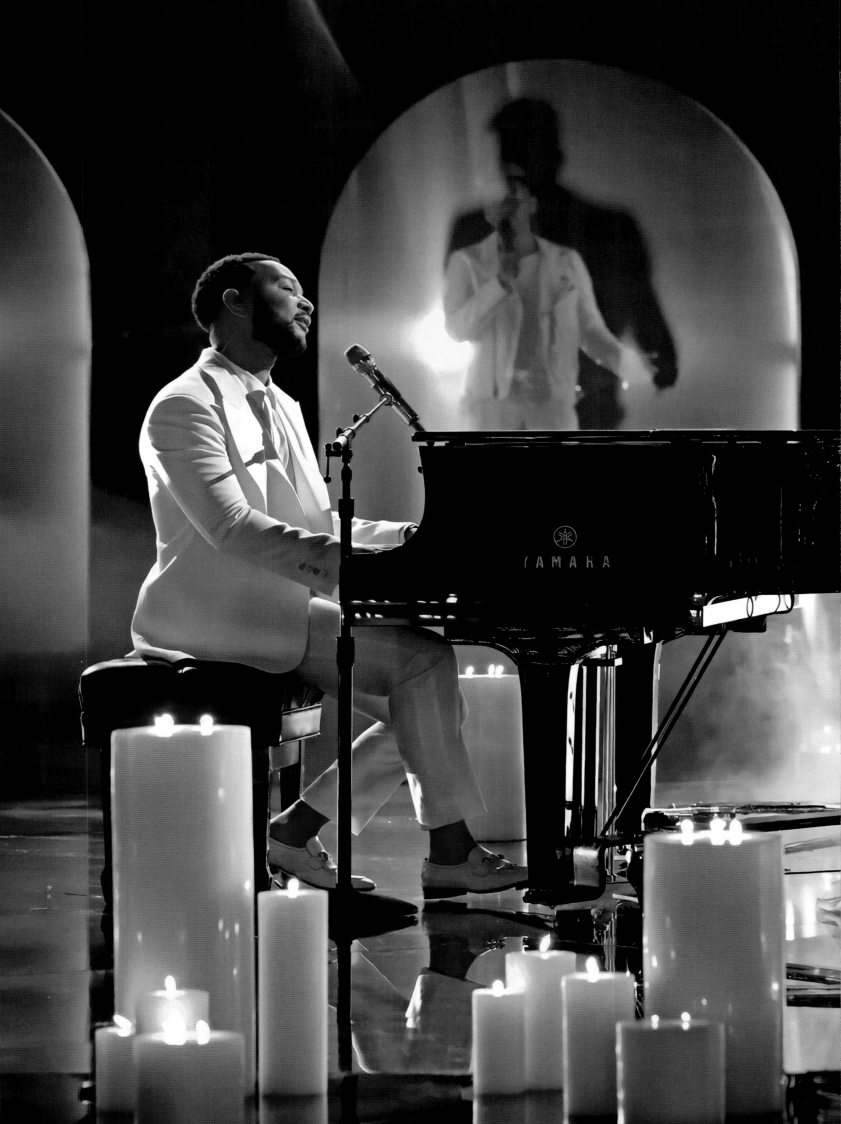

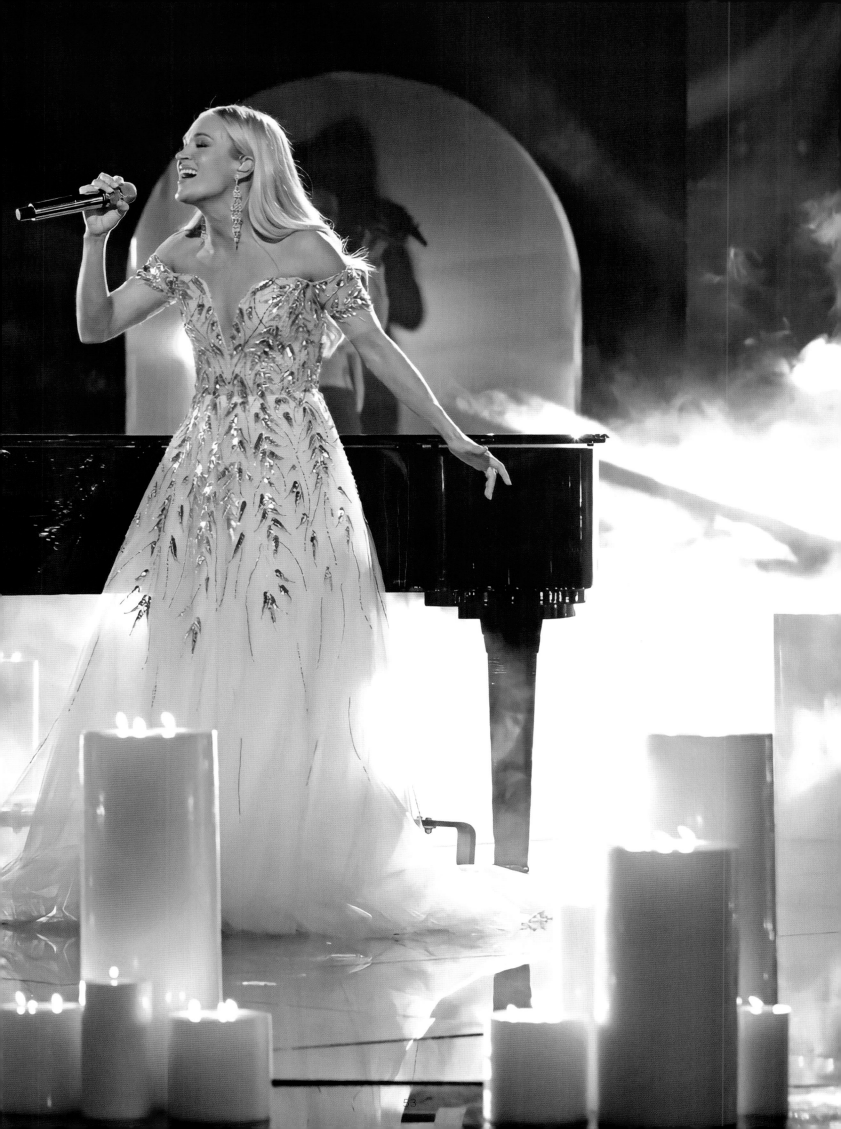

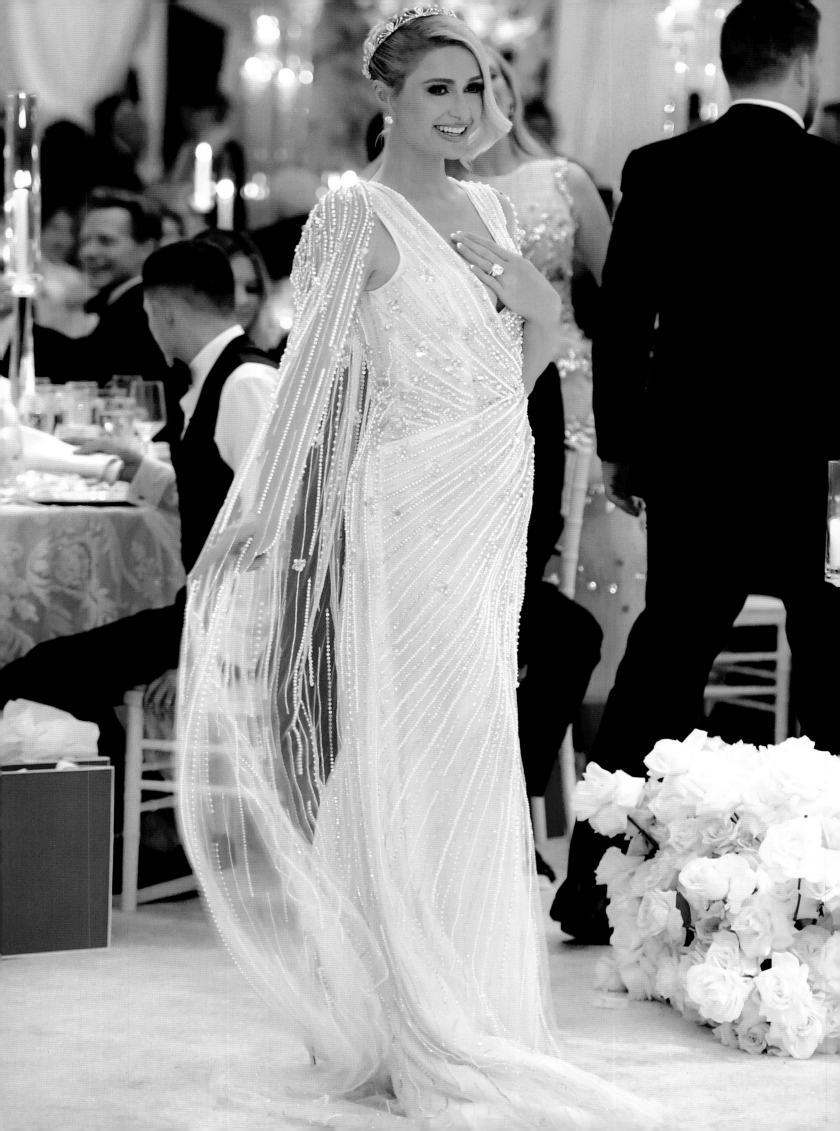

Page 50: Actress **Angela Bassett** in a custom gown at the Glamour Women of the Year Awards, 2022. *Page 51:* Actress **Molly Sims** in a gown from the Spring/Summer 2020 collection at the 78th Venice International Film Festival, 2021. *Previous spread:* Singer **Carrie Underwood** in a strapless gown from the Pre-Fall 2021 collection, performing with **John Legend**, 2021. *Opposite:* **Paris Hilton** has been a champion of our brand from the very beginning. I was so happy to dress her in a custom gown for her beautiful wedding in 2021. *"I love Pamella Roland's dresses. They are so beautiful and chic and I always feel like a princess in them."* **— Paris Hilton**

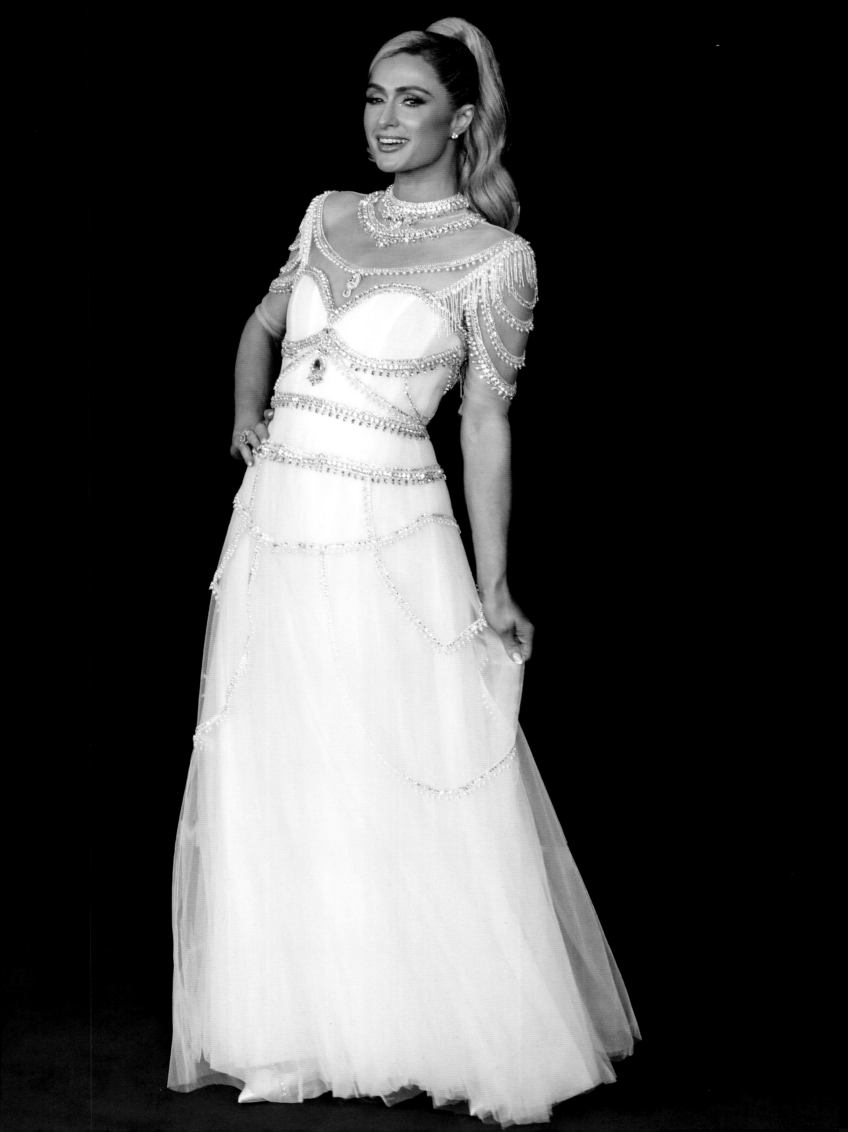

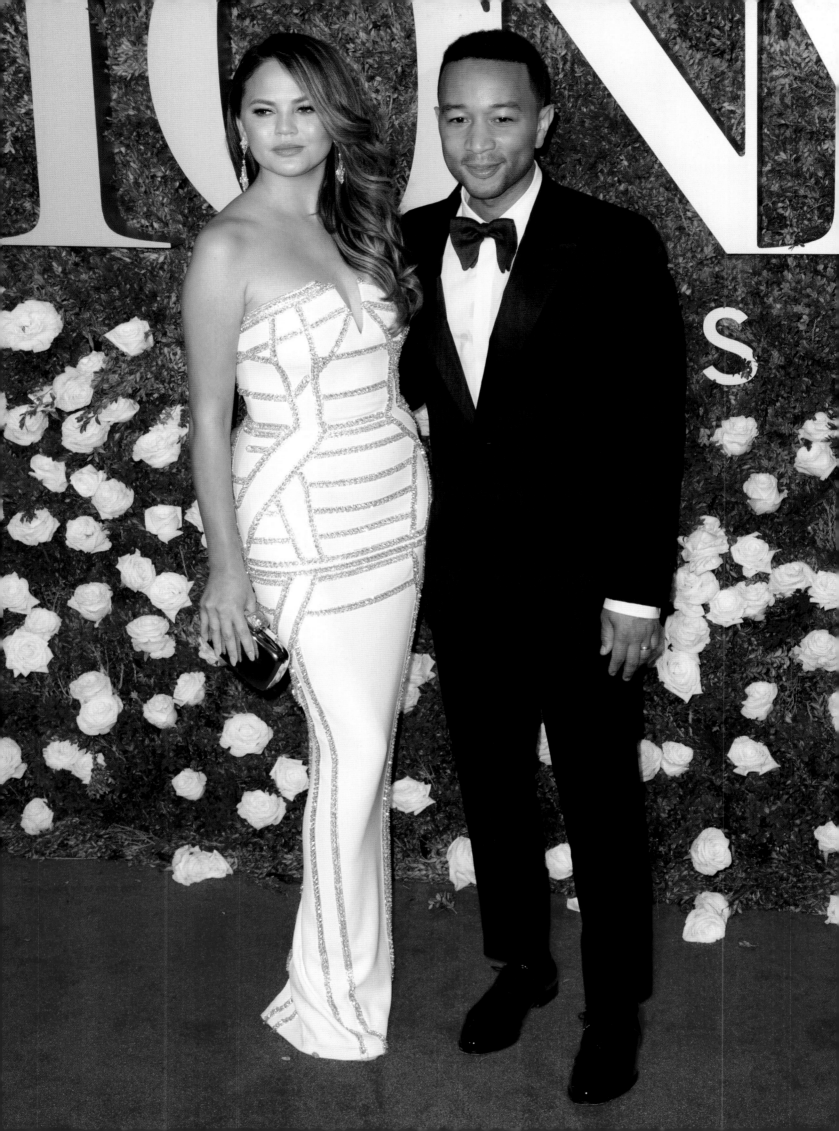

*Previous spread left:* **Paris Hilton** wore a custom gown to the 2021 LACMA Art+Film Gala as a kind of teaser for her nuptials. *Previous spread right:* Model **Chrissy Teigen** in a custom gown with her husband **John Legend** at the 71st Annual Tony Awards, 2017. *Opposite:* Photographer **Renell Medrano** in a tulle ballgown from the Resort 2018 collection with **A$AP Ferg** at the *Heavenly Bodies: Fashion and The Catholic Imagination* Costume Institute Gala, 2018. Dressing the talented photographer was a beautiful surprise, as we met her stylist's last-minute request.

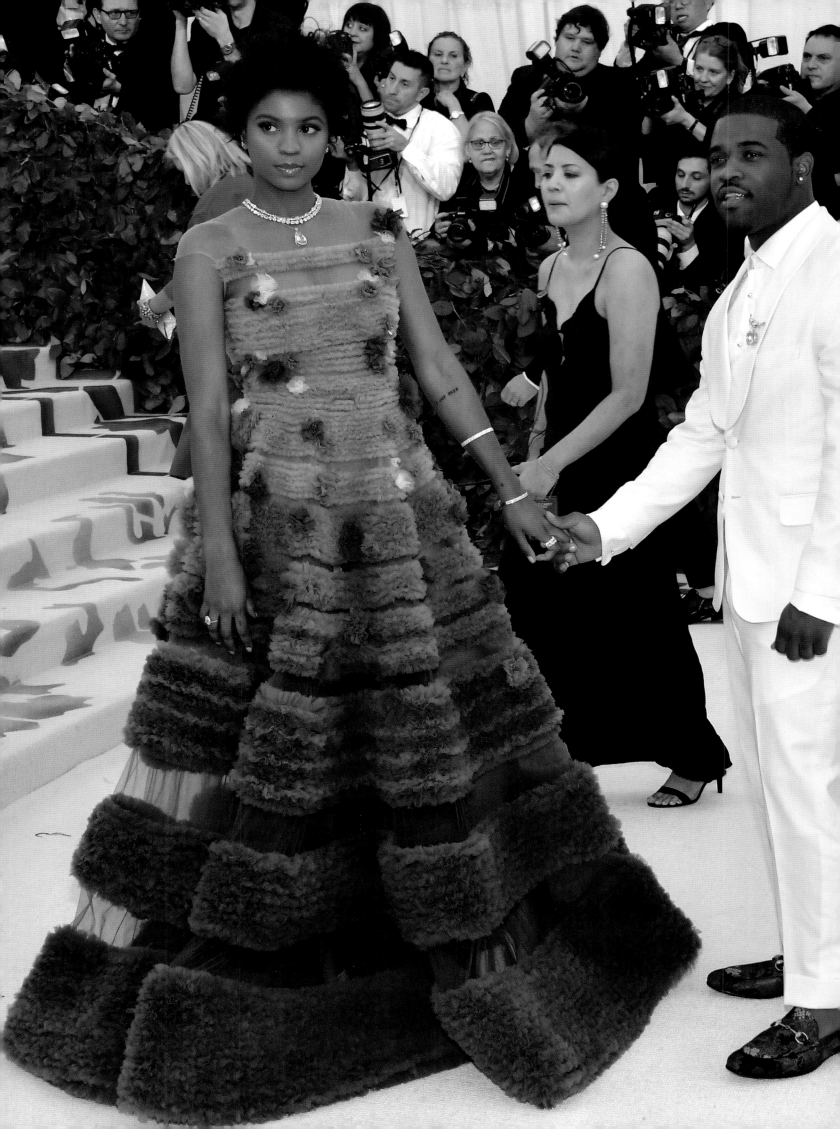

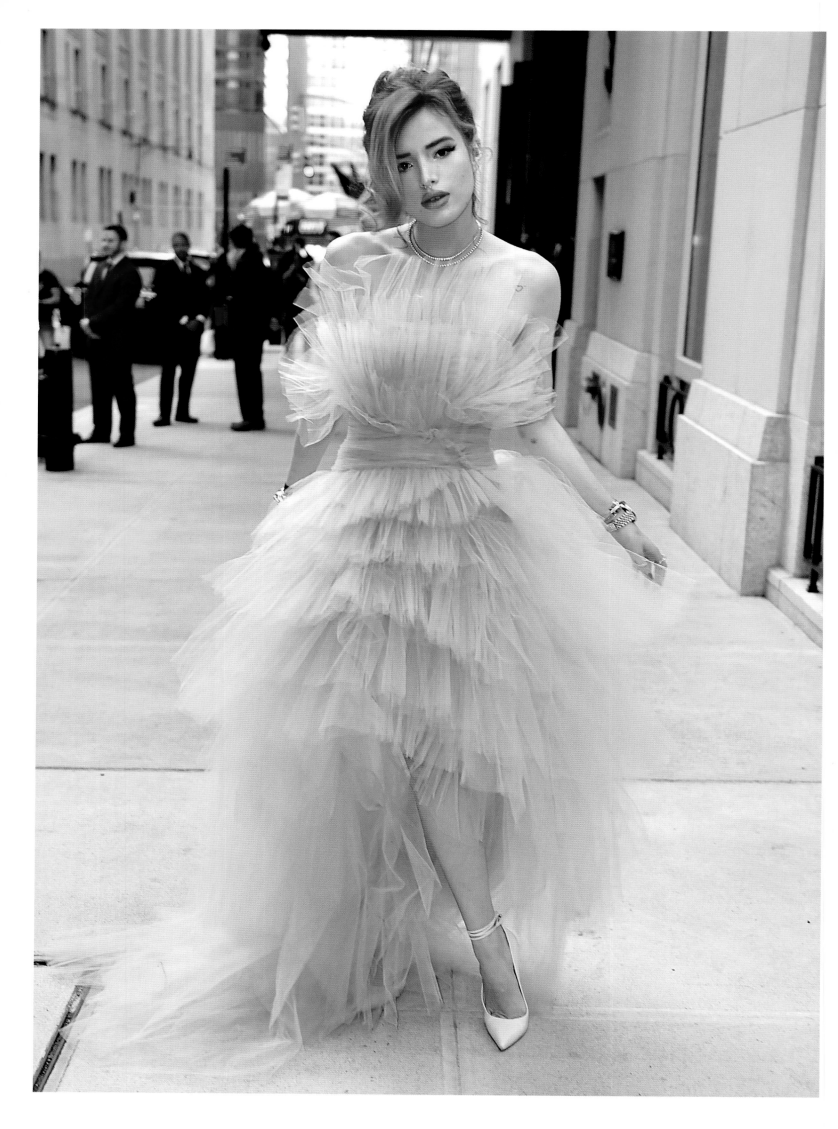

*Opposite:* Not often do we hand a dress straight from the runway to a celebrity, but actress **Bella Thorne** had to have this dress two days after it premiered at the Spring/Summer 2018 runway show. *Following spread, from left to right:* Model **Gigi Hadid** in a custom suit, 2017; actress **Lindsay Lohan** in a jumpsuit from the Spring/Summer 2009 collection; model **Devon Windsor** in a jumpsuit with jacket from the Spring/ Summer 2019 collection; model **Joan Smalls** in a bustier and trousers with jacket from the Pre-Fall 2018 collection.

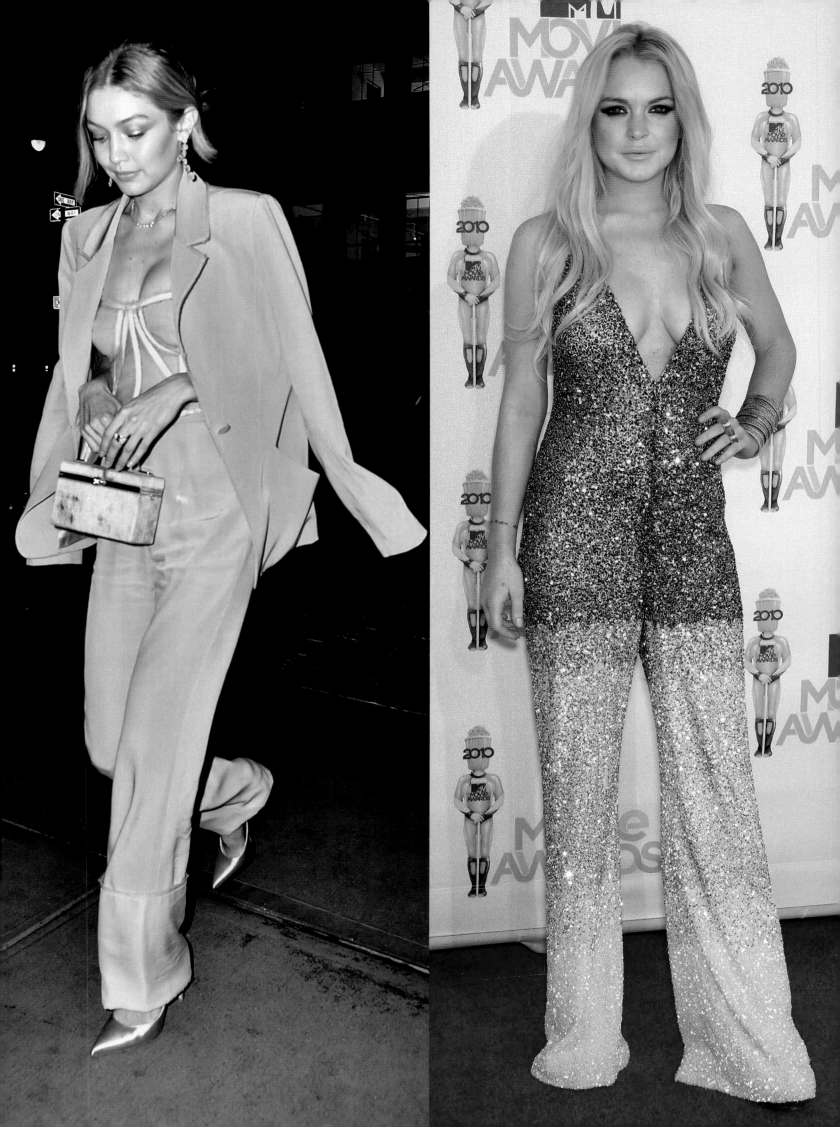

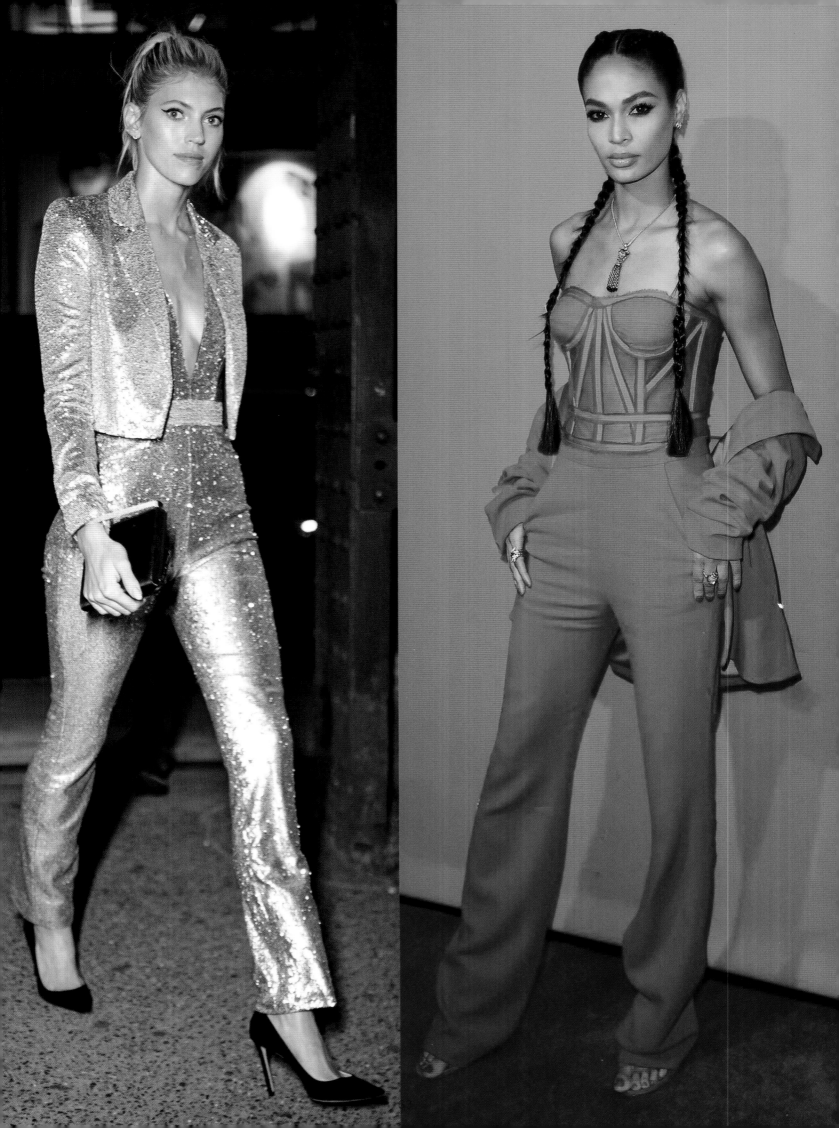

*Opposite:* **Paris Hilton** wears a sequin pearl suit from the Spring/Summer 2020 collection on the cover of UK *Cosmopolitan. Following spread left:* Model **Paola Turani** in a gown from the Spring/Summer 2022 collection at the 75th Annual Cannes Film Festival, 2022. *Following spread right:* Actress **Madalina Diana Ghenea** in a gown from the Spring/Summer 2022 collection at the 75th Annual Cannes Film Festival, 2022. *Page 68:* Actress **Catherine Zeta-Jones** in a leather slit dress from the Spring/Summer 2017 collection on *Jimmy Kimmel Live!*, 2017.

*Page 69:* Actress **Mindy Kaling** in a gown from the Fall/Winter 2022 collection. *"I loved the gown I wore to the baby2baby gala. The column fit is so elegant and simple, but the embroidery was resplendent, it was a great contrast."* — **Mindy Kaling** *Page 70:* TV personality **Kelly Osbourne** in a gown with cape from the Spring/Summer 2013 collection. *Page 71:* Actress **Faye Dunaway** in a gold gown from the Fall/Winter 2007 collection with her son **Liam Dunaway O'Neill** at the 80th Academy Awards, 2008.

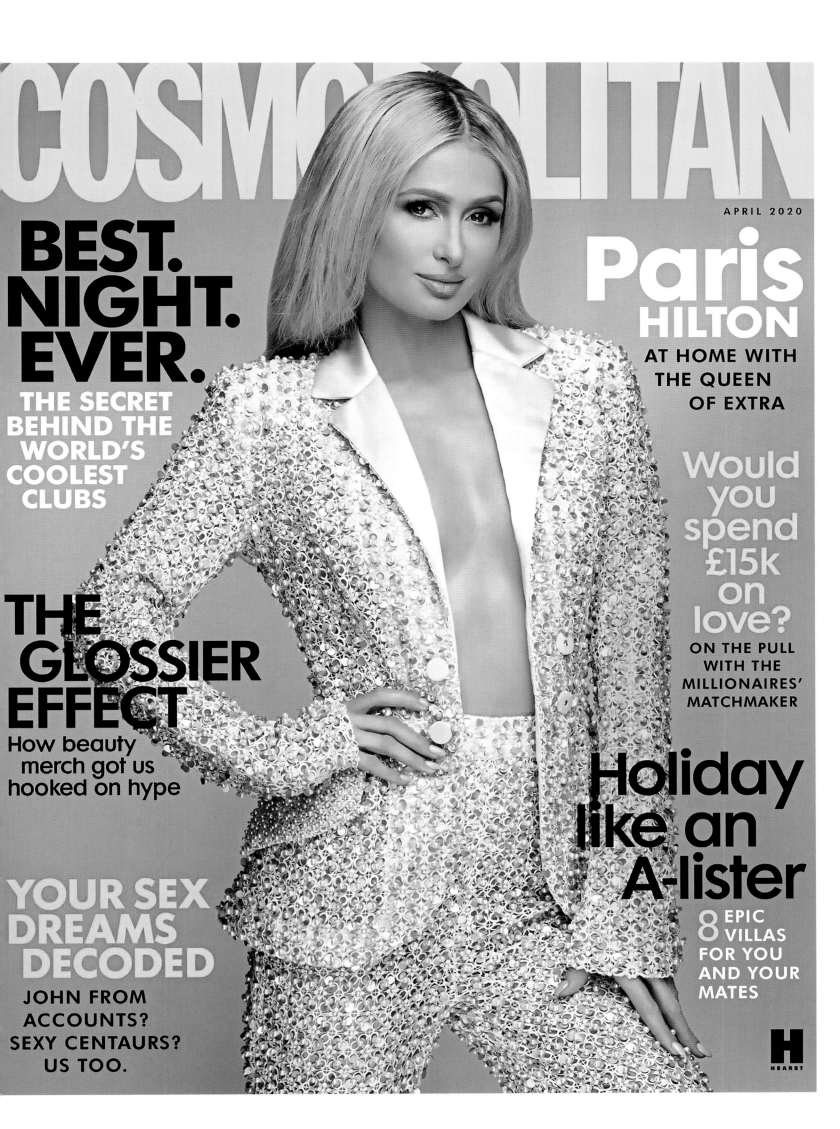

# COSMOPOLITAN

APRIL 2020

## BEST. NIGHT. EVER.

**THE SECRET BEHIND THE WORLD'S COOLEST CLUBS**

## THE GLOSSIER EFFECT

How beauty merch got us hooked on hype

## YOUR SEX DREAMS DECODED

JOHN FROM ACCOUNTS? SEXY CENTAURS? US TOO.

## Paris HILTON

AT HOME WITH THE QUEEN OF EXTRA

## Would you spend £15k on love?

ON THE PULL WITH THE MILLIONAIRES' MATCHMAKER

## Holiday like an A-lister

**8 EPIC VILLAS FOR YOU AND YOUR MATES**

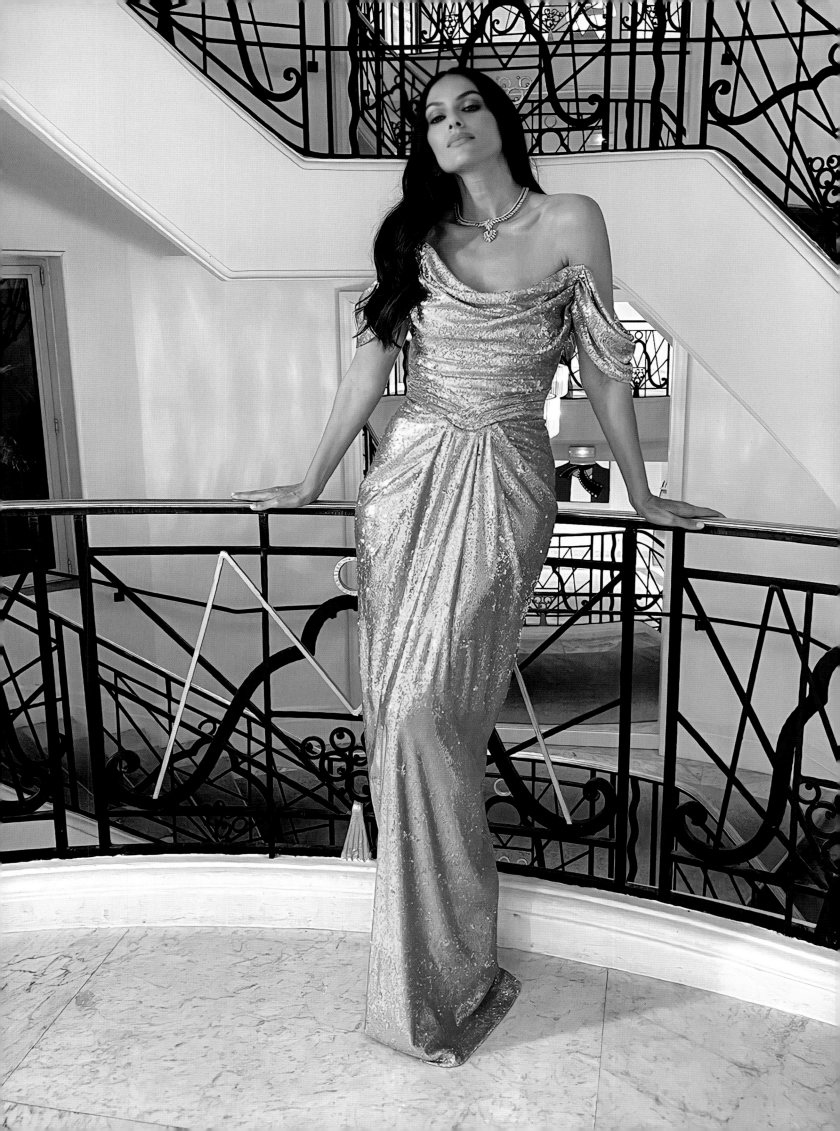

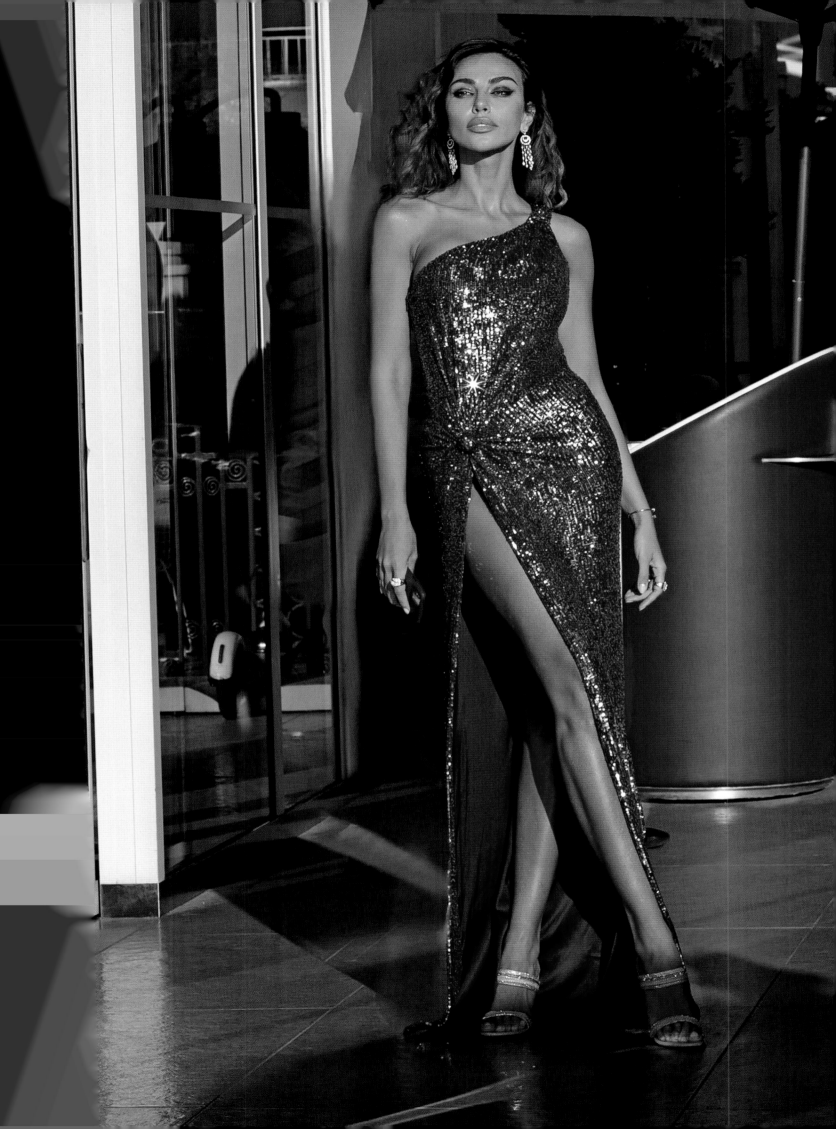

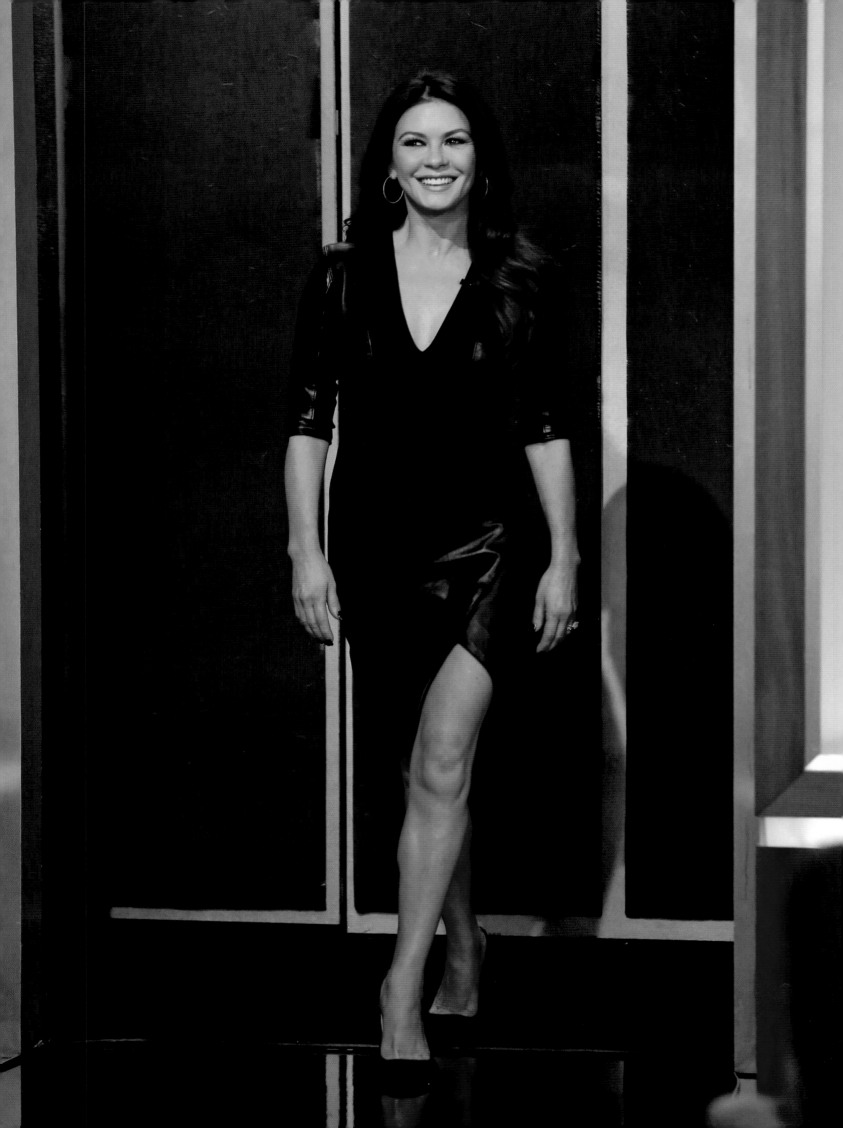

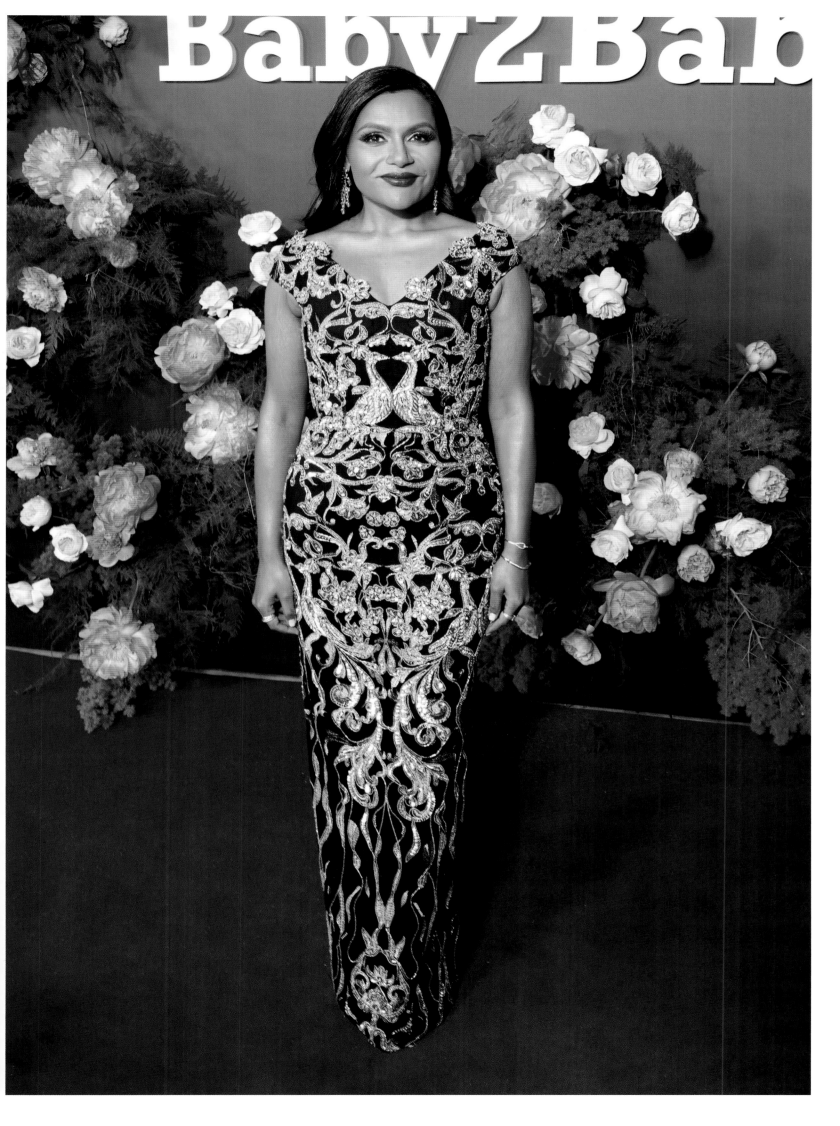

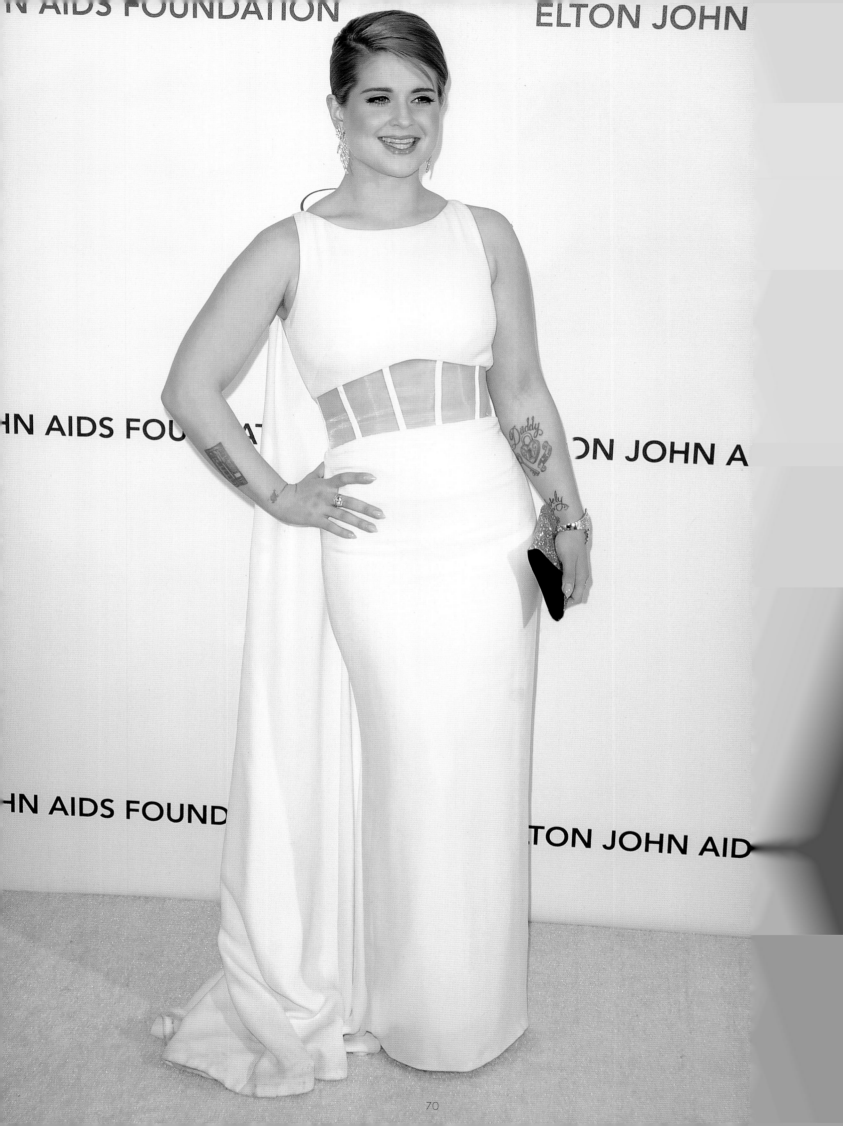

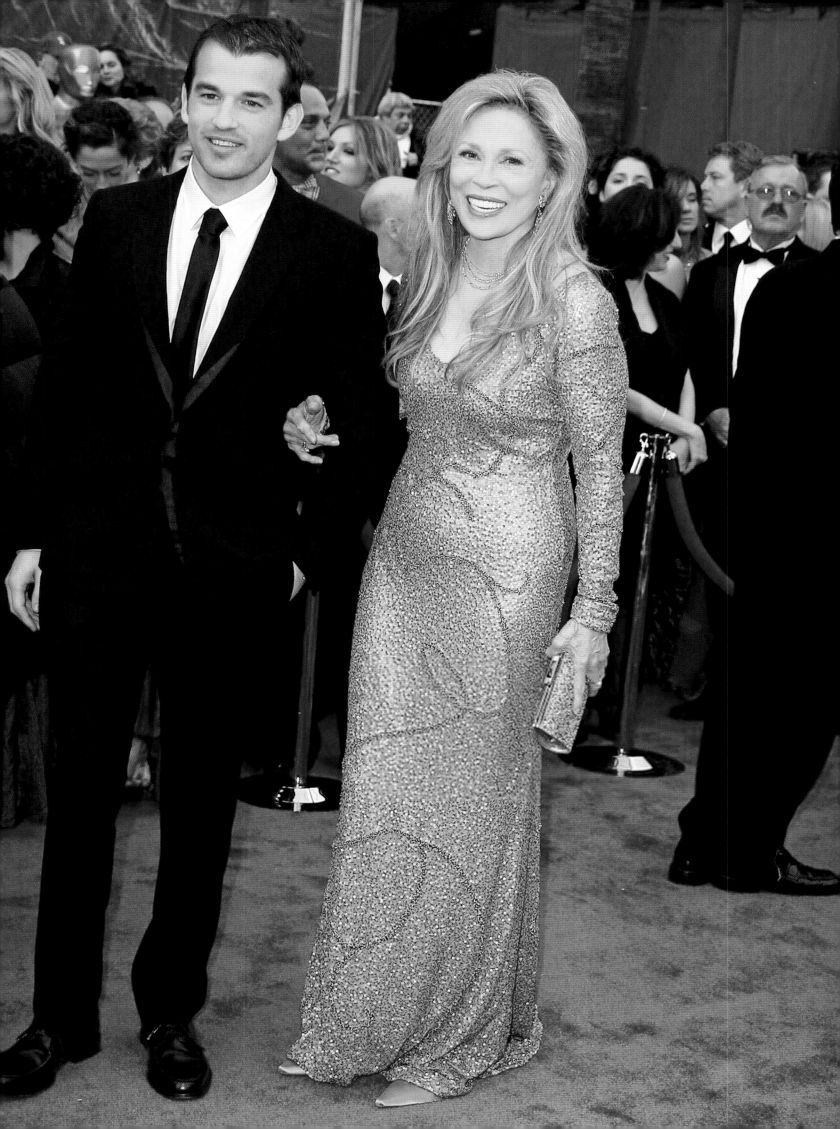

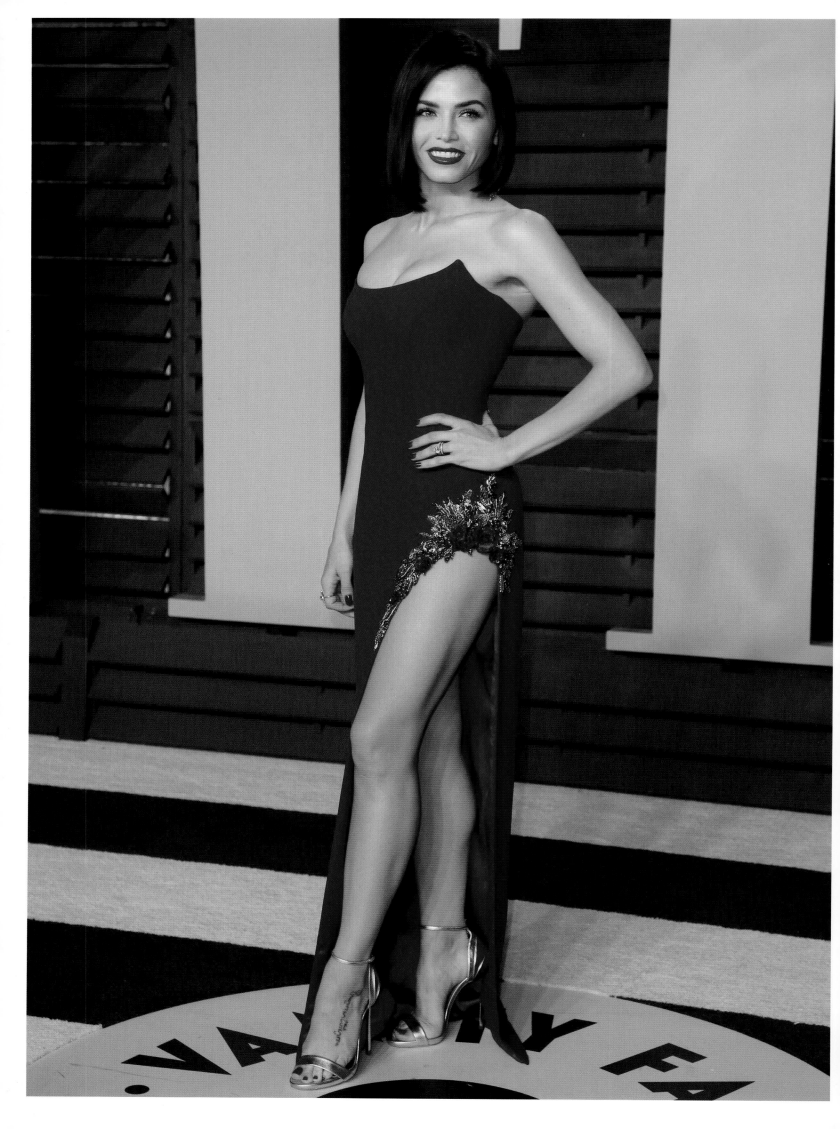

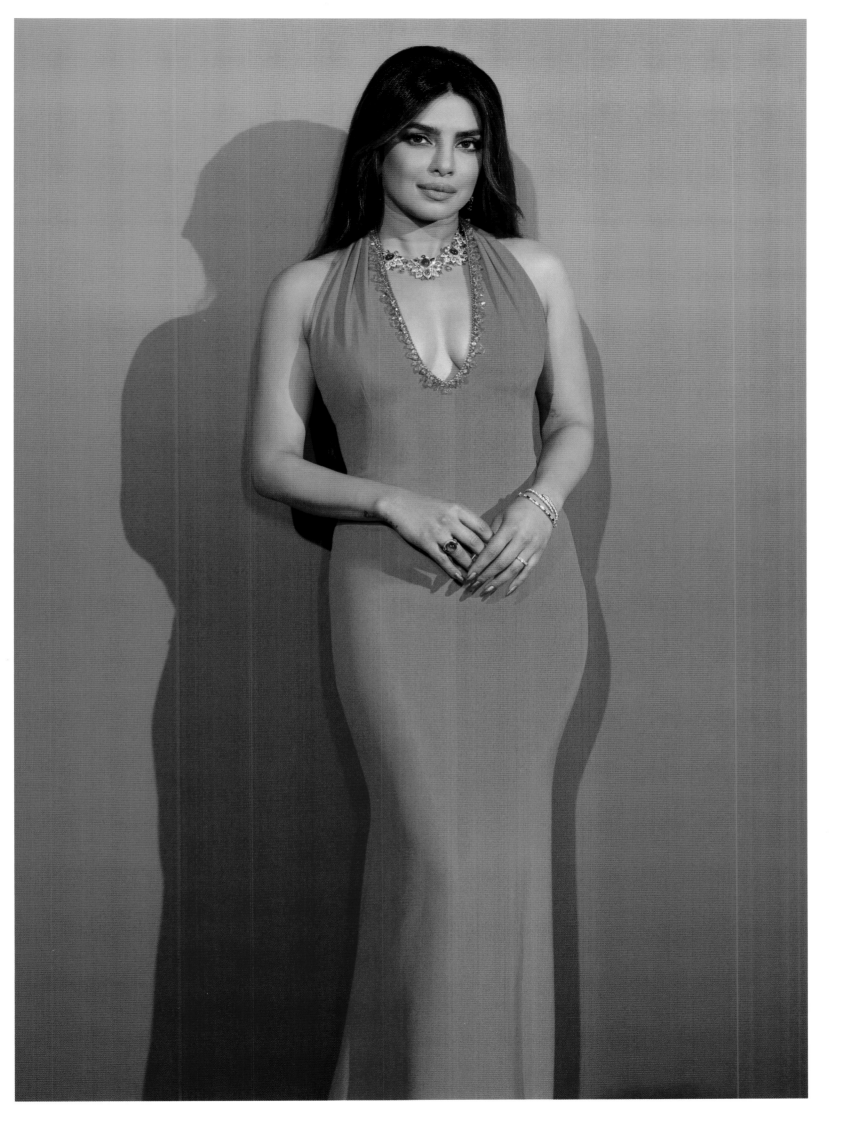

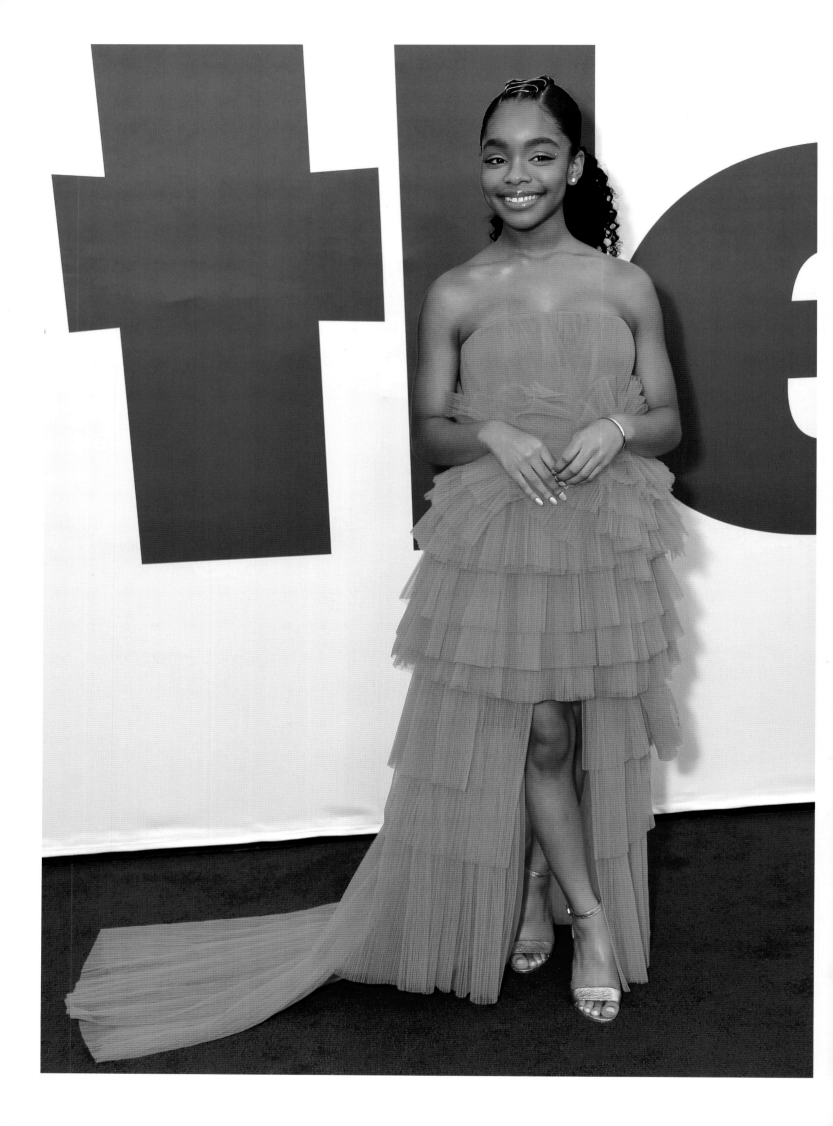

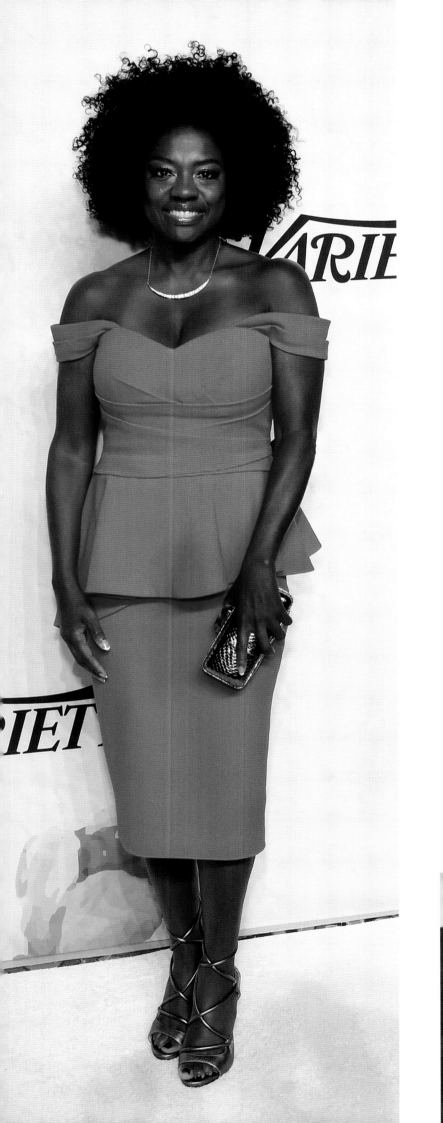
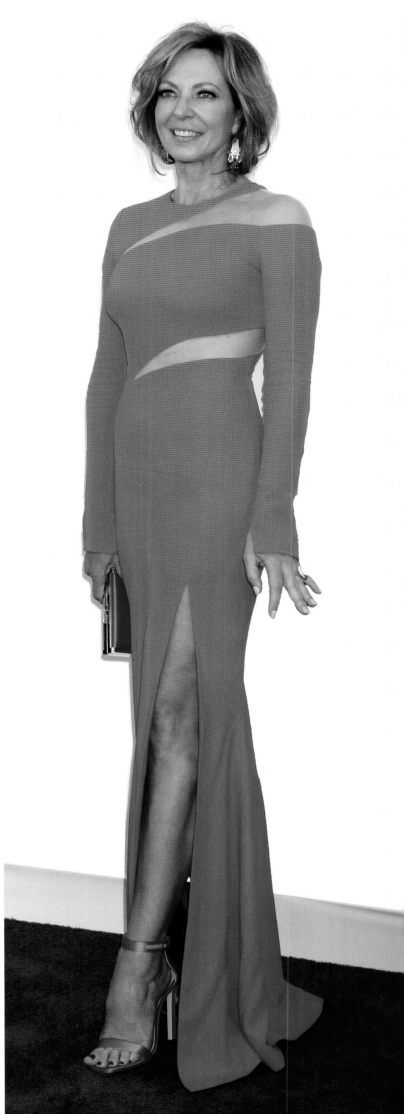

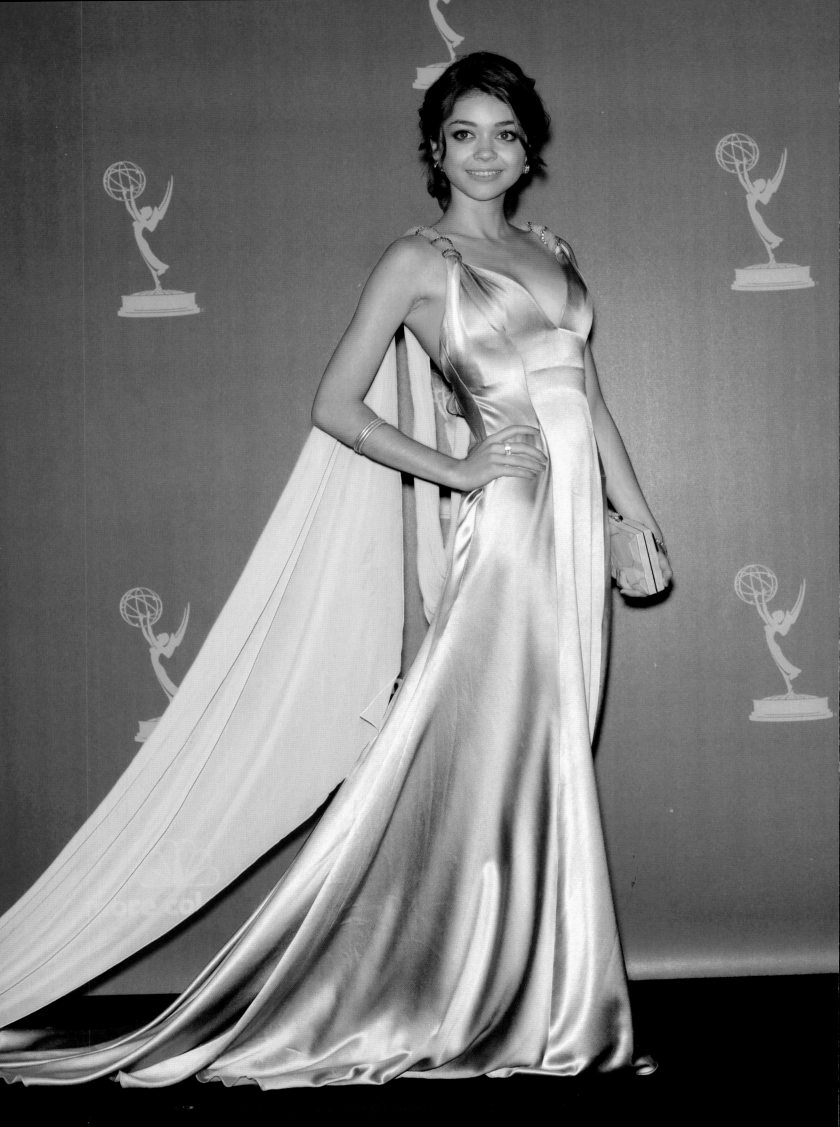

Page 72: Actress **Jenna Dewan** wears a slit gown from the Fall/Winter 2018 collection to the Vanity Fair Oscars party, 2018. *"Pamella's designs are always elegant but have a sexiness to them as well. She knows how to make a woman feel glamorous and strong at the same time."* — **Brad Goreski** *Page 73:* Actress **Priyanka Chopra-Jonas** in a gown from the Resort 2023 collection. *Pages 74–5, from left to right:* Actress **Marsai Martin** in a custom strapless gown, 2019; actress **Viola Davis** in a custom shoulderless cocktail dress, 2018; actress **Allison Janney** in a custom gown, 2018. *Previous spread left:* **Sarah Hyland** in a silver gown from the Fall/Winter 2010 collection at the 62nd Primetime Emmy Awards, 2010. *Previous spread right:* American gymnast **Aly Raisman** in a gown from the Pre-Fall 2020 collection. *Opposite:* **Whitney Houston** in a silver sequin gown from the Spring/Summer 2011 collection for her final performance at the Clive Davis pre-Grammy gala, 2011.

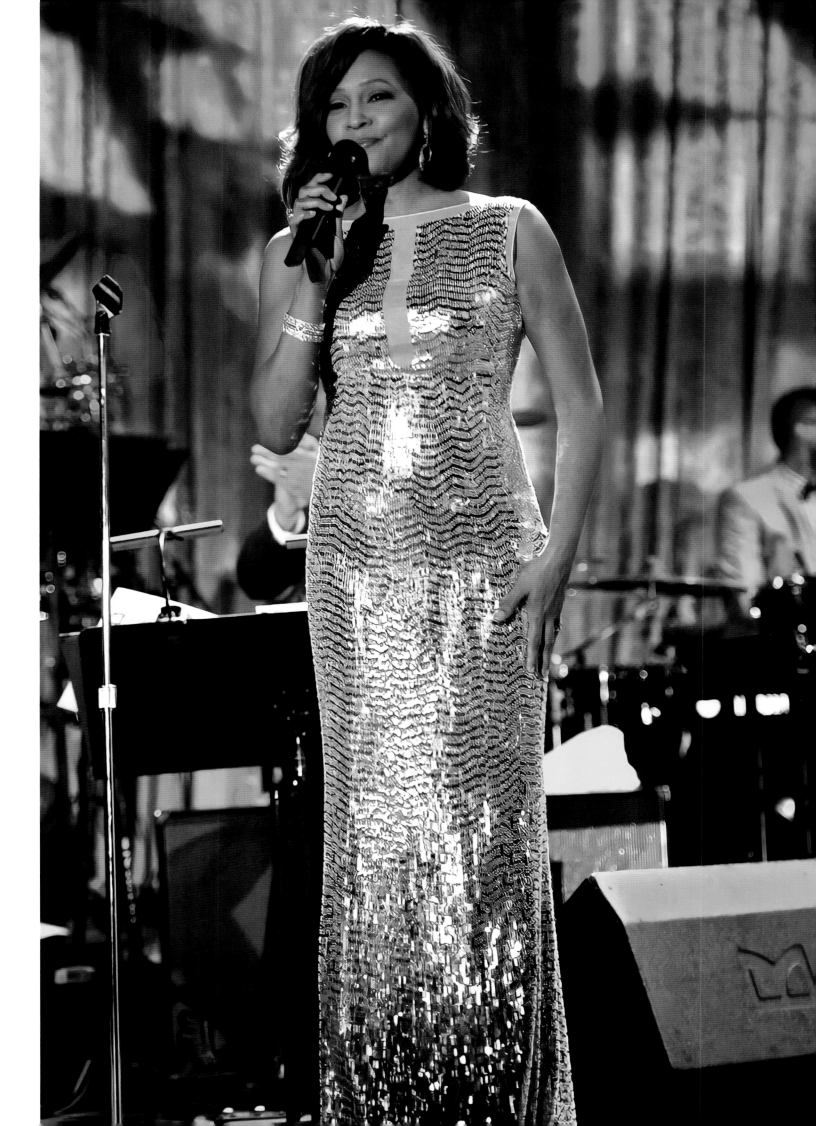

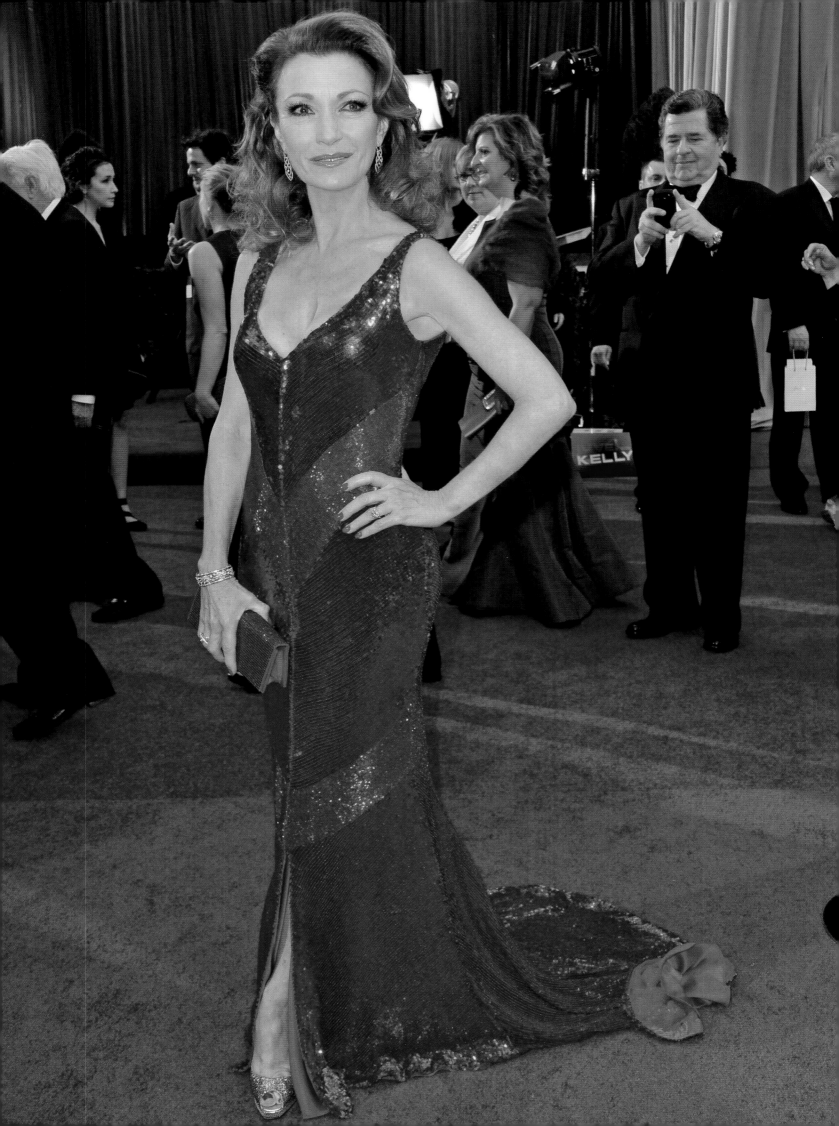

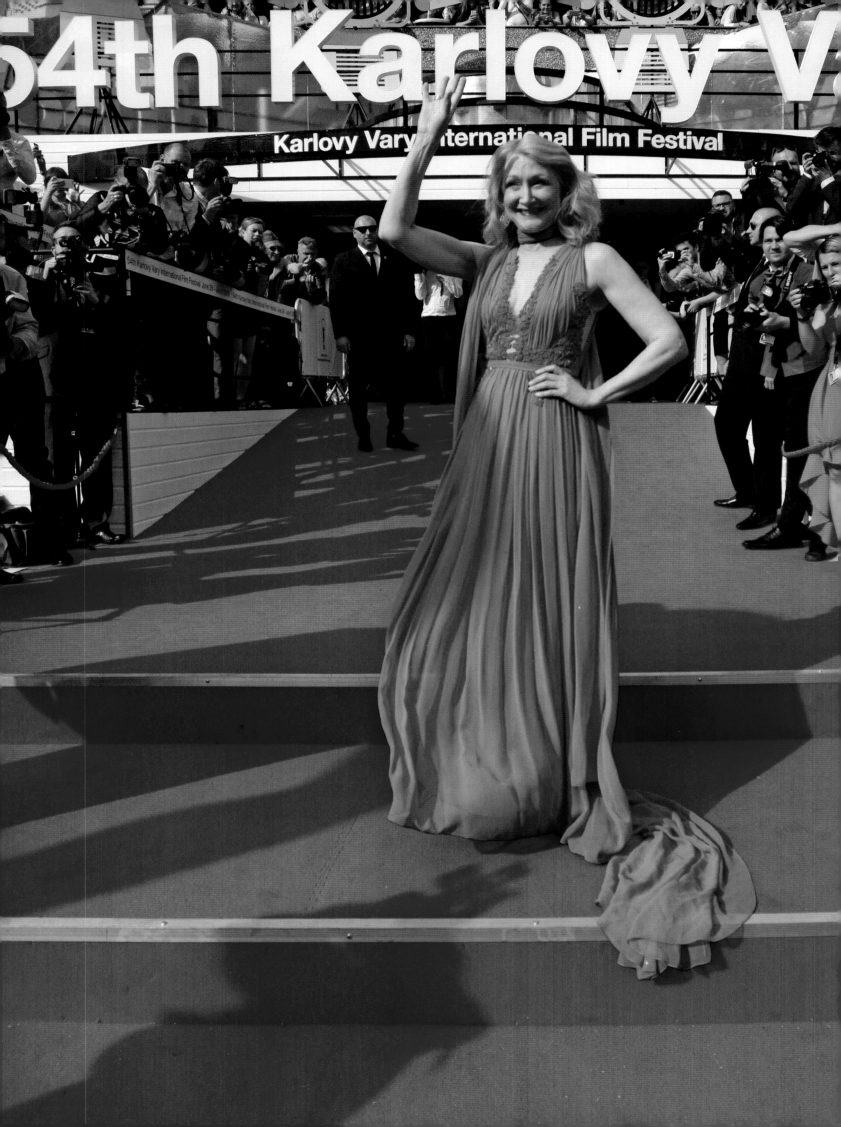

Previous spread left: Actress **Jane Seymour** in a ruby red sequin gown from the Pre-Fall 2012 collection. Previous spread right: Singer **Ciara** in a black sequin gown from the Pre-Fall 2012 collection. Opposite: It is always a pleasure to work with actress **Patricia Clarkson**. She has a wonderful sense of what colors and cuts best suit her body, like this brilliant chiffon piece from the Spring/Summer 2019 collection, which she wore at the 2019 Karlovy Vary International Film Festival.

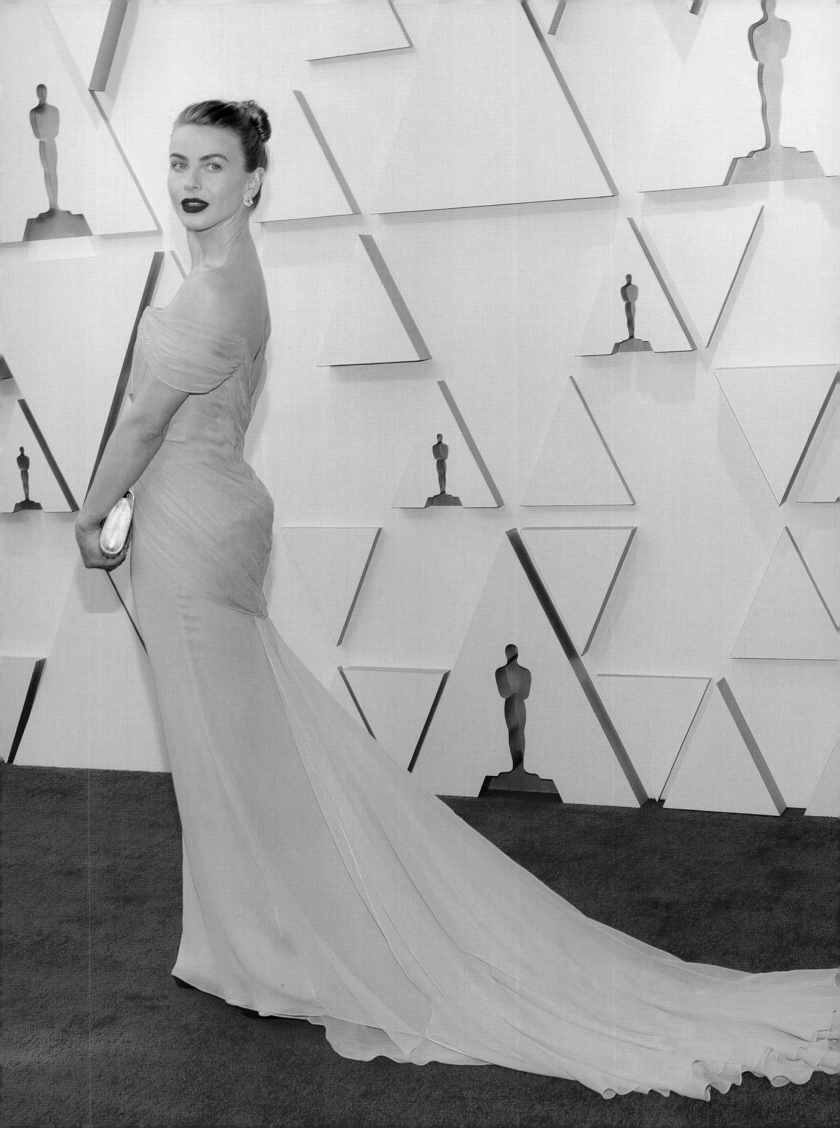

*Opposite:* We do a lot of custom work, but it rarely feels like we are truly collaborating with a client. In the case of dancer and actress **Julianne Hough** and this stunner, we really did work together. Julianne and her team came to us with ideas for silhouettes and colors. The result was this vibrant, delicately hand-pleated chiffon gown with a train destined for the red carpet. *Following spread left:* Entrepreneur **Nicky Hilton Rothschild** in a gown from the Resort 2020 collection. *Following spread right:* Model **Hilary Rhoda** in a strapless gown from the Pre-Fall 2014 collection.

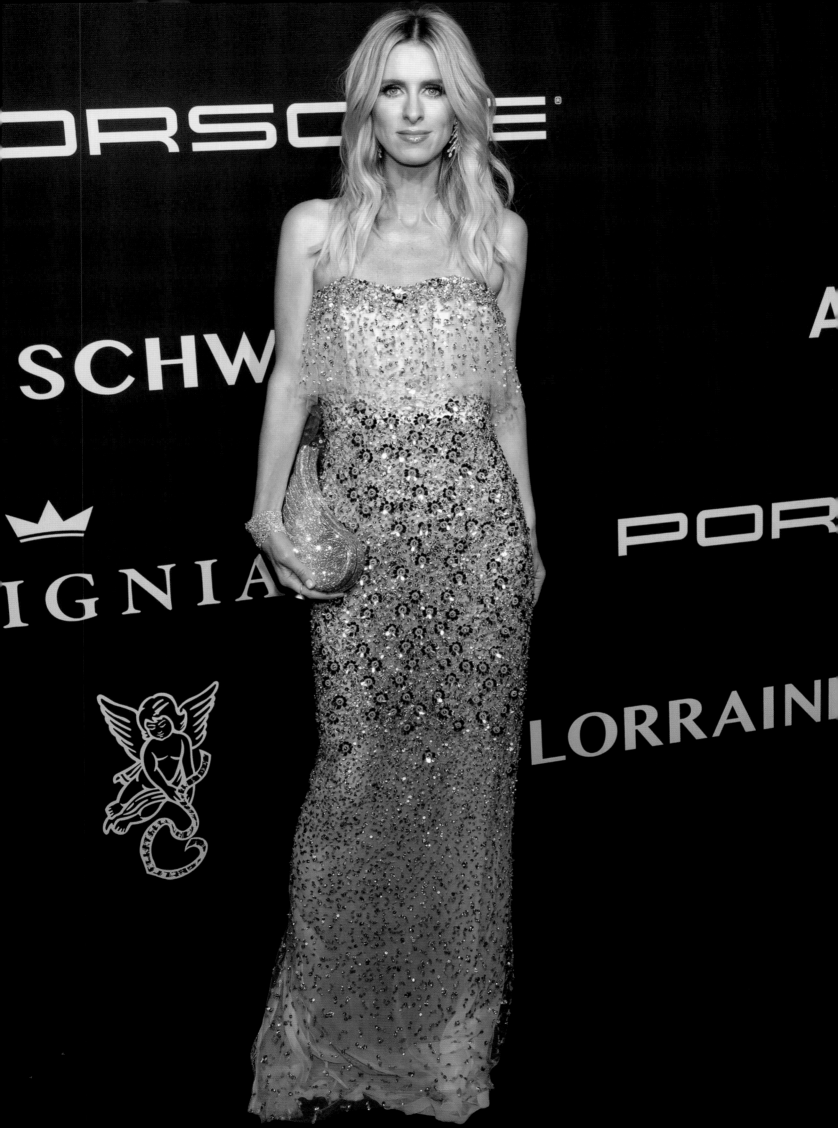

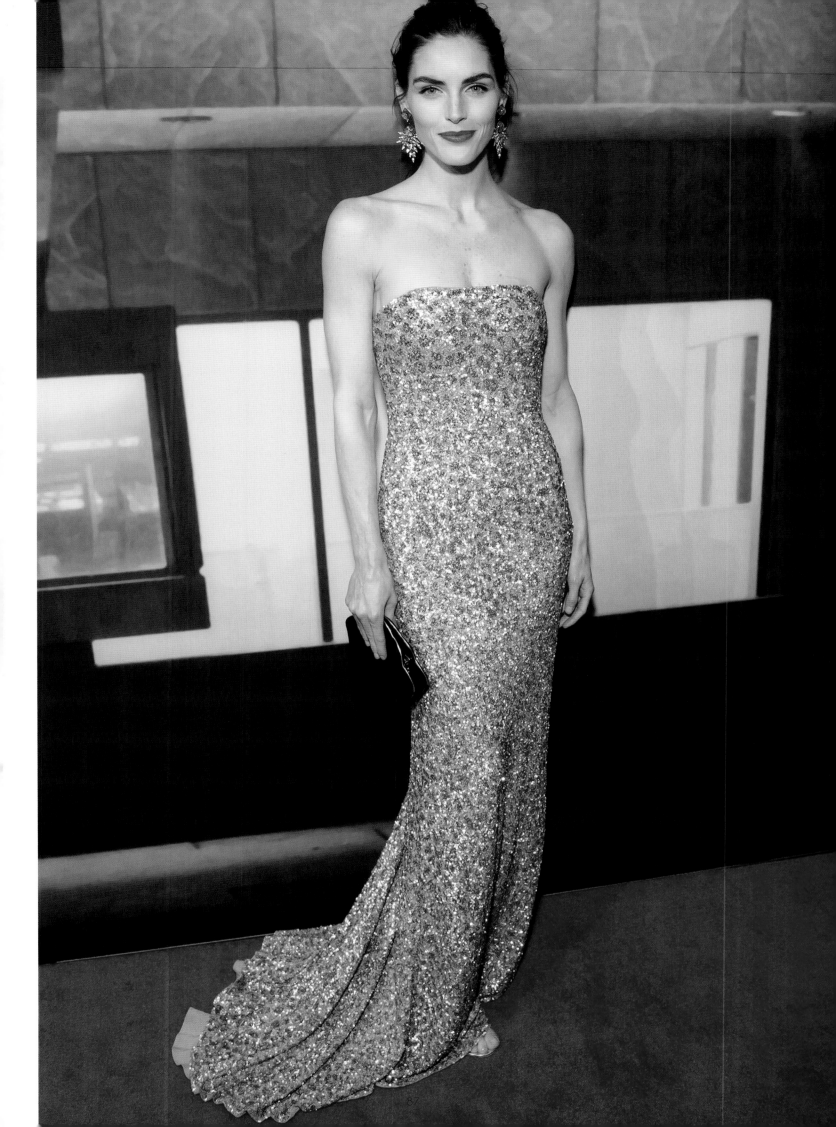

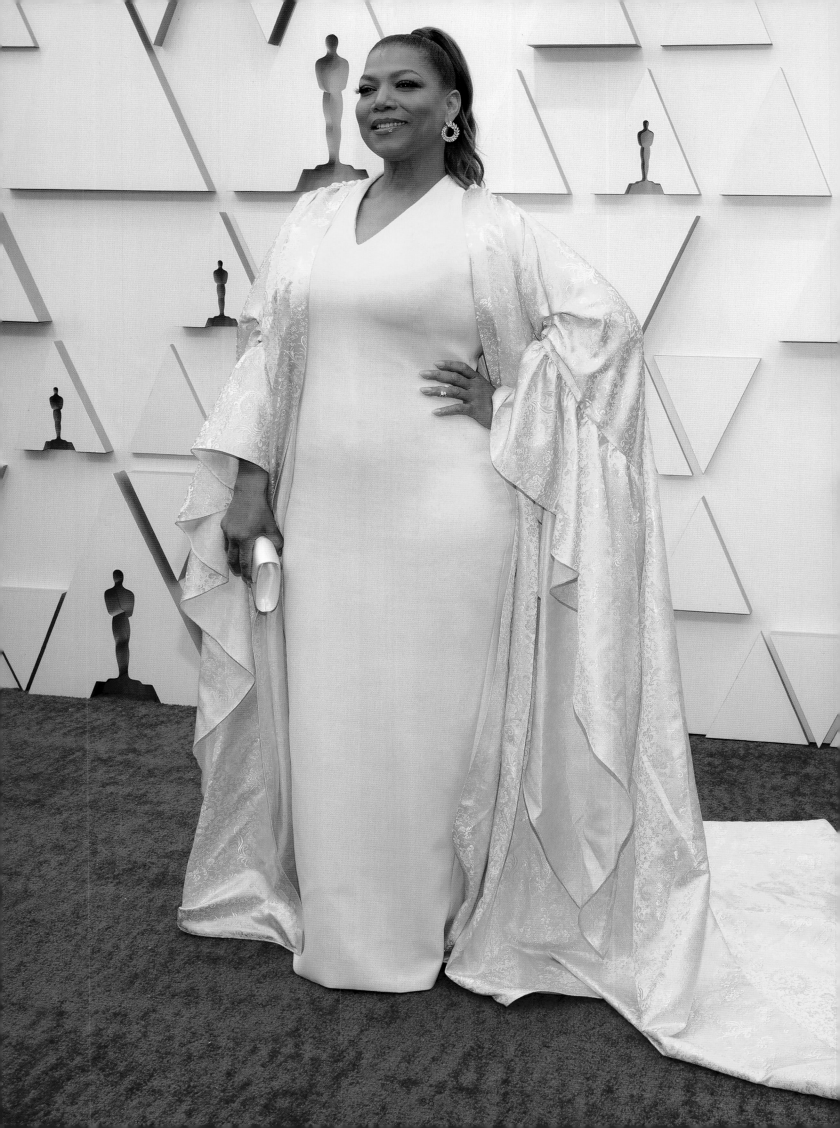

*Opposite:* I have had the pleasure of working with musician and actress **Queen Latifah** a number of times. Knowing the Oscars would be a major moment for her, I wanted to do something truly spectacular for her. I tried a look that was a little different: a sweeping printed cape over a simple, fitted column gown. It was an Oscars red carpet standout. *Following spread left:* Singer **Nicole Scherzinger** in a dress from the Resort 2020 collection. *Following spread right:* Actress **Lea Michele** in a gown from the Fall/Winter 2016 collection.

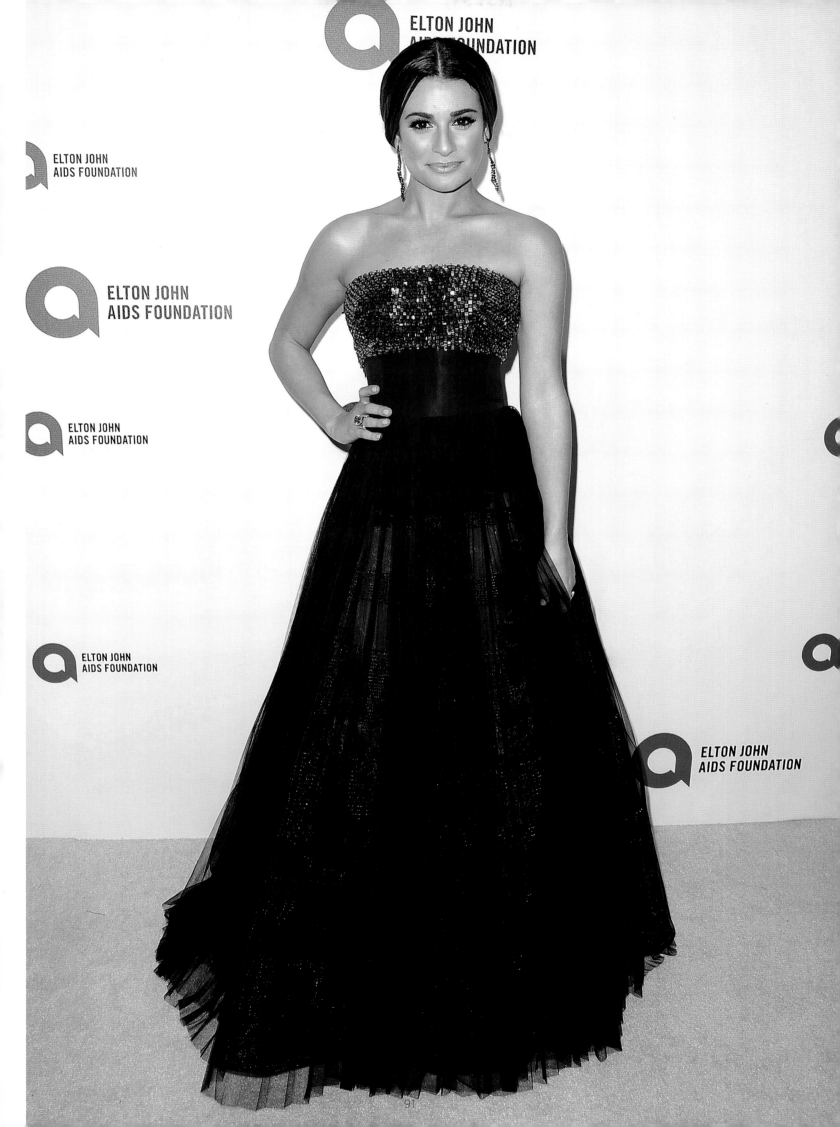

*Opposite:* I love dressing up-and-coming talent like actress **Ema Horvath**. She chose this bold bow motif cocktail dress. *Following spread, from left to right:* Actress **Rachel Brosnahan** in a gown from the Fall/Winter 2022 collection; actress **Laverne Cox** in a beaded gown from the Fall/Winter 2019 collection; singer **Kelsea Ballerini** in a gown from the Pre-Fall 2017 collection.

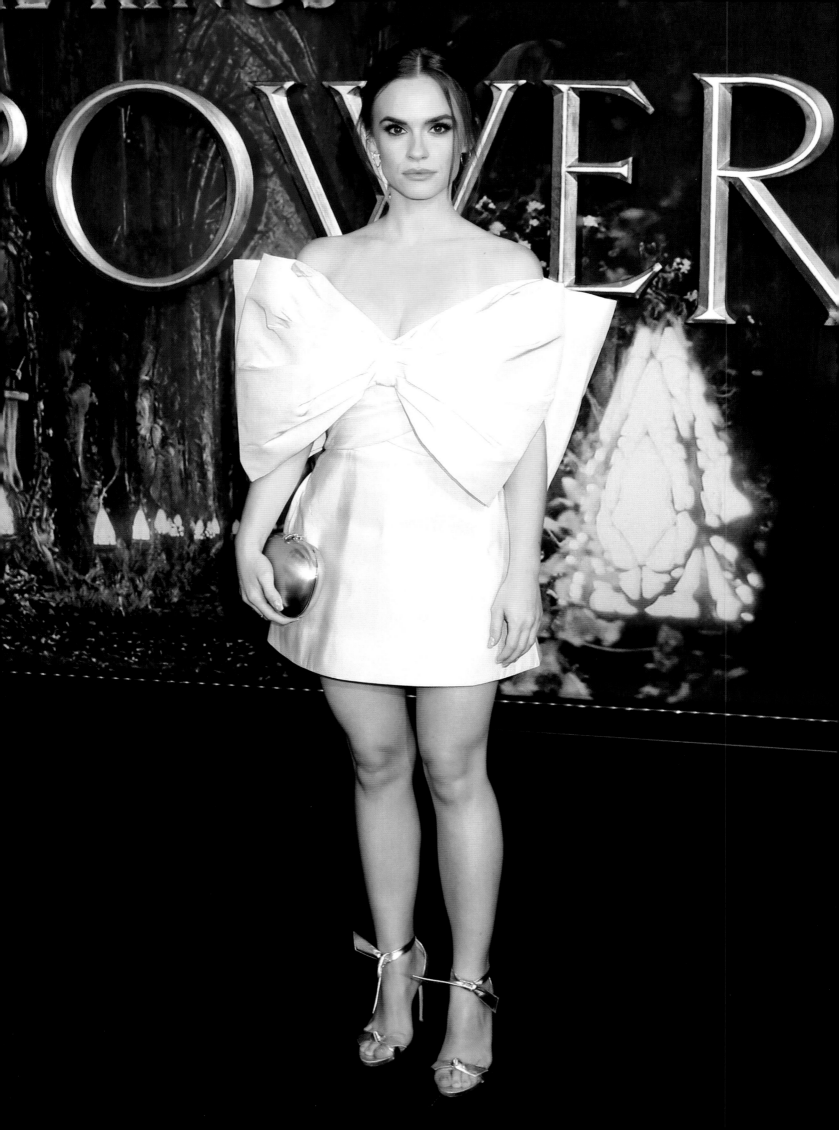

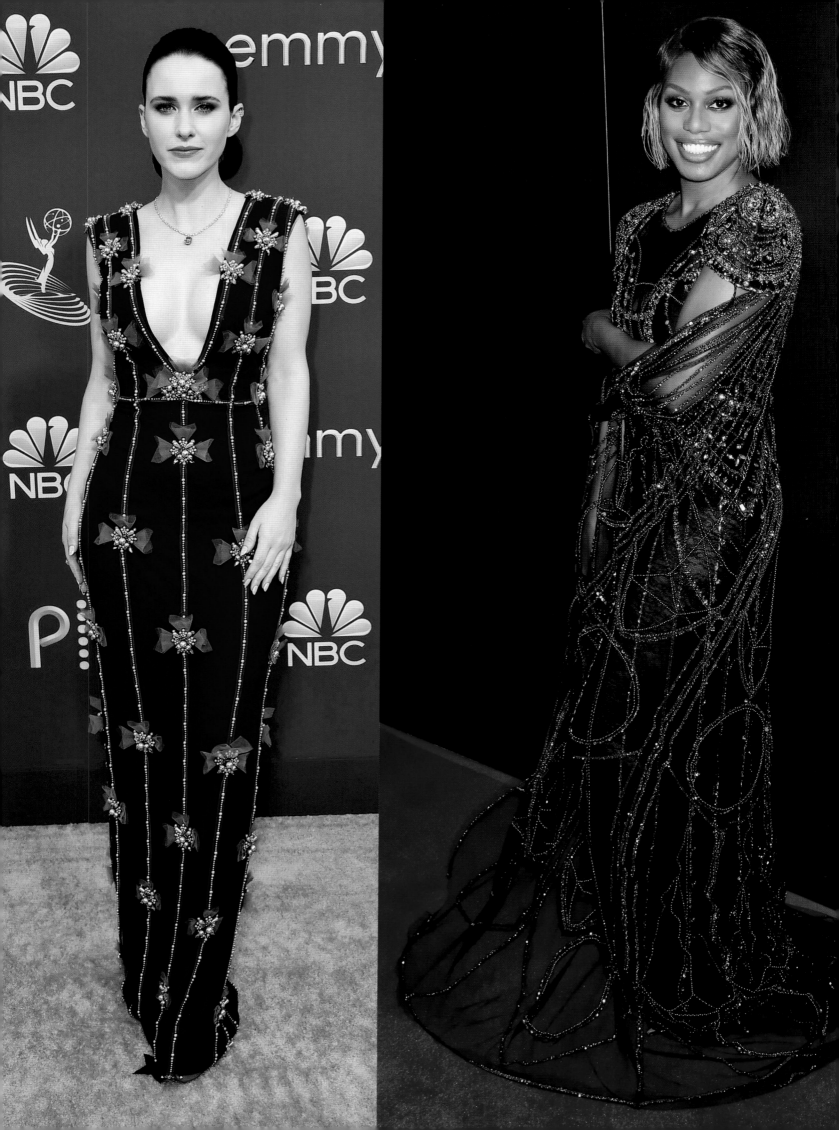

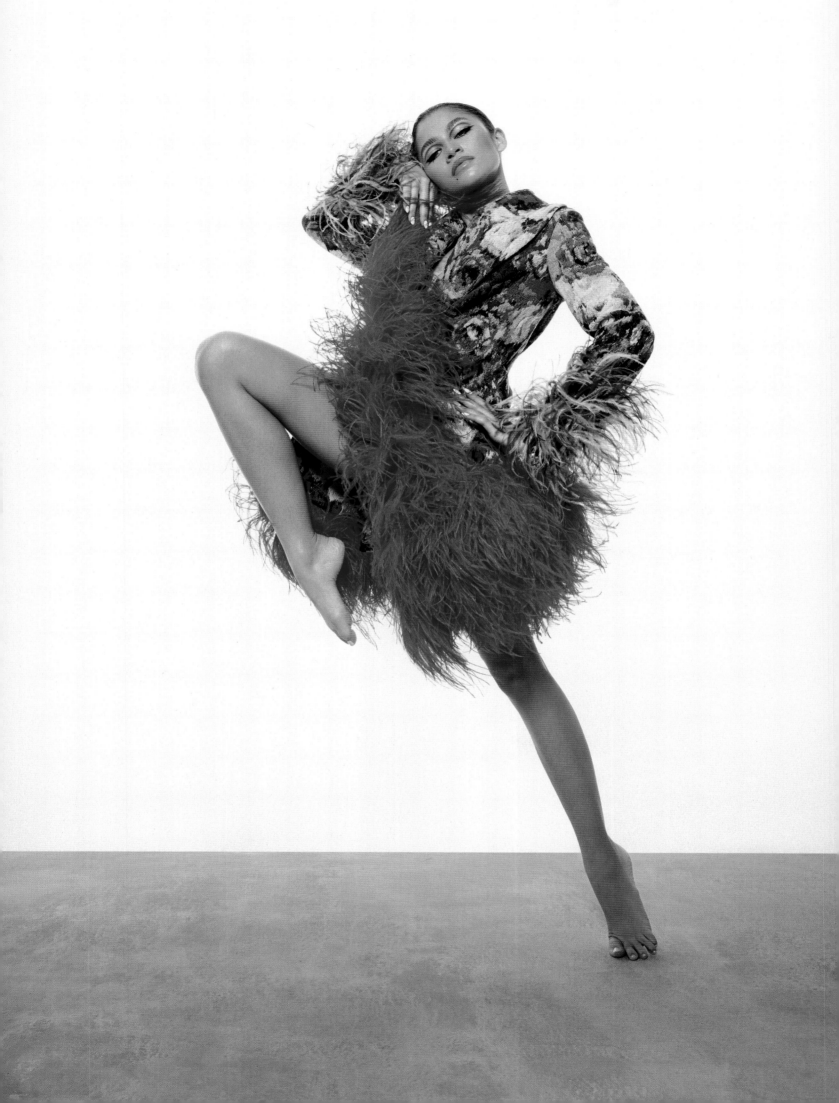

# in magazines

Our red carpet–ready pieces have starred in the glossy pages of some of the biggest magazines. Seeing our pieces in print offers me the opportunity to see my garments on actors I admire.

Editorial work in magazines provides exposure to a new range of fans. I especially love seeing the imaginative scenes creative teams construct. Magazines amplify or reimagine the fantasies in the runway shows, sometimes bringing my pieces to new places I would never have dreamed of. I rarely know what a creative team has in store; seeing the final images is almost like experiencing the pieces for the first time. My dresses have been whisked away to breathtaking locations for shoots. They can be seen in motion in exciting new ways, like when Zendaya wore one of my coats and took a balletic leap that made the lush feather trim dance. I loved seeing Dame Helen Mirren wrap herself in the tulle cape on a gown from Spring/Summer 2020. Cynthia Erivo's December 2020 *Essence* magazine cover showed the sweep of an organza and ostrich coat from my Fall 2019 collection in a playful way. The coat was paired with bright teal shoes, which made this look especially fun.

The glamour has come home too. My friend Nigel Barker photographed my daughters Cassandra and Sydney wearing my pieces in a campaign for our fragrance. As a mother and a designer, I was so moved to involve my family with my work.

*Opposite:* Actress **Zendaya** told an important, gorgeous story with our jacquard coat in her *Essence* magazine tribute to trailblazing supermodel Donyale Luna. *Following spread left:*

**Dame Helen Mirren** in a gown from the Spring/Summer 2020 collection. *Following spread right:* Actress **Ashleigh Murray** in a feather-covered gown from the Spring/Summer 2019 collection.

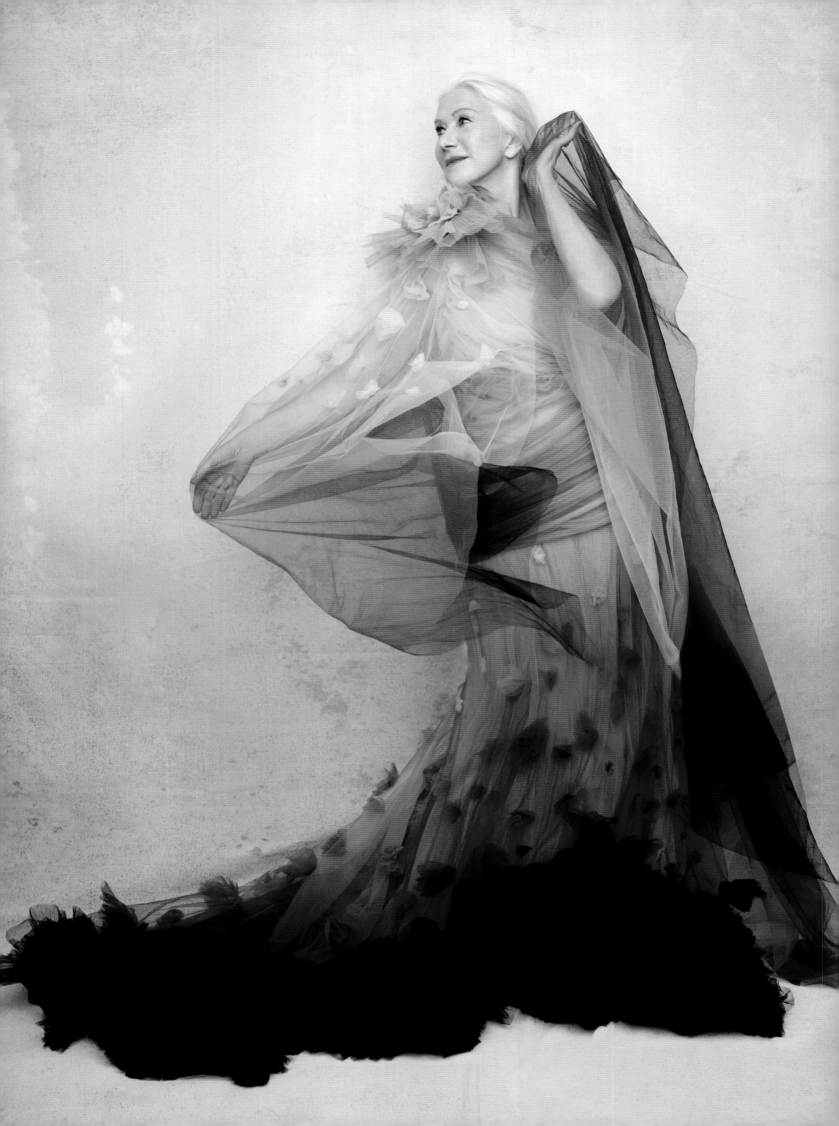

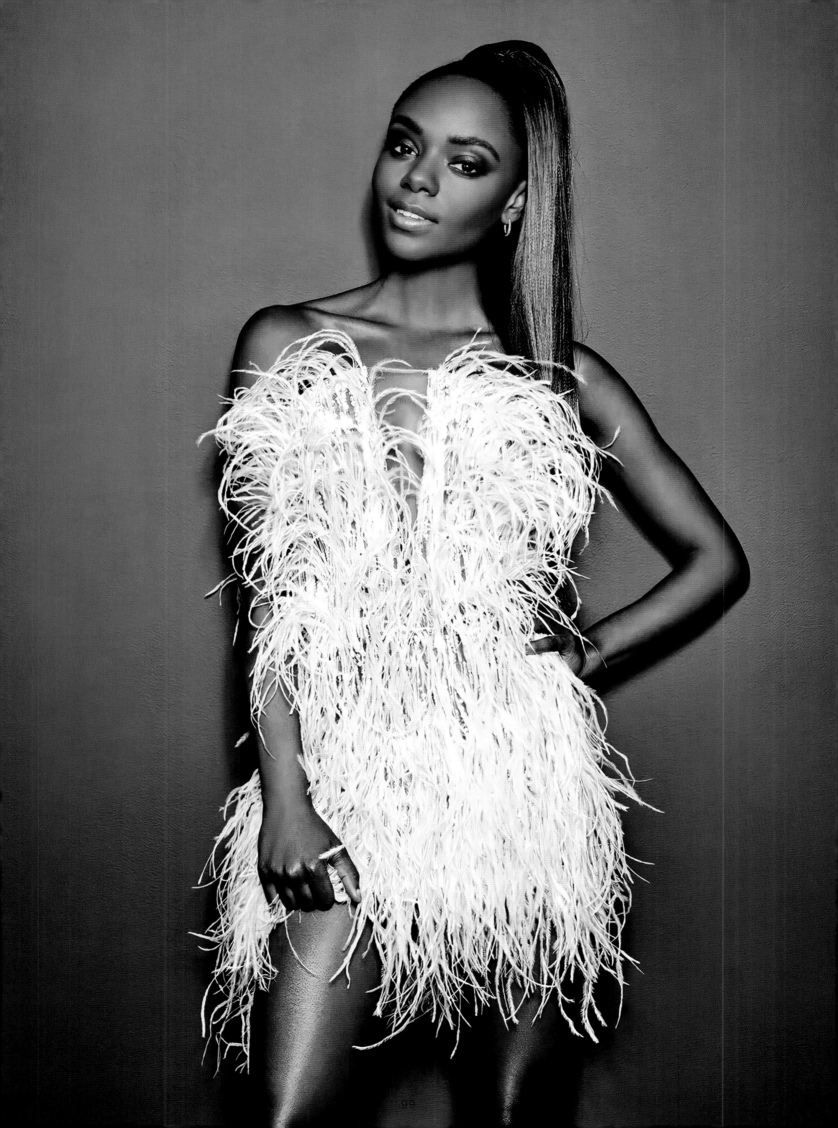

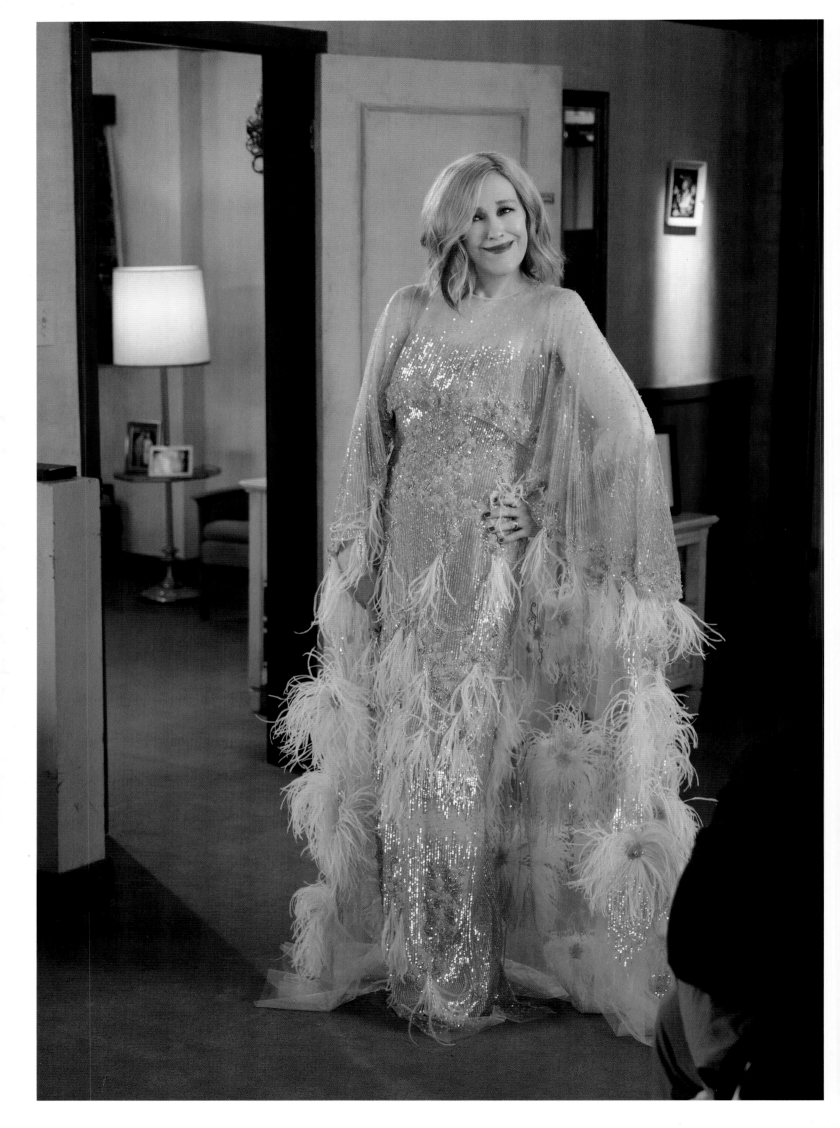

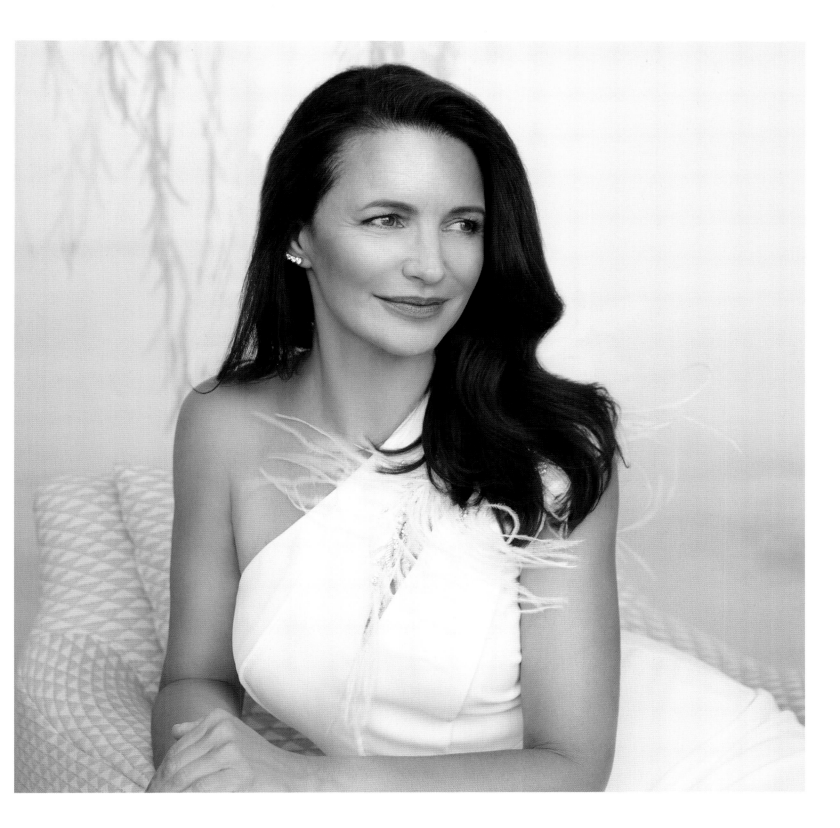

*Above:* Actress **Kristen Davis** looks like a dream in this editorial about the TV series *And Just Like That*, the sequel to *Sex and the City*. Between dressing Kim Cattrall and this shoot, I feel like part of the legacy of this show in a small way. *Opposite: Schitt's Creek's* hilarious Moira Rose, portrayed by actress **Catherine O'Hara**, is just the kind of big personality to dazzle in this opulent gown. *"This dress was referred to as THE dress in the script. For the reveal in this scene, wardrobe had me wait where no one would see me until I entered on 'action.' Ha! Such fun. Eugene, Daniel, and Annie could only whisper their lines in the celestial presence of this breathtakingly beautiful dress."*
— Catherine O'Hara

*Above and opposite:* My daughters **Cassandra** and **Sydney** are my muses. They inspire me constantly. They look gorgeous in these shots taken by my frequent collaborator and good friend **Nigel Barker**.

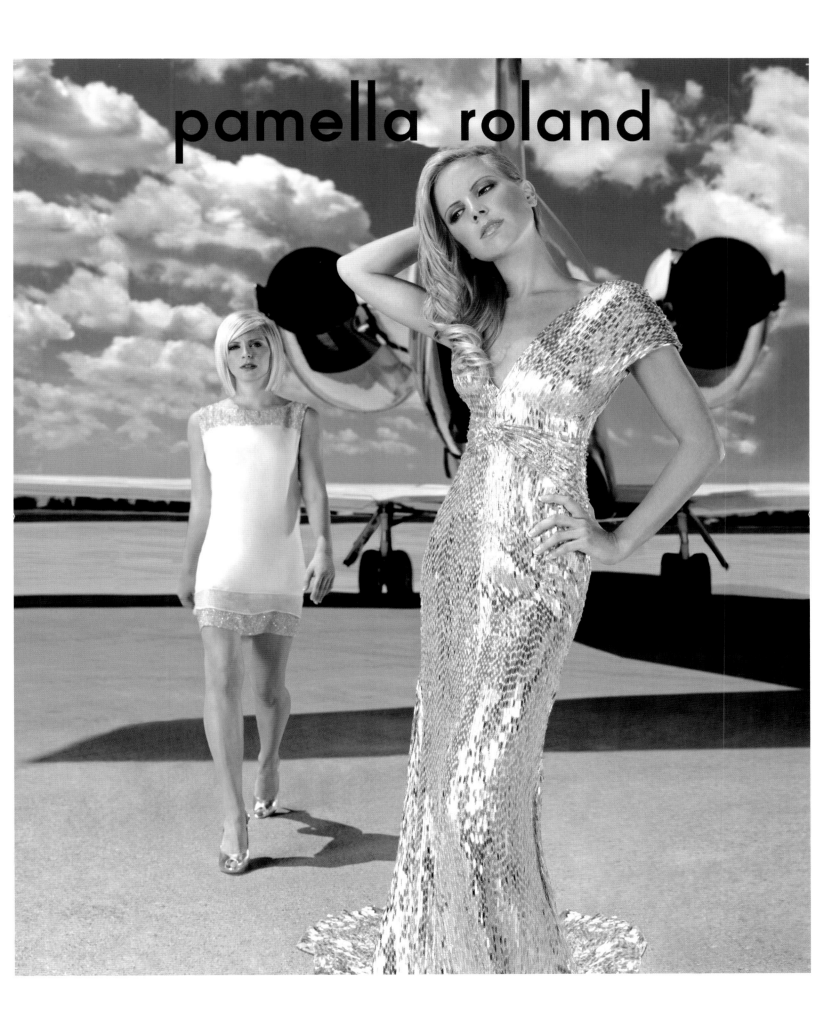

# ESSENCE

DIGITAL COVER

## THE STORY OF HARRIET TUBMAN:
### REMINDING US THAT SLAVERY WAS NOT A CHOICE

*Cynthia Erivo*

## THE BRITISH ACTRESS FINDS HER NORTH STAR FROM BROADWAY TO HOLLYWOOD

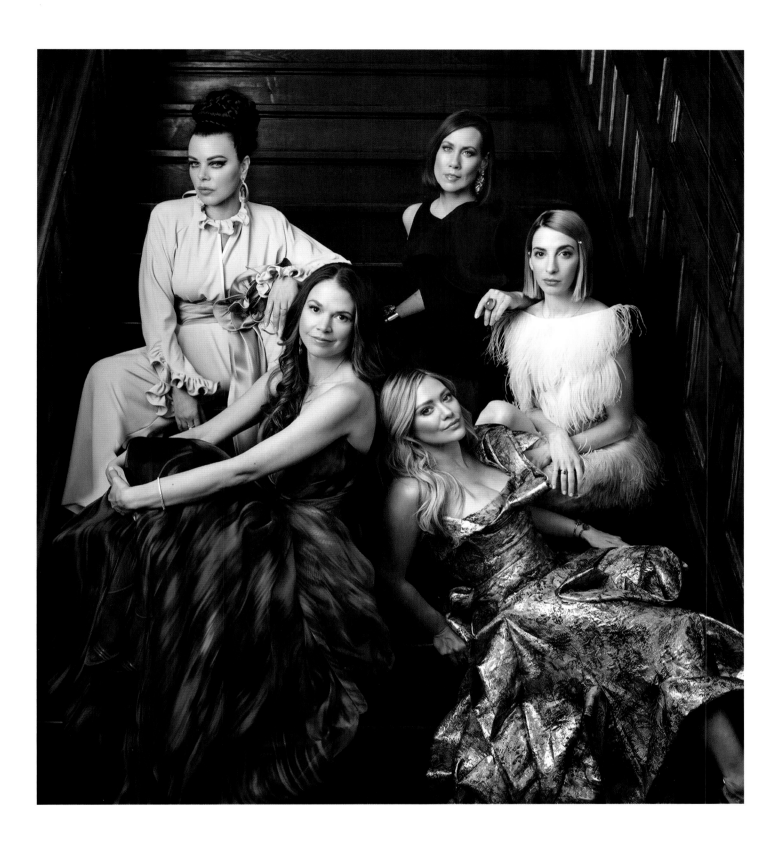

*Above:* **Jacqueline Demeterio**, costume designer for the TV show *Younger*, dressed actress **Sutton Foster** in our pieces several times during the show's run. As always, Sutton looks fabulous. *Opposite:* Actress **Cynthia Erivo** is an amazing talent, and she brings so much life to this purple opera coat. *Following spread:* A dreamy editorial featuring a gown from the Fall/Winter 2018 collection.

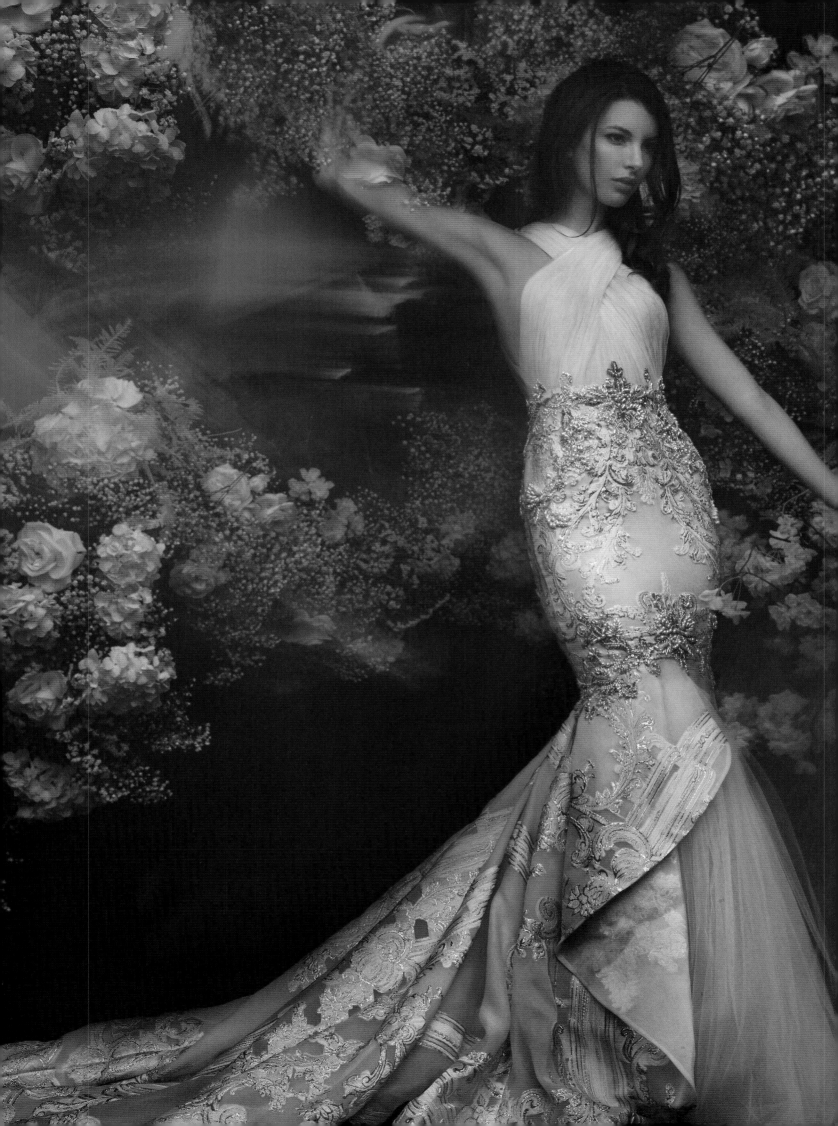

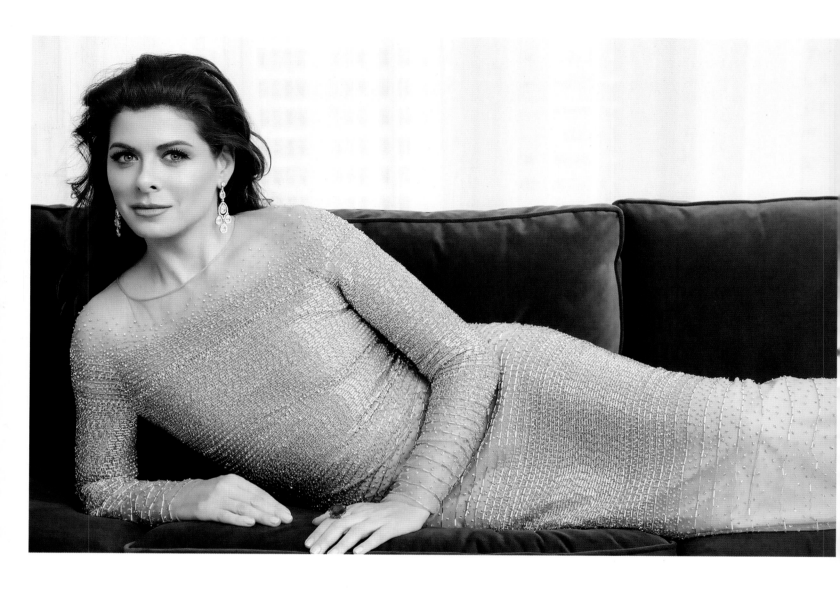

*Above:* Actress and longtime client **Debra Messing** looks so elegant in this gown from the Resort 2017 collection. *Opposite, clockwise from top left:* Writer and actress **Quinta Brunson** in a gown from the Spring/Summer 2022 collection; actress **Lana Condor** in a fuchsia gown from the Spring/Summer 2020 collection; TV personality **Kim Kardashian** in a look from the Spring/ Summer 2014 collection; actress **Malin Akerman** in a tulle cocktail dress from the Spring/Summer 2018 collection, which is our most worn and photographed dress of the last seven years. *Following spread:* Actress **Eleanor Tomlinson** in a tulle ballgown from the Resort 2018 collection, in a 2018 spread in *Town and Country UK*.

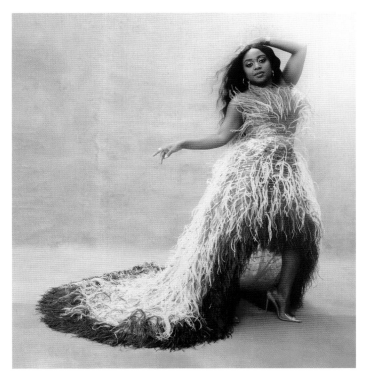

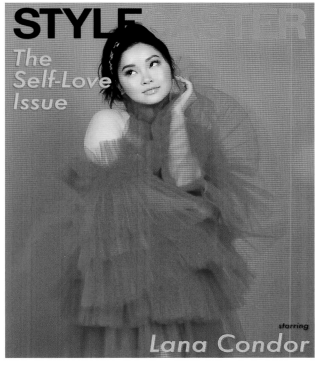

# STYLE

**The
Self-Love
Issue**

*starring*
**Lana Condor**

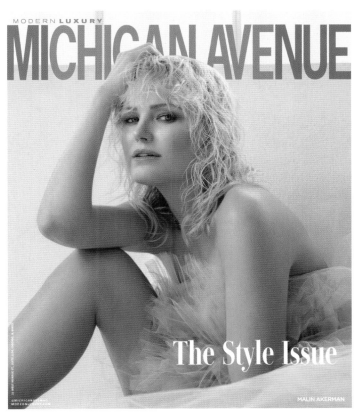

MODERN **LUXURY**
# MICHIGAN AVENUE

The Style Issue

MALIN AKERMAN

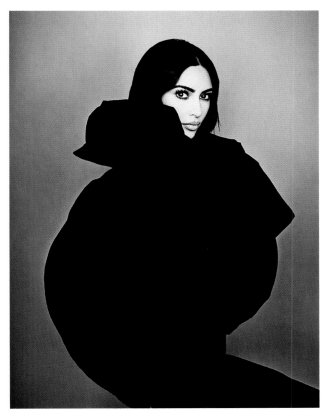

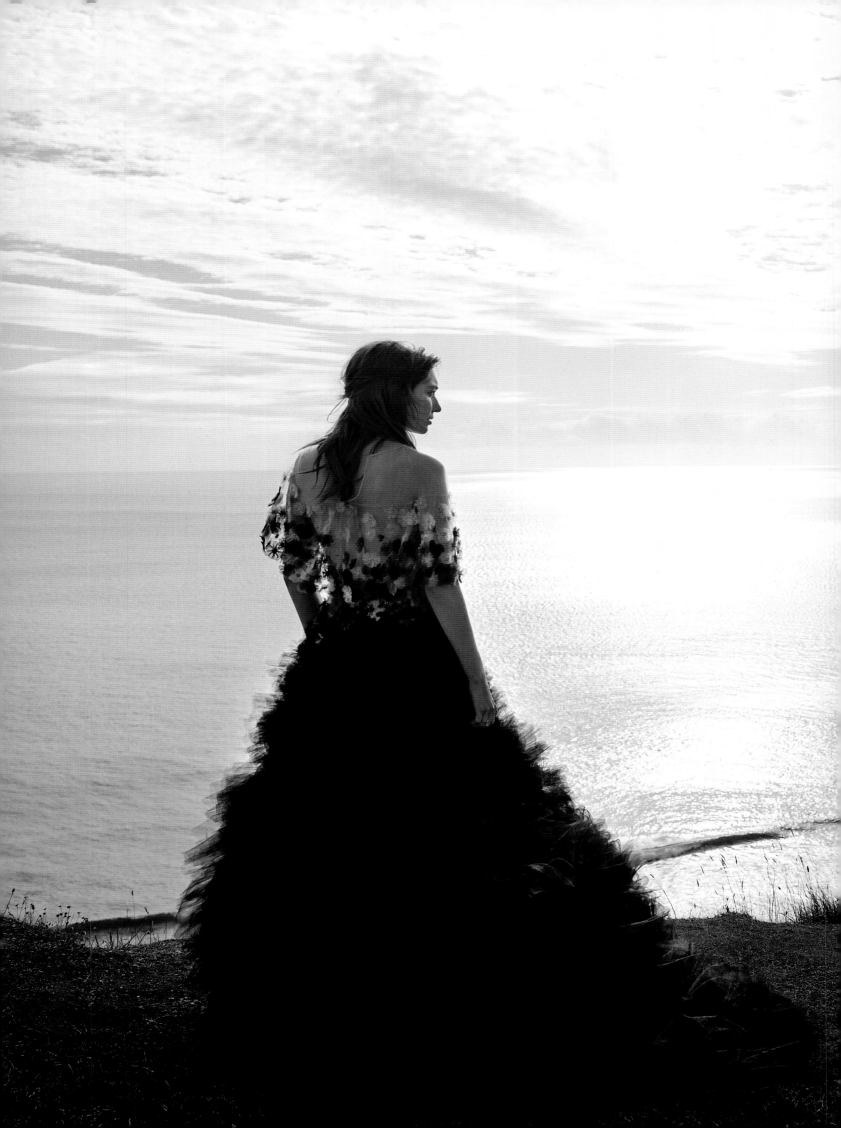

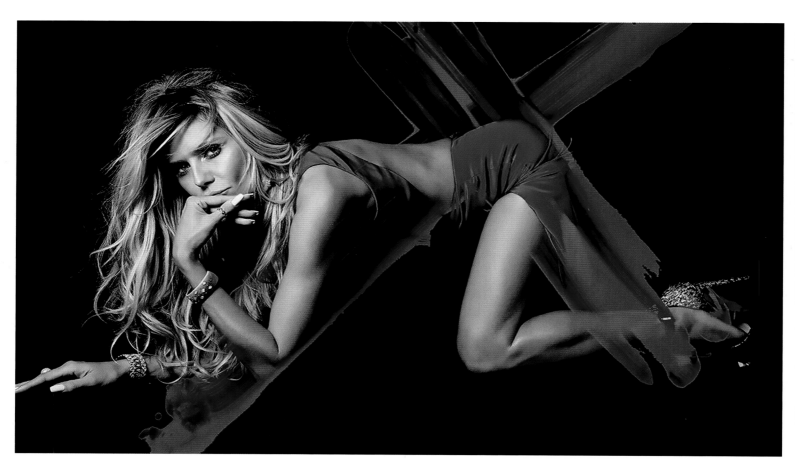

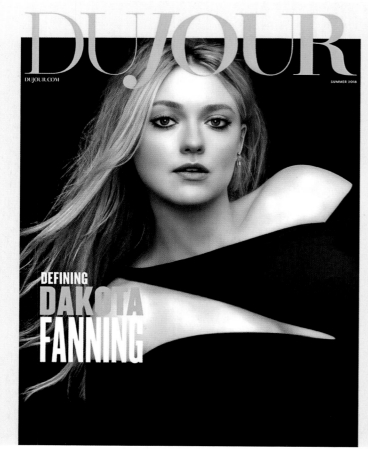

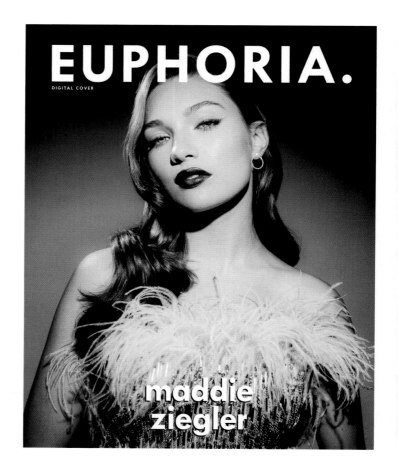

# WWD

Fashion. Beauty. Business.

# Golden Ticket

Angela Basset may have donned a gleaming silver sequined Pamella Roland gown with Chopard jewels on Tuesday evening in Beverly Hills, but for her the night was pure gold as she walked away with a Golden Globe for her role in "Black Panther: Wakanda Forever." And she was spot on fashion-wise too – the red carpet was filled with sparkle and shine. *For more, see pages 15 to 18.*

PHOTOGRAPH BY **GILBERT FLORES**

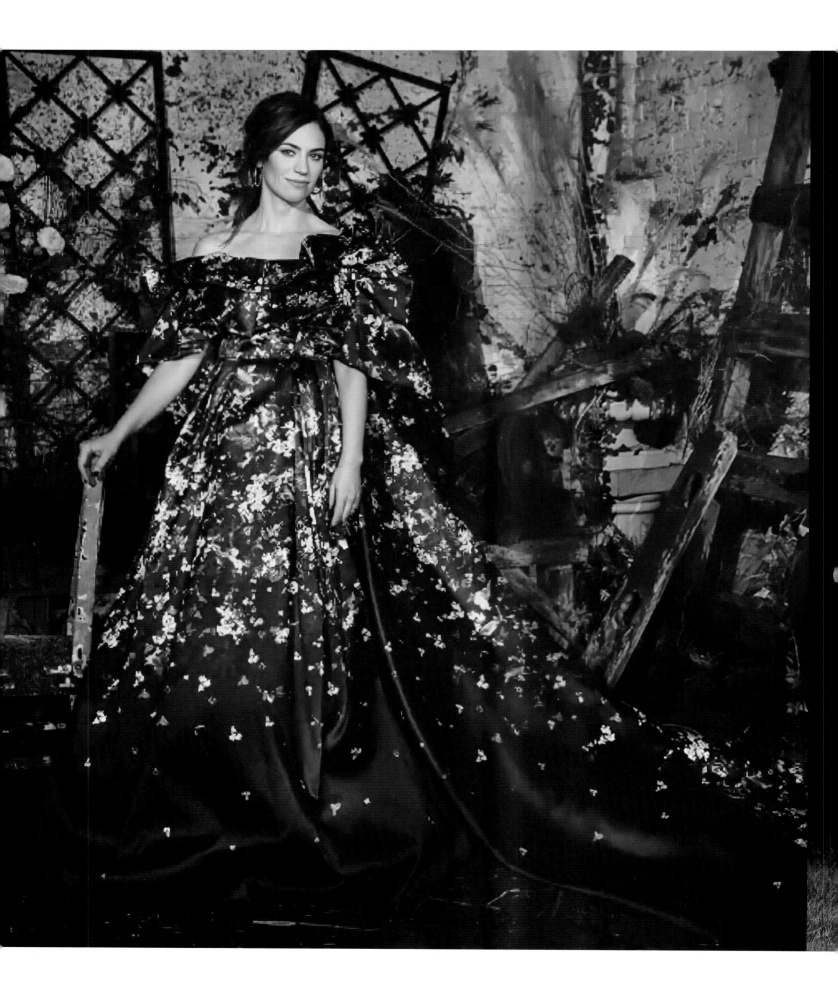

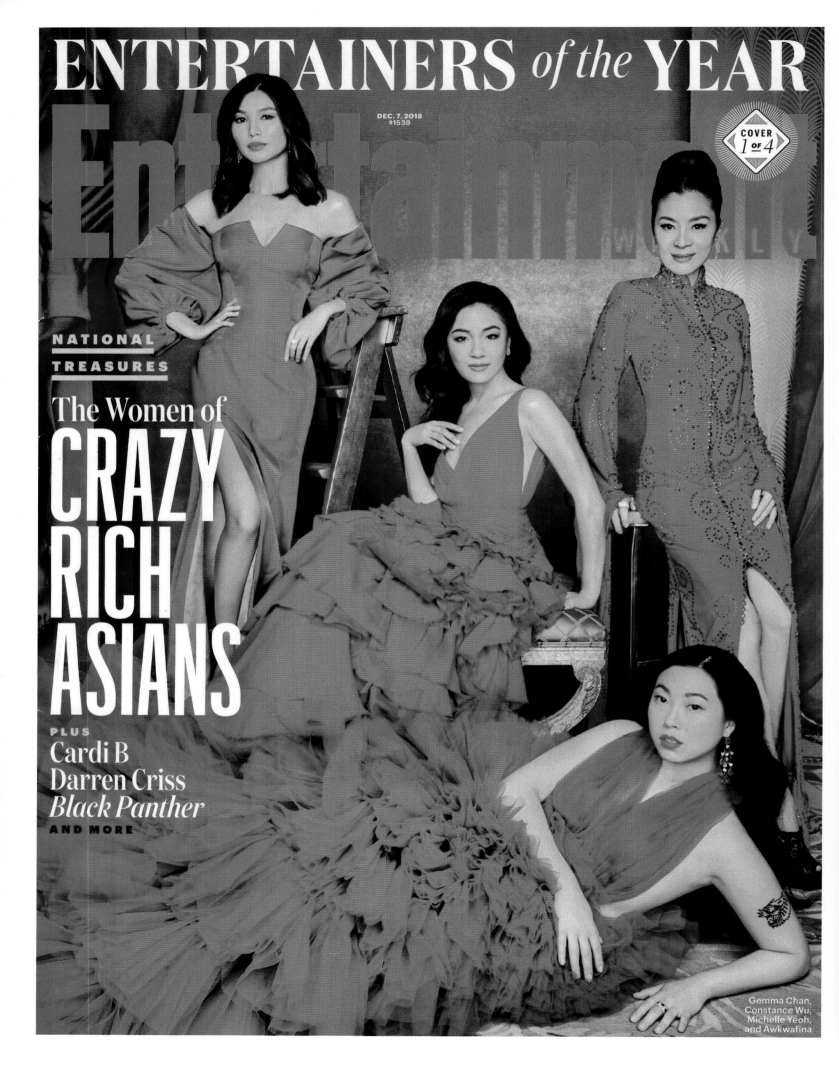

# ENTERTAINERS *of the* YEAR

DEC. 7, 2018
#1539

COVER
1 OF 4

**NATIONAL
TREASURES**

## The Women of
# CRAZY
# RICH
# ASIANS

**PLUS**
Cardi B
Darren Criss
*Black Panther*
**AND MORE**

Gemma Chan,
Constance Wu,
Michelle Yeoh,
and Awkwafina

Page 112, clockwise from top: Model **Heidi Klum** in a custom dress, 2016; actress **Maddie Ziegler** in a gown from the Spring/Summer 2020 collection on the cover of *Euphoria*; actress **Dakota Fanning** in a gown from the Pre-Fall 2018 collection on the cover of *DuJour* magazine, 2018. *Page 113:* Actress **Angela Bassett** in a custom column gown, 2023. *Previous spread left:* Actress **Maggie Siff** wears a gown from the Fall/Winter 2019 collection in a feature article in *Watch!* magazine. *Previous spread right:* Model **Cristen Chin Barker** wears a pink gown from the Spring/Summer 2019 collection and **Kimberly Chin** wears a flowing piece from the Pre-Fall 2018 collection. *"Pamella pours herself into everything she does and understands intimately and intrinsically what a woman wants and likes to feel when they dress up and go out. So much so that my wife will be seen in nothing else. Pamella is now our family."* — **Nigel Barker** *Opposite:* **Constance Wu** (center) in a Pre-Fall 2018 gown on the cover of the December 16, 2018, issue of *Entertainment Weekly. Following spread:* A great escape. A model in a billowing gown from the Spring/Summer 2018 collection.

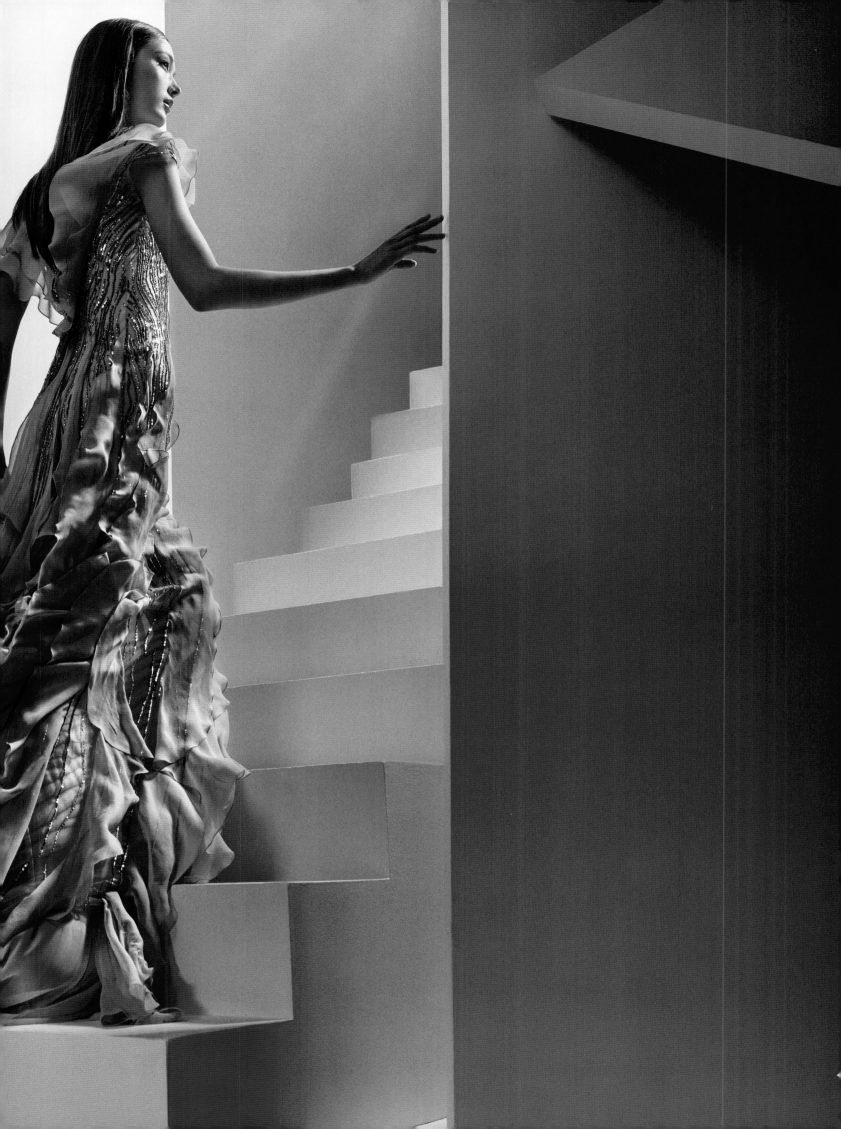

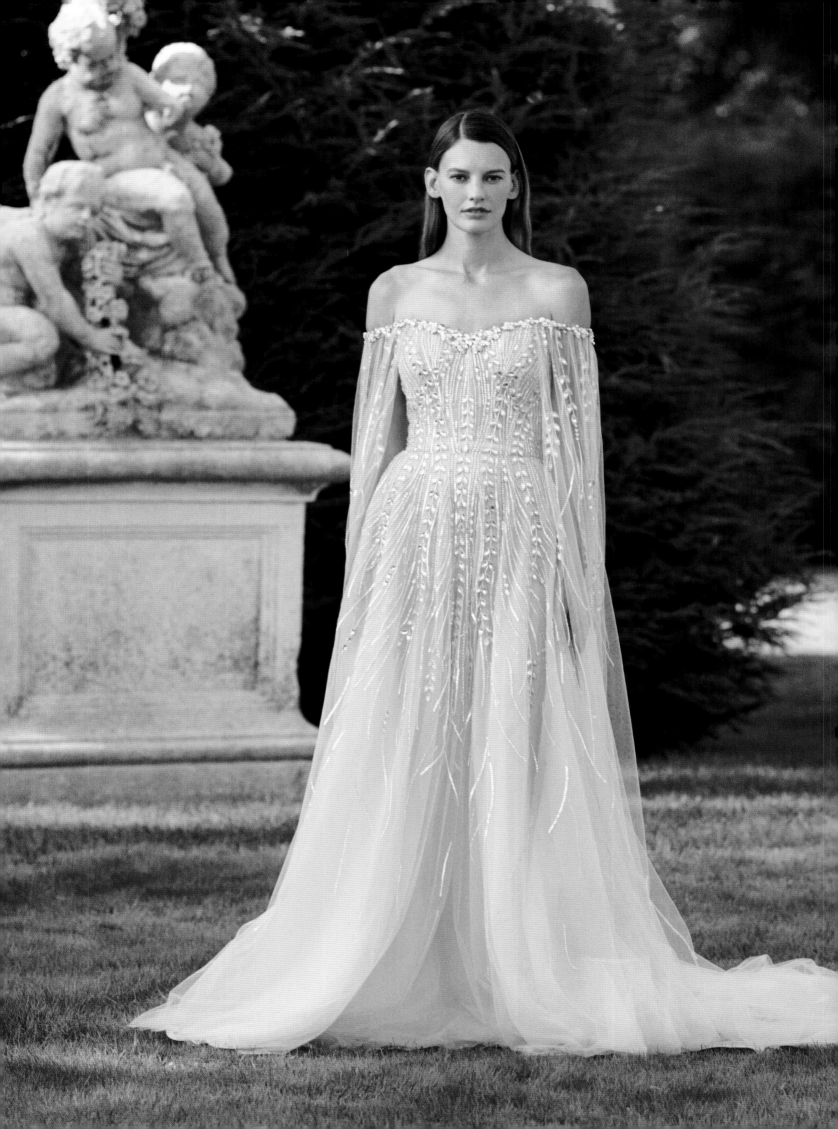

# adapting to new modes of expression

My team and I were uncertain about the future like everyone else was when the COVID-19 pandemic began. The company had faced challenges before—even recessions—but the pandemic was unlike anything we had ever seen or could have imagined. I am grateful to the New York City team members who ventured to the offices and showrooms in those early days to save the collections on which we were working.

The pandemic required us to adapt. The team really stepped up to meet the challenges of the time. Seeking new opportunities to connect with our customers, we relaunched PamellaRoland.com in September 2020, invested in our social media, and produced virtual trunk shows.

Our photo shoots were the silver lining of this time. Instead of presenting runway shows, we created safe, socially distanced photo shoots. They were a way to tell the collection stories, as well as use my love of architecture in new ways. I worked with my design team to whisk our Spring/Summer 2022 collection away to a Carolean-style mansion in Long Island, where the rich colors and dazzling sequins stood out against columns, fountains, and sun-dappled gardens. For the Fall/Winter 2022 campaign, the design team and I headed just north of Manhattan to a gorgeous Renaissance Revival-style estate overlooking the Hudson River. The ballrooms and sweeping staircases were dreamy backdrops. Although I am happy we can gather for runway shows again, I look back on those photo shoots and appreciate how we turned difficult circumstances into something fabulous.

*Opposite:* Photographs allow us to tell the collection story in ways we cannot on the runway. Location shoots have their challenges. We rushed against the sun to finish this shoot at Old Westbury Gardens on Long Island before sunset. *Following two spreads:* Details on gowns from the Pre-Fall 2019 collection.

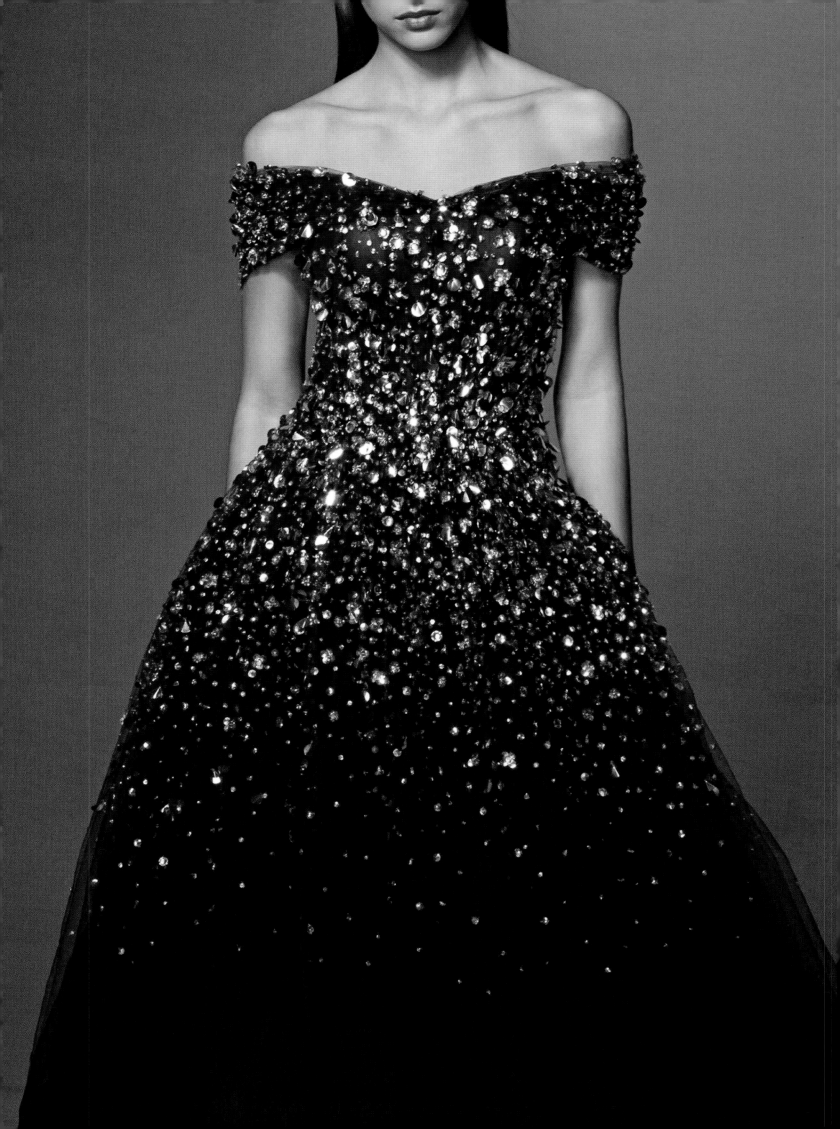

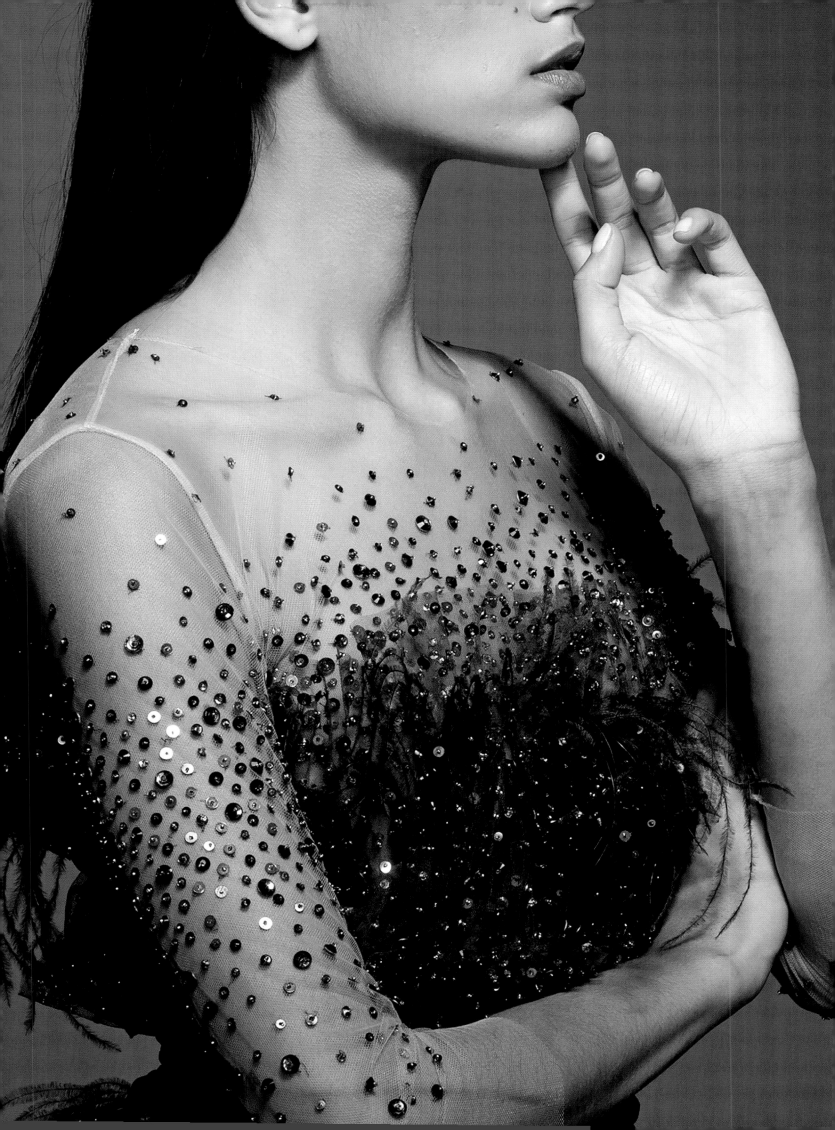

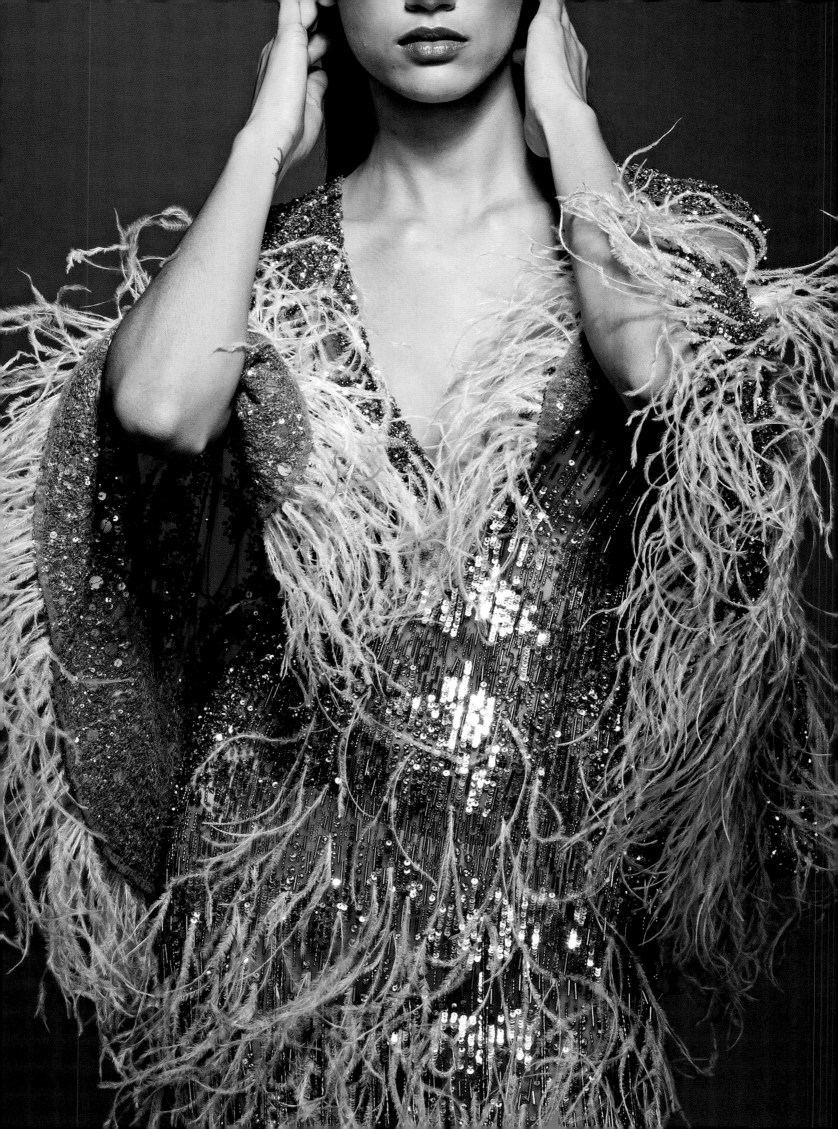

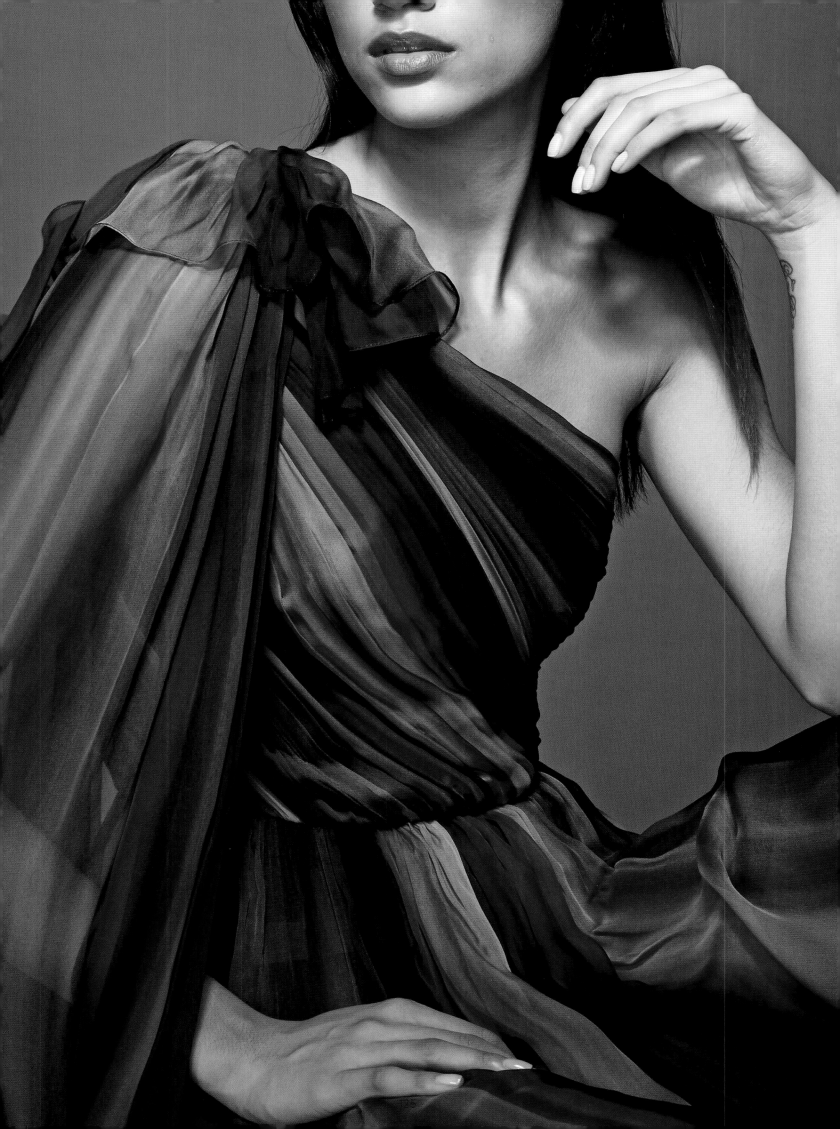

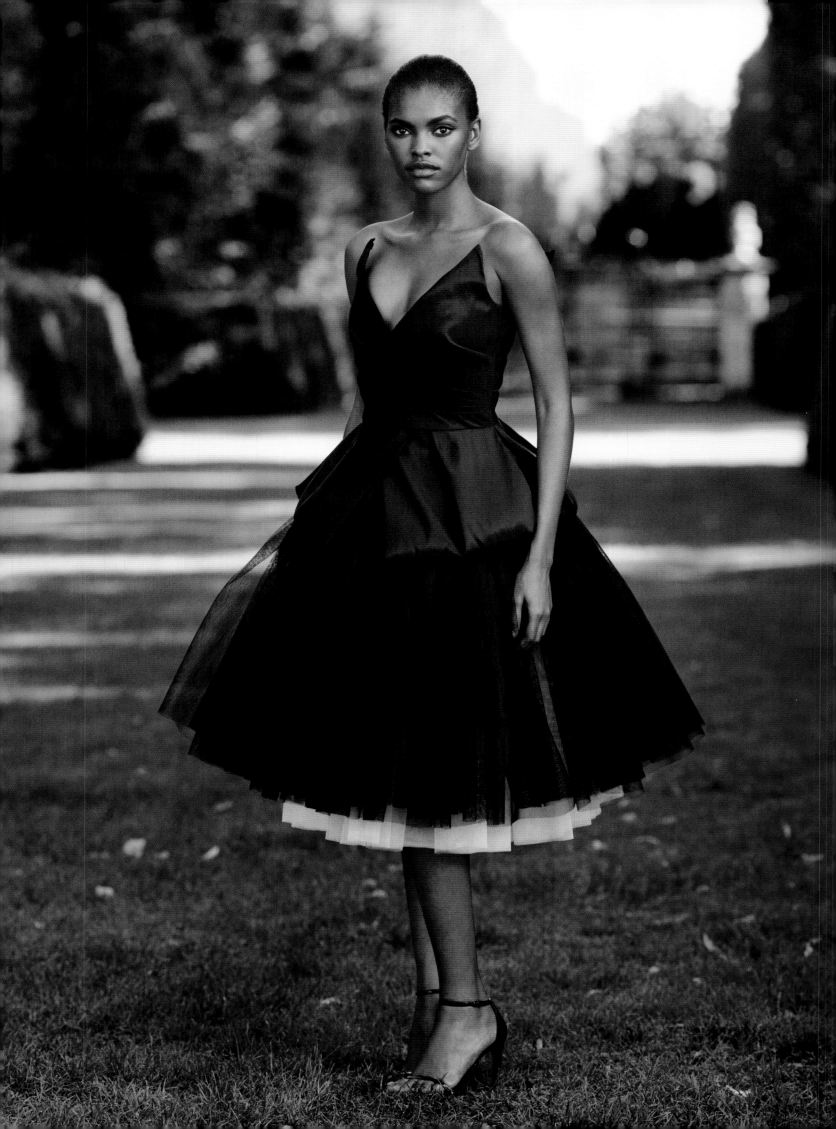

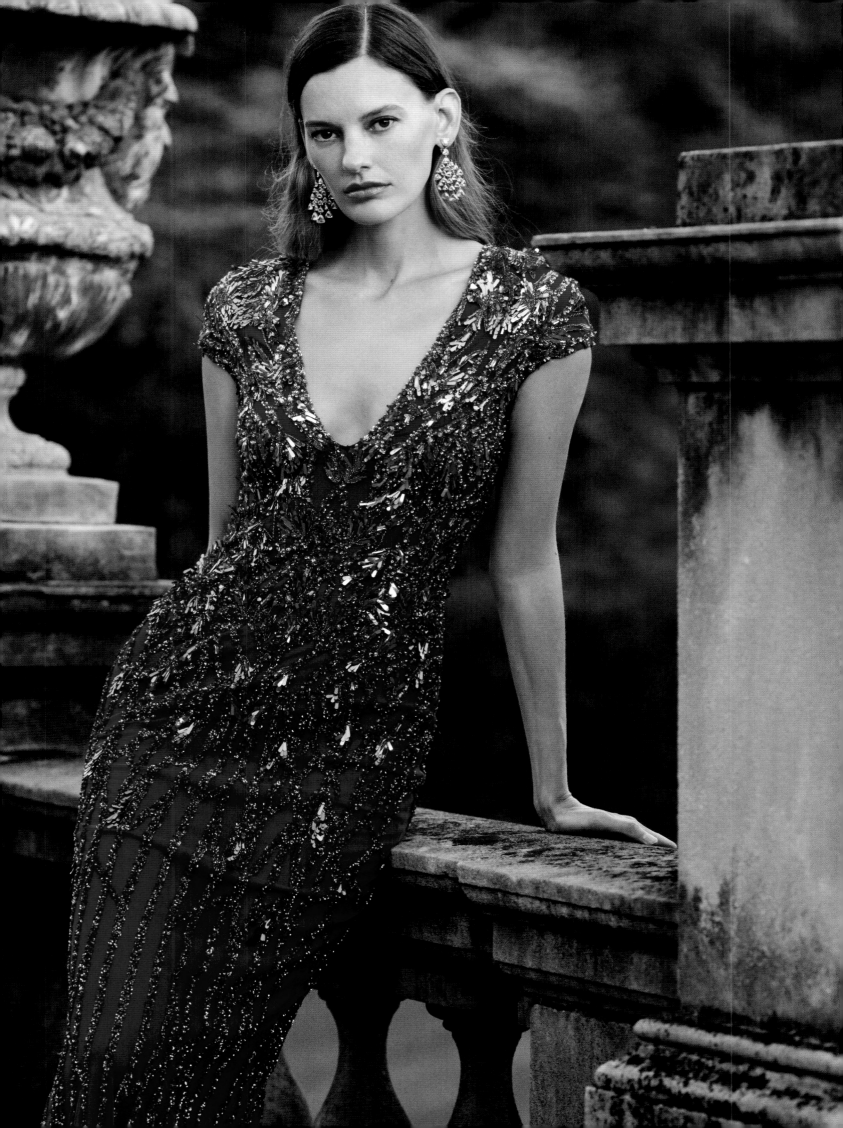

*Previous spread:* Selections from the Spring/Summer 2022 collection. *Opposite:* My Spring/Summer 2022 collection channeled the color and opulence of Peter Carl Fabergé's Imperial eggs, works of art traded among the Romanovs as Easter gifts. Setting this photo shoot on the lush grounds of Old Westbury Gardens on Long Island helped us to capture the eggs' glamour and spirit of renewal.

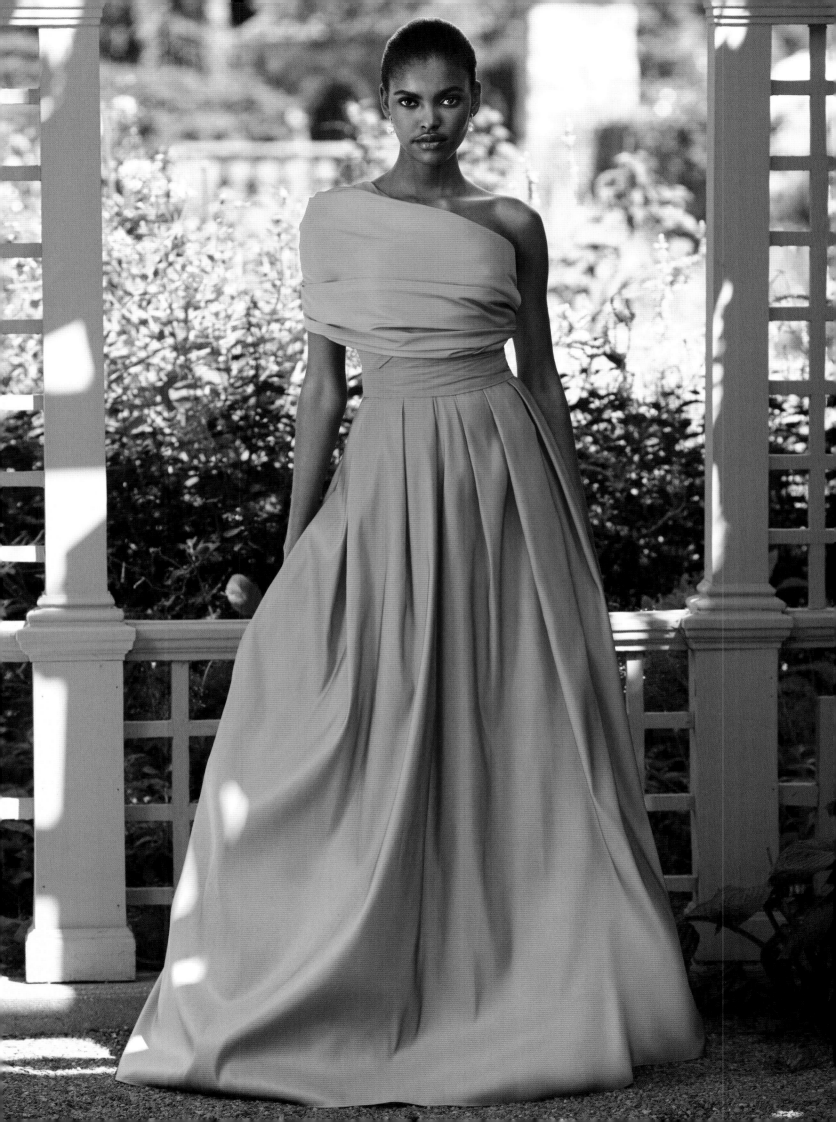

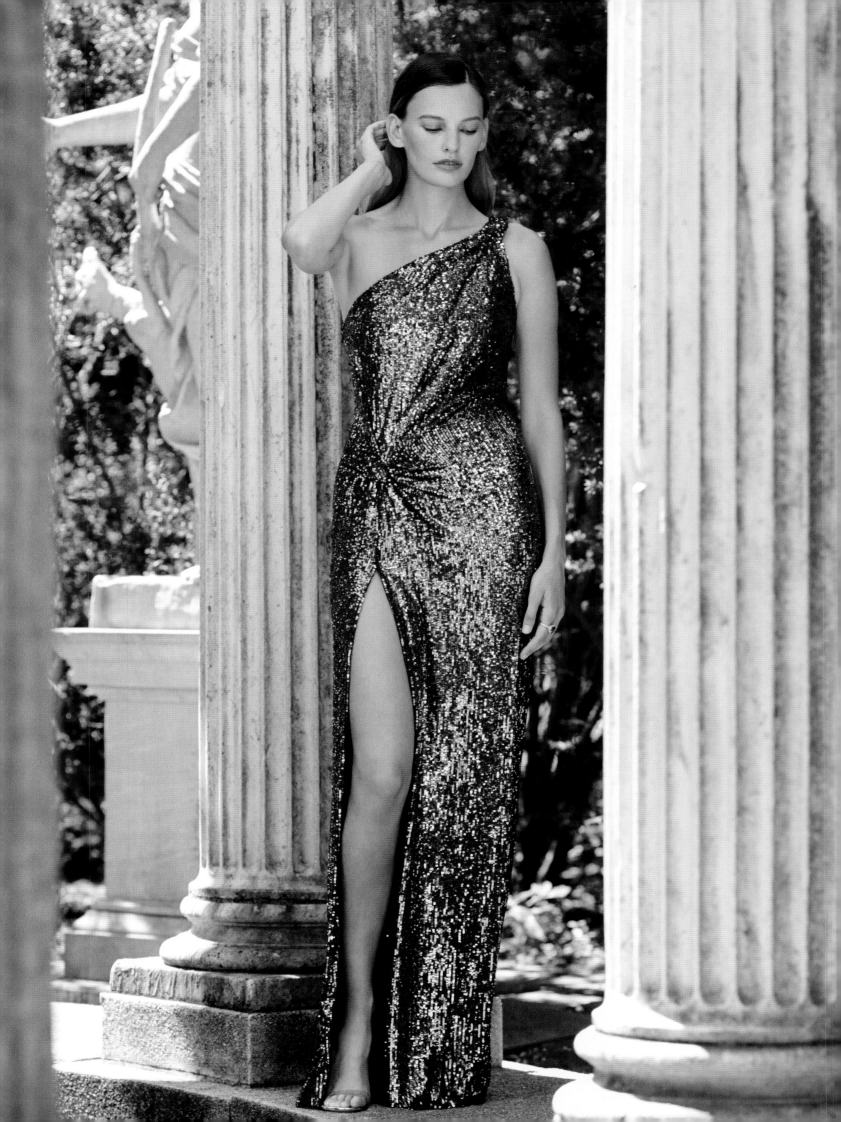

*Opposite:* An iris sequin one-shoulder gown from the Spring/Summer 2022 collection. *Following spread:* A black and iris stretch crepe tuxedo Jacket with beaded fringe from the Spring/ Summer 2022 collection.

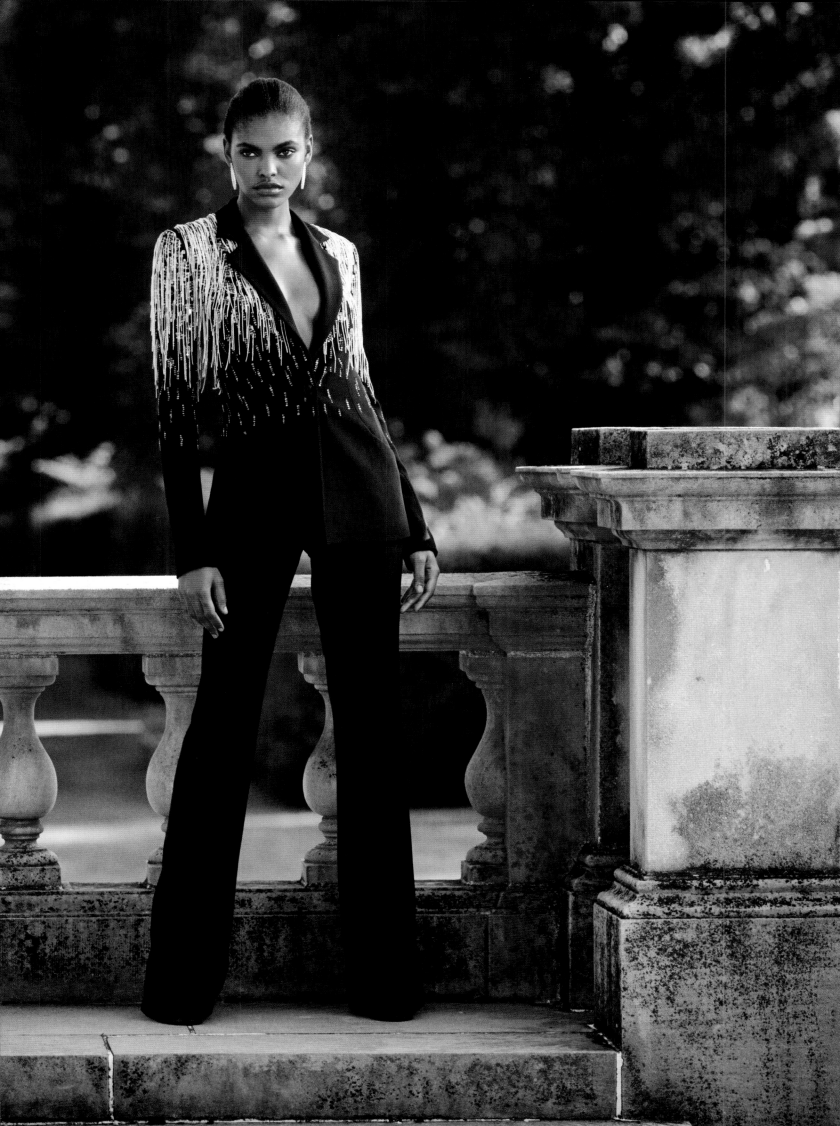

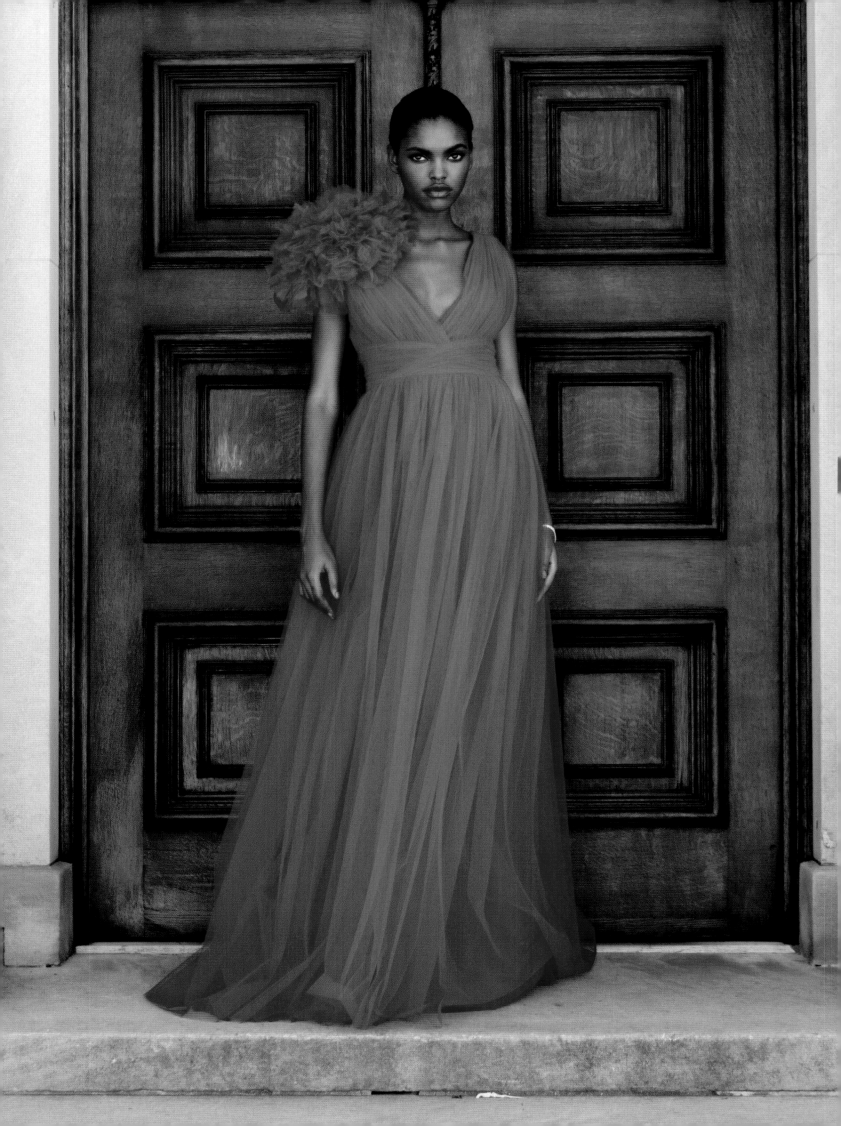

*Opposite and following spread:* The venue is everything to a fabulous occasion, which is why we took our Fall/ Winter 2021 collection to Alder Manor in Yonkers, New York. Cocktail dresses from the Fall/Winter 2021 collection.

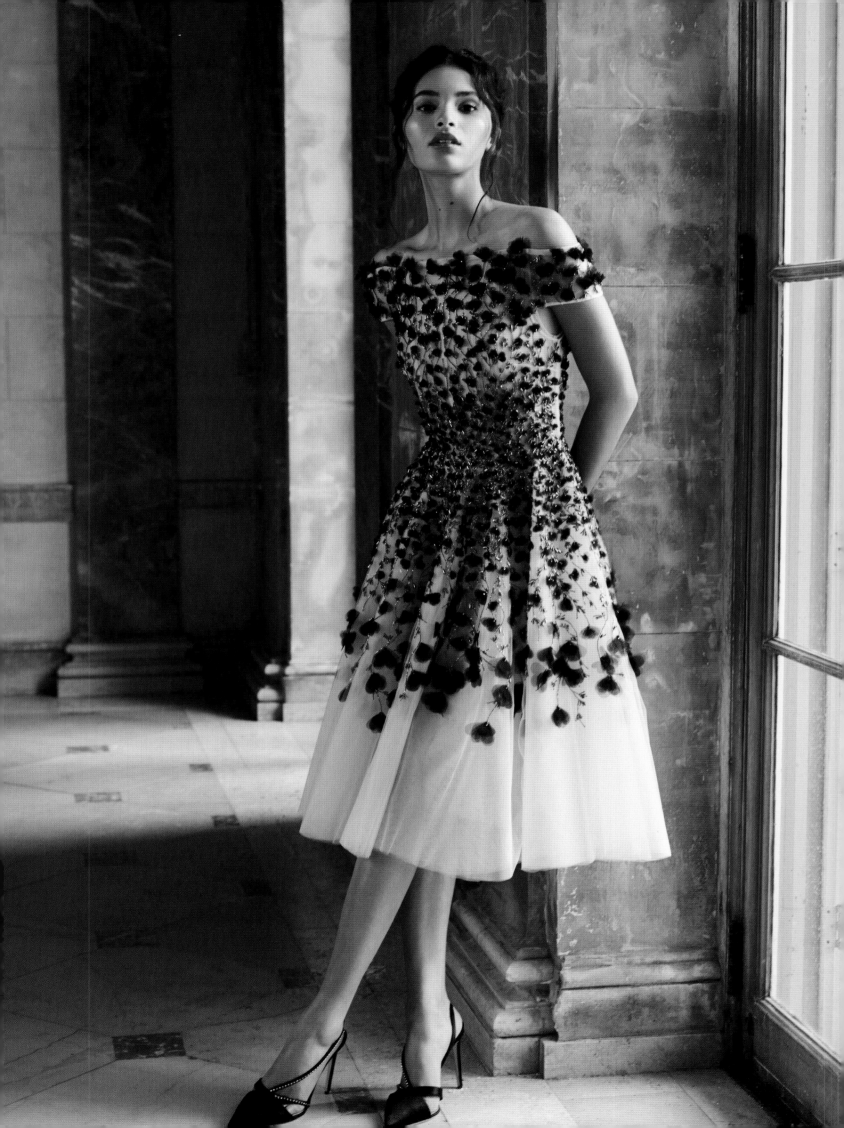

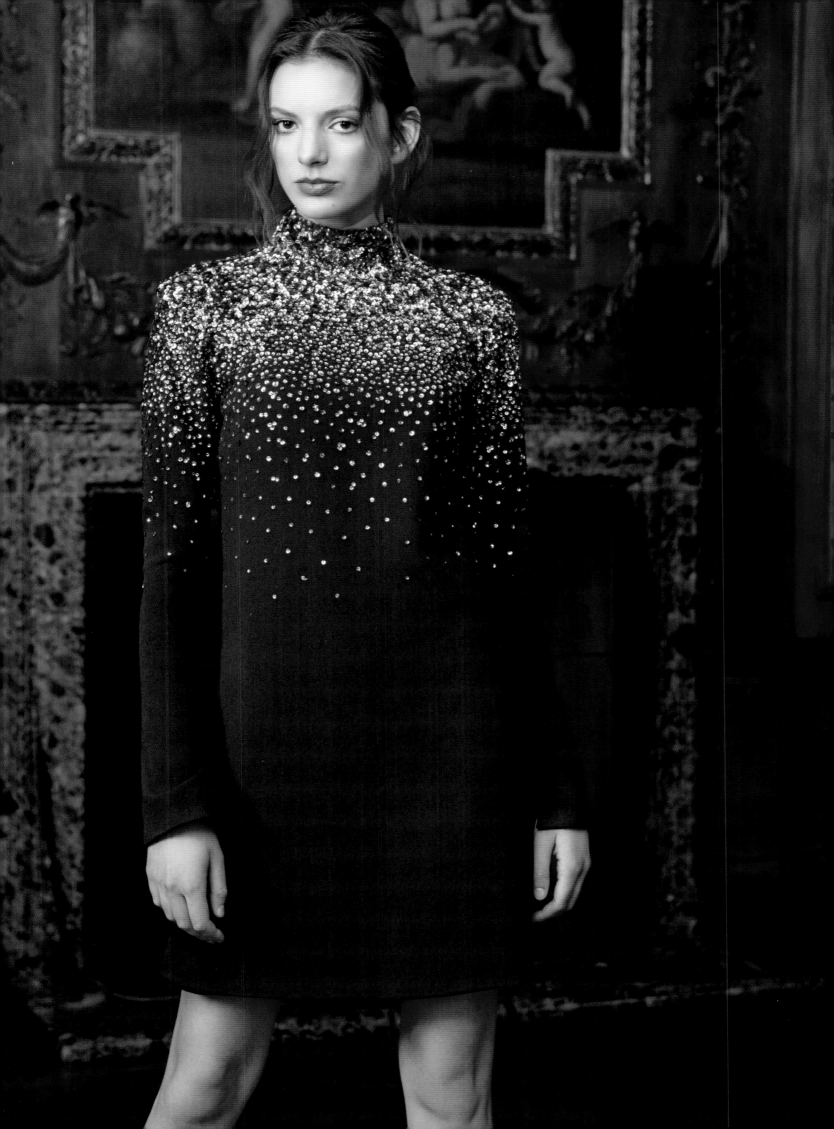

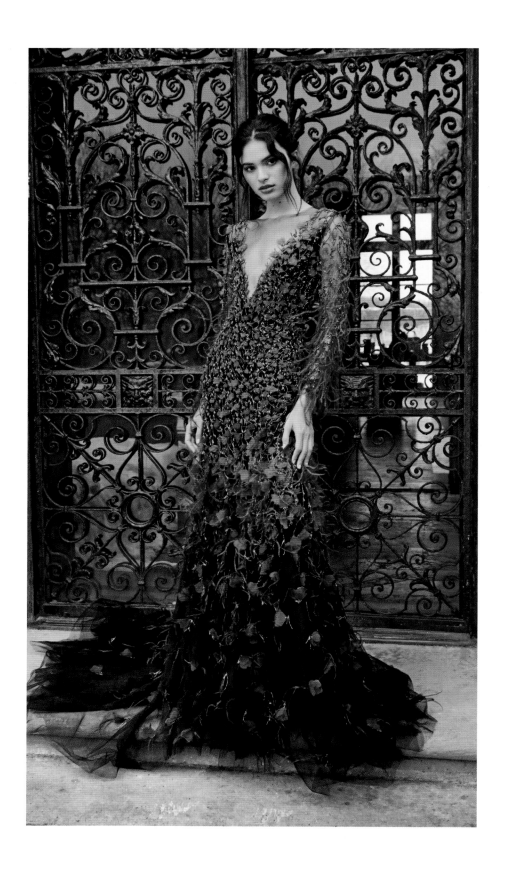

*Above:* A black and multi-embroidered gown with ostrich feathers from the Fall/Winter 2021 collection. *Opposite:* Red and gold details.

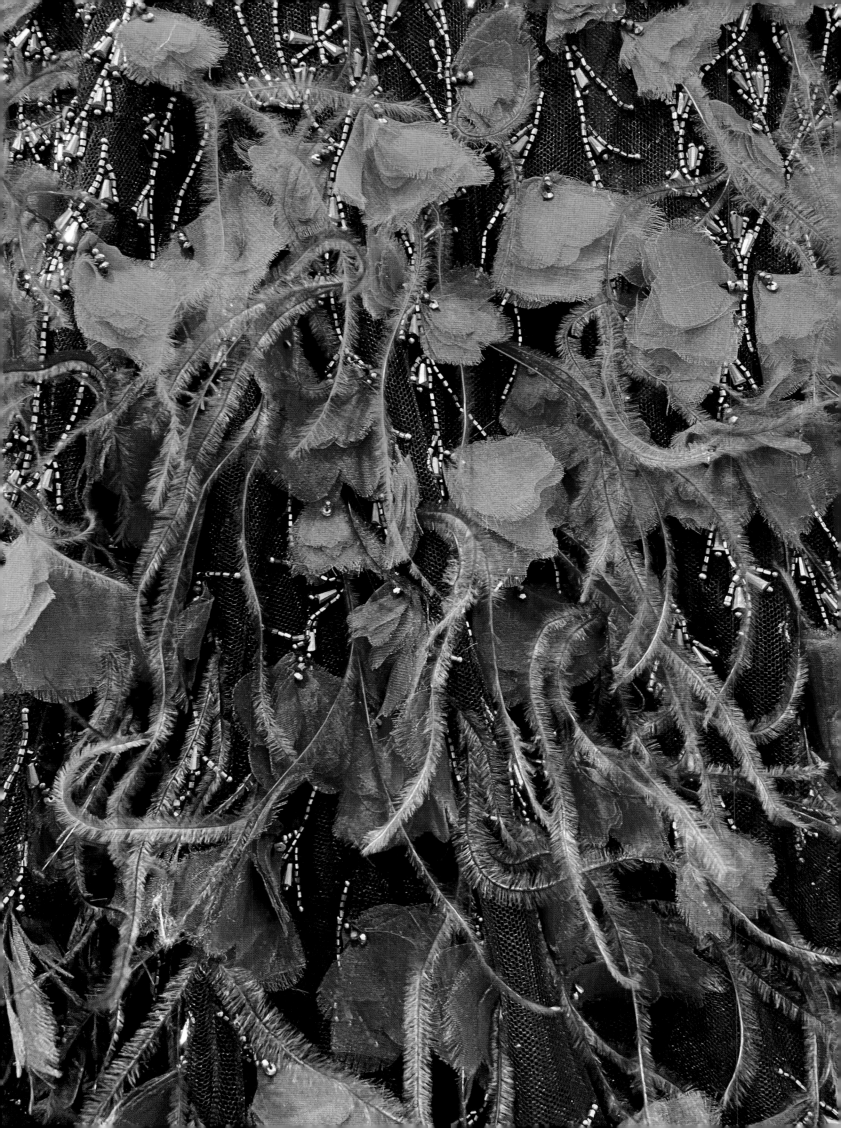

*Opposite:* I worked closely with my design team to find locations that lived up to the sumptuous silhouettes in our Fall/Winter 2021 collection.

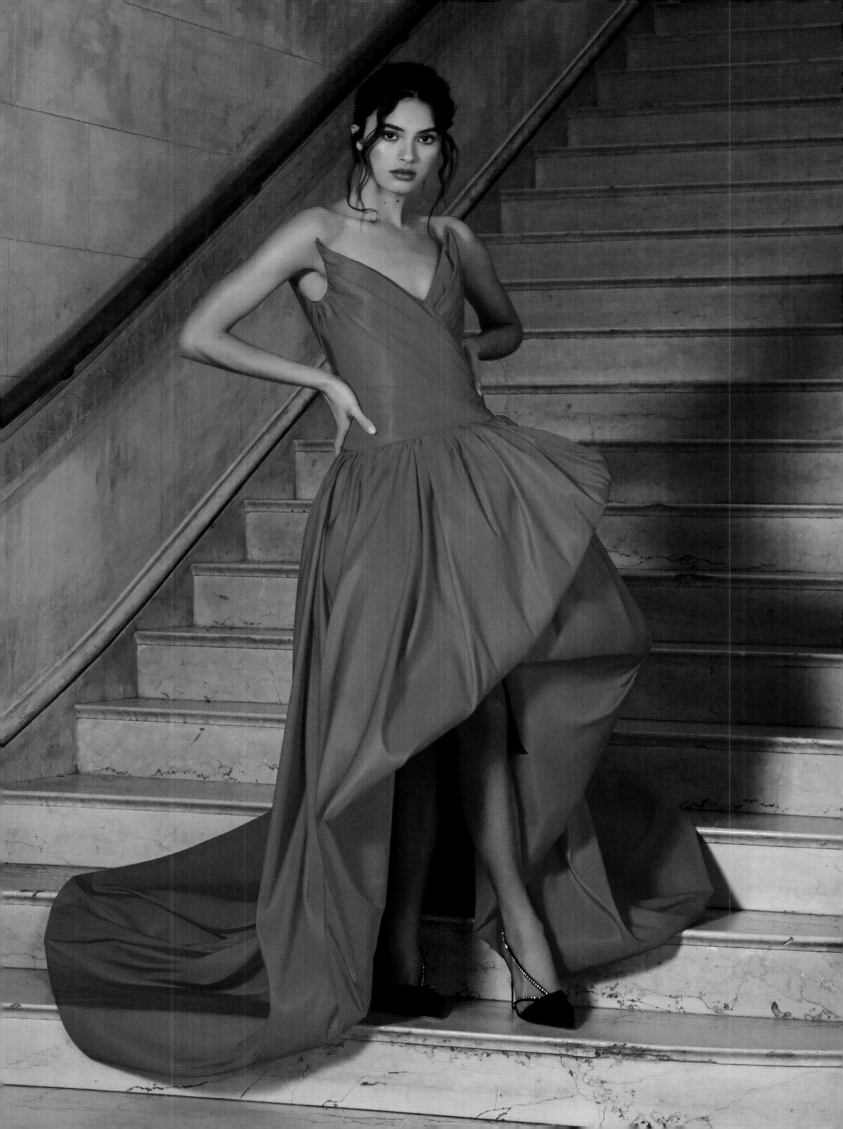

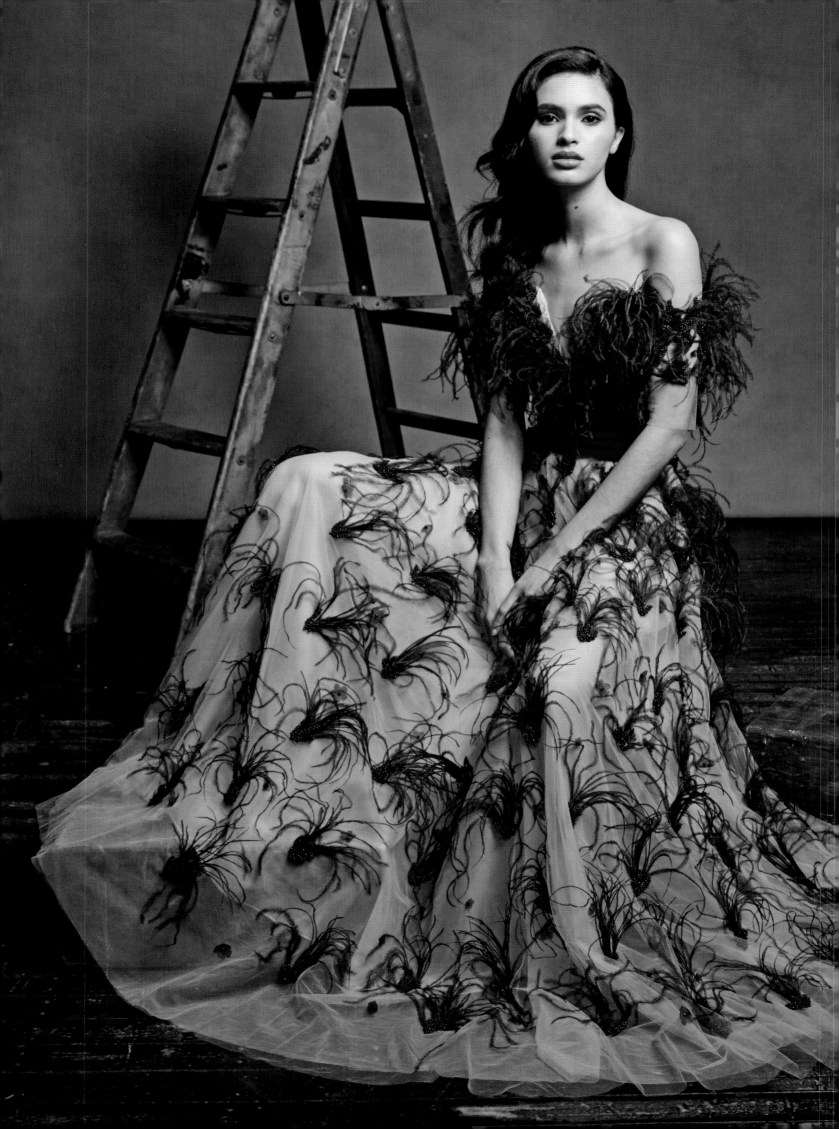

*Opposite:* Sometimes, a minimalist set like the one used in this photo is perfect for a maximalist garment. The effect was just as stunning as what we get from highly involved shoots. *Page 146:* A blush multi-embroidered tulle long-sleeve gown from the Pre-Fall 2022 collection. *Page 147:* Illustration of the gown by Andrew Cruz, design director.

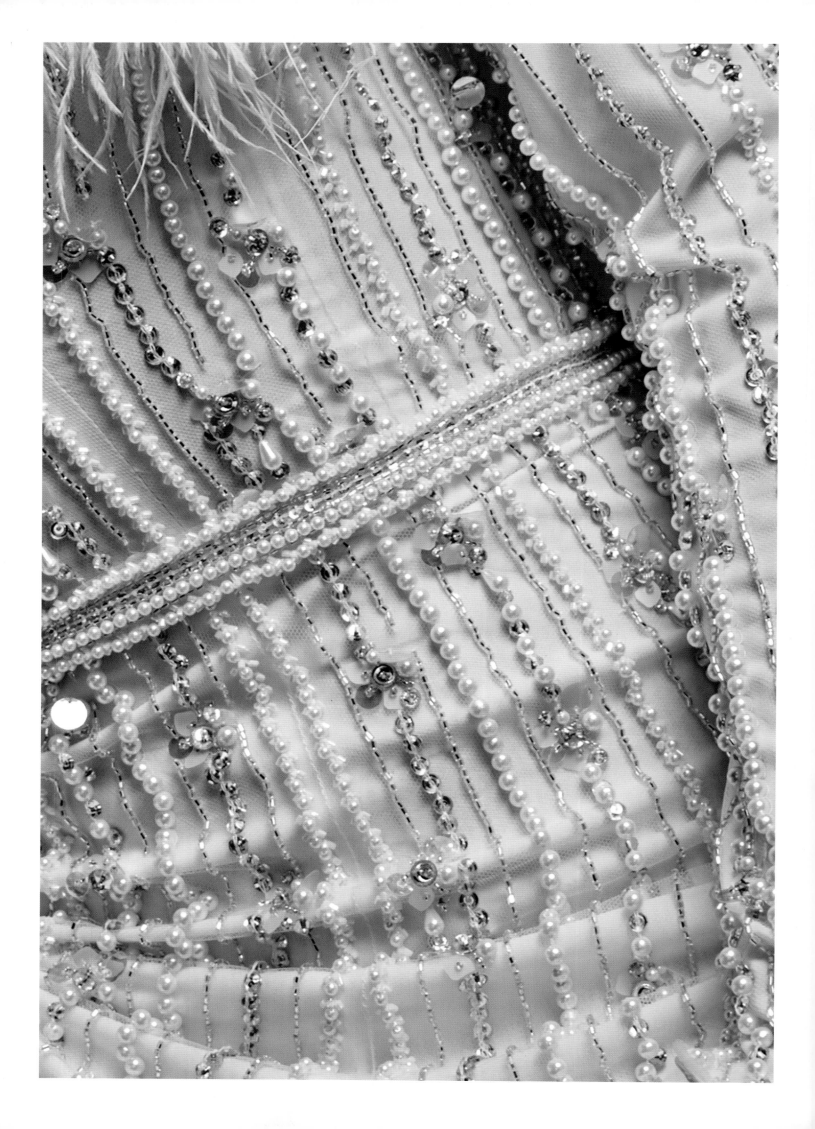

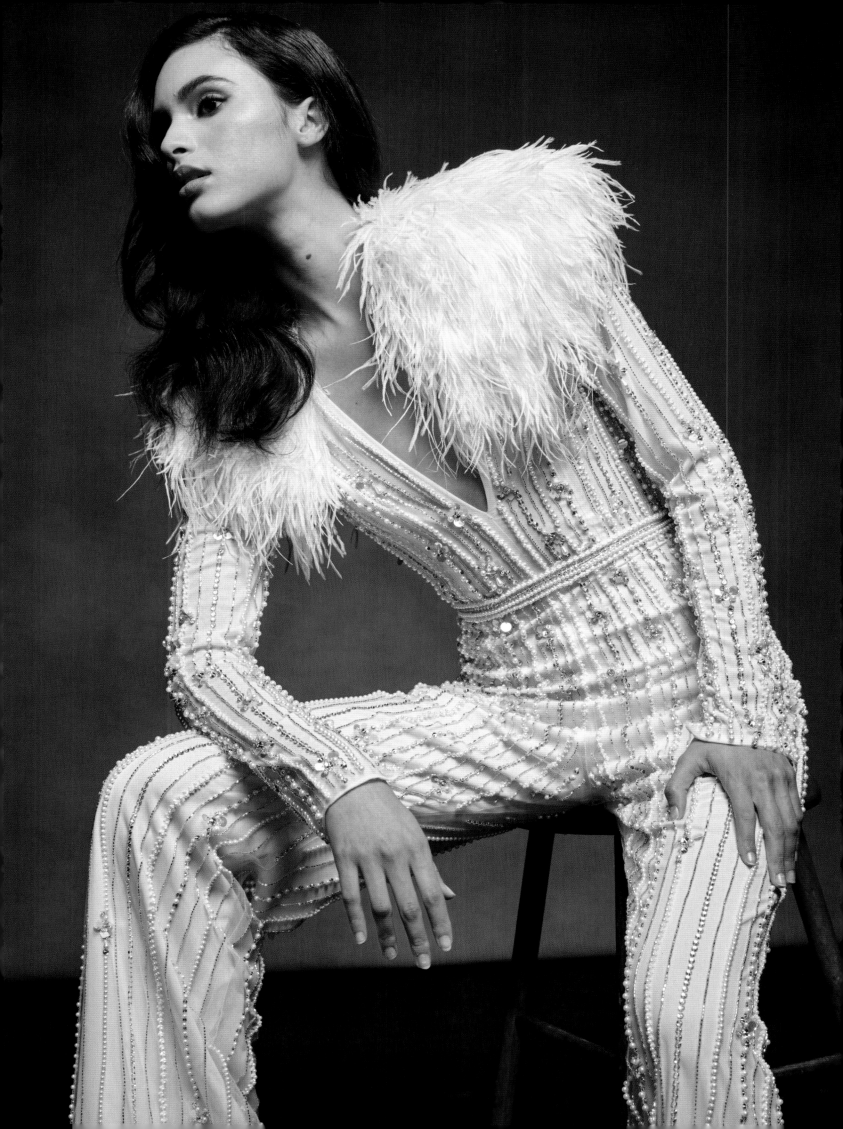

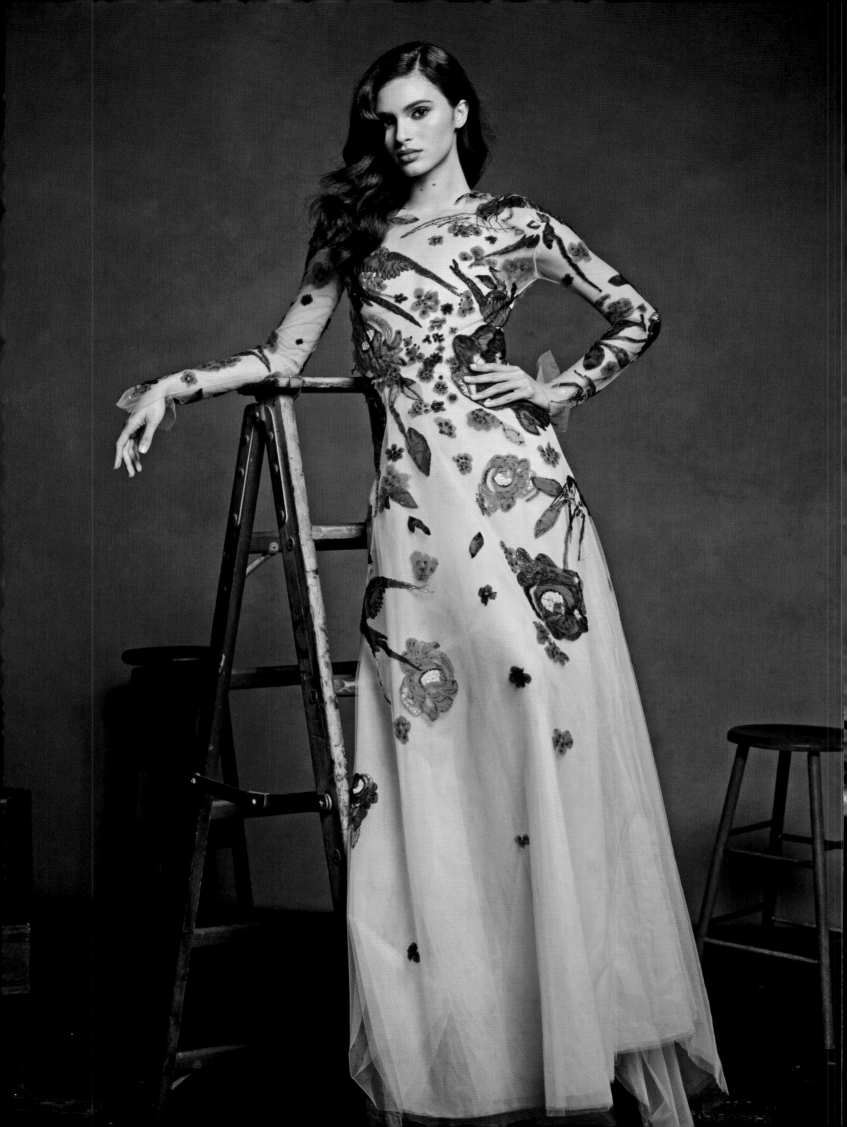

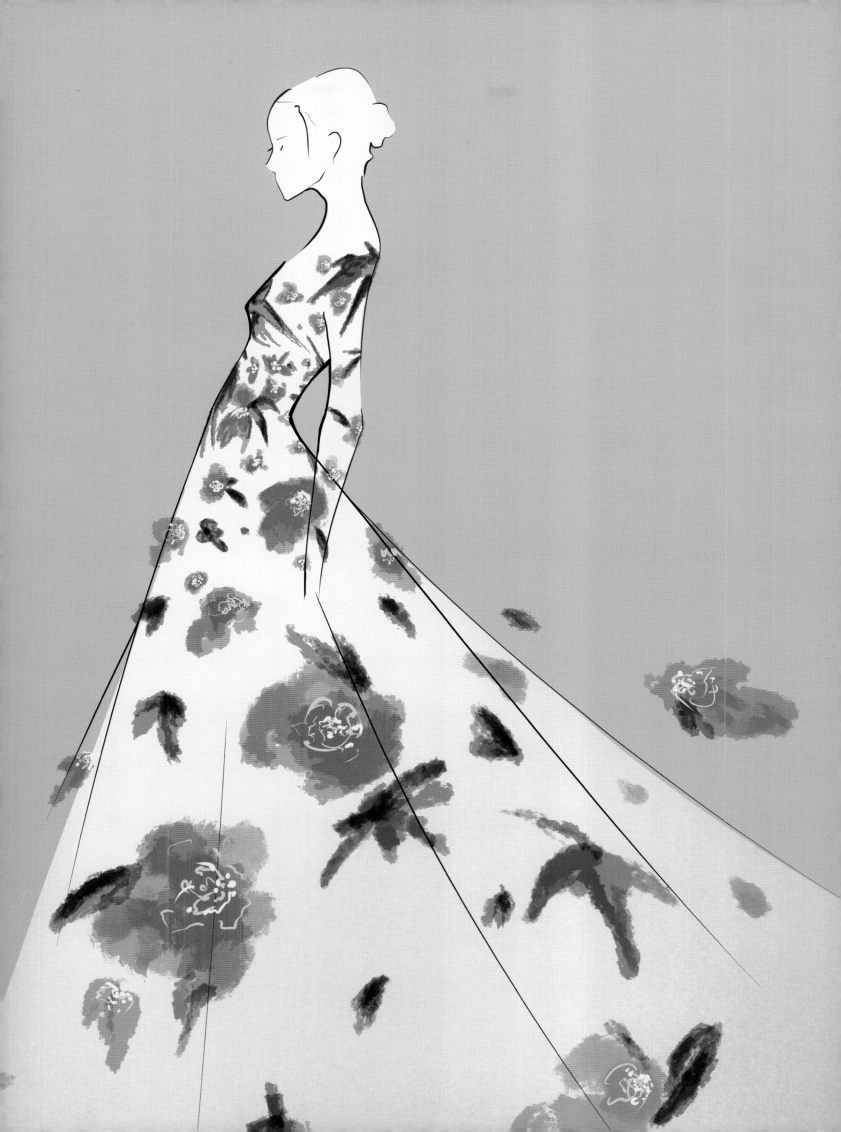

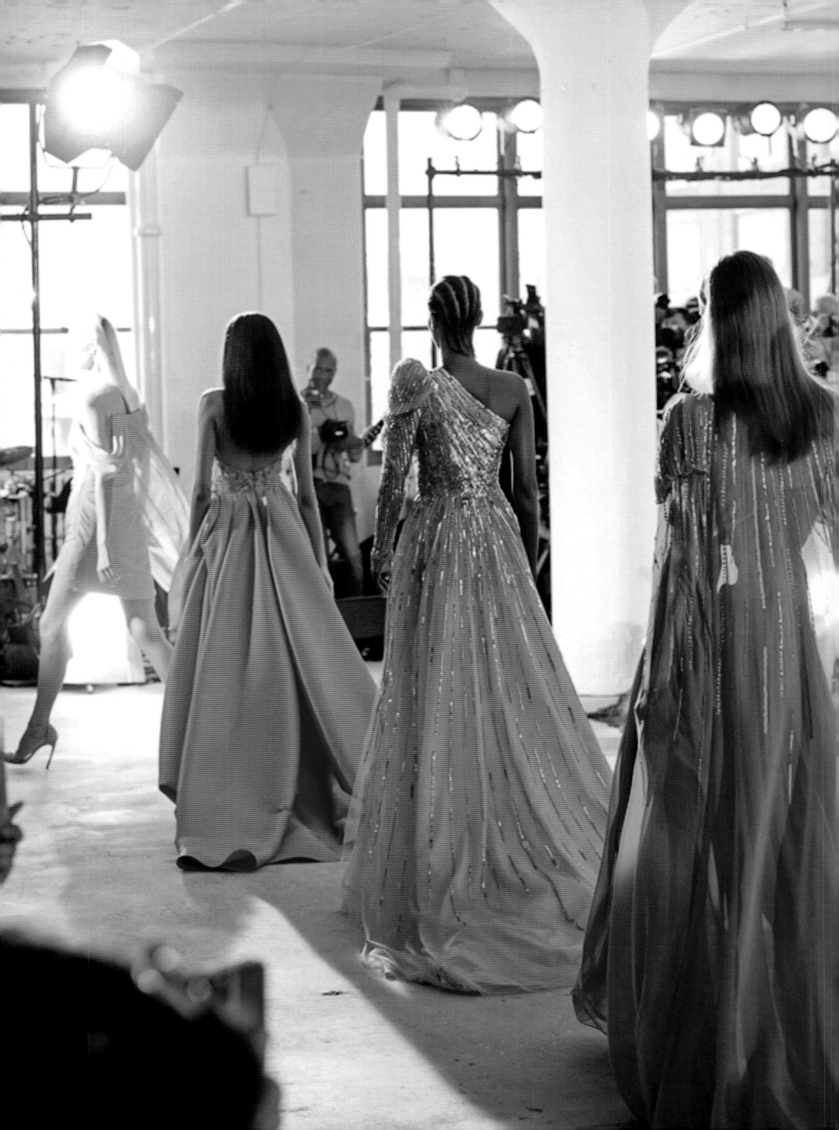

# collections
## some of my favorites

Sometimes, even I cannot believe the number of collections we have produced over the last twenty years. Careful consideration and plenty of hard work goes into the thirty or so looks we usually present on the runway. I spend countless hours looking at swatches and doing fittings. Seeing each design come to life is still magical after so many years in the business.

Almost every season is inspired by or, in some way, influenced by my love for art and travel. I became fascinated by modern art in college. After graduating, I developed my own collection of paintings and sculptures. I have had the honor to serve on several museum boards, including the Whitney Museum of American Art in New York City. My designs have been influenced or inspired by Tiffany glass, Mark Rothko, and Frank Stella, among others.

My travels have taken me around the world, allowing me to experience a wonderful wide range of stunning colors, architecture, and history. I am grateful to have traveled extensively with my family. I even lived in Japan when my children were young. These influences and passions of mine appear in my runway presentations season after season. I aim for our pieces to transport people somewhere new and exciting, even if they are dressing for a garden party at their own home.

*Opposite:* The closing walk of the Spring/Summer 2022 runway show. *Following three spreads:* Looking back on the last twenty years of runway presentations.

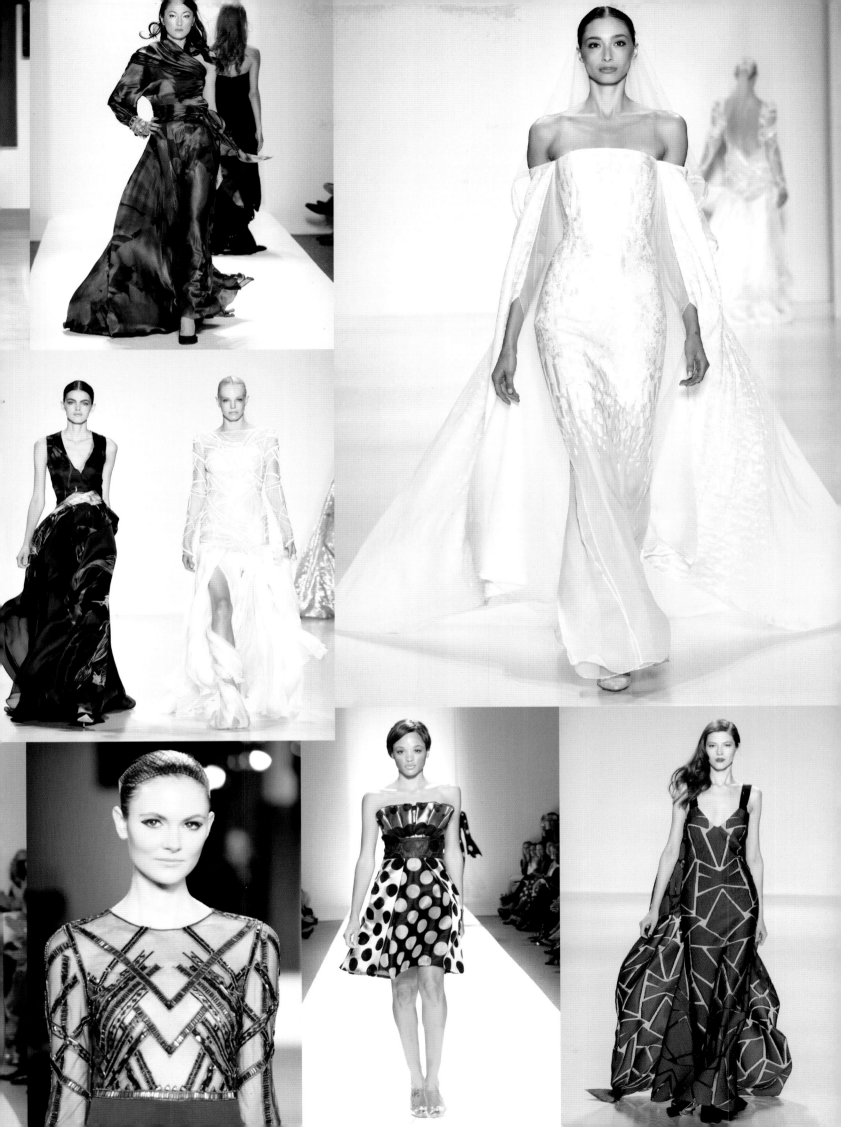

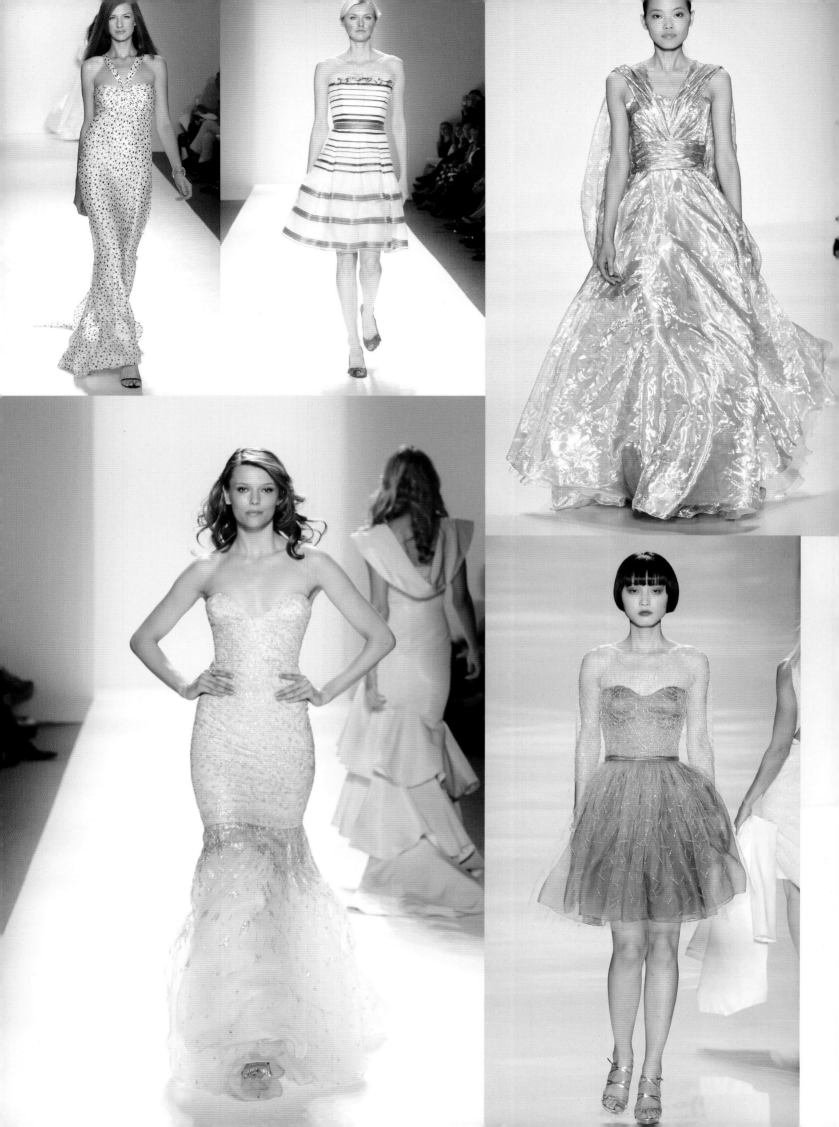

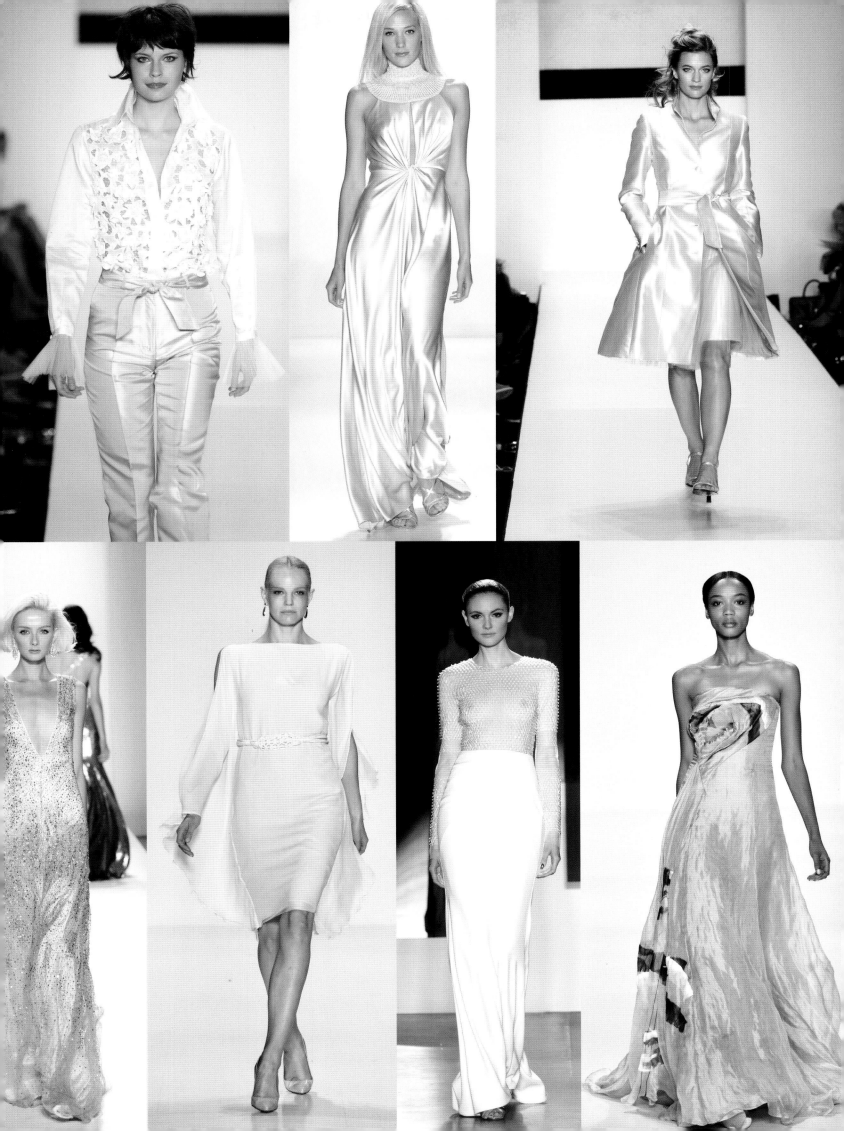

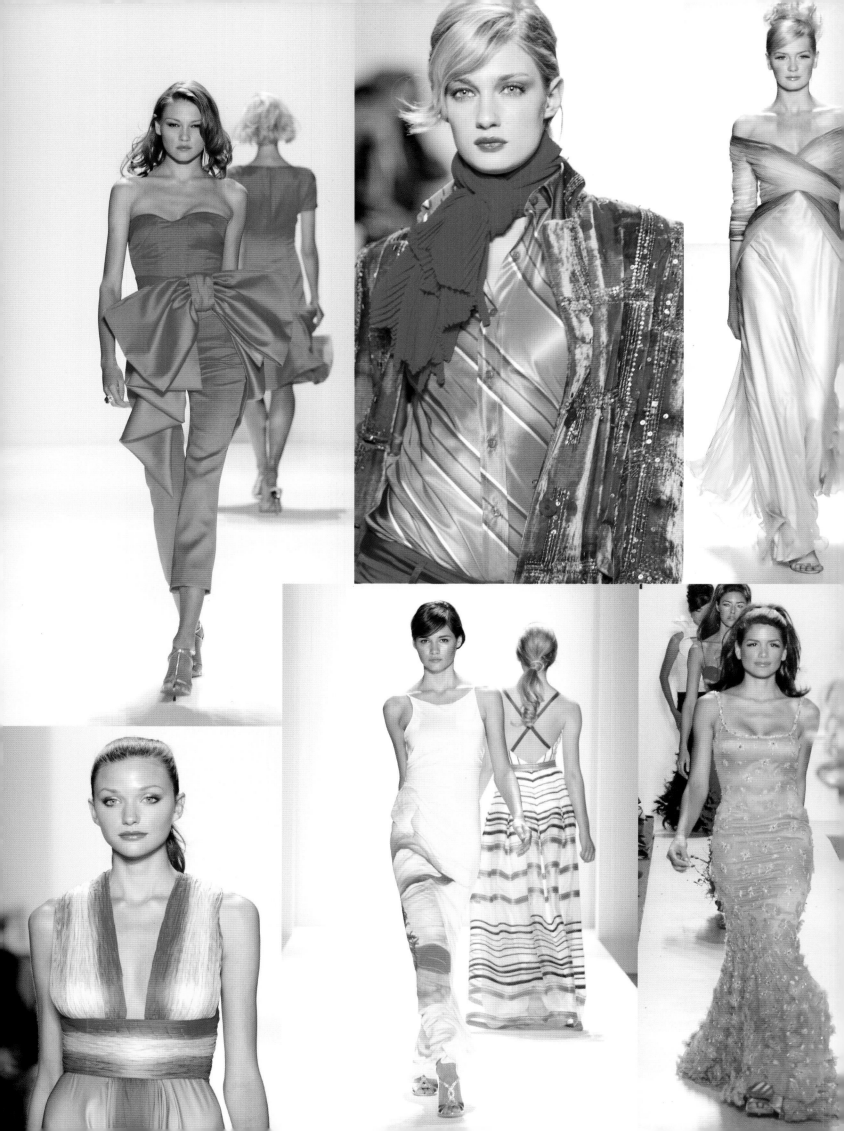

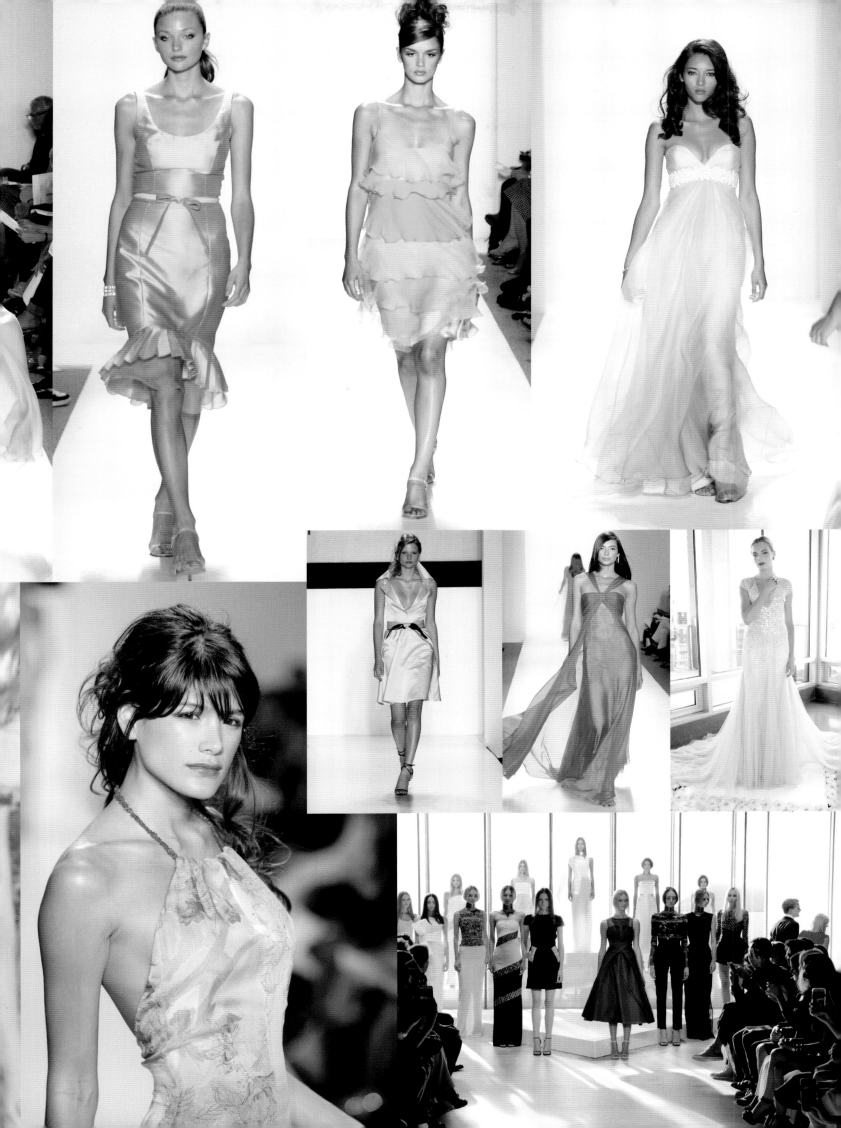

**SS16**

spring/summer
2016

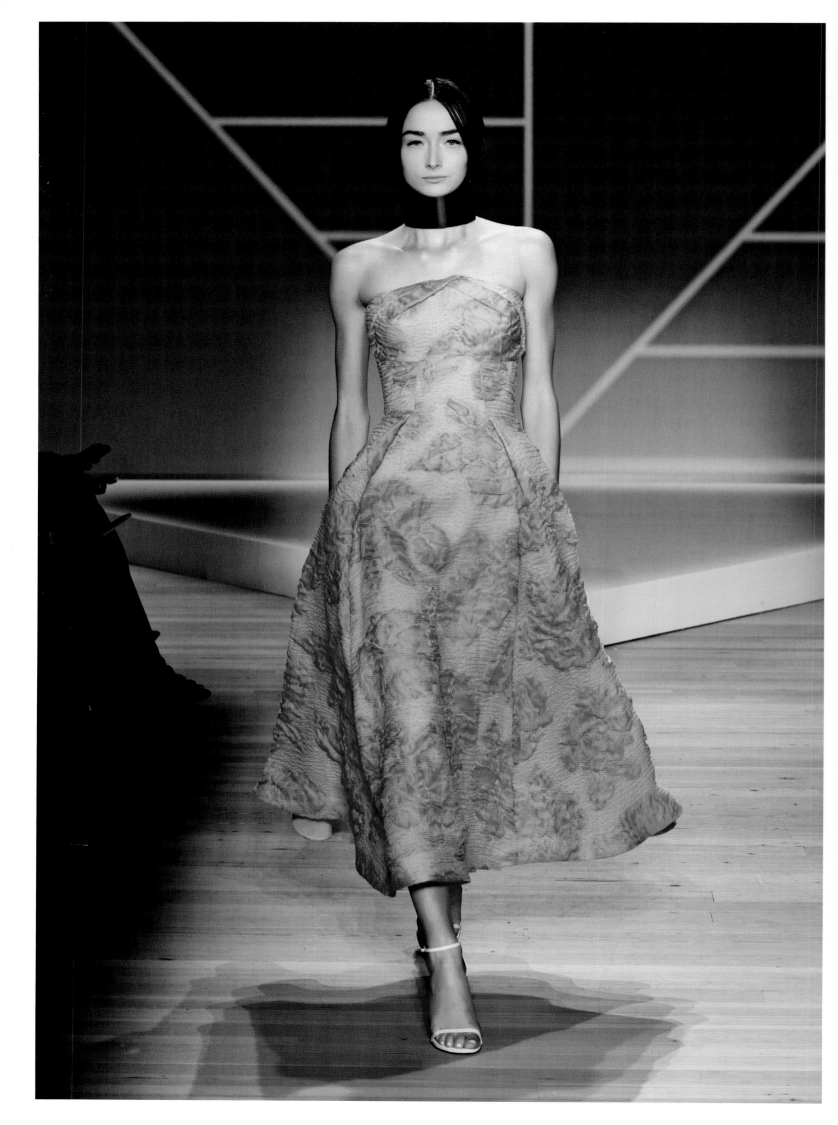

# spring/summer twenty-sixteen

The Spring/Summer 2016 runway show was a special one because my team and I presented it at the Whitney Museum of American Art in its new home in Manhattan's Meatpacking District. As vice president of the museum's board of trustees and an art lover, I was honored to be the first fashion designer to show there.

Painter and sculptor Frank Stella inspired this particular collection. I pared back my signature sequins, paillettes, and crystals to bring focus to Stella's use of shape and unusual materials. His geometric patterns came to life on my garments through square pieces of mirrors, which were paired with beading for a gridded effect, and precise, dramatic pleating. I modernized the classic illusion yoke dress with crosshatched beading made from plexiglass.

The season's color palette of citron, aquamarine, warm pinks, cream, and bold oranges came straight from Stella's canvasses. I leaned into liquid organza to evoke the gleam of metals and plastics in his sculptures. My team even developed fabrics with LED fibers in honor of Stella's futuristic style.

Of course, no Stella-inspired collection would have been complete without incorporating a reference to his *Black Paintings* series (1958–1960), the minimalist works that shook the art world. I layered tonal texture on each black garment, using appliqués, thick cording, beading, or folded accents, reimagining a wardrobe staple.

*Opposite:* A sherbet cloque fils-coupe tea length dress, Spring/Summer 2016. *Following spread left:* A mint satin back cady faille gown with a beaded tulle bodice. *Following spread right:* A citron liquid look organza dress with beading.

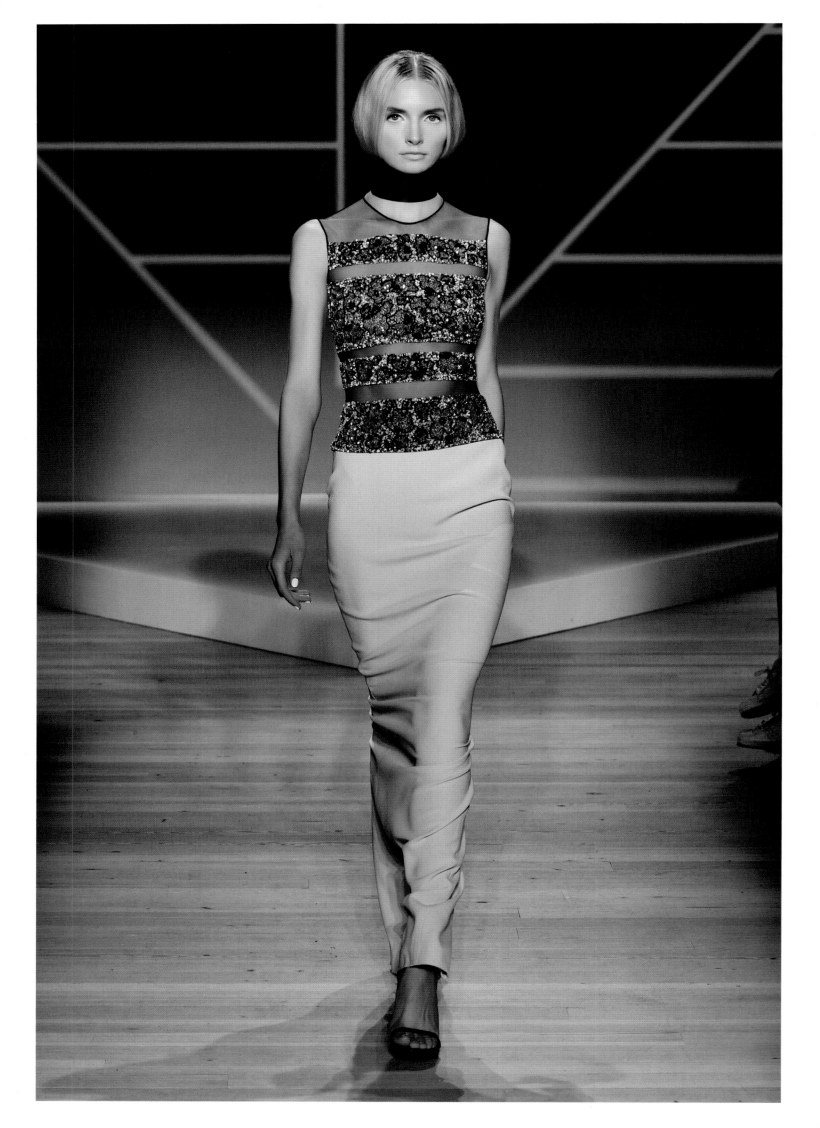

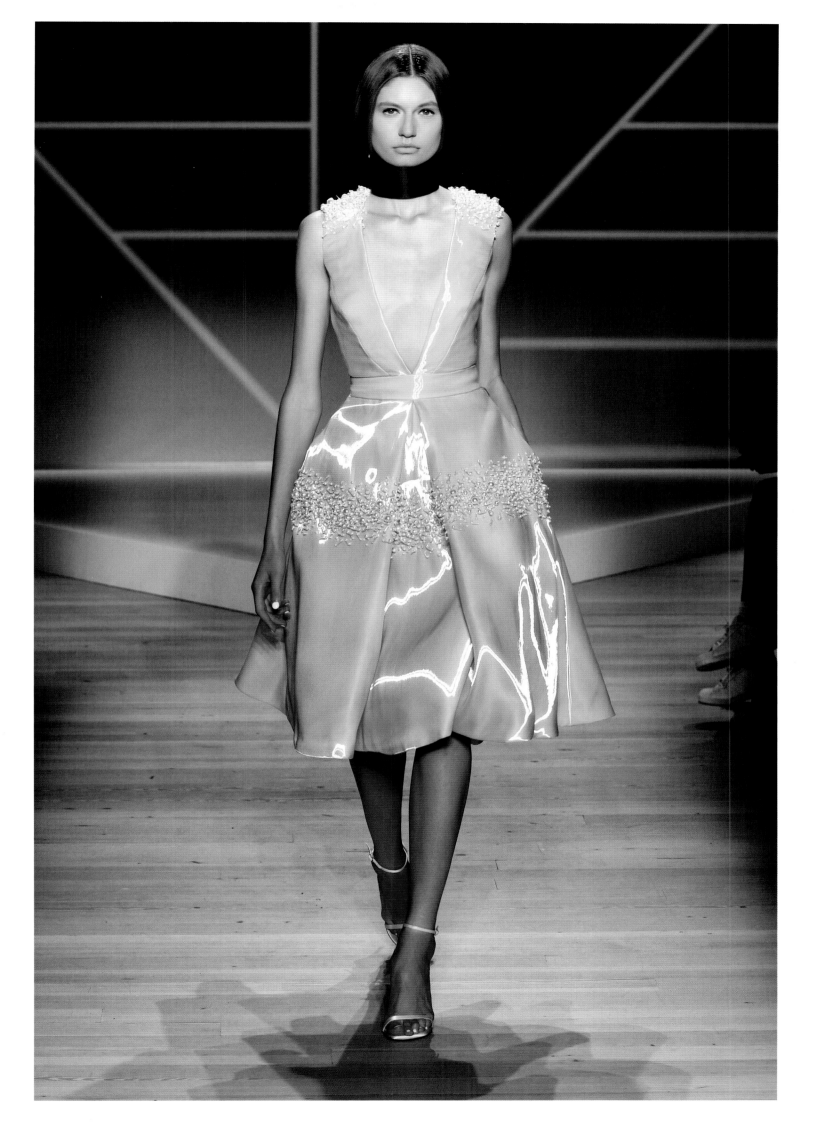

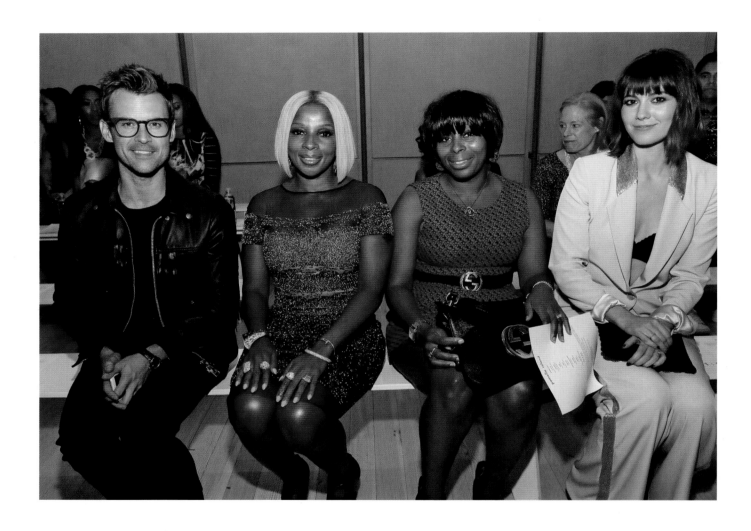

I owe much of my success to the stylists and clients present and future who come to my runway shows. *Above:* Stylist **Brad Goreski**; singer and longtime client **Mary J. Blige**, who is wearing Pamella Roland; her sister **LaTonya Blige-DaCosta**; and actress **Mary Elizabeth Winstead**. *Right:* A black silk heavy georgette jumpsuit with a beaded signature sequin bodice.

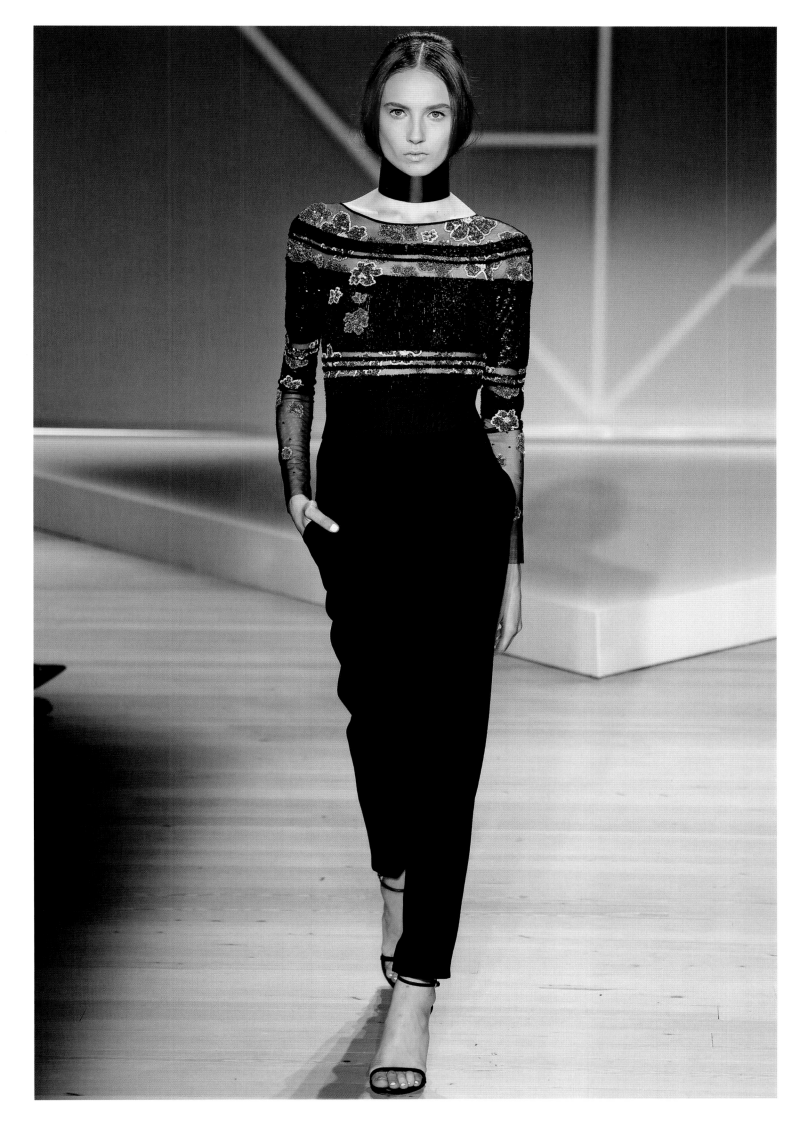

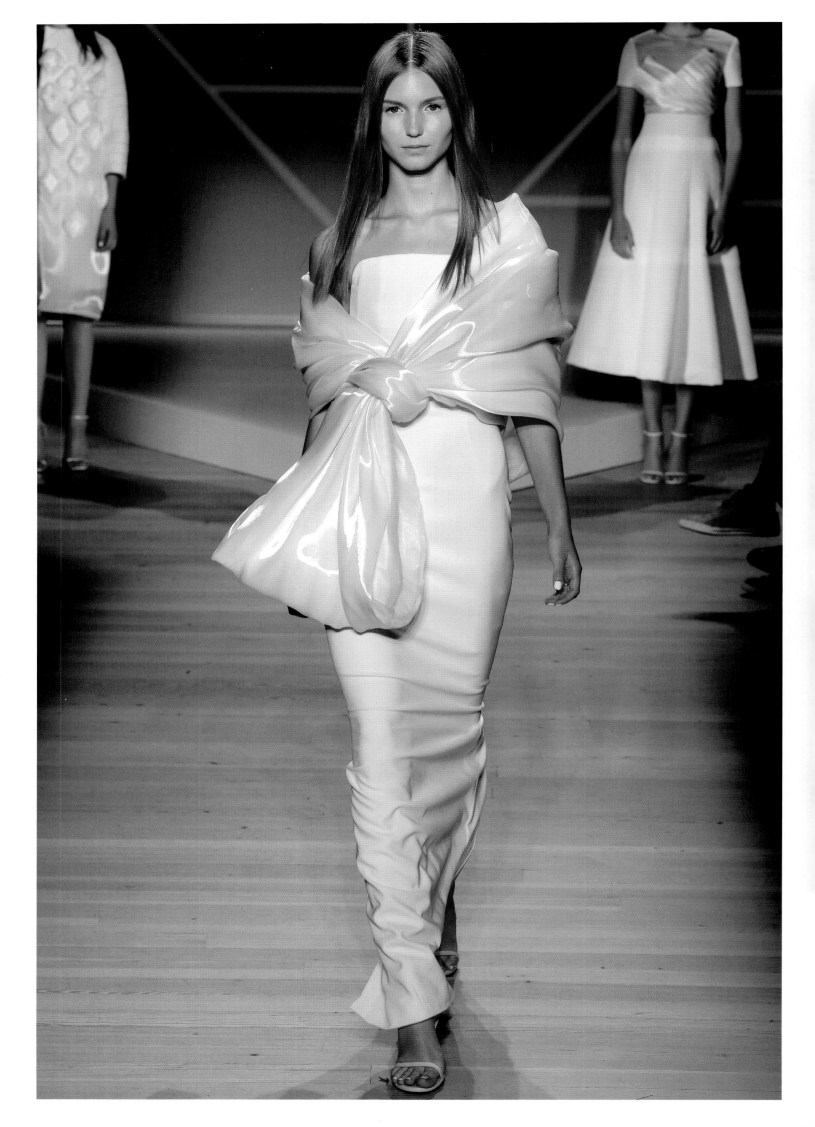

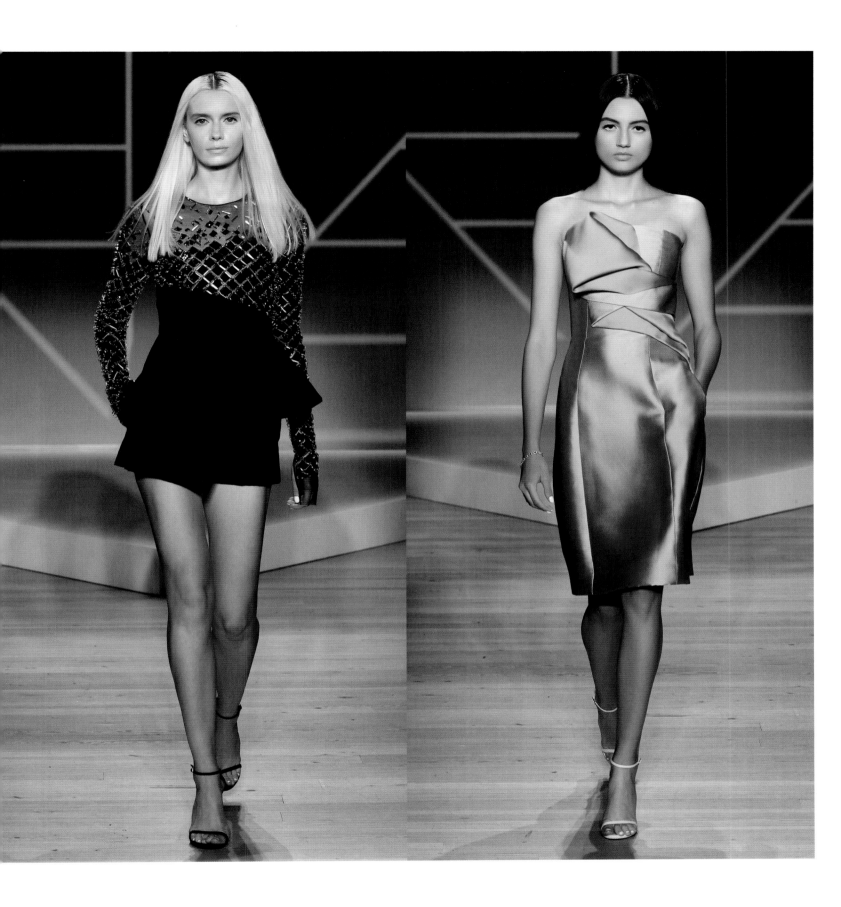

*Above and opposite:* Modern art is always so inspiring. I love the challenge of translating a painter's or sculptor's aesthetic to a new, wearable medium. The Spring/Summer 2016 tribute to artist Frank Stella remains a favorite.

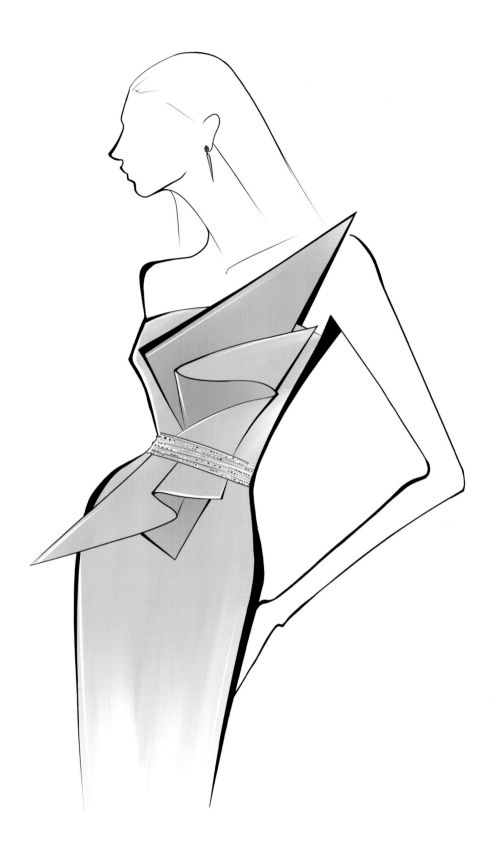

An orange and blush double-faced
satin origami gown with a beaded belt.

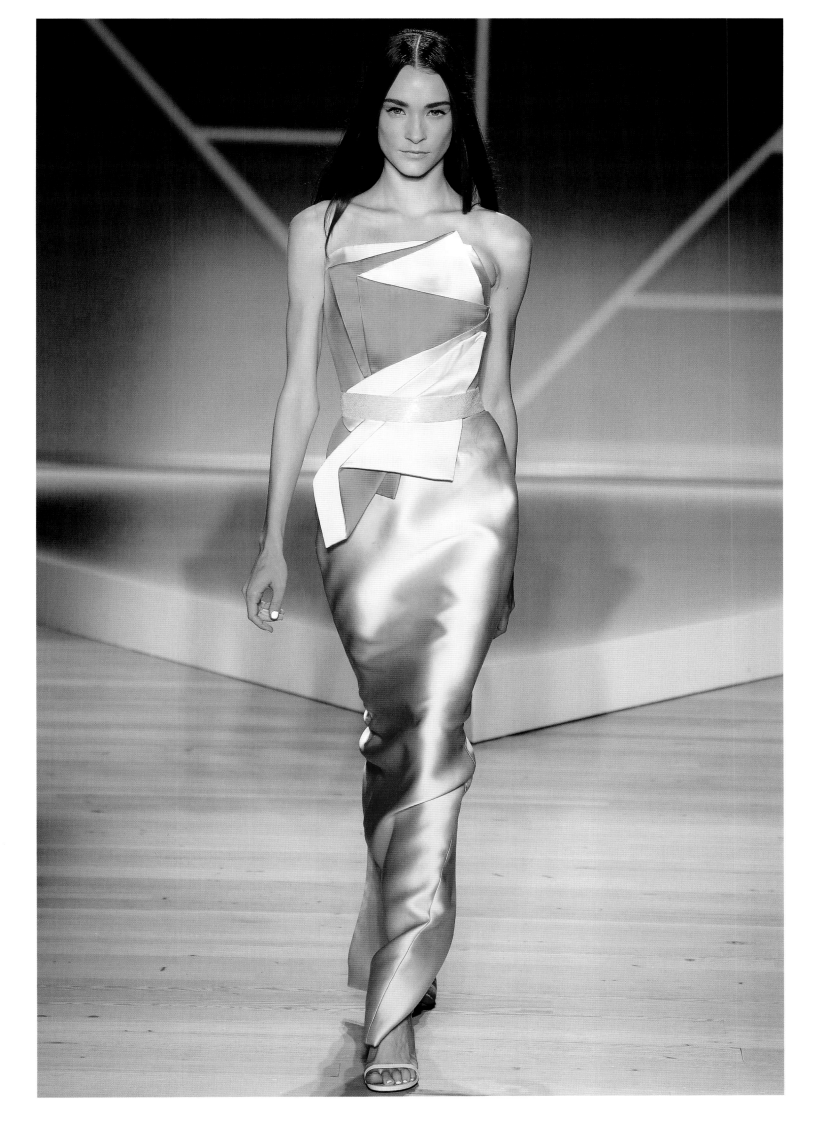

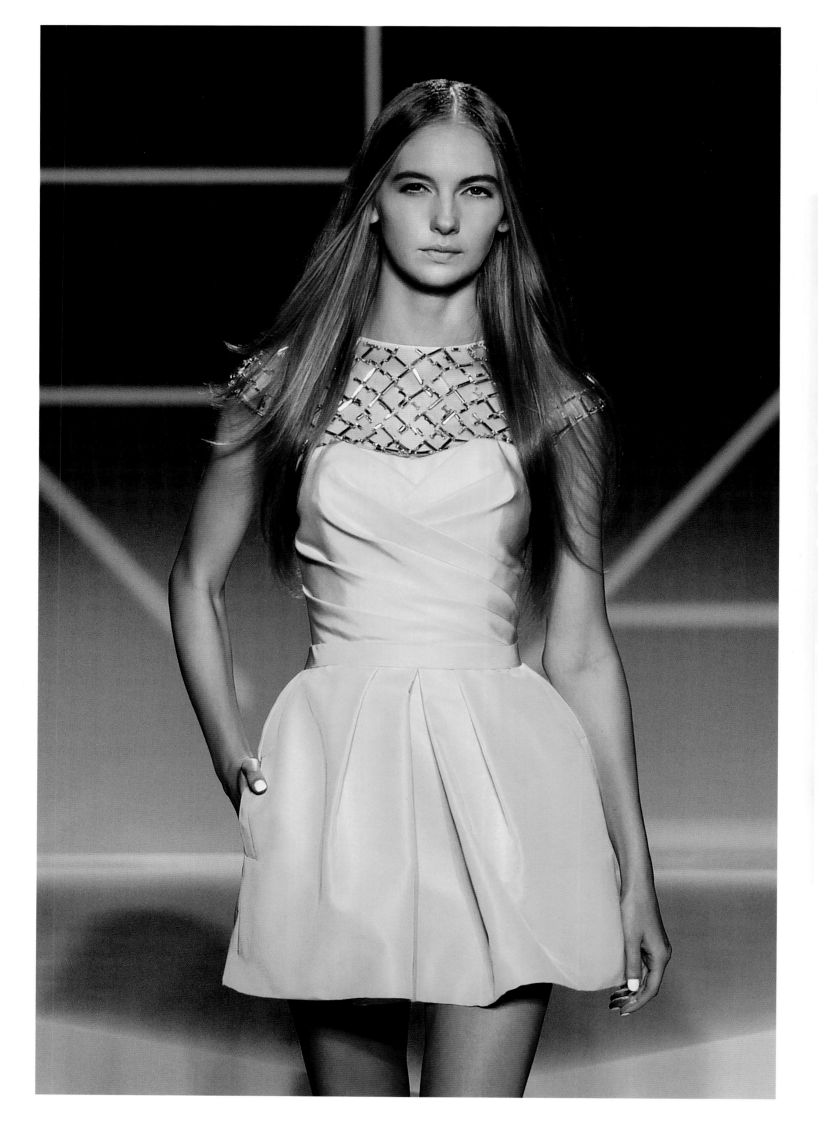

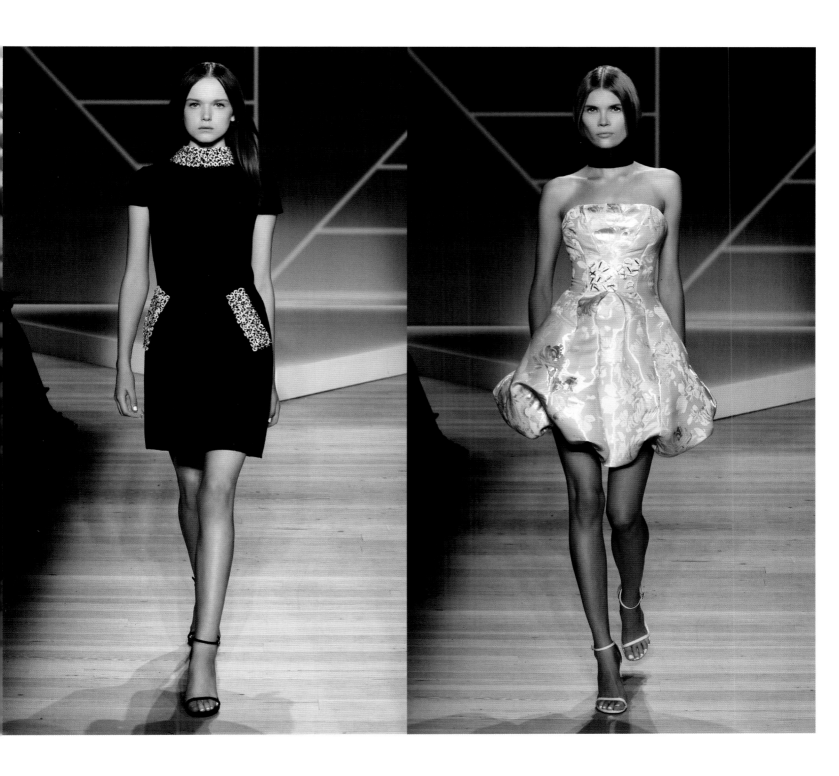

*Opposite:* A citron silk faille tulip romper with beaded yoke. *Above, left:* A black georgette dress with Plexi plaquette.

*Right:* A mint and silver liquid look jacquard bubble dress with beading.

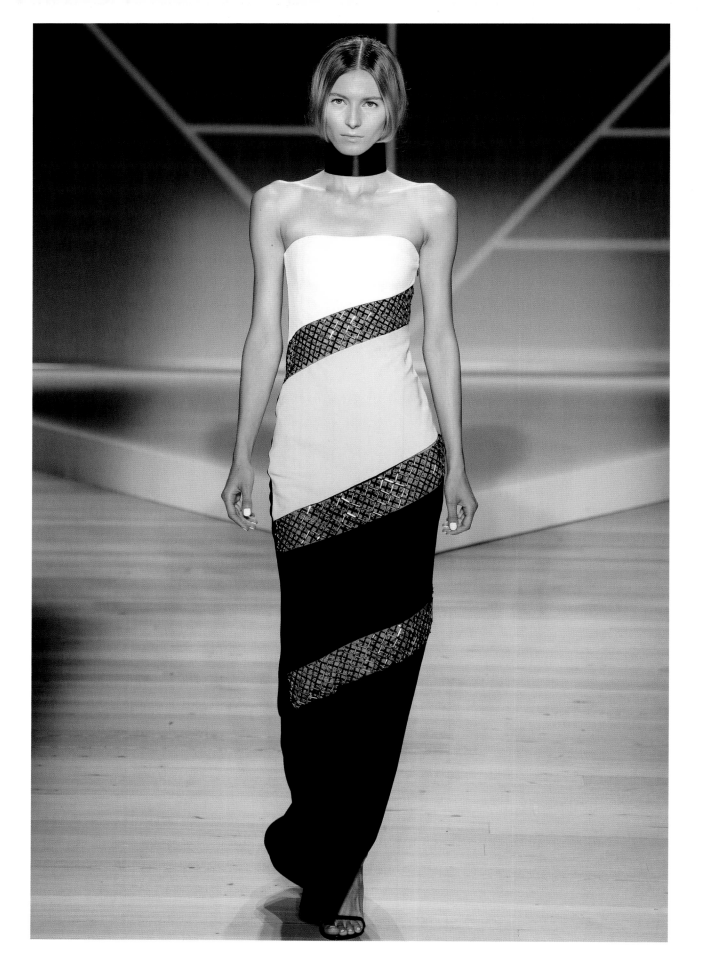

*Above:* An ivory, mint, and black heavy georgette gown with sheer beading from the Spring/Summer 2016 collection. *Opposite:* A citron signature sequin grid dress from the Spring/ Summer 2016 collection. *Following spread:* An ivory liquid-look organza gown with beaded nebula lace drape from the Spring/Summer 2016 collection.

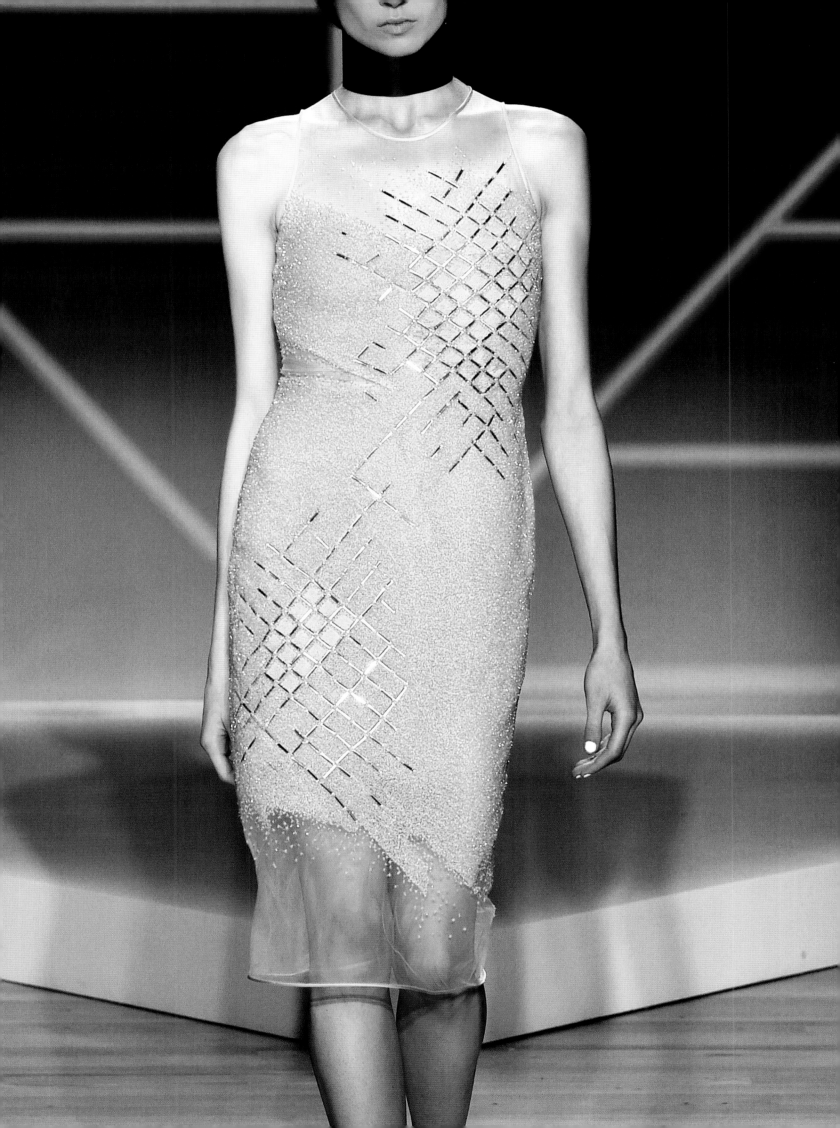

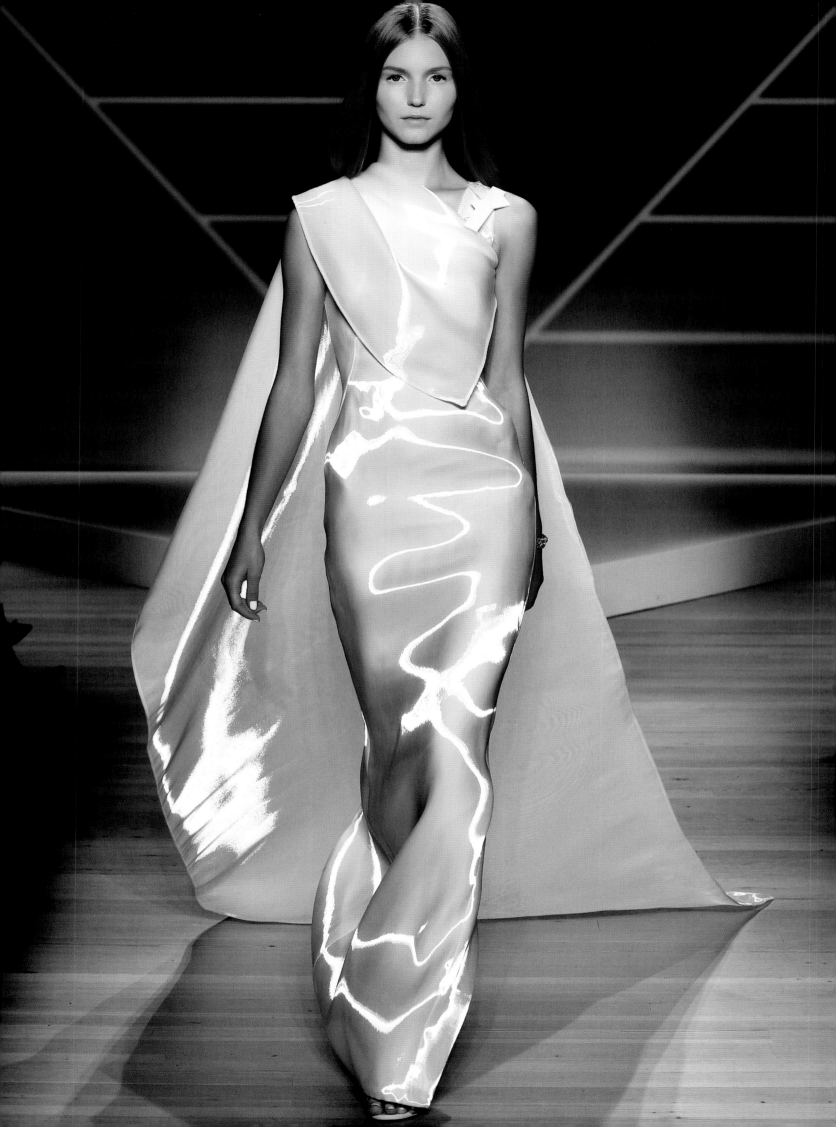

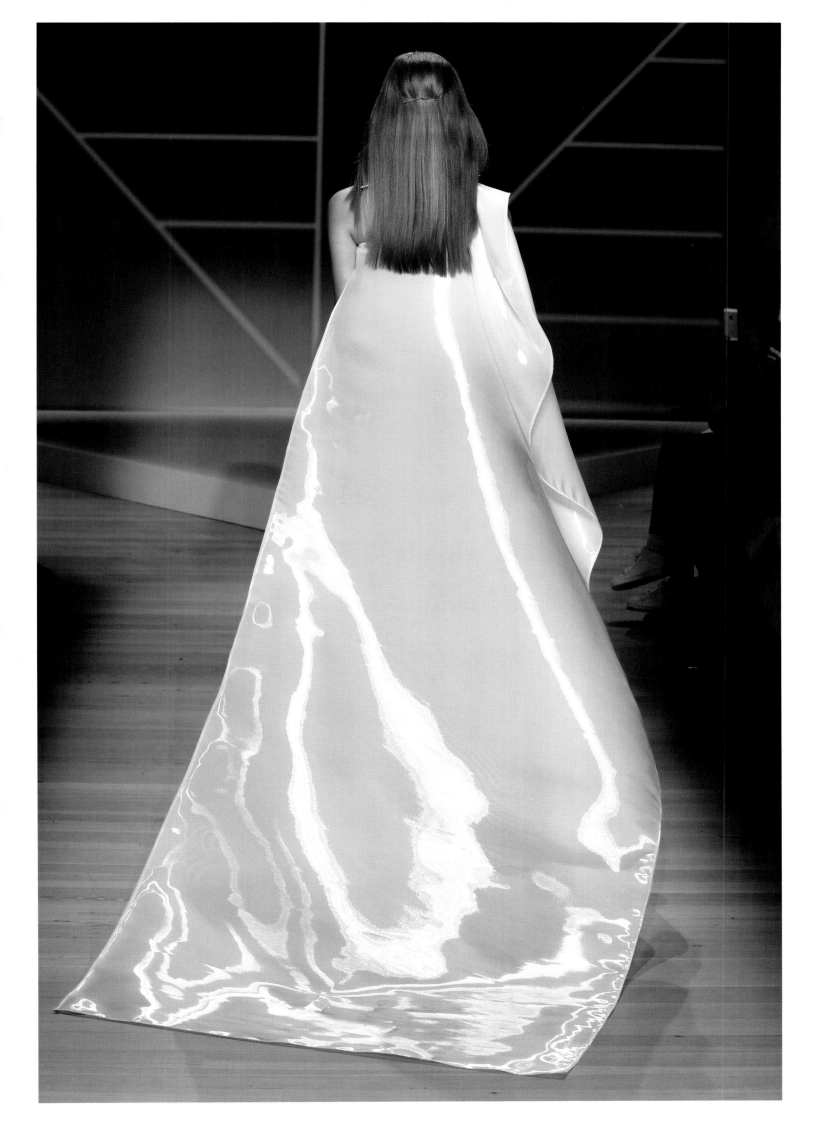

# SS20

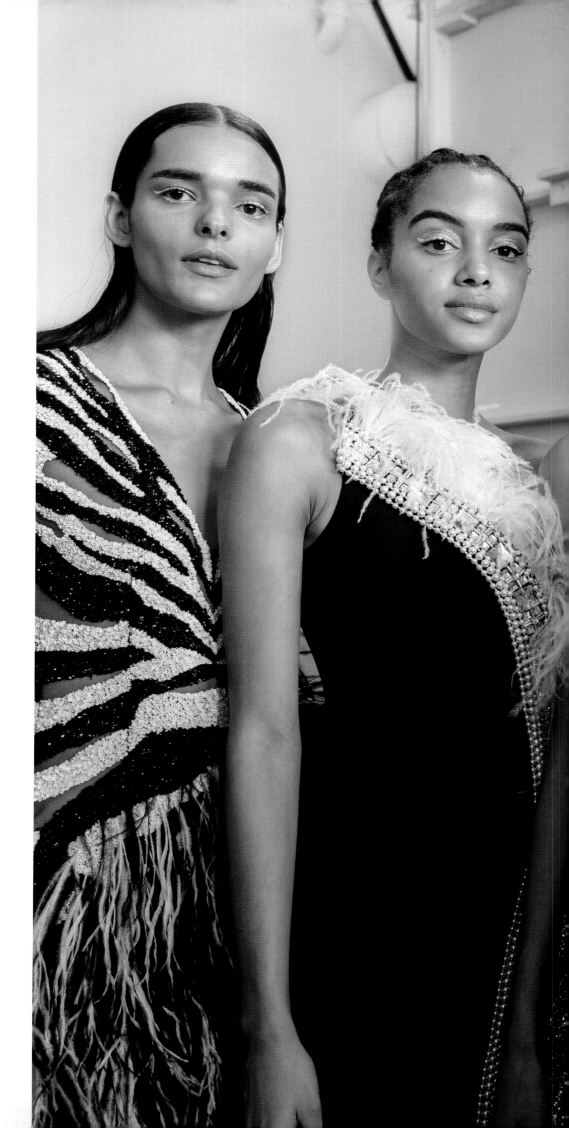

spring/summer
2020

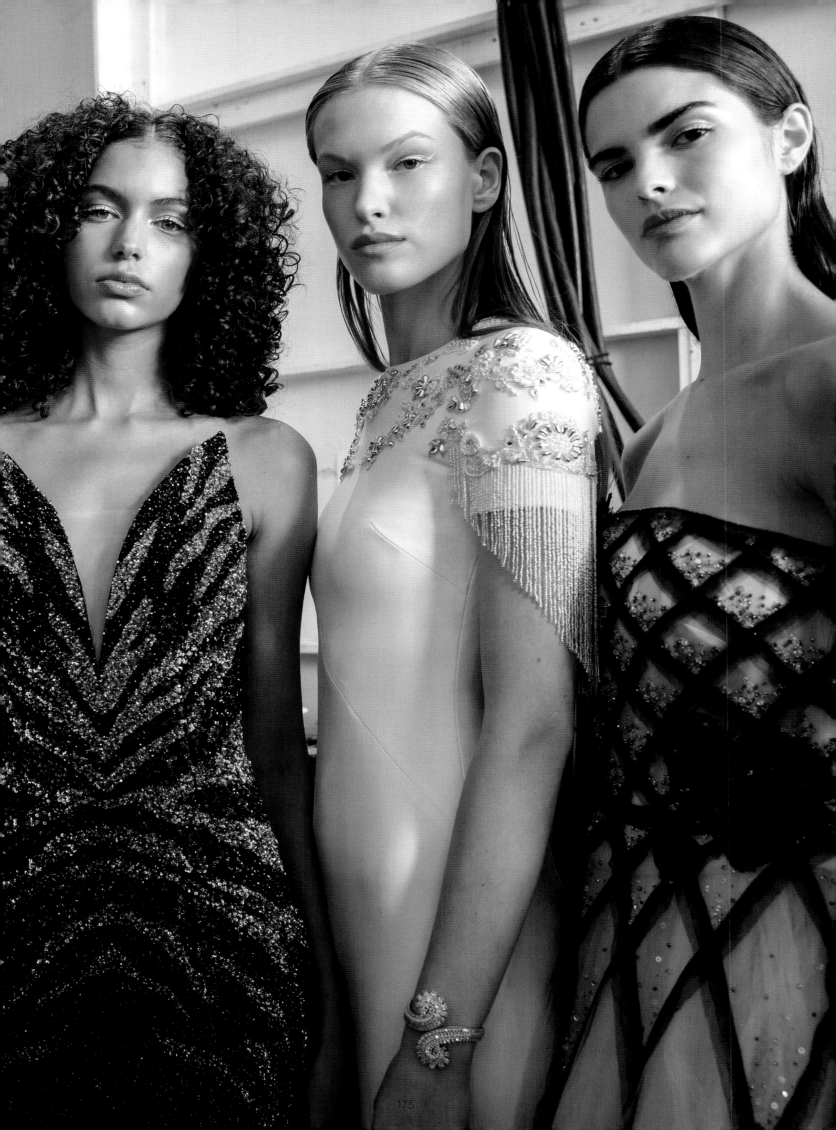

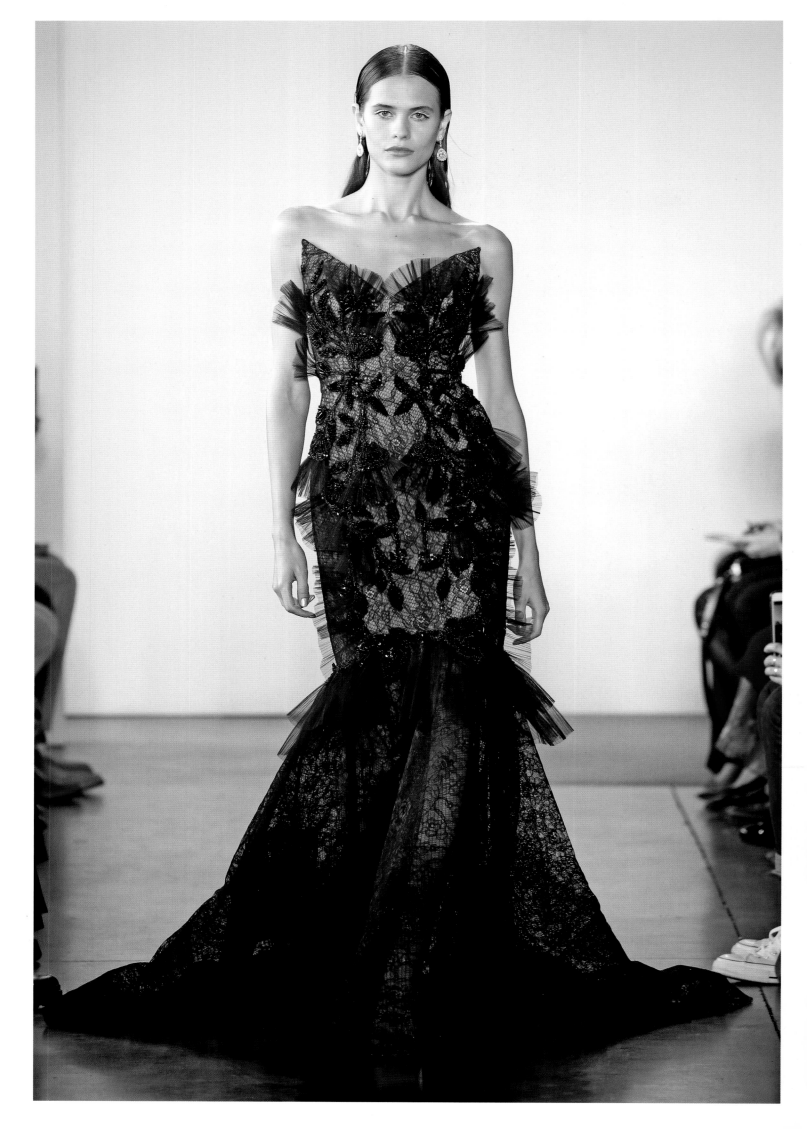

# spring/summer twenty-twenty

The Spring/Summer 2020 collection was perhaps my boldest take on spring florals. Gardening and spending time with my family outdoors bring me so much joy. It was something I wanted to translate to a collection in an elevated way. When I presented the collection, I sent a lush bouquet of roses, peonies, periwinkles, delphiniums, and lavender down the runway.

In addition to the staple gowns, I knew it was important to create varied lengths and suiting too. These days, occasion dress codes are changing and are open to interpretation more than ever. It is no longer a faux pas to show a little leg at a formal affair, or for women to wear pants or a jumpsuit to a black-tie dinner. I love the way my artisans sculpted the two mini-dresses in tulle in this collection. They were perfect for younger Pamella Roland fans.

Of course, we included the sweeping, shoulder-baring gowns that have become synonymous with the brand. Several of them showed the softer side of tulle. Dimensional petal appliqués brought the garden to life, as did the lush peplum and statement shoulder pieces. I enjoyed creating unexpected color combinations, like poppy into lavender, with dégradé sequin embroidery. Sophisticated metallic details on the florals added glamour.

The Spring/Summer 2020 collection did not only stay in the garden but also ventured to the savannah, presenting an elegant take on the zebra motif. I kept the proportion of the stripes large so they would stand up to the lush sequins, feathers, and beading. There was nothing tame about these pieces.

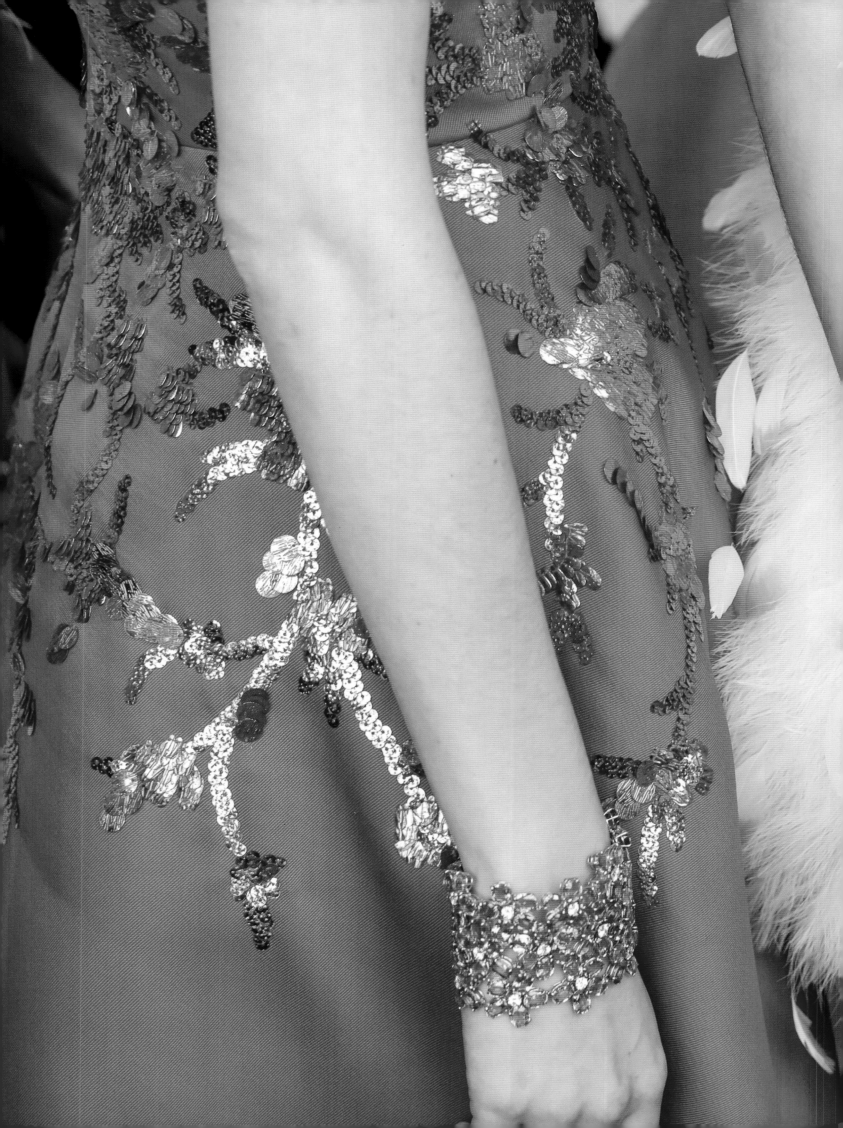

*Previous spread:* Textures from the Spring/Summer 2020 collection. *Opposite:* Four of our lovely models just before the Spring/Summer 2020 runway show. *Following spread:* A lilac hammered sequin grid cocktail dress with flower motif embroidery from the Spring/Summer 2020 collection.

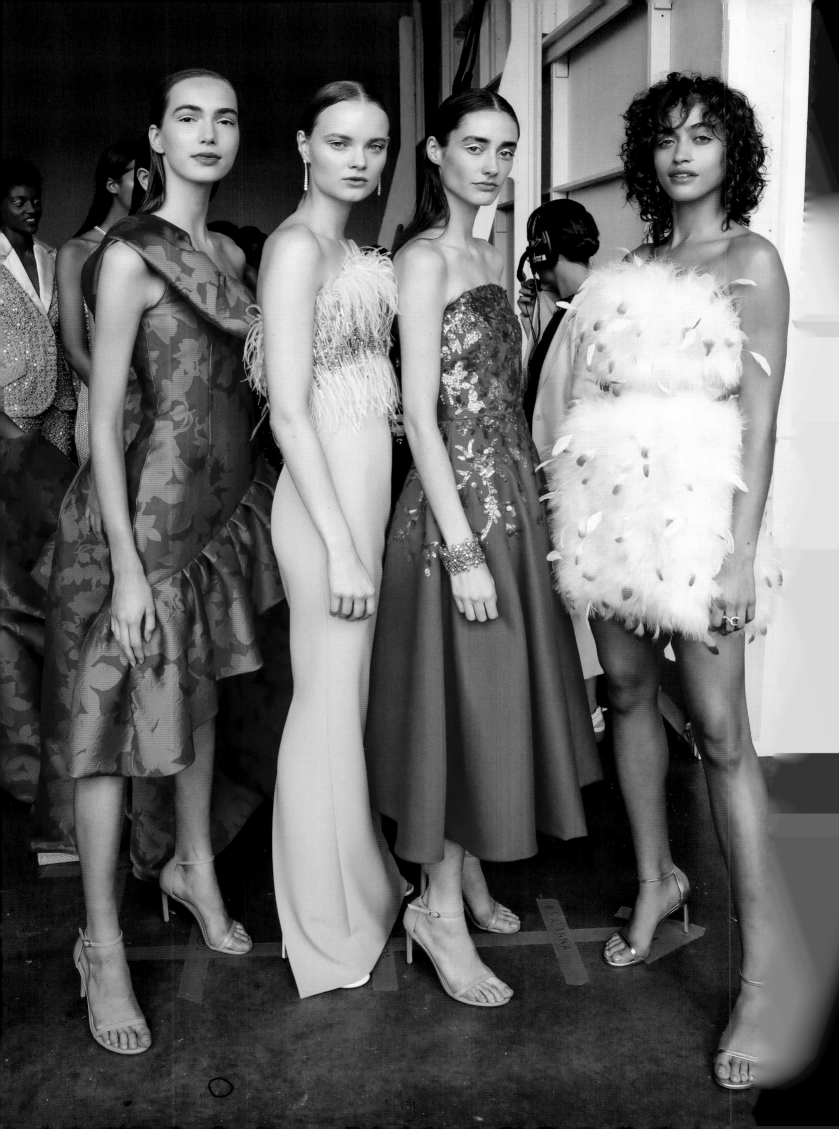

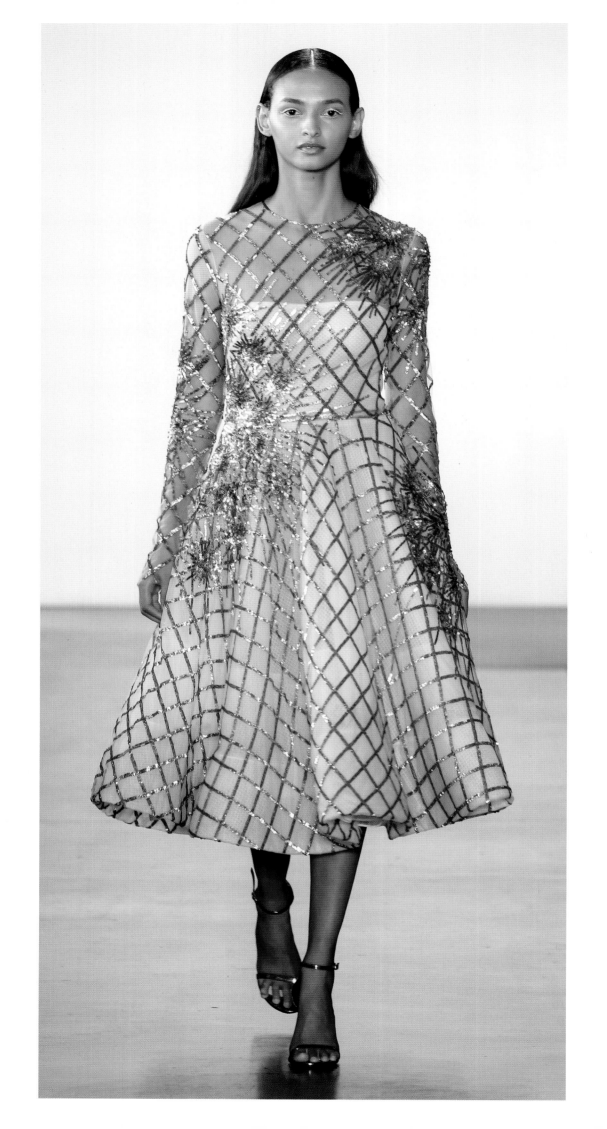

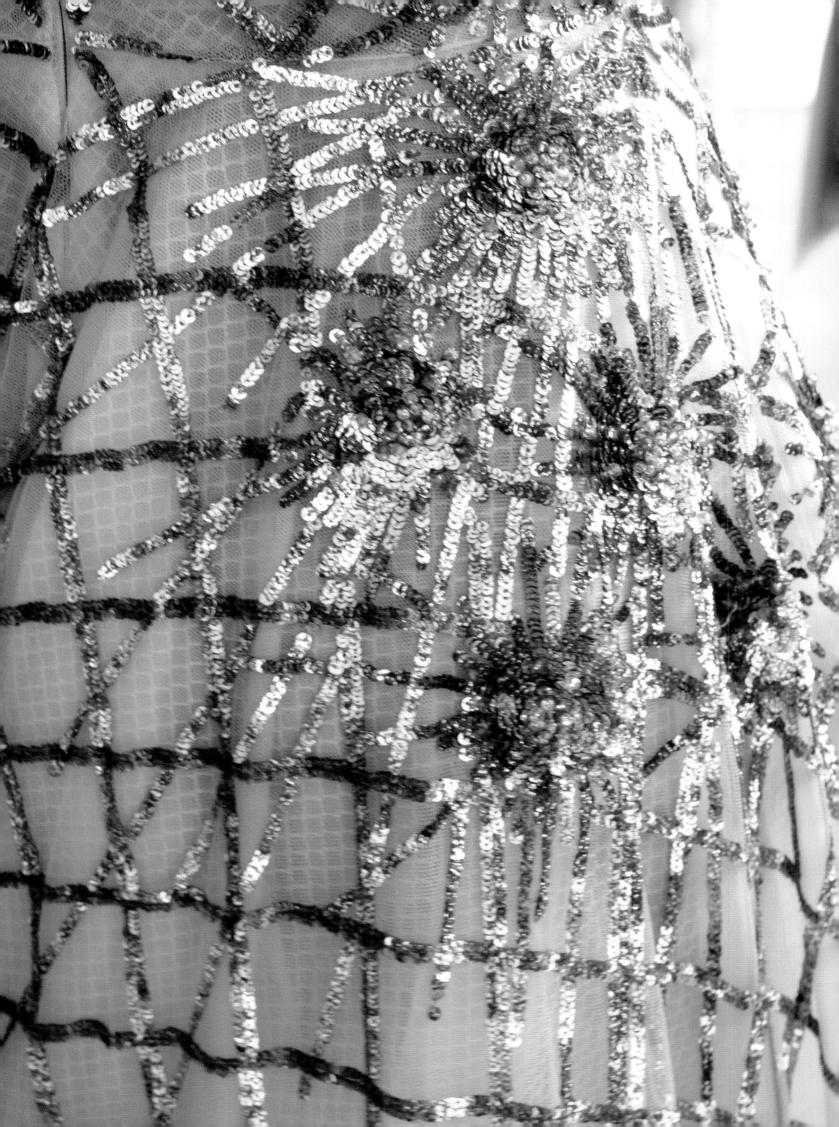

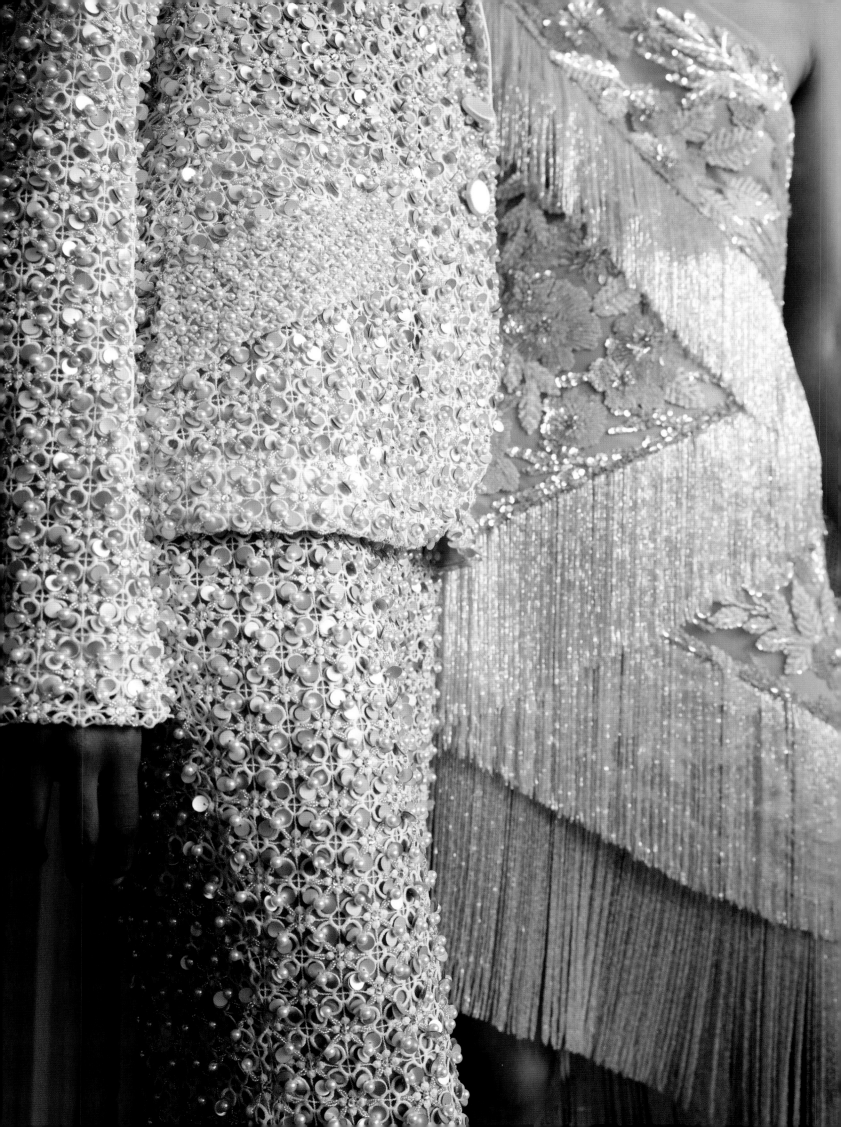

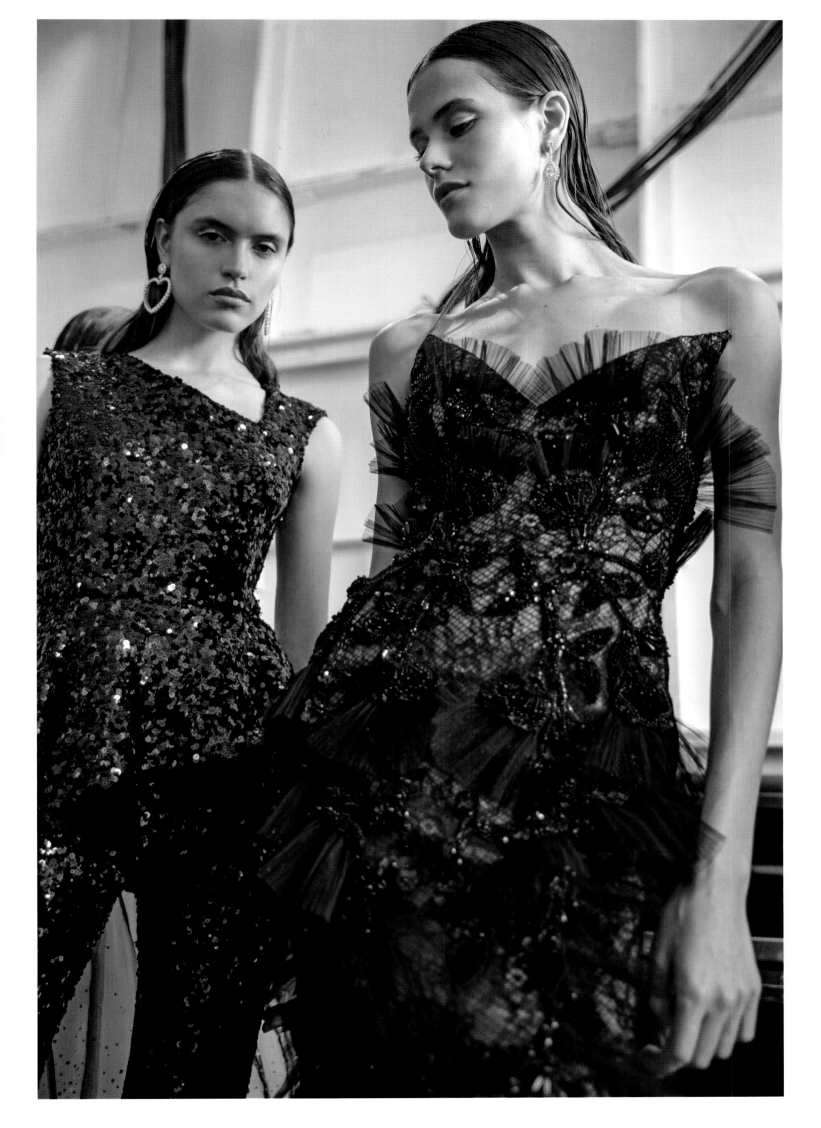

*Previous spread:* Embellishments in the Spring/Summer 2020 collection. *Opposite:* I still reference my time living in Japan in my work.

An example is this gleaming two-tone floral Mikado gown from the Spring/Summer 2020 collection.

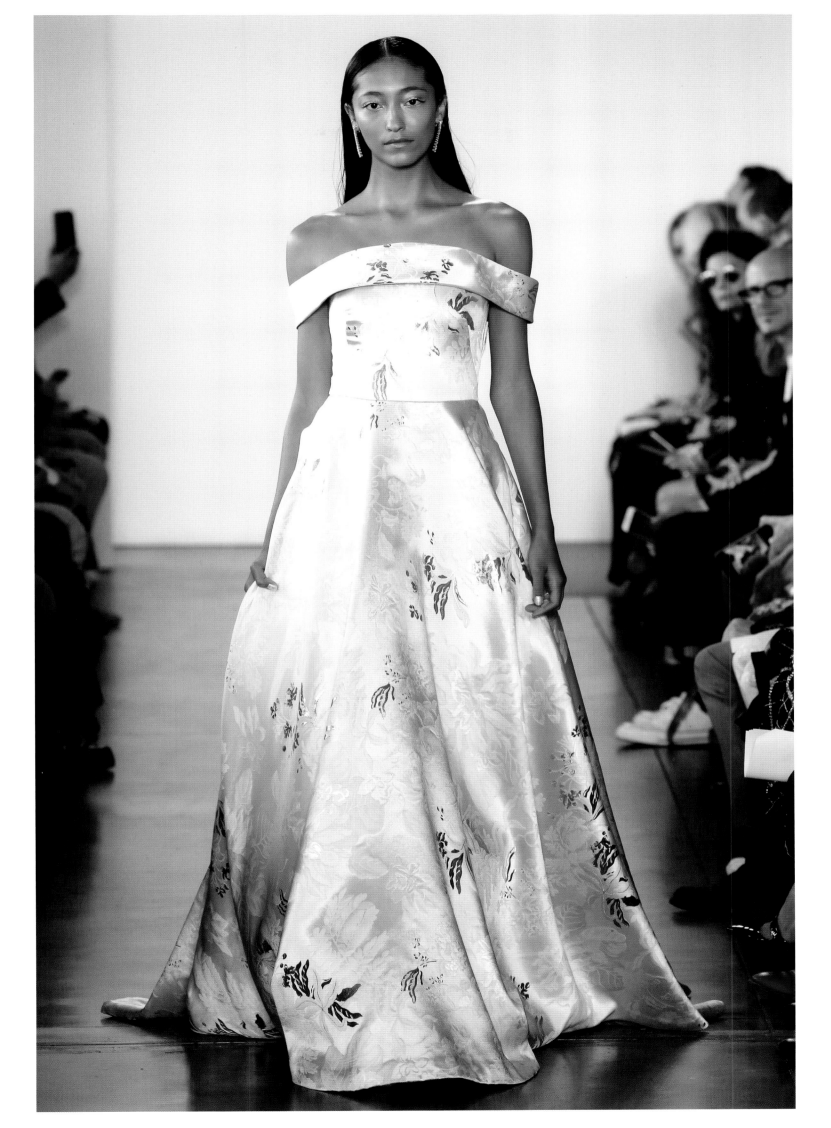

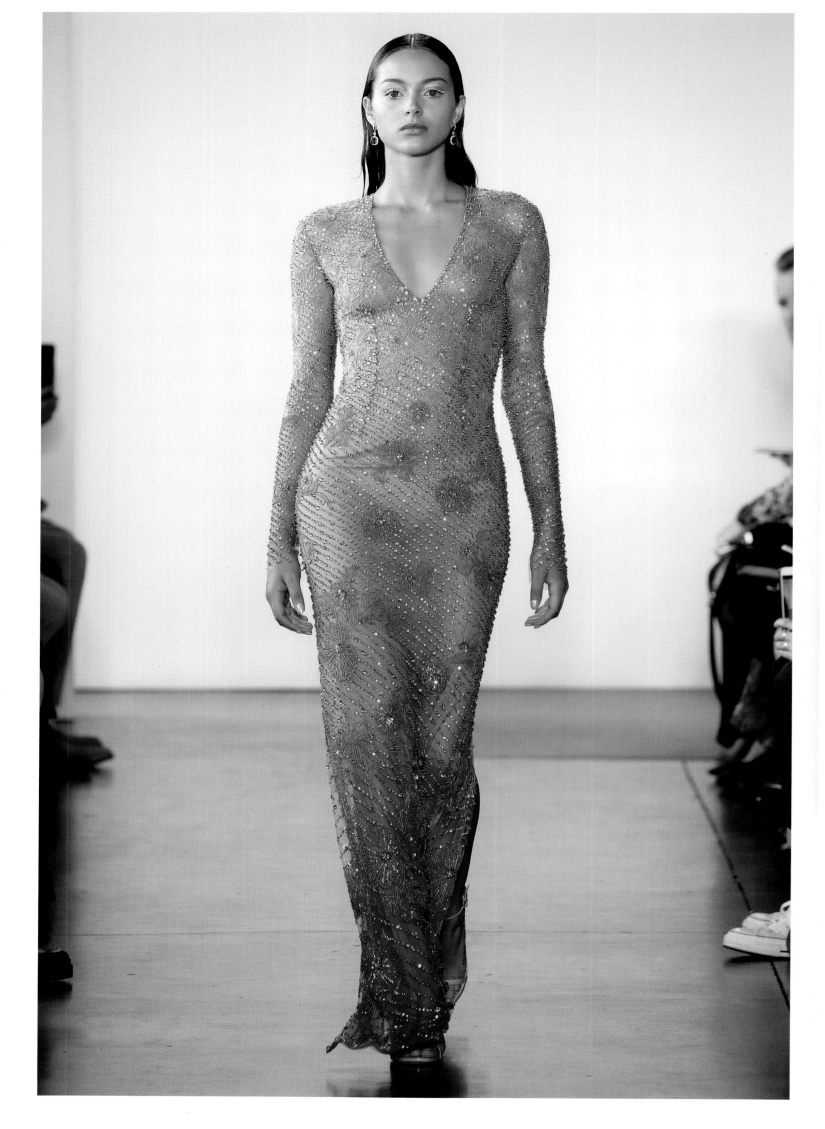

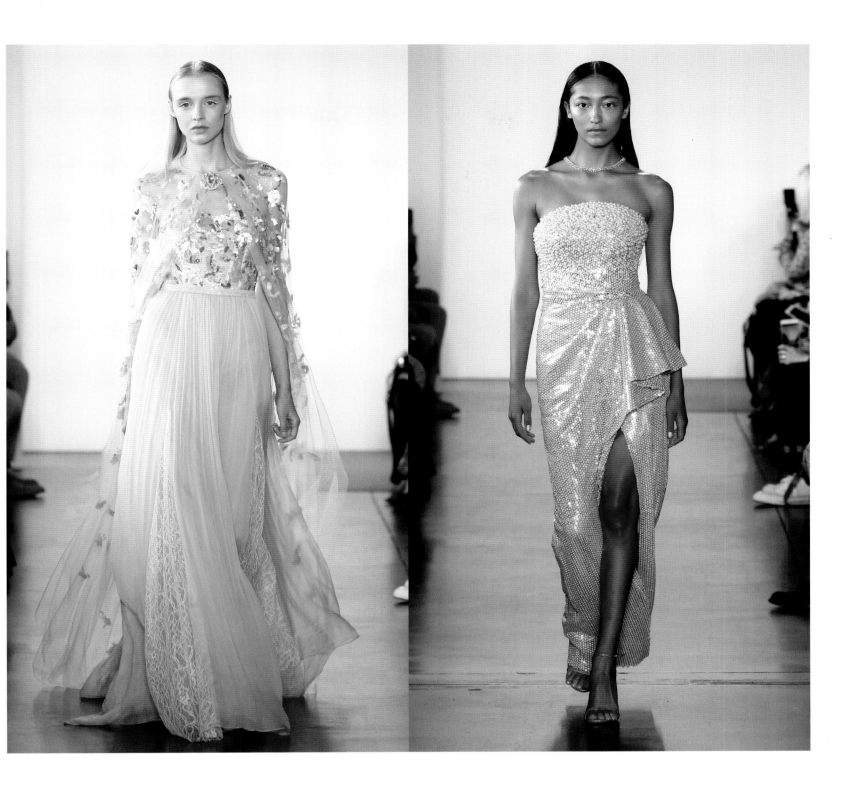

I really enjoyed finding many ways to bring the garden to the runway for the Spring/Summer 2020 collection. *Above left:* A pale rose chiffon and lace gown with hammered sequin embroidered bodice. *Above right:* A rose gold strapless, draped sequin gown with pearl degradé embroidered bodice. *Opposite:* A chartreuse ombré crystal embroidered gown with floral motif degradé.

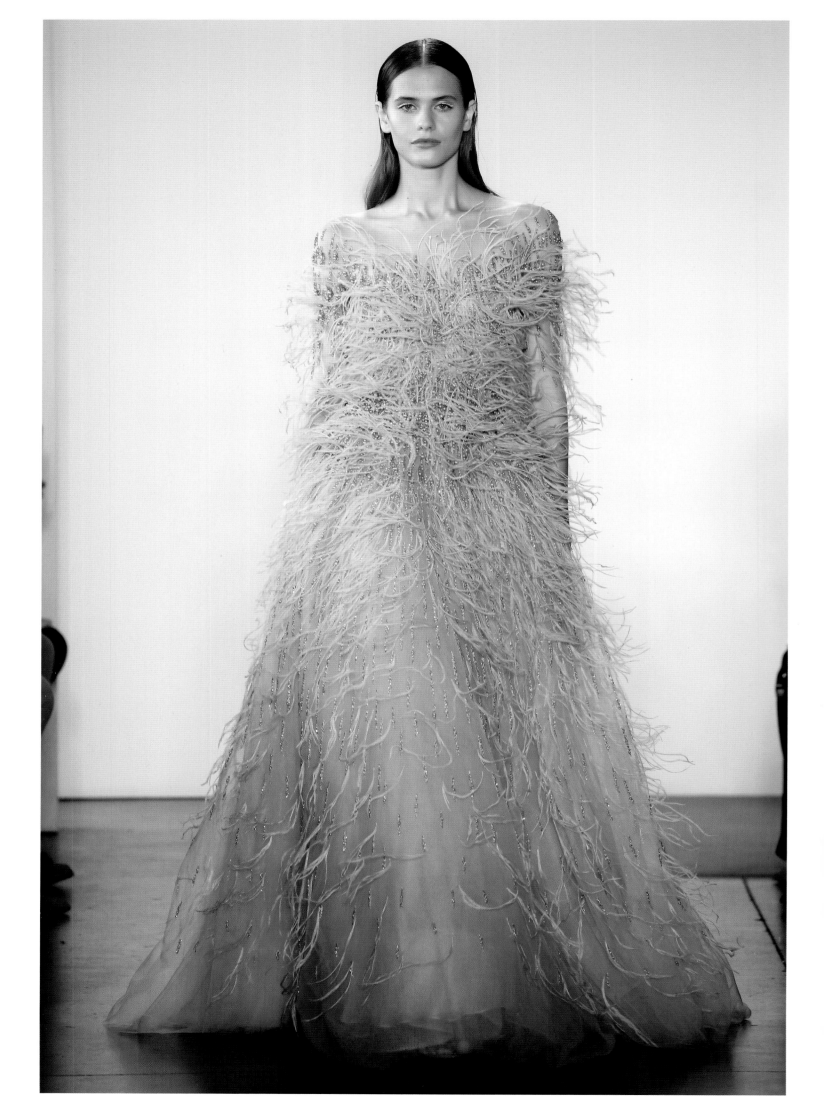

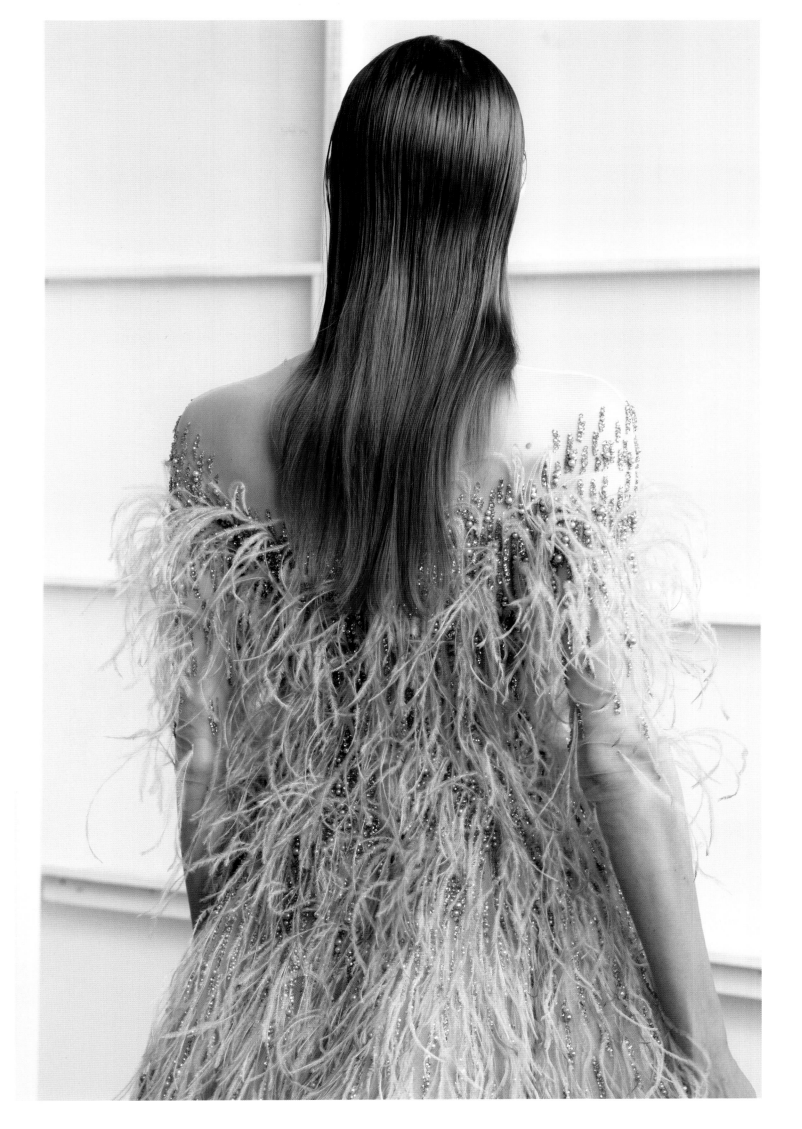

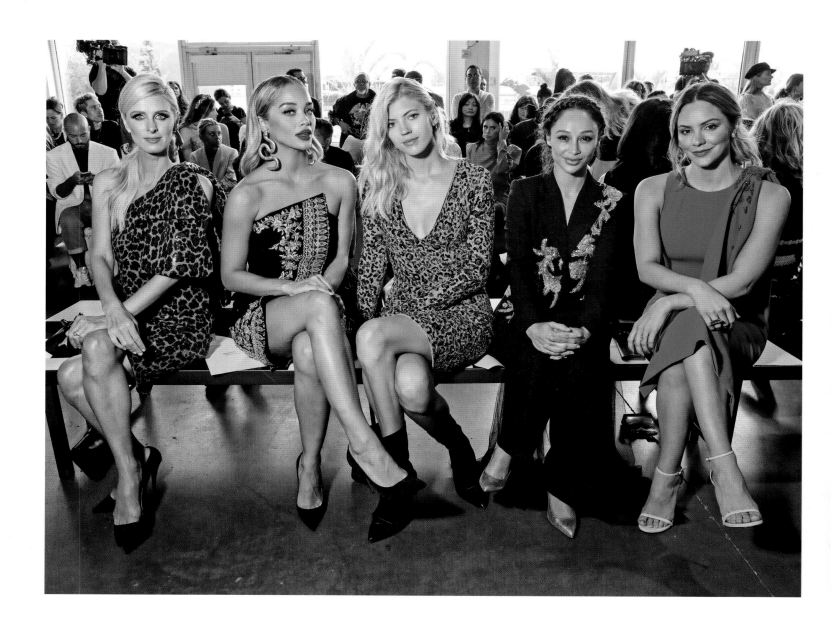

*Previous spread:* A periwinkle/gold ombré sequin ballgown with ostrich feather degradé from the Spring/Summer 2020 collection. Clients love to see what the next season will bring. *Above, from left to right:* Famous fans **Nicky Hilton Rothschild**, **Jasmine Sanders**, **Devon Windsor**, **Cara Santana**, and **Katharine McPhee** wait for the Spring/Summer 2020 runway show to start, while wearing their favorite Pamella Roland pieces. *Opposite:* A rose and purple ombré draped tulle gown with 3D floral appliqués. *Following spread:* Close-up of two-tone pieces from the Spring/Summer 2020 collection.

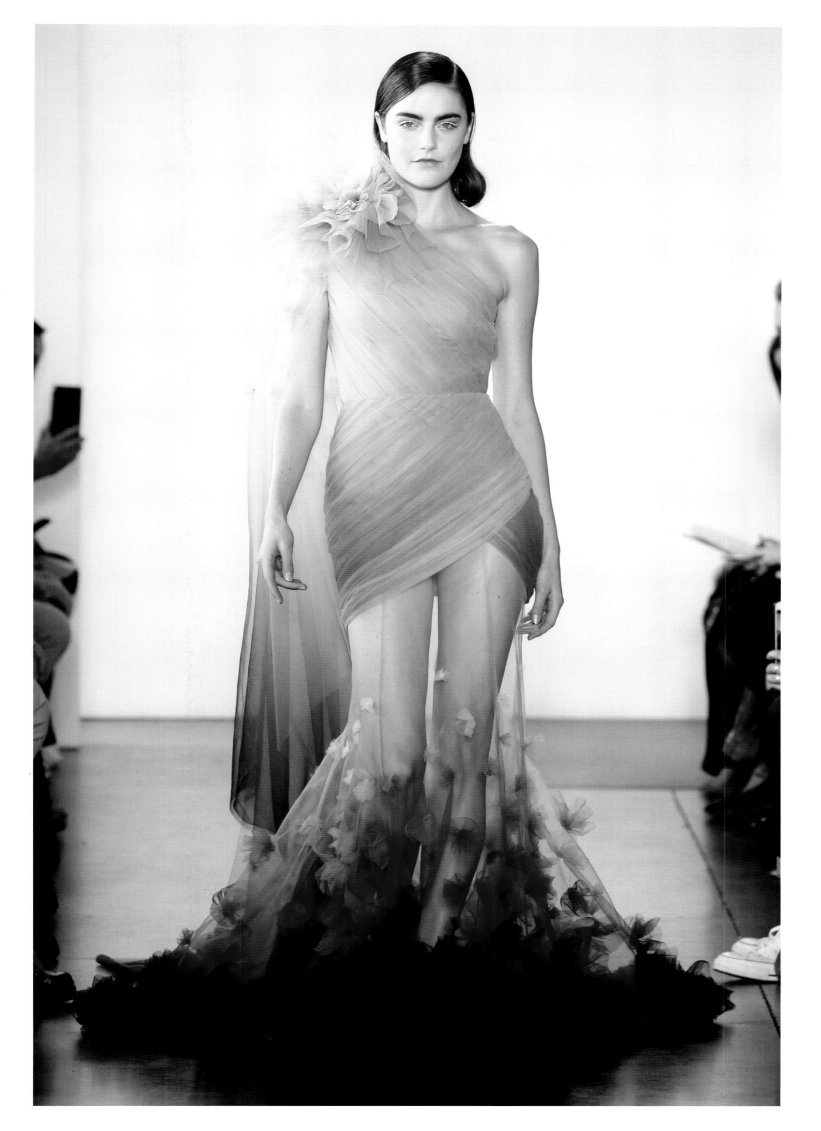

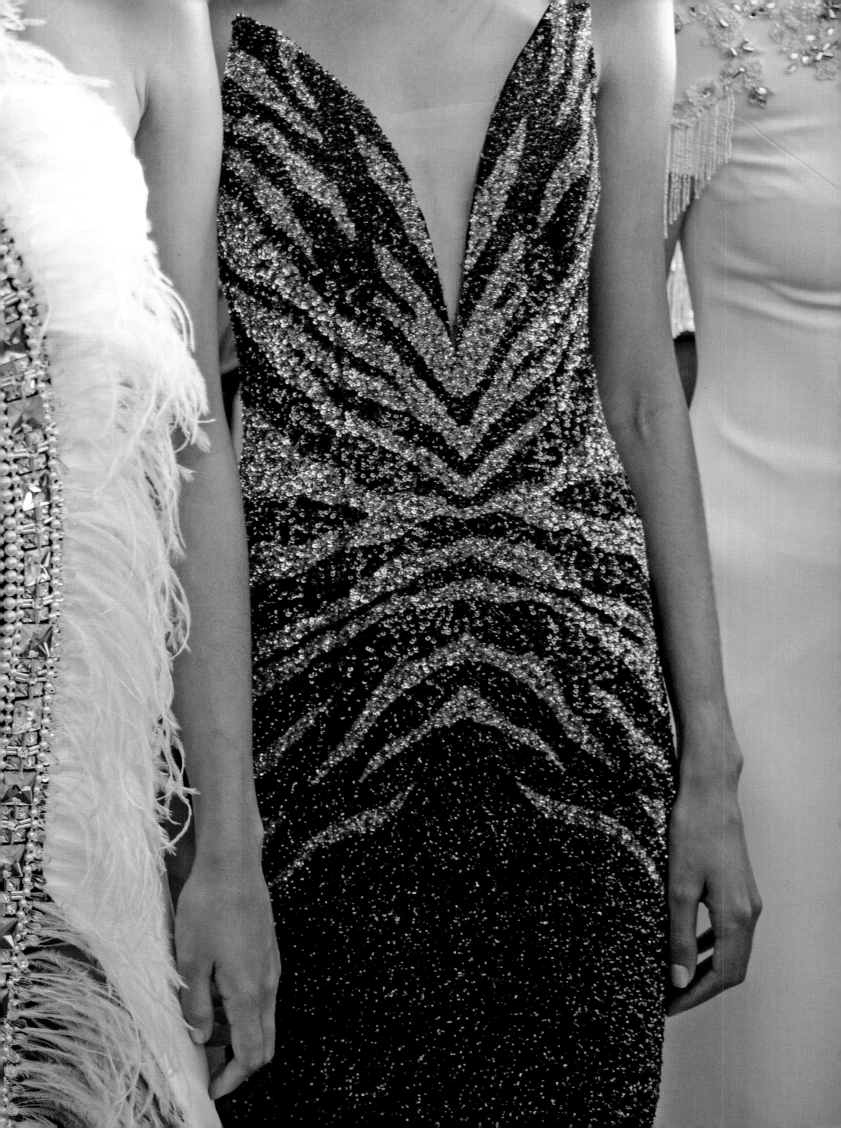

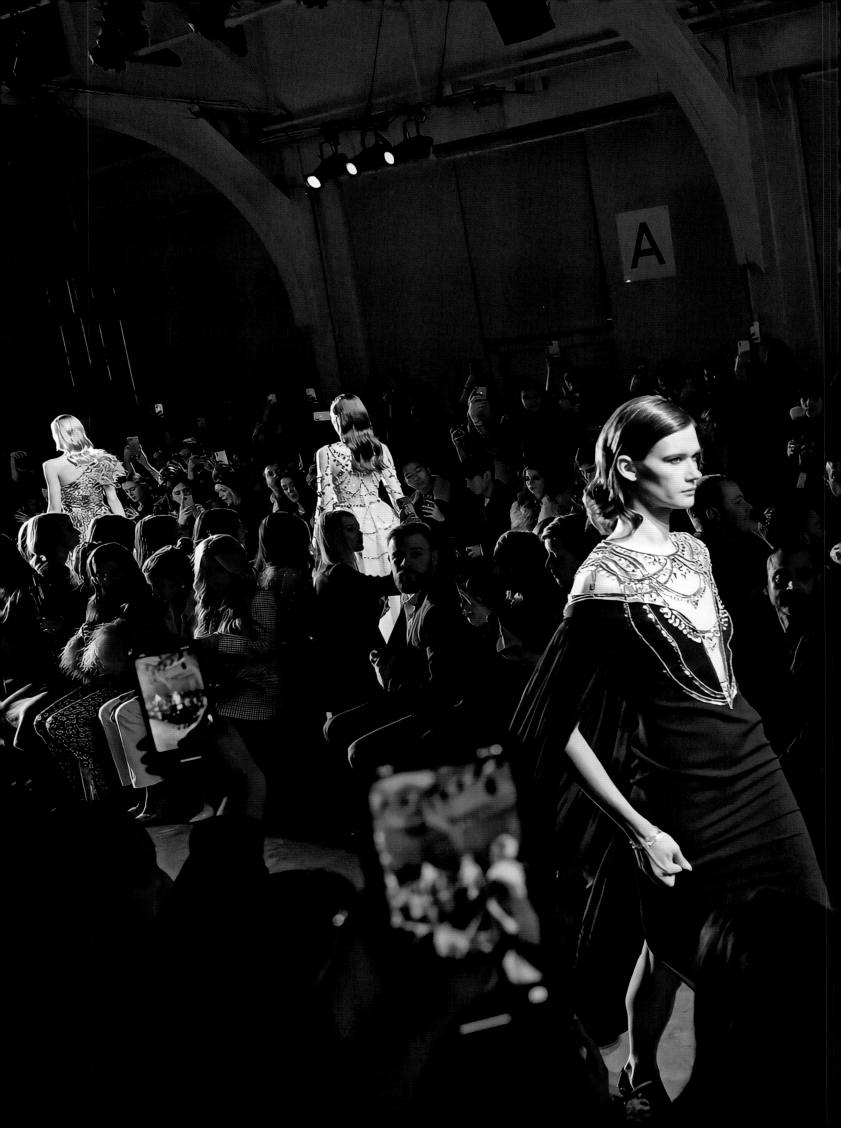

f w 2 0

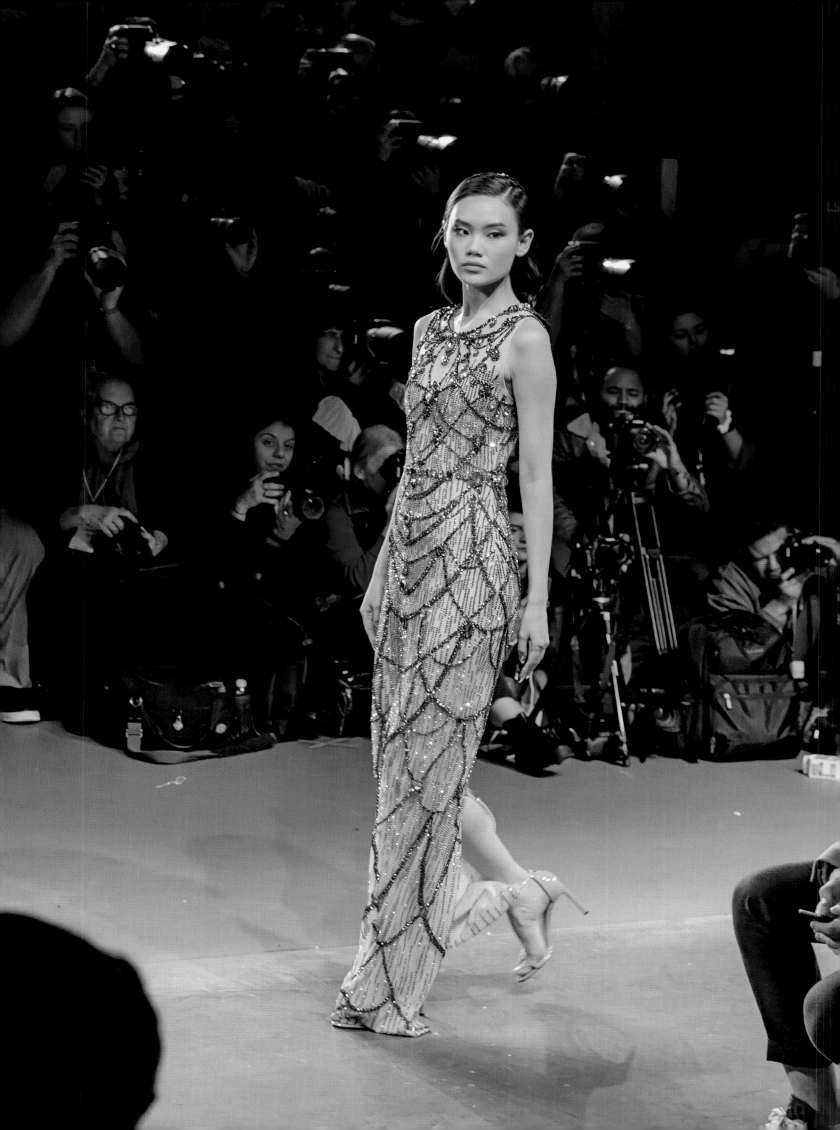

# fall/winter twenty-twenty

I truly appreciate Paris as a city for fashion. For the Fall/Winter 2020 collection, however, I drew inspiration from the Palace of Versailles, which is located about ten miles outside the City of Lights. I felt especially inspired by the palace's ornate interiors, including its chandeliers, tapestries, furniture, and art. It is a landmark I have visited repeatedly. Fall/Winter 2020 felt like the right moment to bring inspiration into a collection.

For this season, I combined new shapes, like bishop sleeves, with my classic ball and column gowns, tailored suits, and capes fit for a queen. I wanted to further channel the opulence of Versailles by using a palette of bold jewel tones; dreamy ombrè and dégradé; soft, romantic draping; and gleaming metallics. The artisans in my atelier created a gem-inspired jacquard with flecks of gold—an allusion to the gilt in the palace. Pearls, a favorite of Marie Antoinette, were also scattered throughout the collection. I highlighted select shapes by layering strands of crystals to evoke the movement and brilliance of the palace's chandeliers.

One of my favorite pieces in this collection was a coat in a tapestry-inspired jacquard, finished with multicolored paillette- and feather-embroidered cuffs. I wanted to layer textures to embrace the decadent, more-is-more approach that the French royals of Versailles took to, decorating themselves and their sprawling palace.

Signature Pamella Roland elements—dimensional lace and ostrich and marabou feathers—brought an opulence to the collection, which was rivaled only by Louis XIV's legendary wardrobe.

*Opposite:* A jeweled gown from the Fall/Winter 2020 collection.

*Opposite:* A candid shot of some Fall/
Winter 2020 details. The crystals sparkle
even when the lens is out of focus.

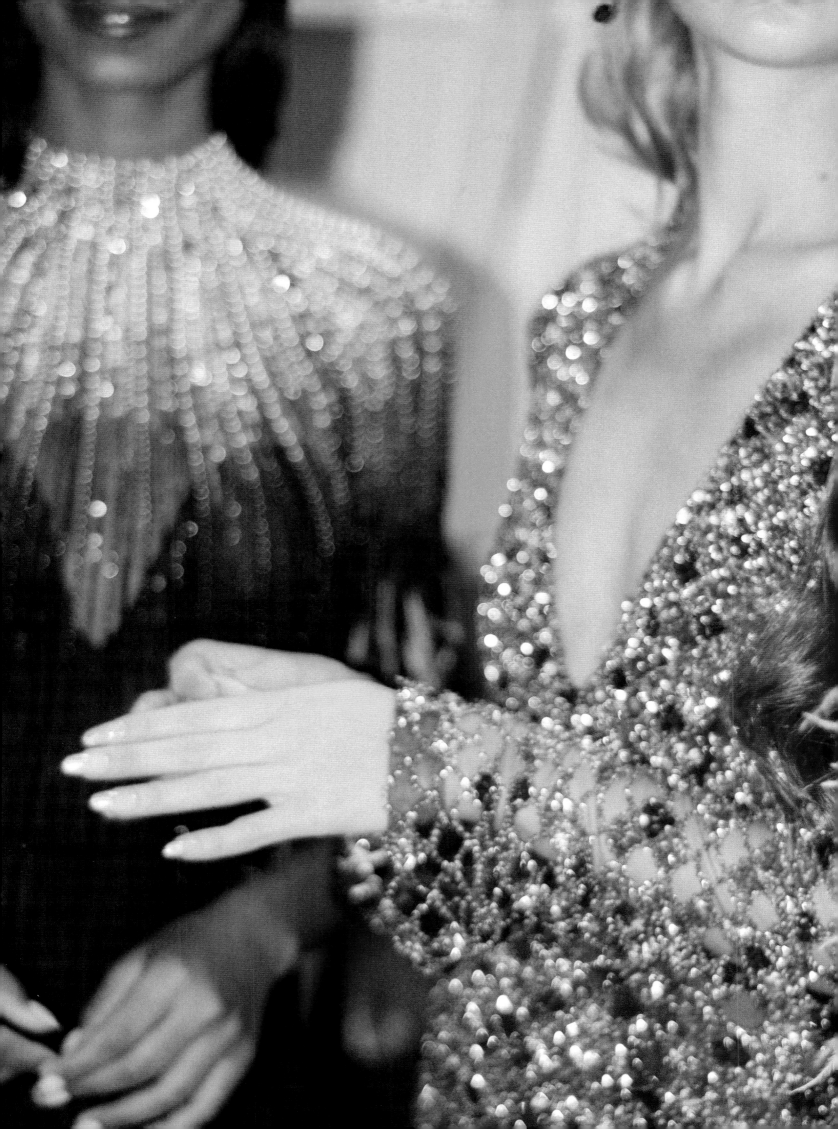

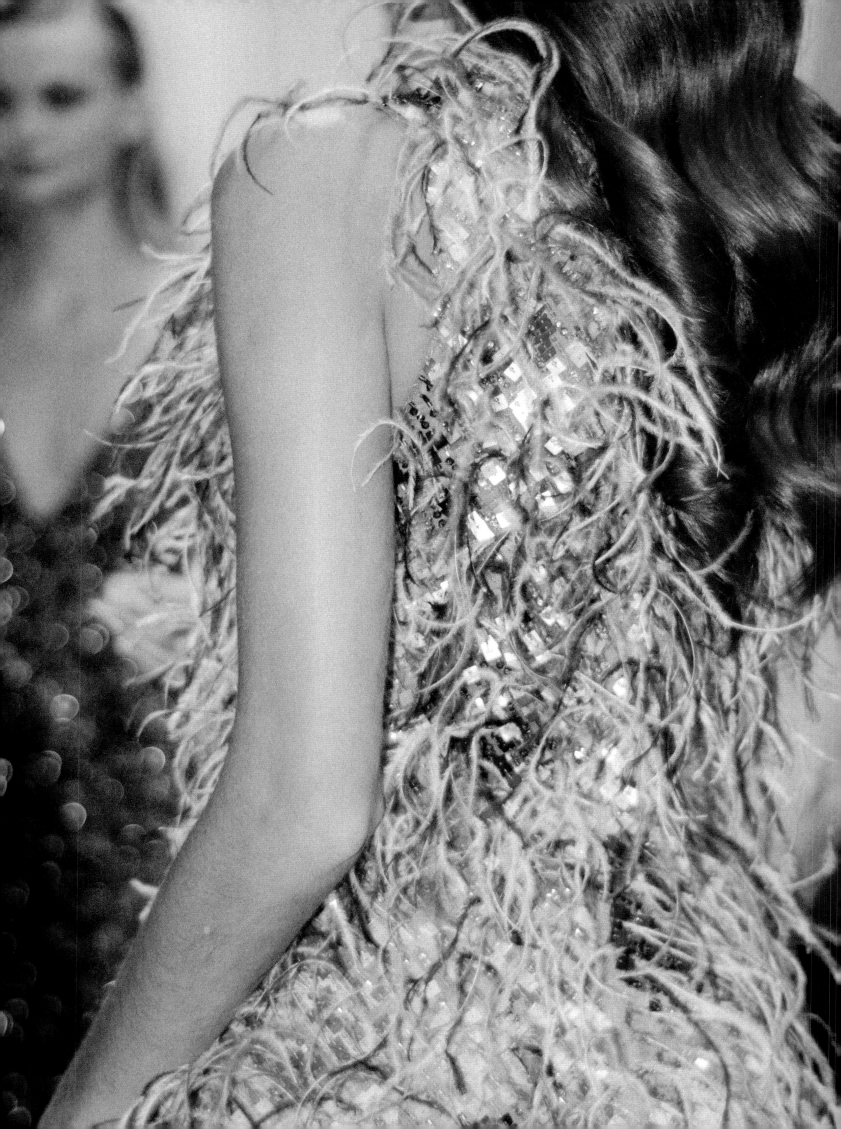

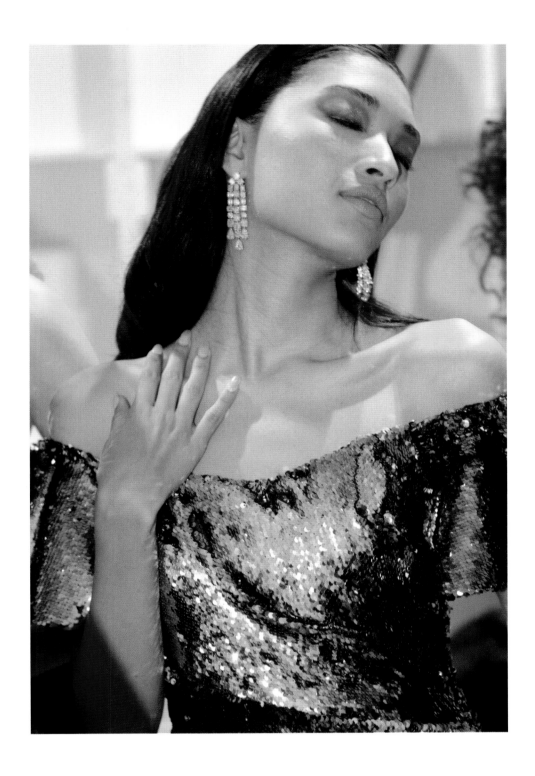

*Above:* Gowns require jewelry. Longtime jewelry sponsor Chopard always has the right finishing touches for our runway shows. *Opposite:* Back details from the Fall/Winter 2020 collection.

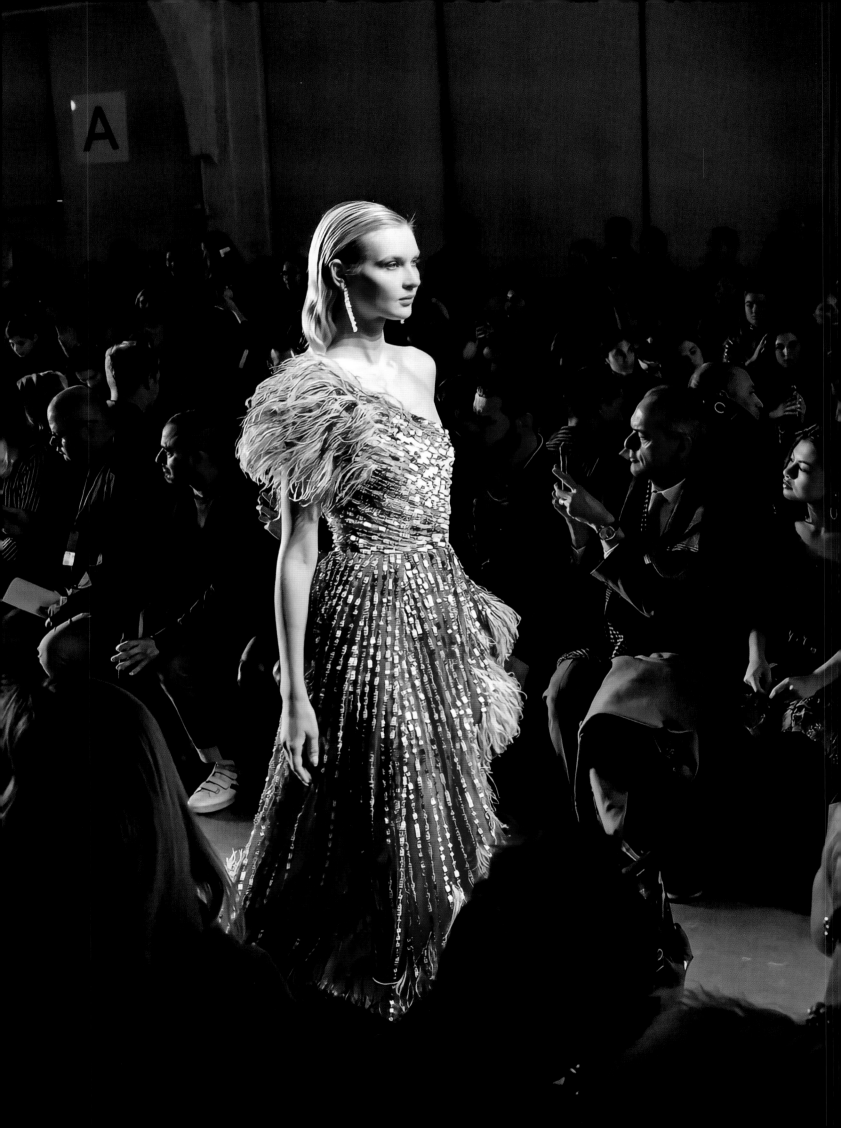

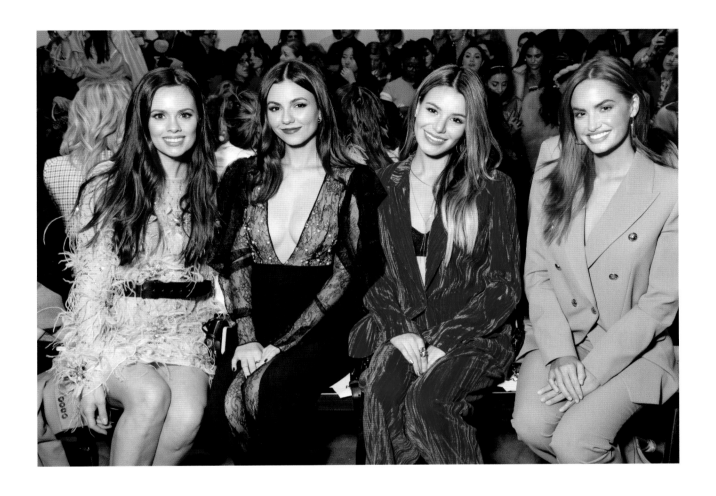

*Above:* Stylist **Madison Guest** has been dressing actress **Victoria Justice** in our pieces for years, and they are both a joy to work with. They joined us in the front row at our Fall/Winter 2020 runway show, along with Victoria's sister, **Madison Reed**, and model **Haley Kalil**. *Opposite:* A rose multi-feather and sequin paillette embroidered one-shoulder ballgown from the Fall/Winter 2020 collection. *Following spread:* A sapphire multi-ombré sequin and 3D tulle embroidered caped gown from the Fall/Winter 2020 collection. *Pages 208–9:* Backstage anticipation at the Fall/Winter 2020 runway show.

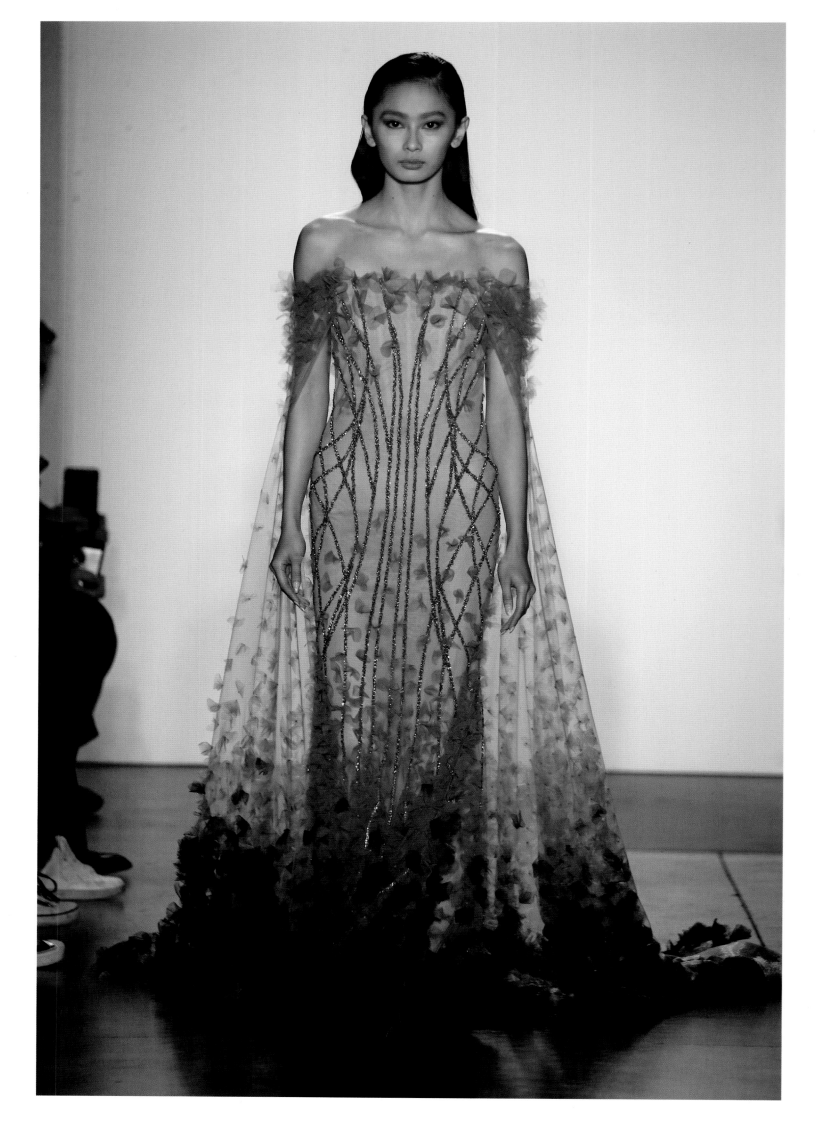

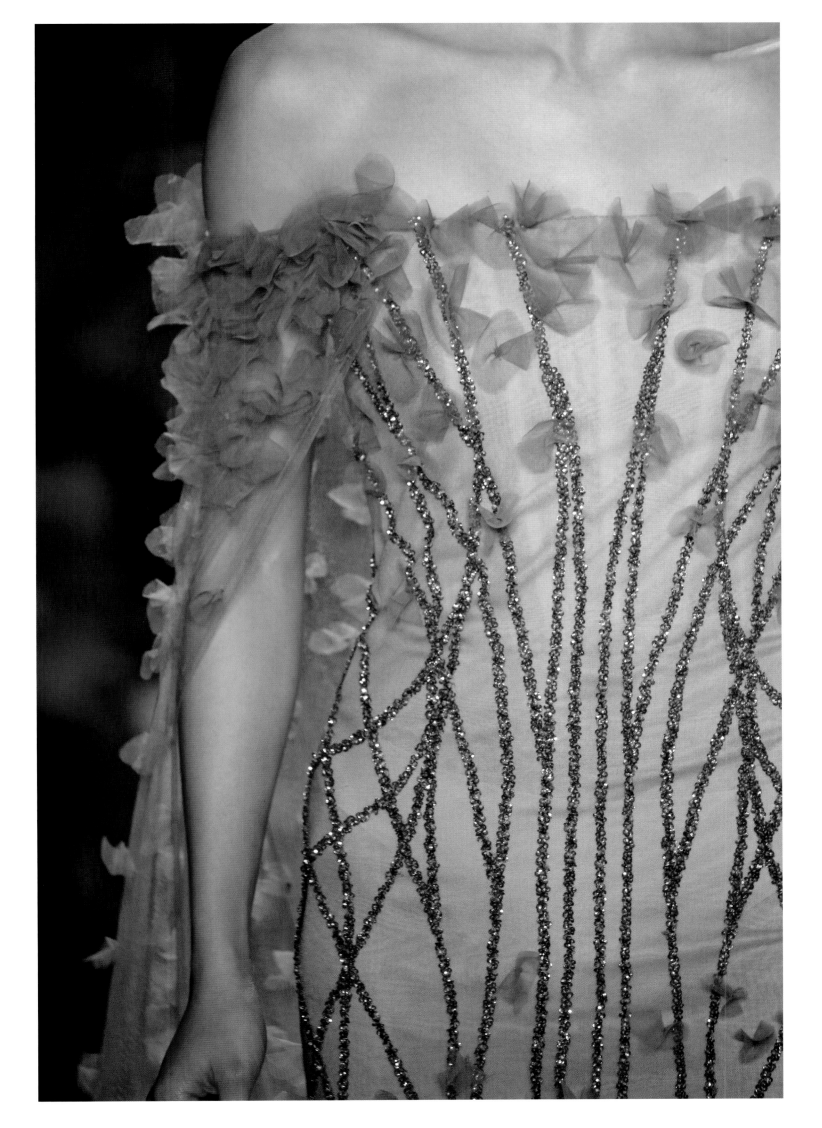

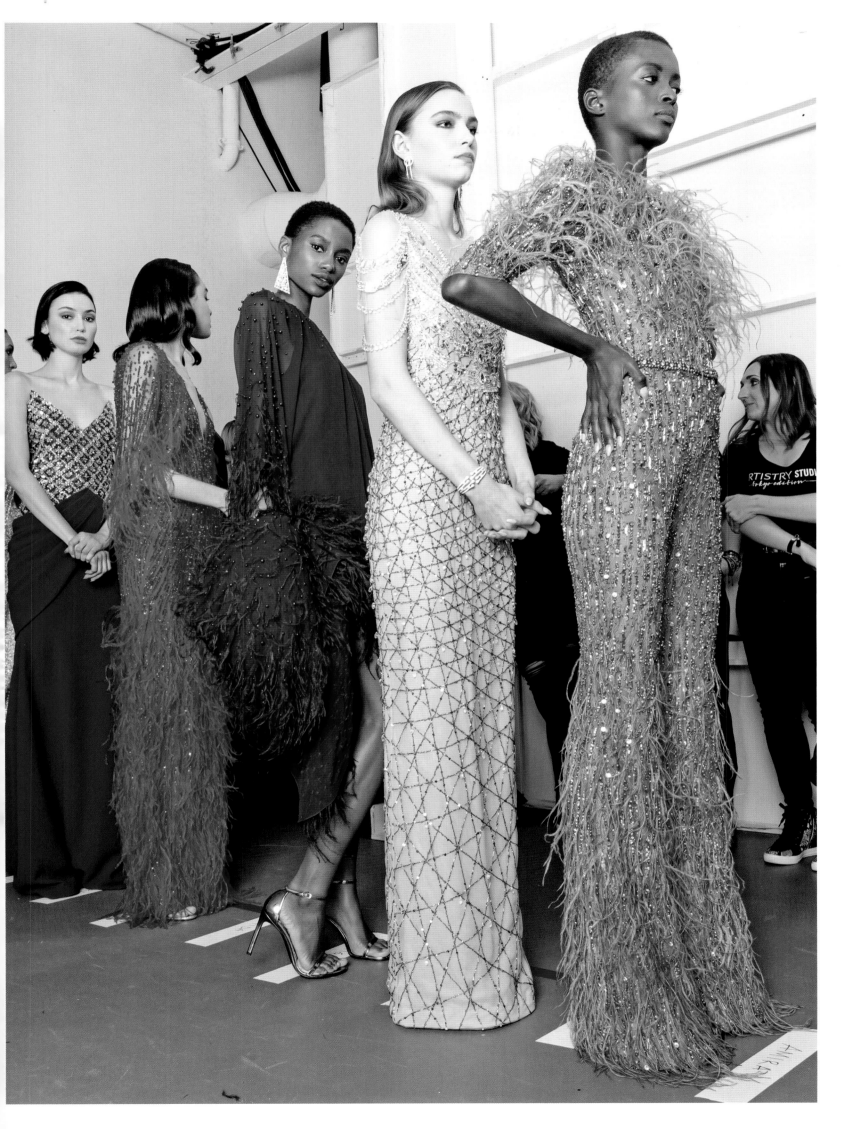

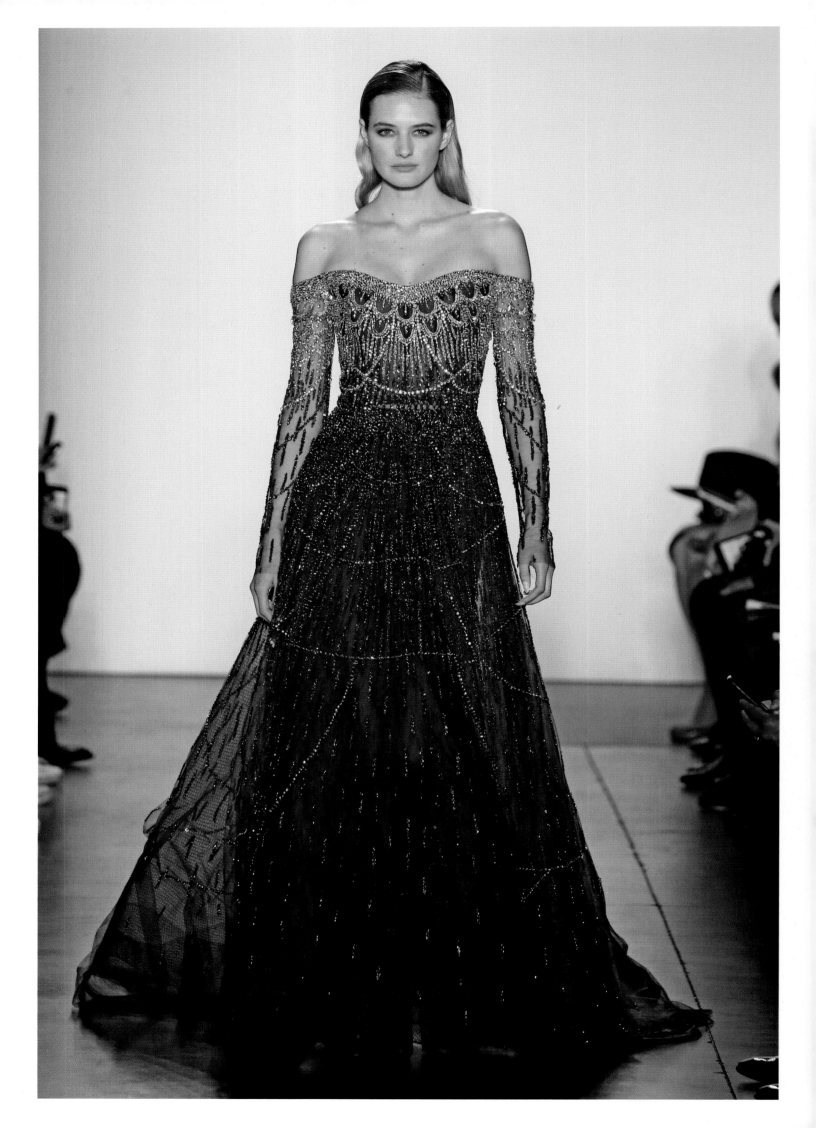

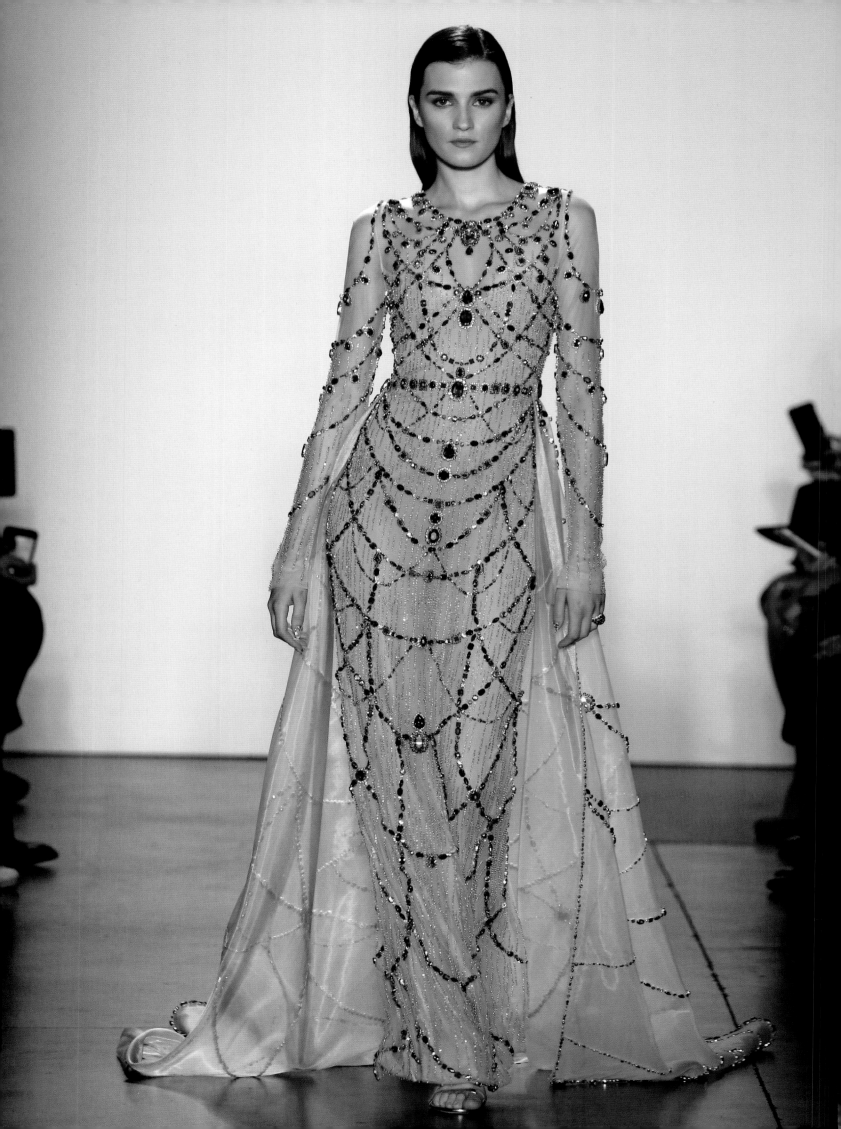

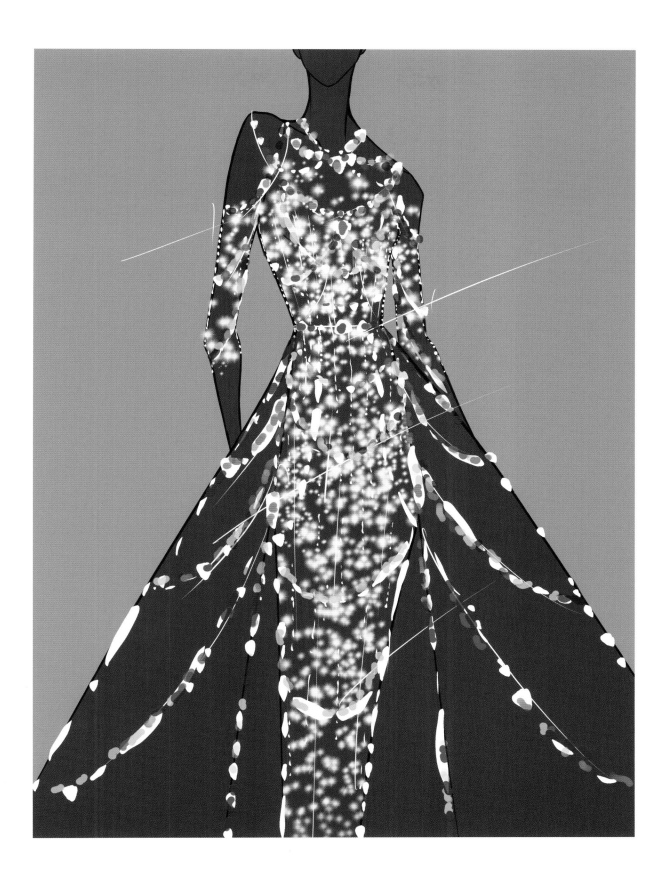

*Previous spread left:* A sapphire/amethyst chandelier sequin embroidered ballgown from the Fall/Winter 2020 collection. *Previous spread right:* A gold and multi-hologram draped strapless sequin embroidered gown from the Fall/Winter 2020 collection. *Above:* Design Director Andrew Cruz's illustration captures the brilliance of the crystals. *Opposite:* A look from the collection inspired by the Palace of Versailles. This gown is jewelry itself.

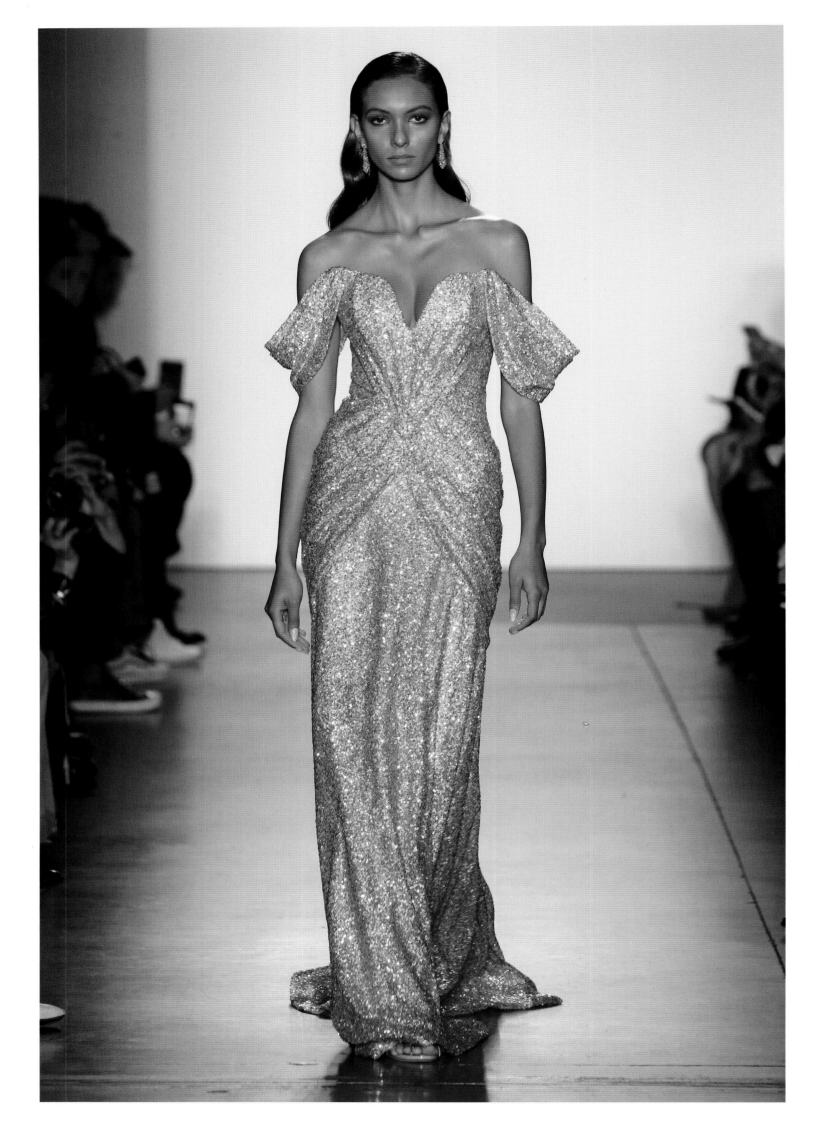

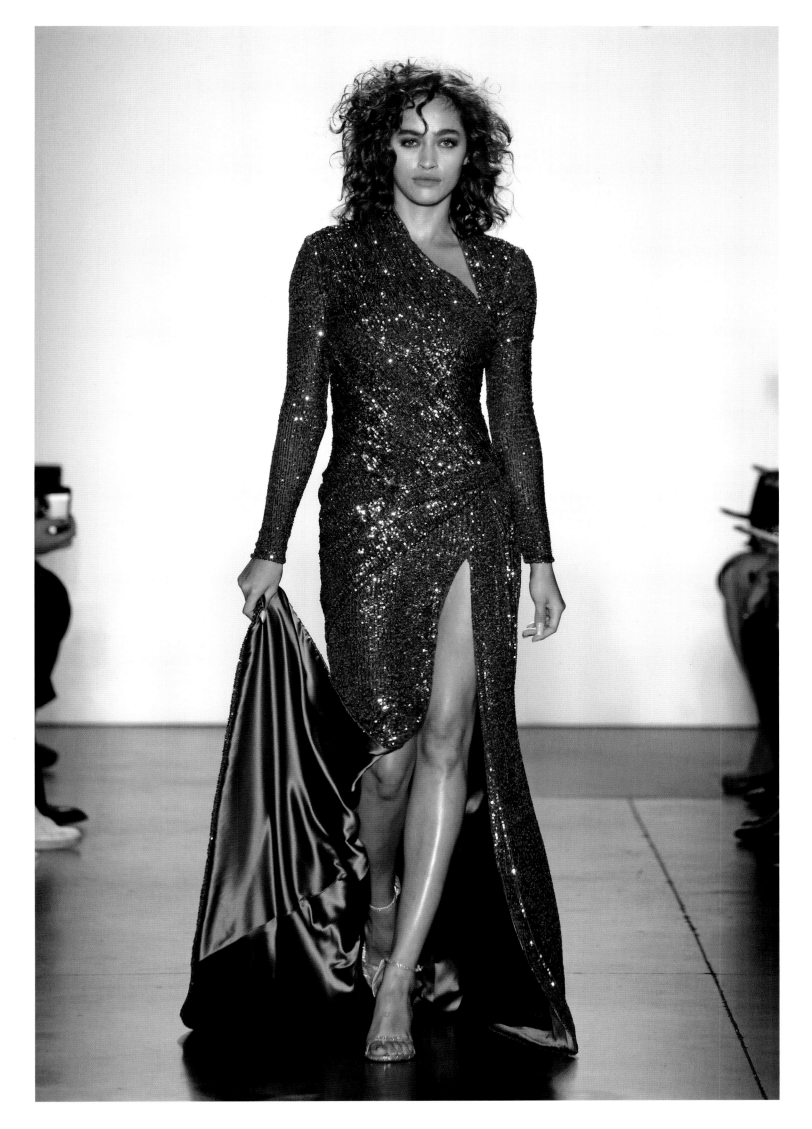

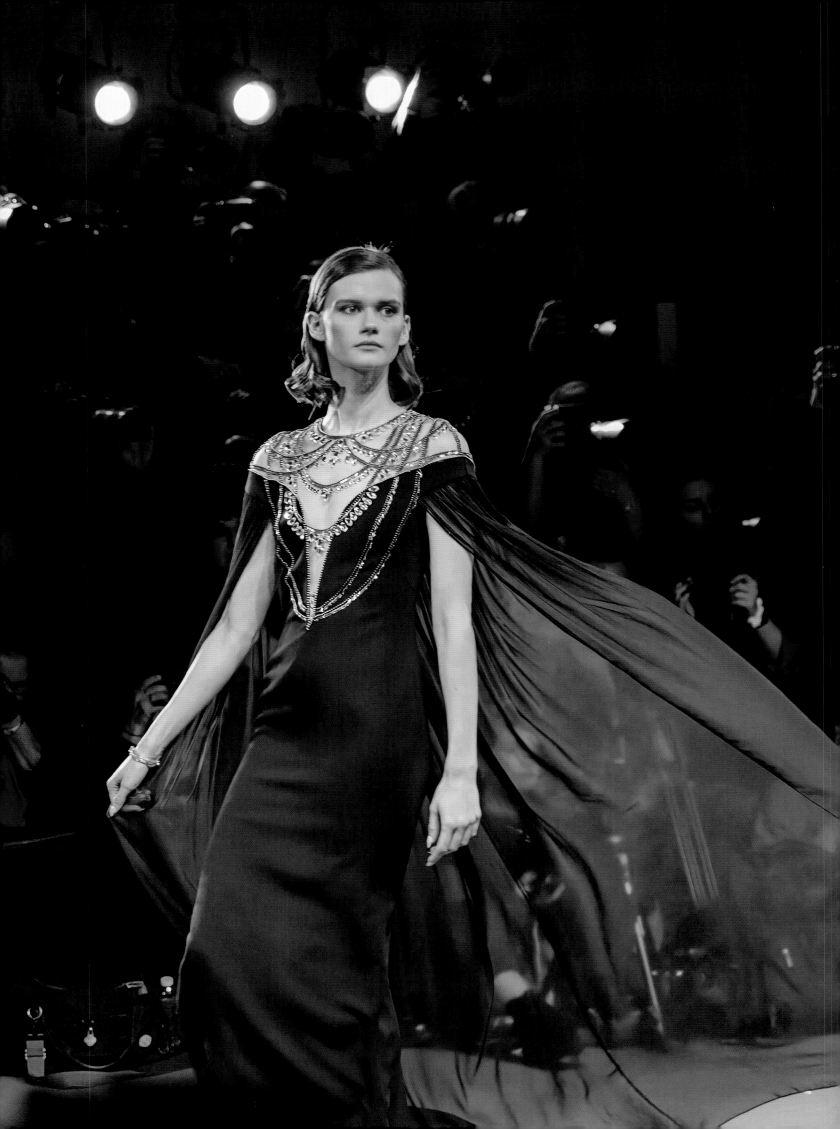

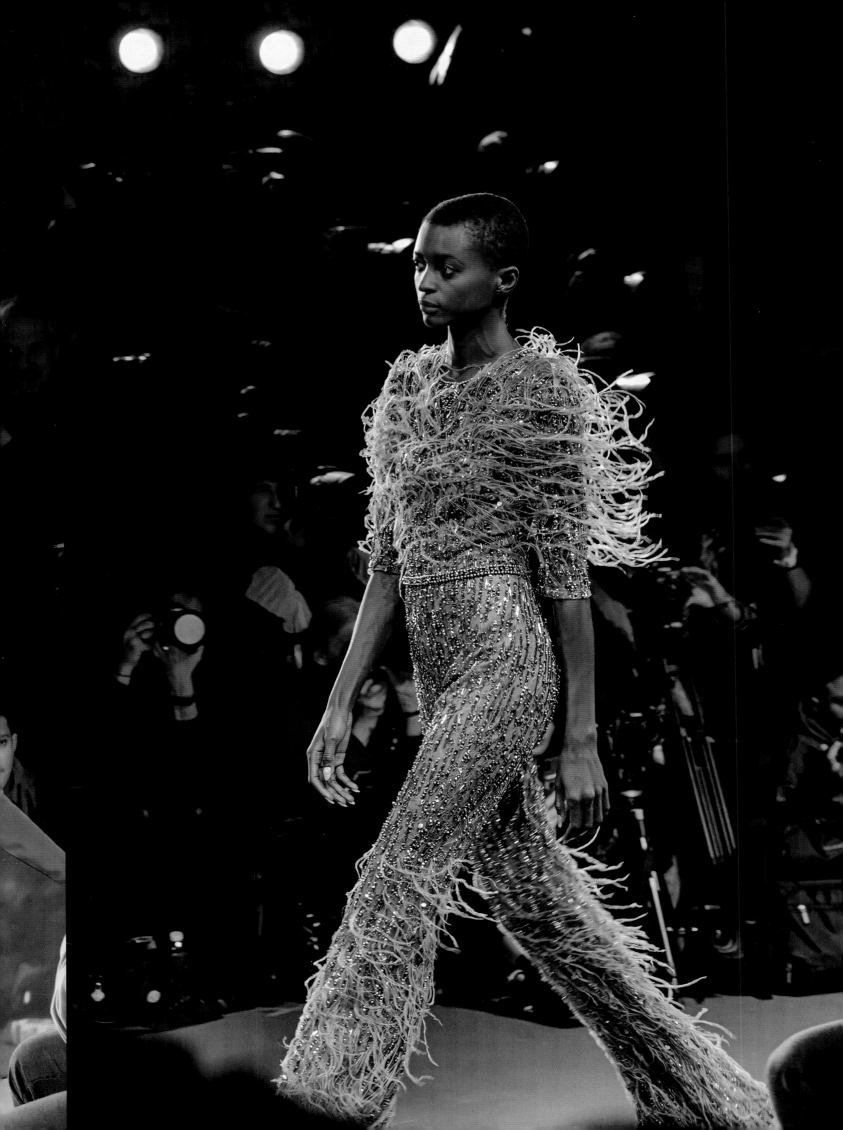

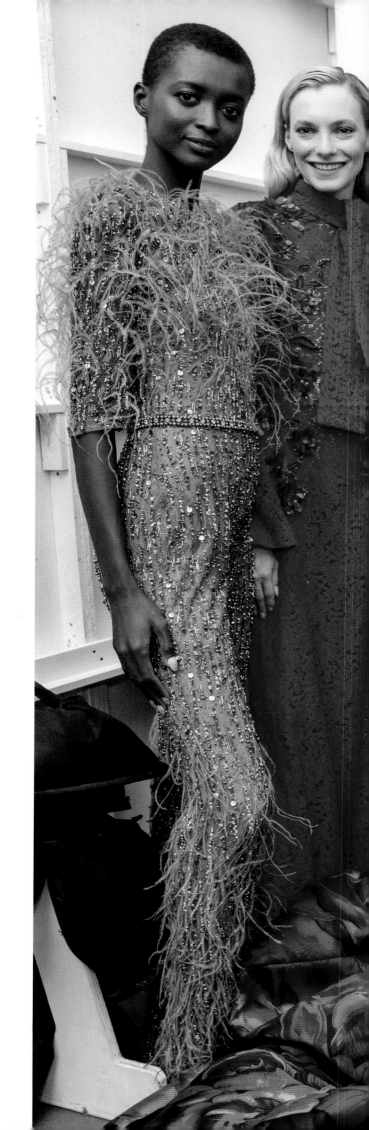

*Page 214:* A gold multi-hologram draped strapless sequin embroidered gown from the Fall/Winter 2020 collection. *Page 215:* A green topaz asymmetric draped sequin gown from the Fall/Winter 2020 collection. *Previous spread left:* An onyx and silver crepe gown with a chiffon cape and crystal-embroidered neckline from the Fall/Winter 2020 collection. *Previous spread right:* An aquamarine sequin embroidered lace jumpsuit with ostrich feathers from the Fall/Winter 2020 collection. *Opposite:* Me with the models at the Fall/Winter 2020 runway show. I pride myself on being the kind of designer with whom models like to work with. Not only do I treat them with respect, I also choose the right dress to complement them best.

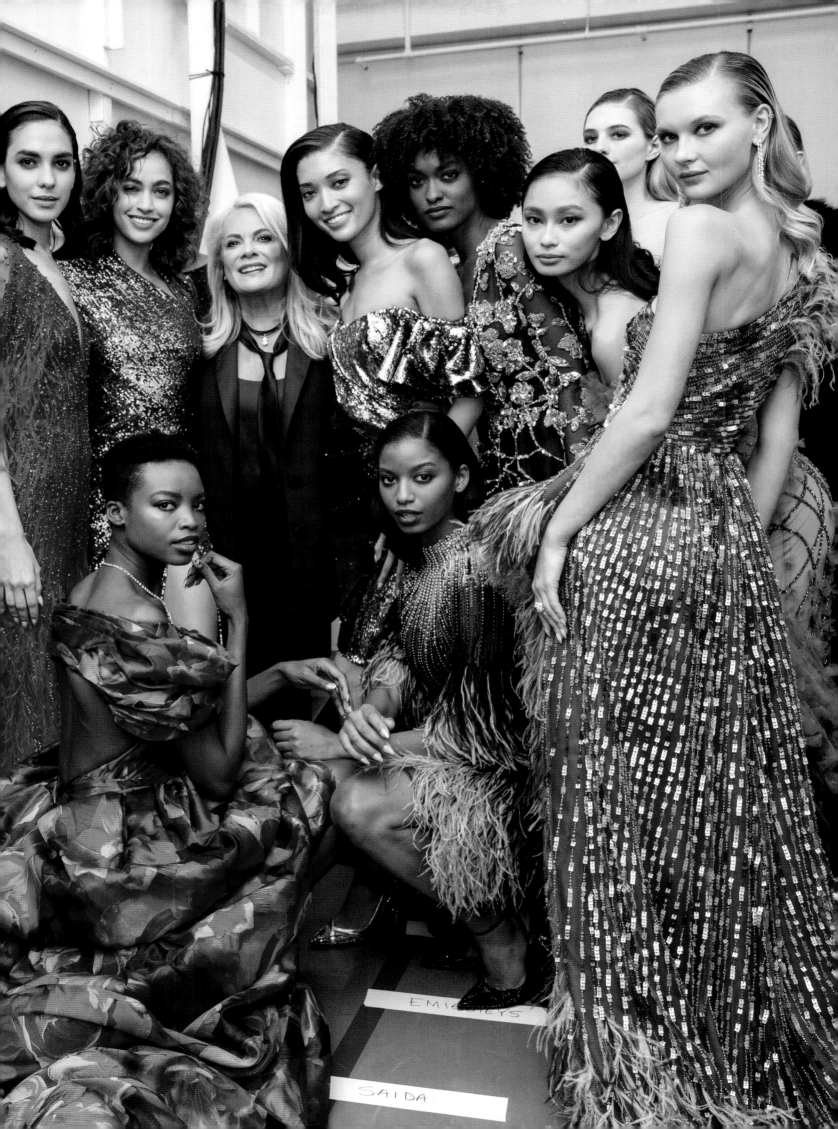

# SS23

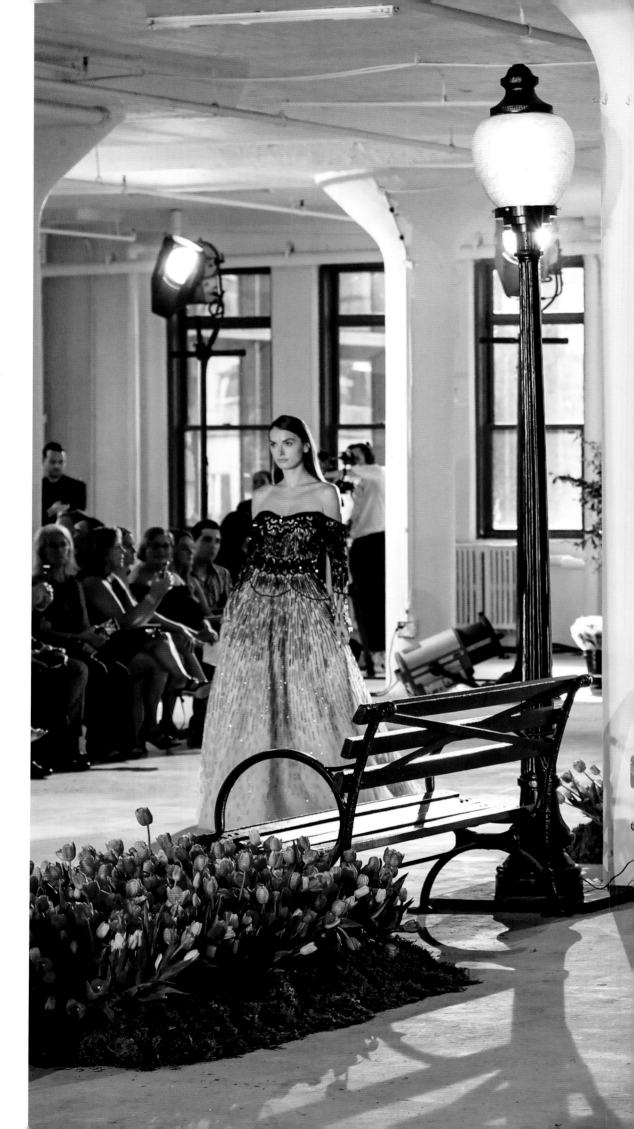

spring/summer
2023

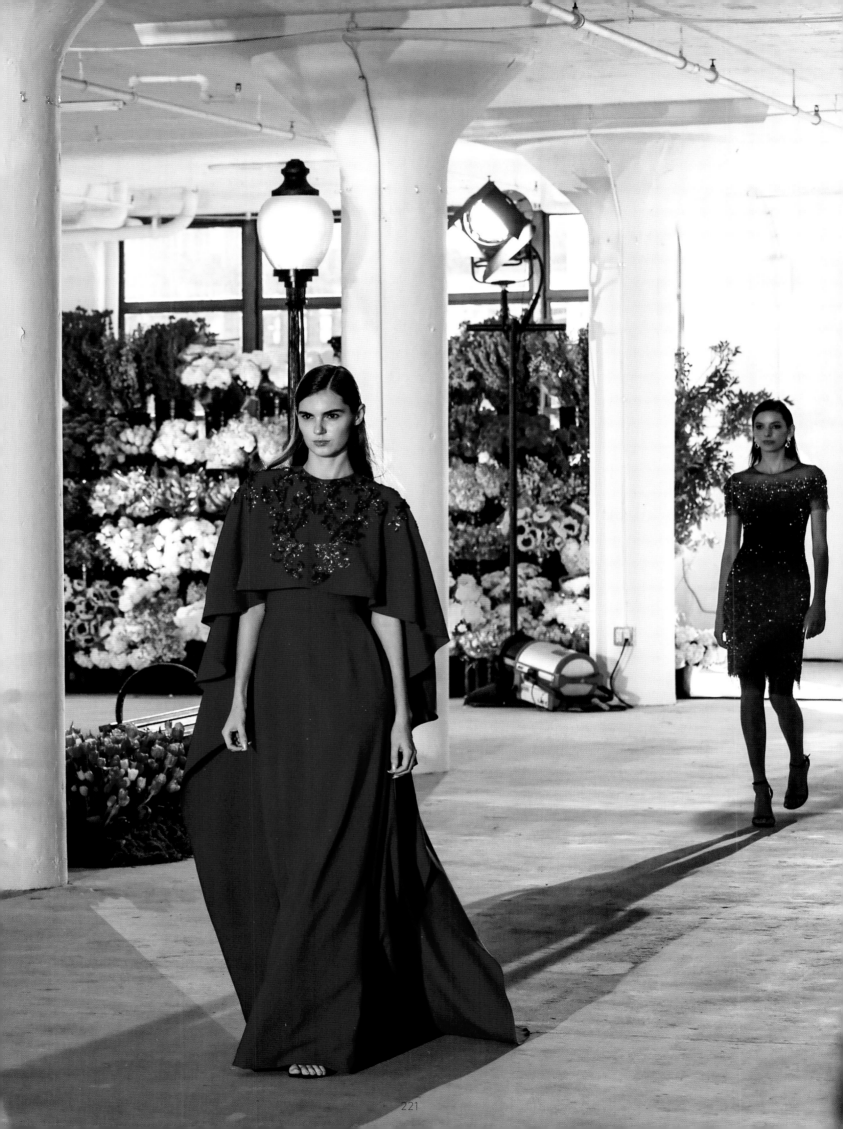

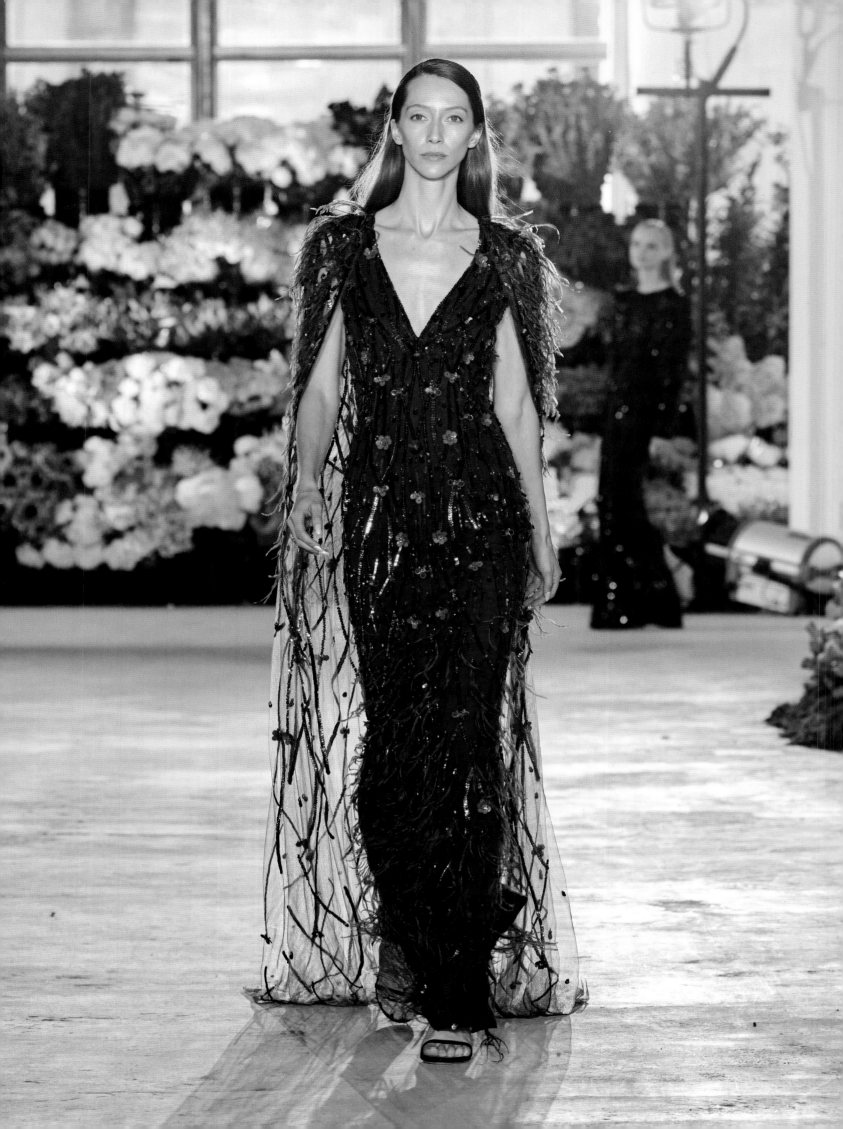

# spring/summer twenty-twenty three

The Spring/Summer 2023 collection was all about celebrating the elements that have become Pamella Roland signatures over the last 20 years. In celebration of this milestone, I wanted to elevate my classic silhouettes like dramatic sleeves, single-shoulder dresses, and capes with the detailing my clients have come to love.

I chose a bold, eclectic palette of cream, pastels, jewel tones, and metallics. Select pieces featured the delicate custom appliqués and head-turning ombrè embellishments in sequins and feathers created in my atelier season after season. In fact, feathers were a bigger feature than ever in this collection. They added high-glam impact and airiness to the pieces. The collection also featured beading in a big way. Beading was draped across the shoulder or highlighted the dresses' petal motifs. My take on fringe featured dramatic tiers of shimmering beaded strands or pearly beads that added seductive movement. This collection was also a chance to showcase new approaches to unexpected evening wear silhouettes, like the short suit. It was worn with a richly embellished bustier that highlighted the corseting that make my dresses both structured and comfortable.

The Spring/Summer 2023 runway show brought me back to where I launched the company: New York City, a place that really knows how to throw a party. The set for the runway show in Spring Studios drew on iconic city markers, like the corner flower shop and park benches, showing that bold, elegant women can bring a celebration wherever they go.

*Opposite:* An amethyst embroidered tulle caped gown. *Following spread:* My clients crave bold colors and decadent details—from the Spring/Summer 2023 collection.

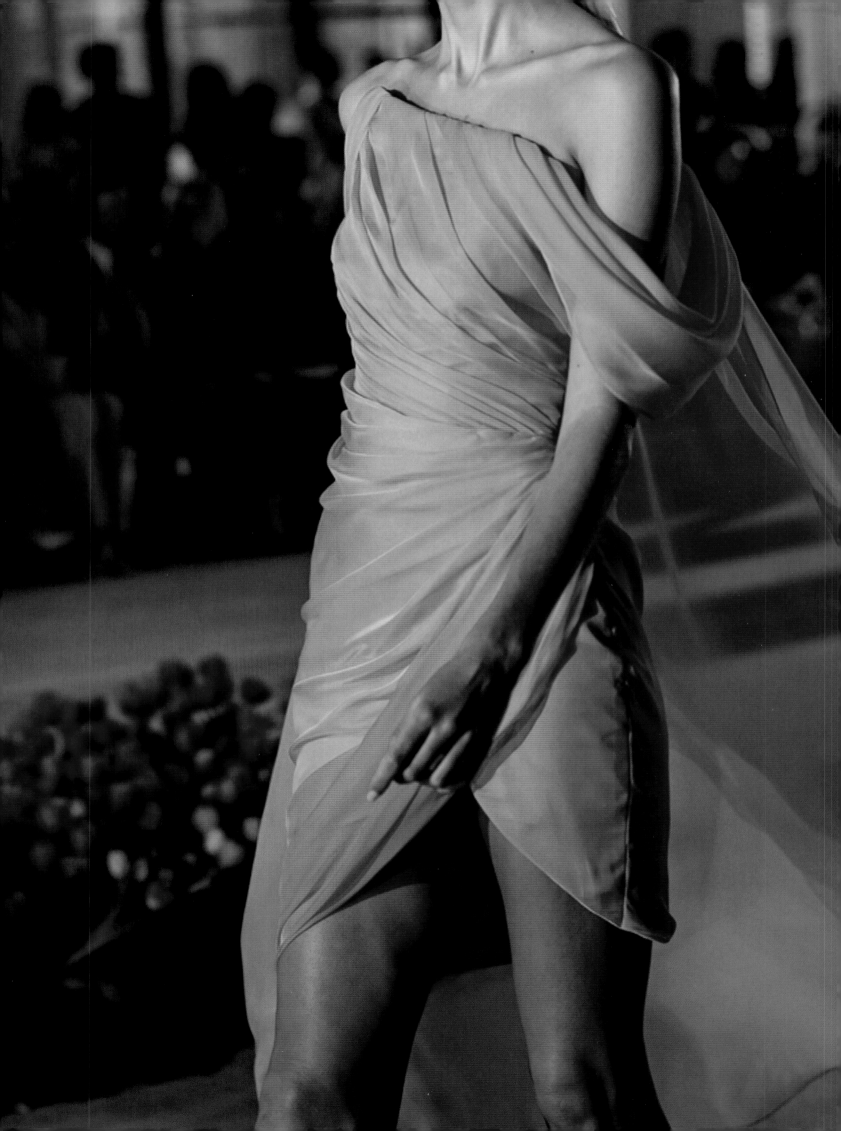

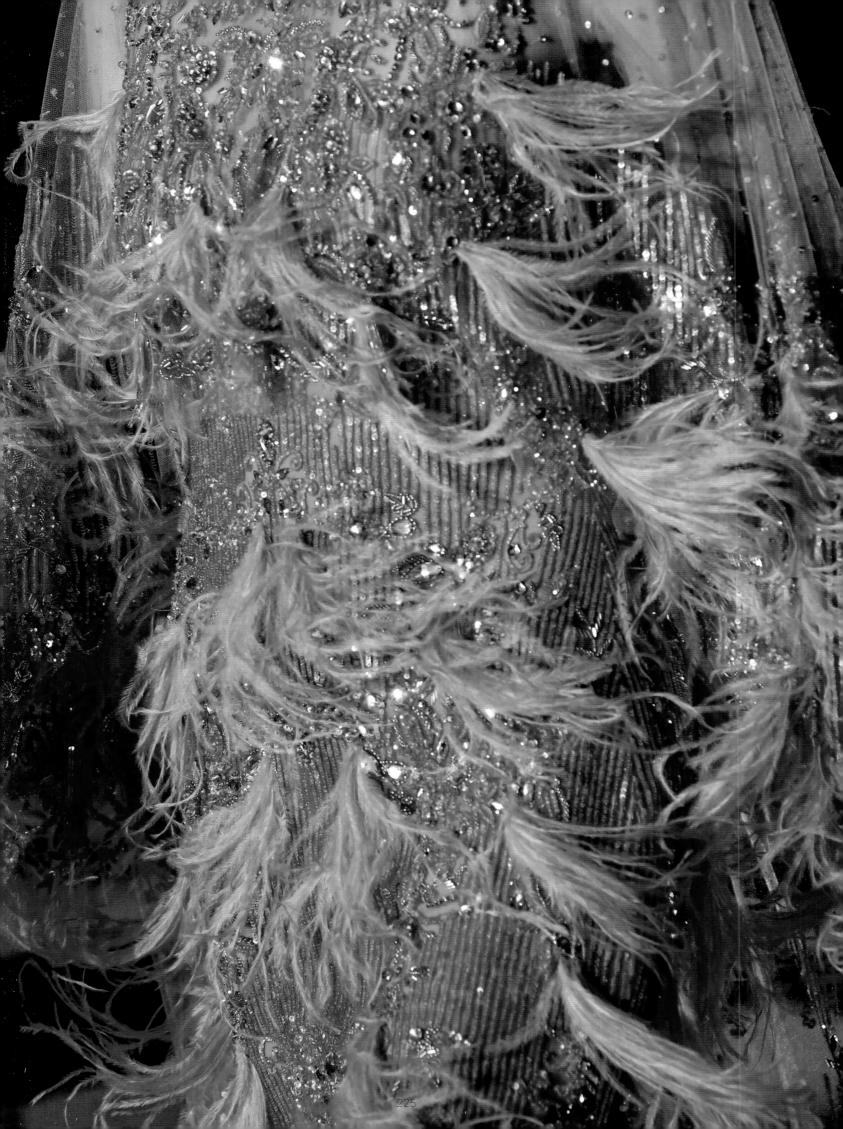

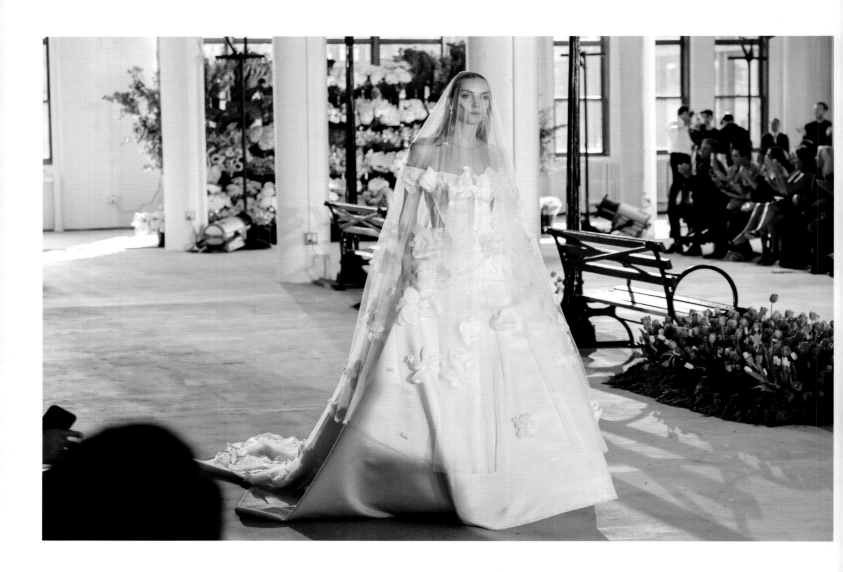

*Above and opposite:* In the past, designers used to end their fashion shows with a show-stopping bridal gown. I revived the tradition at our 20th anniversary show, placing our bride's bouquet on her veil and train.

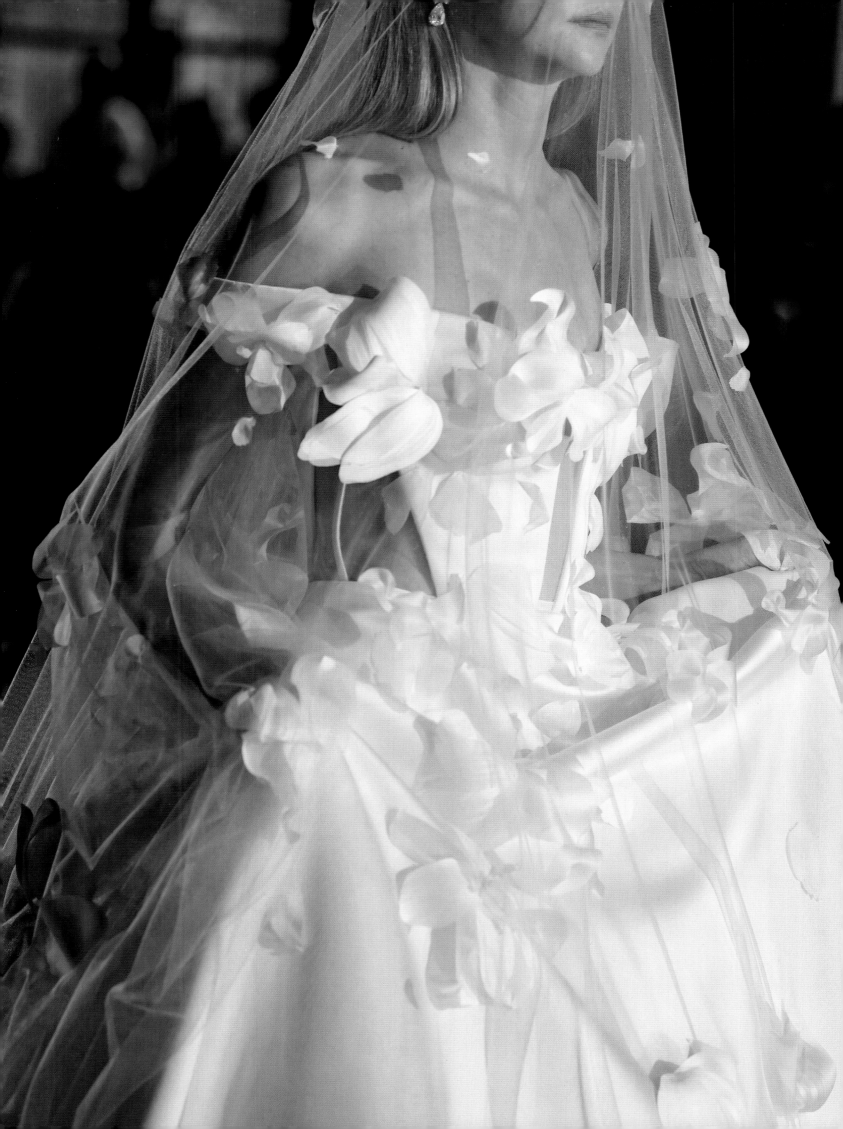

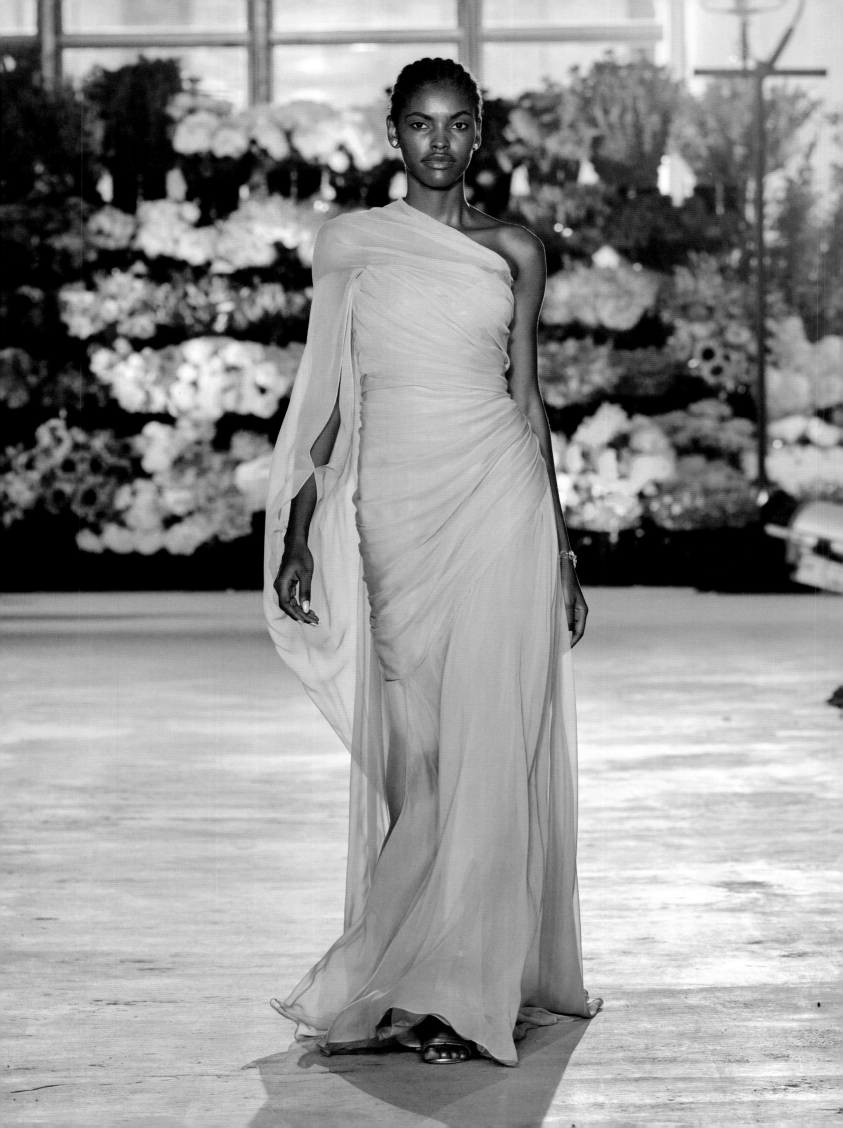

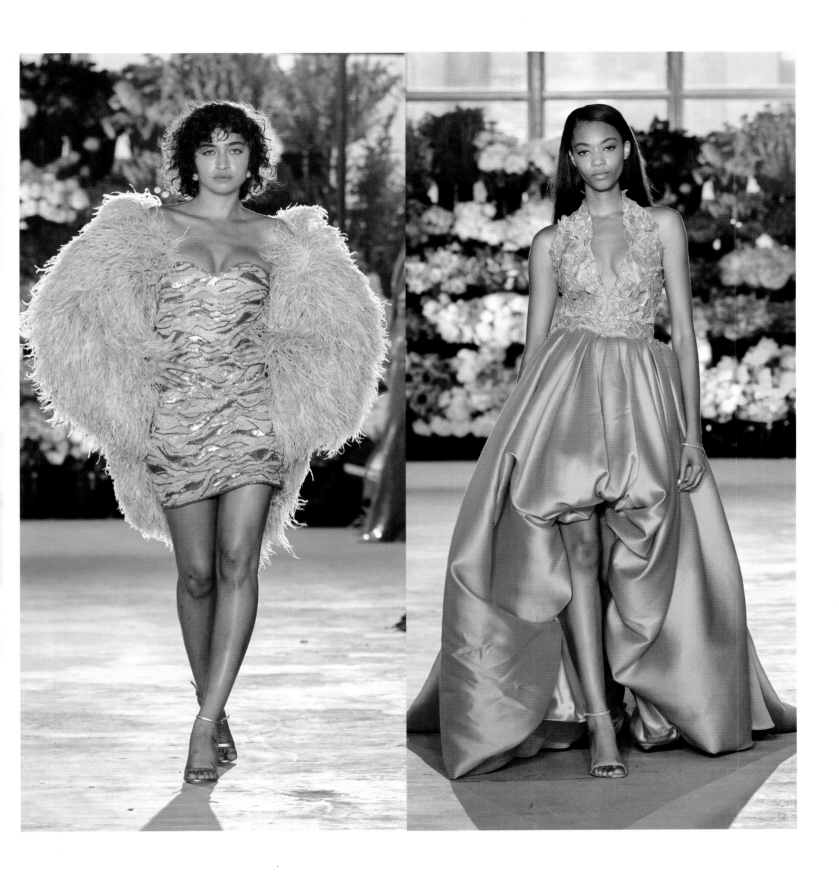

*Above and opposite:* A range of pretty pastels from the Spring/Summer 2023 collection. *Following spread:* A sapphire

embroidered pleated tulle gown from the Spring/Summer 2023 collection.

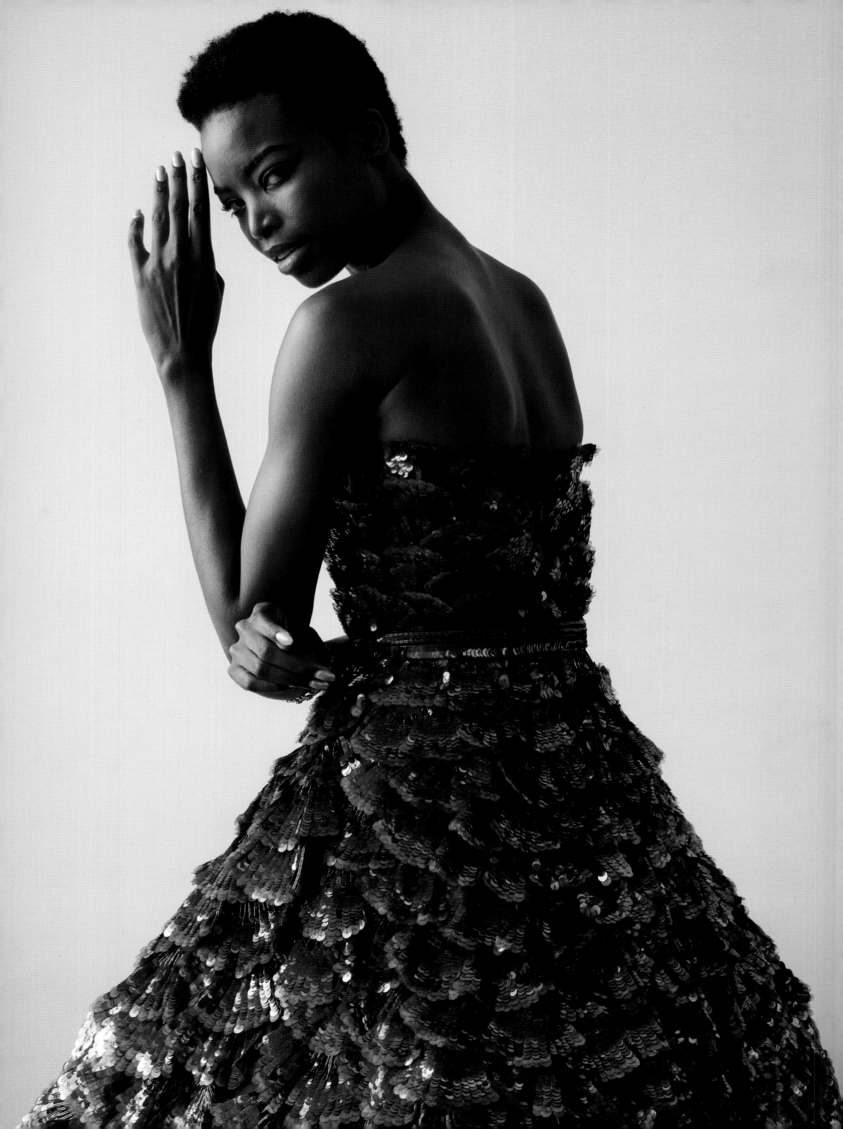

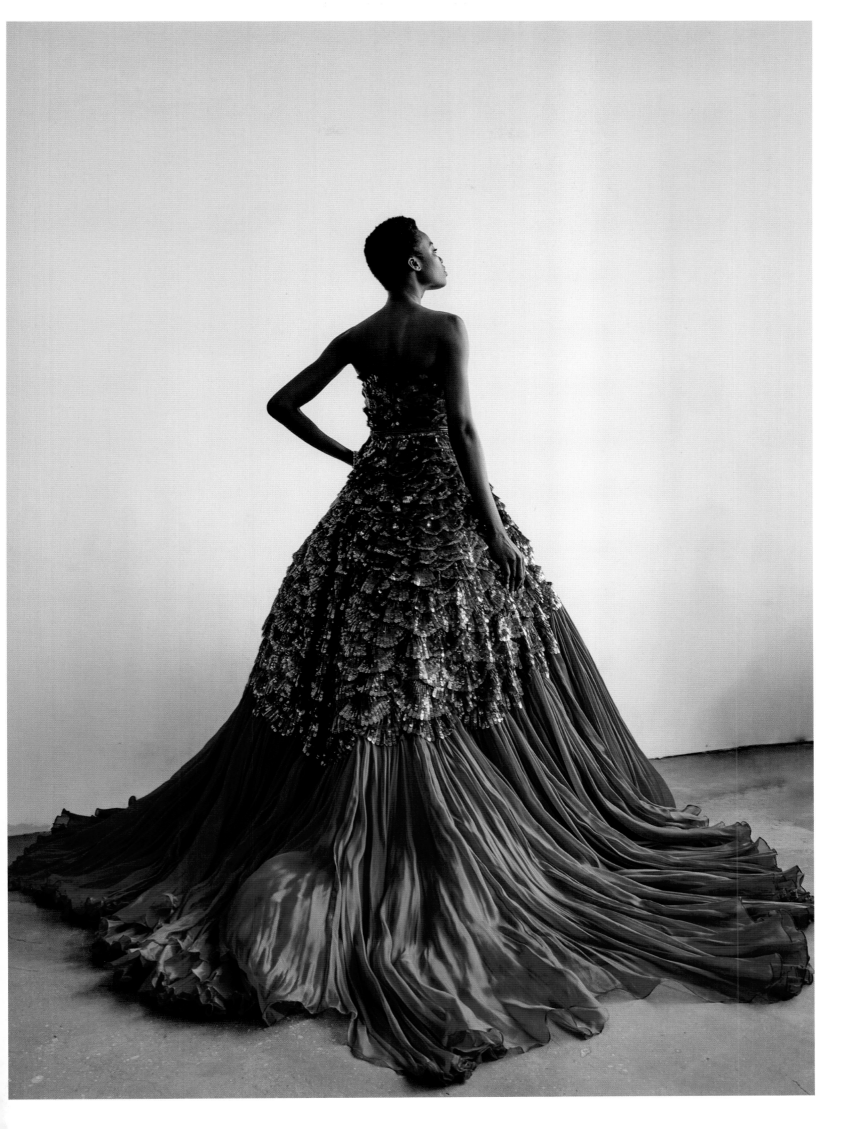

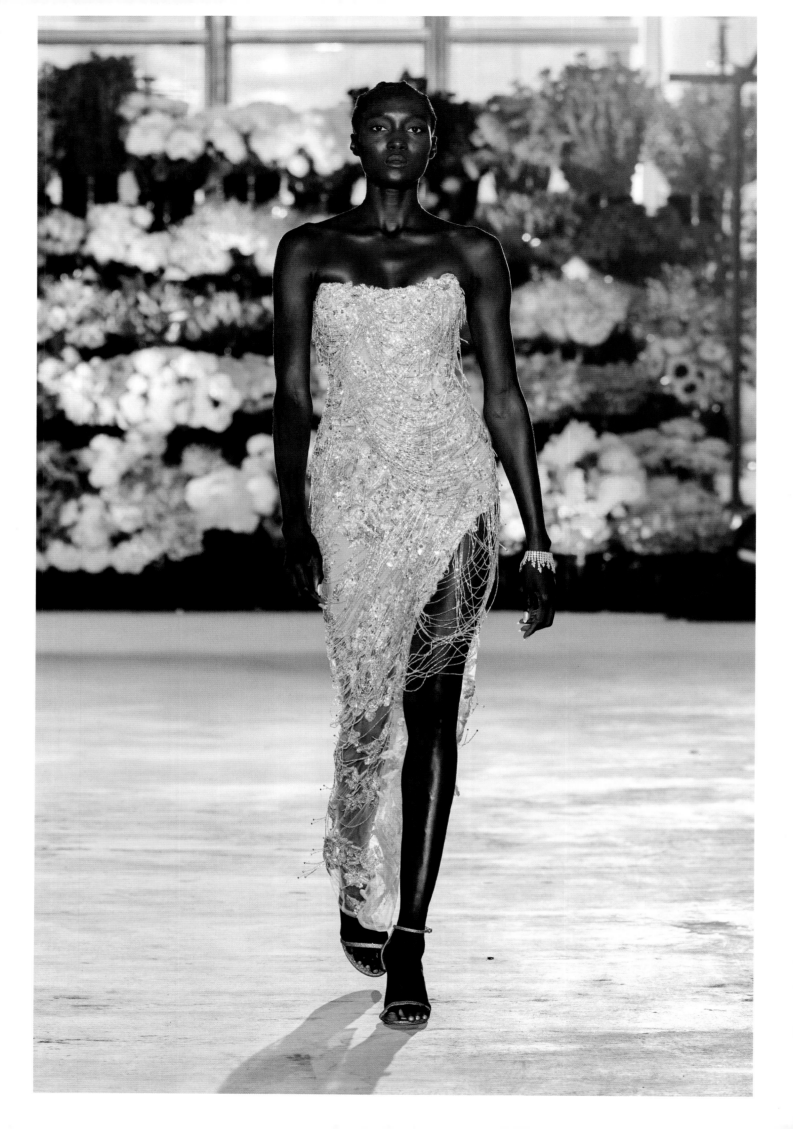

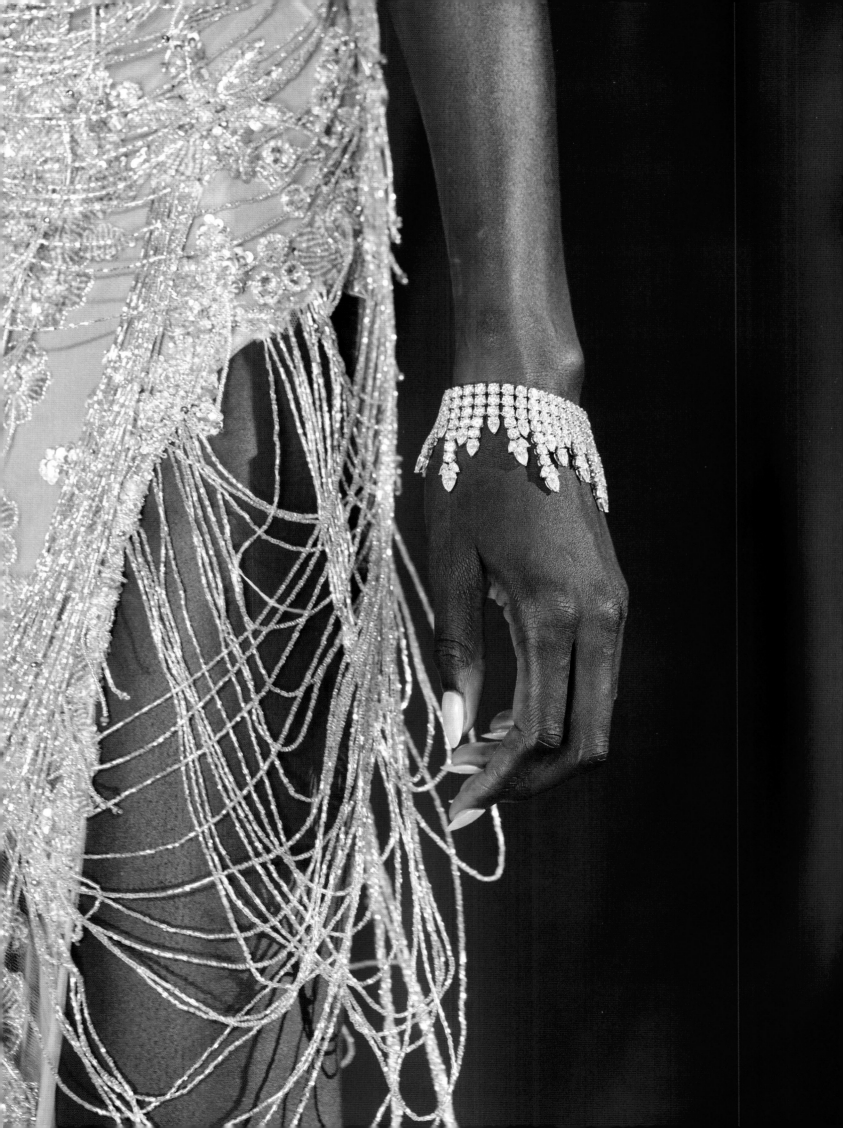

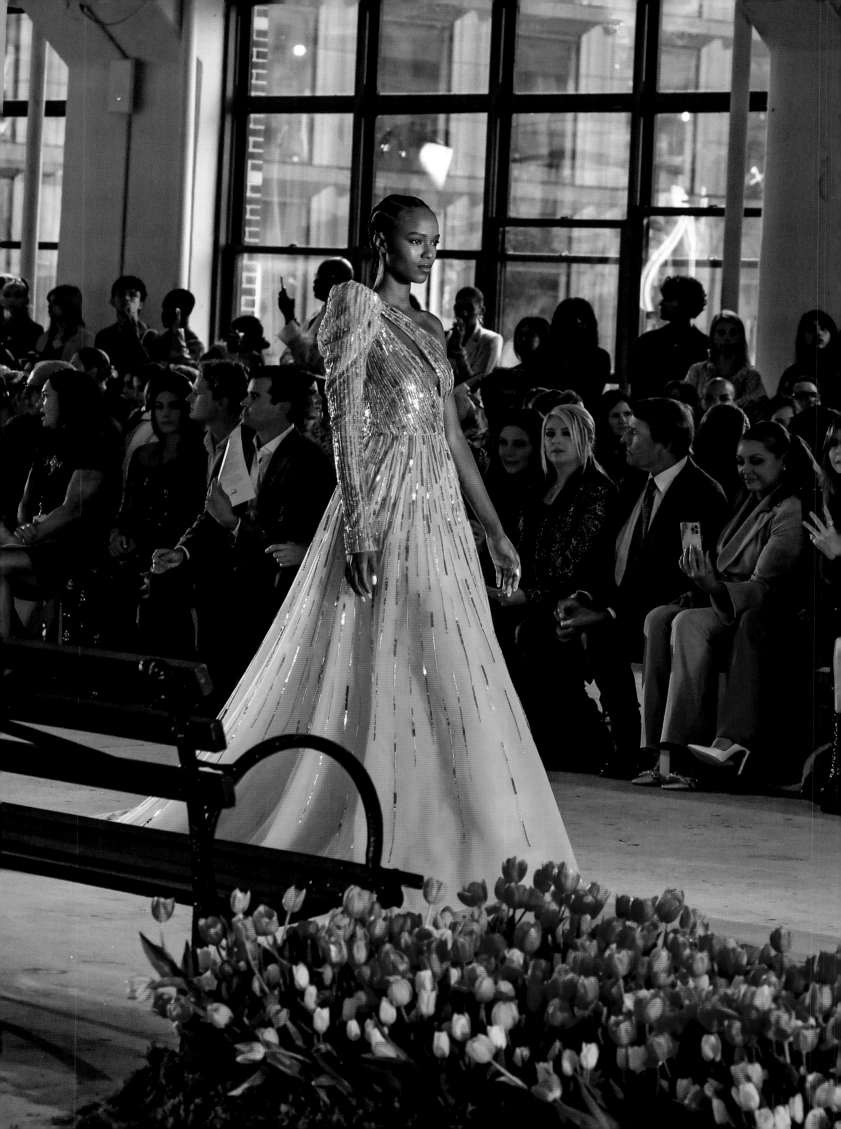

*Previous spread:* A nude and silver embroidered tulle fringe gown from the Spring/Summer 2023 collection.

*Opposite:* Friends, family, and VIPs watch the Spring/Summer 2023 runway show.

pf
2
3

pre-fall
2023

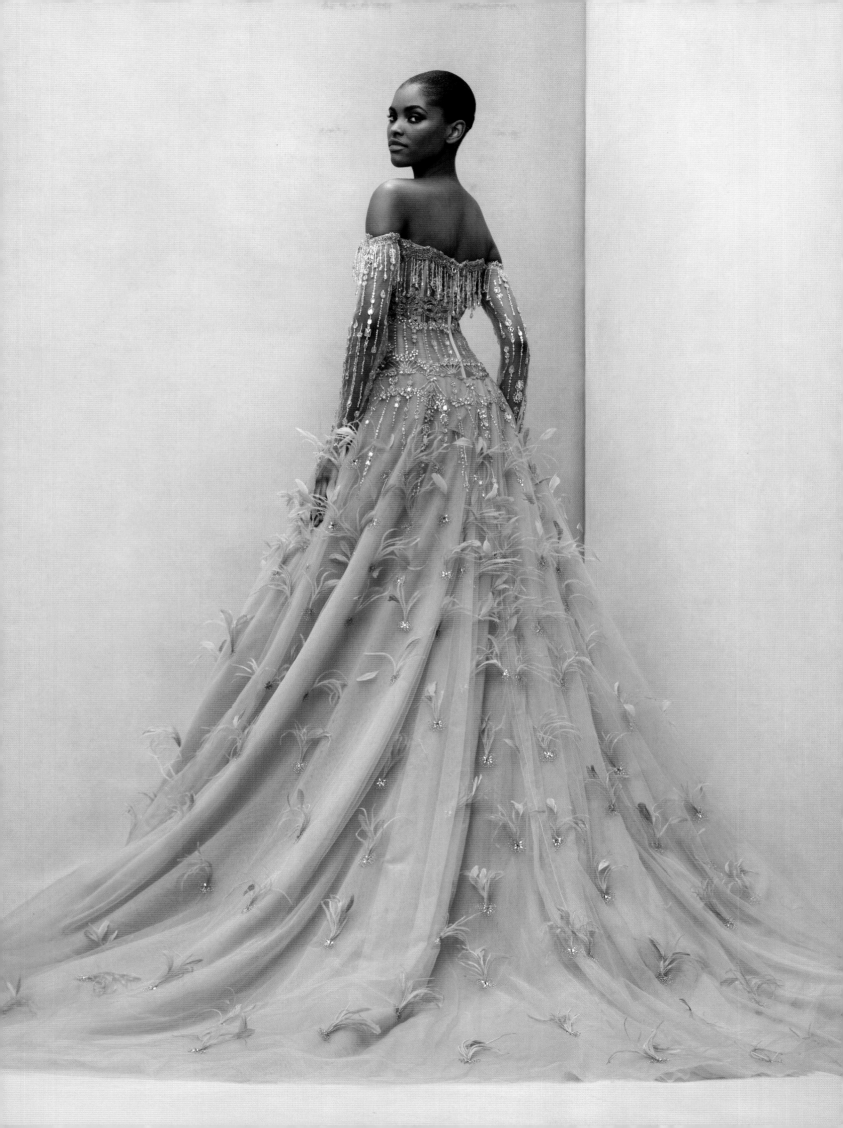

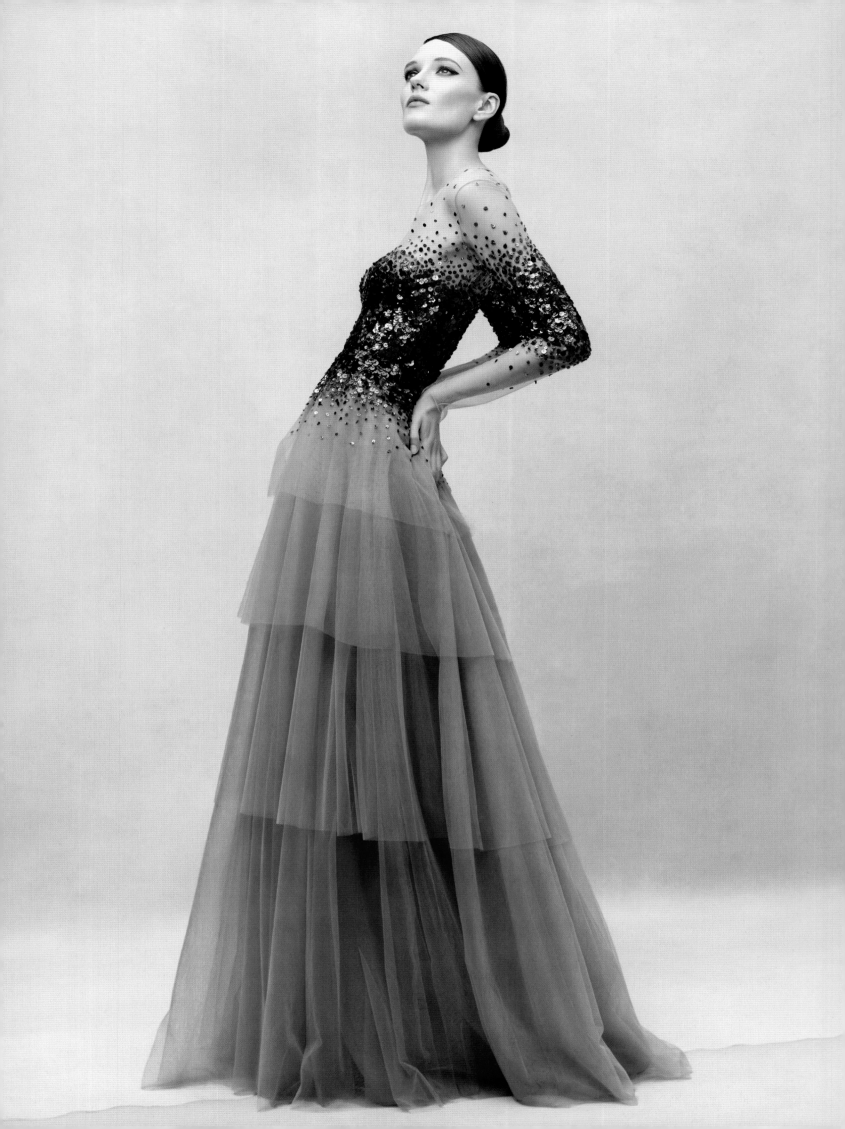

# pre fall twenty-twenty three

The pre-pandemic celebrations that have always brought joy are thankfully returning. To celebrate newly full social calendars, I decided to pay tribute to the Golden Age of Hollywood. The silhouettes and details from the 1940s, 1950s, and 1960s define glamour as we know it.

This collection captures the polished, sophisticated style of my favorite classic movie stars—all in a Technicolor palette of jewel tones, metallics, whites, and ethereal pastels. Gowns and cocktail dresses showcase the soft and dreamy draping for which we have become known. The design team also created an oversized floral print Mikado for three dresses, bringing more texture and playful femininity to the collection. Our signature scene-stealing capes returned in varied dimensions, as did our ombre coloring, although it is more subtle than in previous seasons. Dramatically sculpted busts on gowns and cocktail dresses evoke the coy sensuality of the Golden Age. Hand sewn sequins, 3D-printed crystals, and feathers add enough drama for any leading lady.

My team and I challenged ourselves to be innovative in our interpretations. It was important to me that the midcentury references were there but the garments needed to be more than a reproduction. For those who want more current options, we incorporated embellished suiting with a rebellious edge and statement-making jumpsuits. Every piece is ready for its close up.

*Opposite:* A gown from the Pre-Fall 2023 collection. *Following four spreads:* Selections from the Pre-Fall 2023 collection.

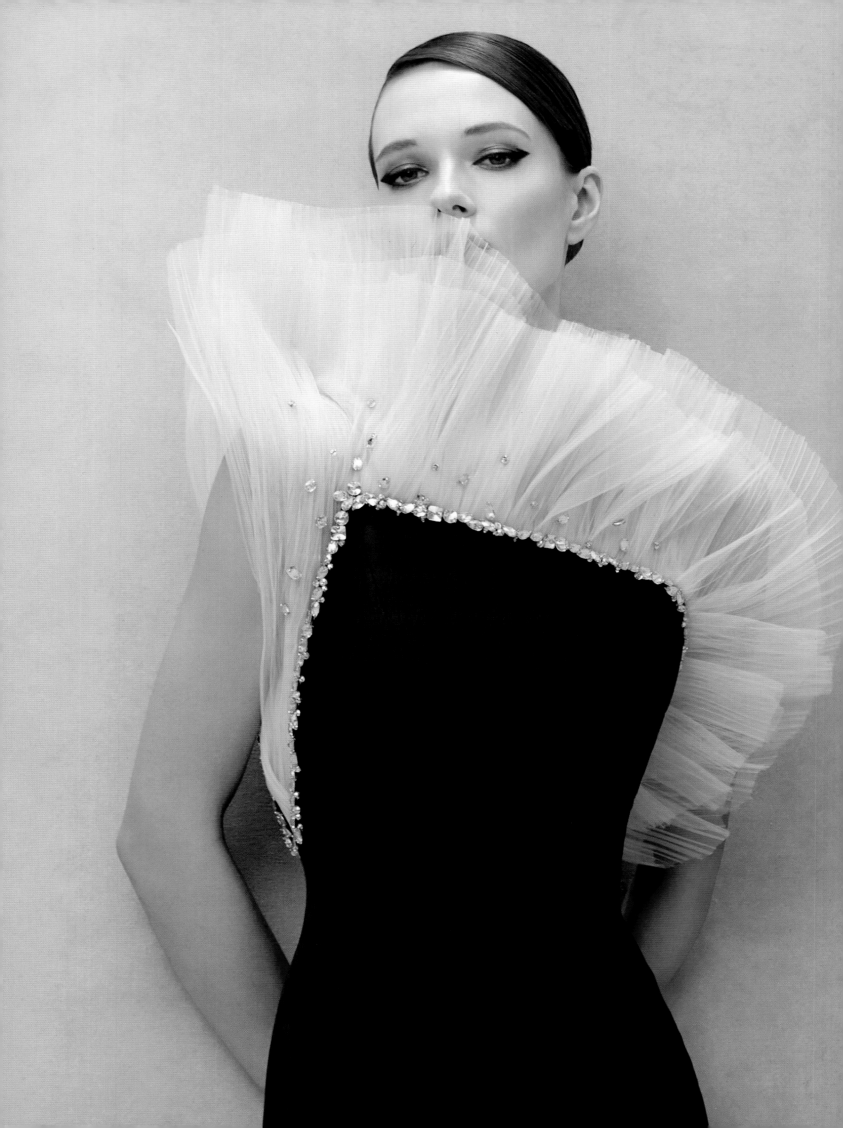

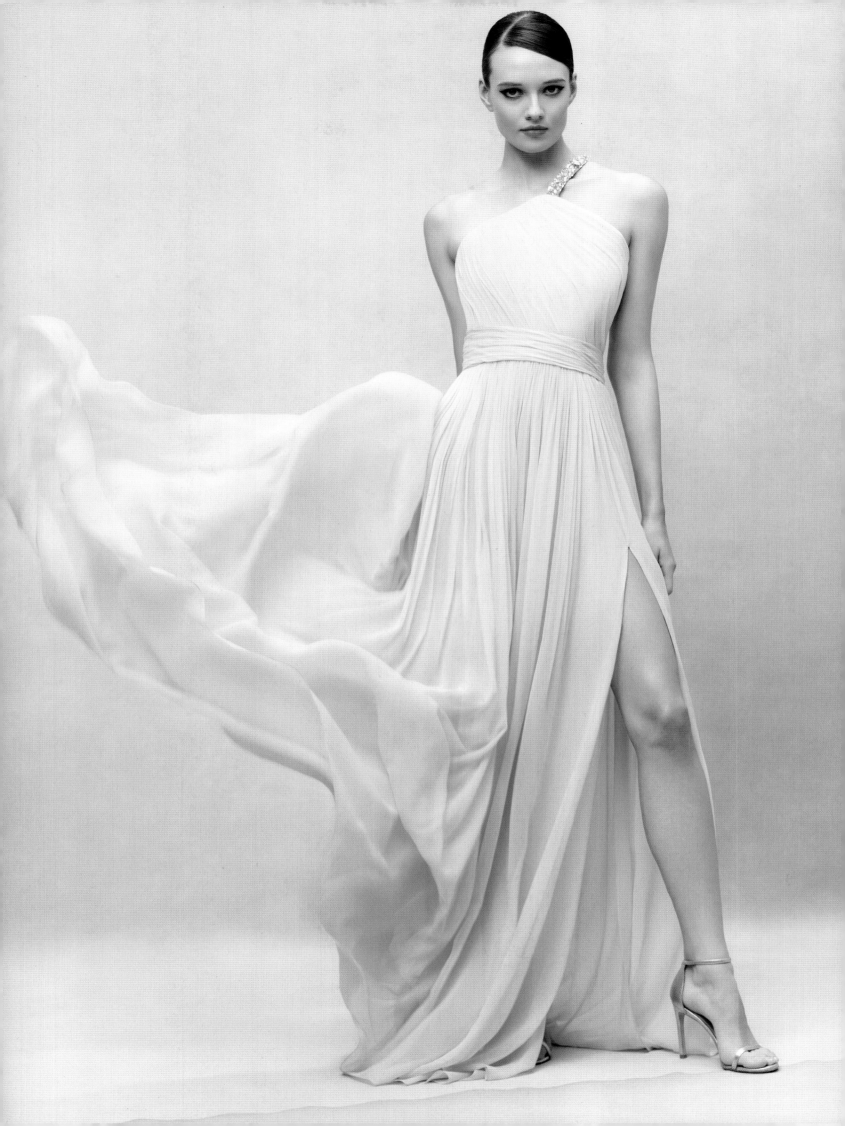

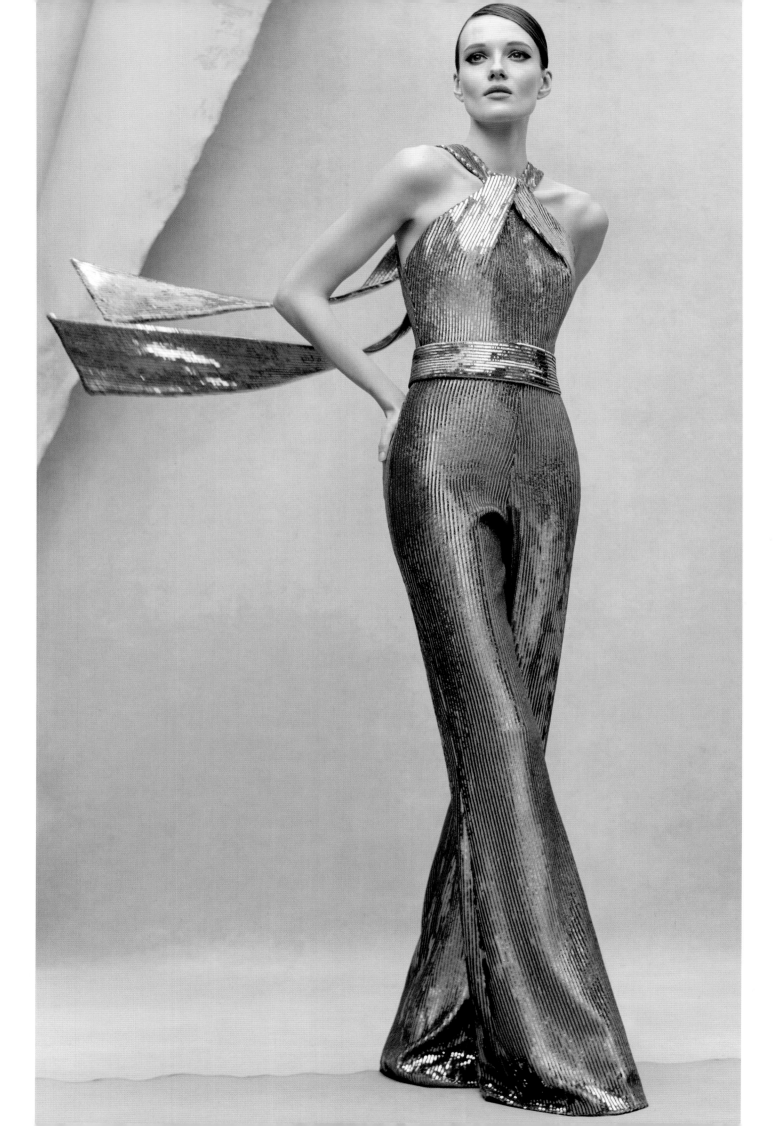

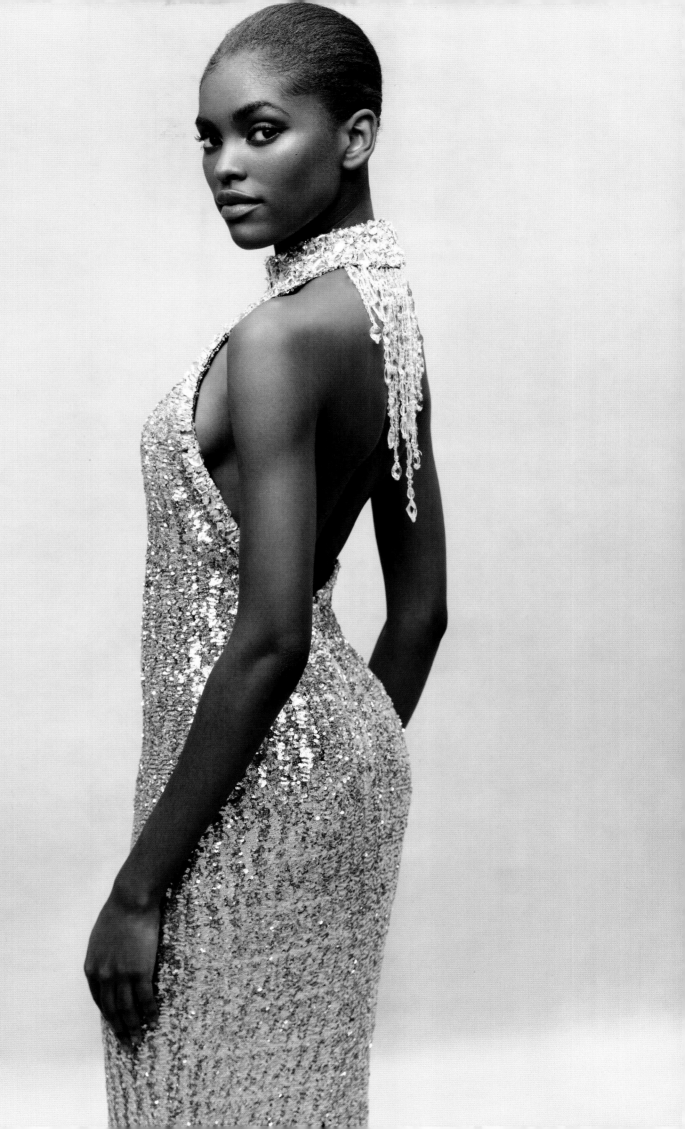

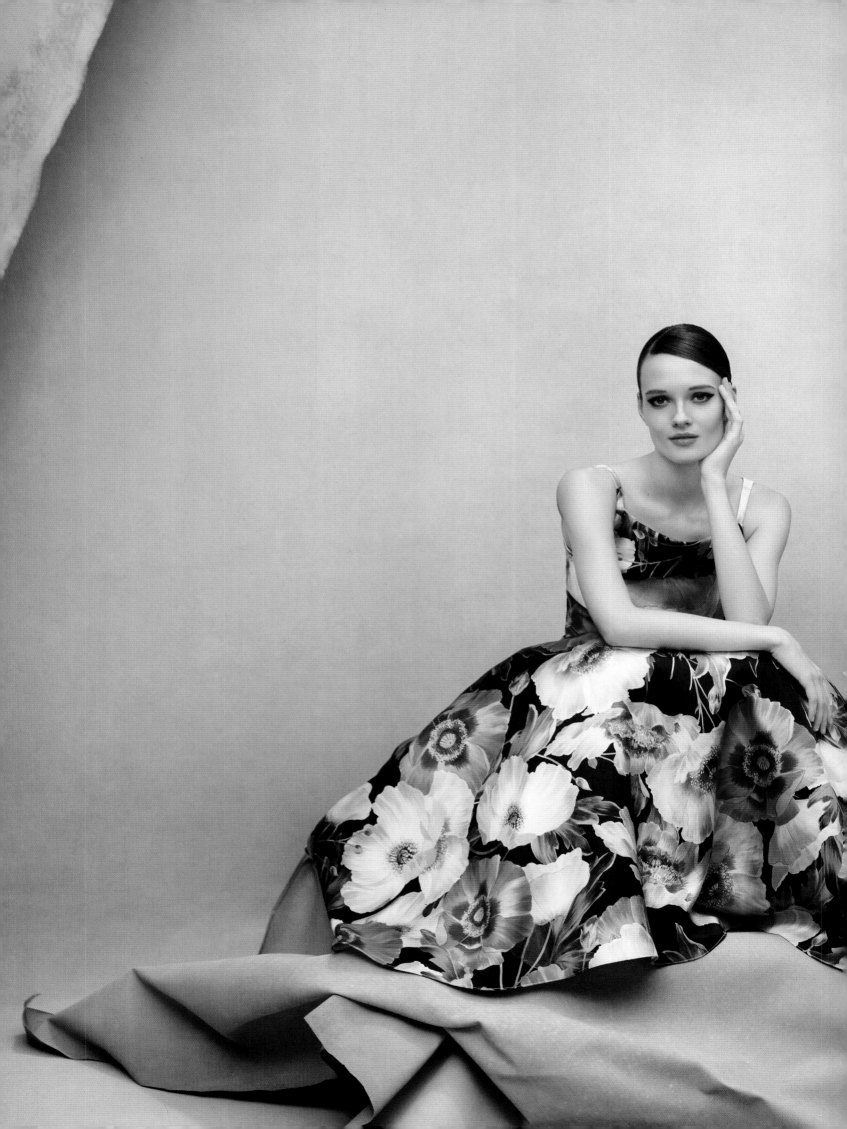

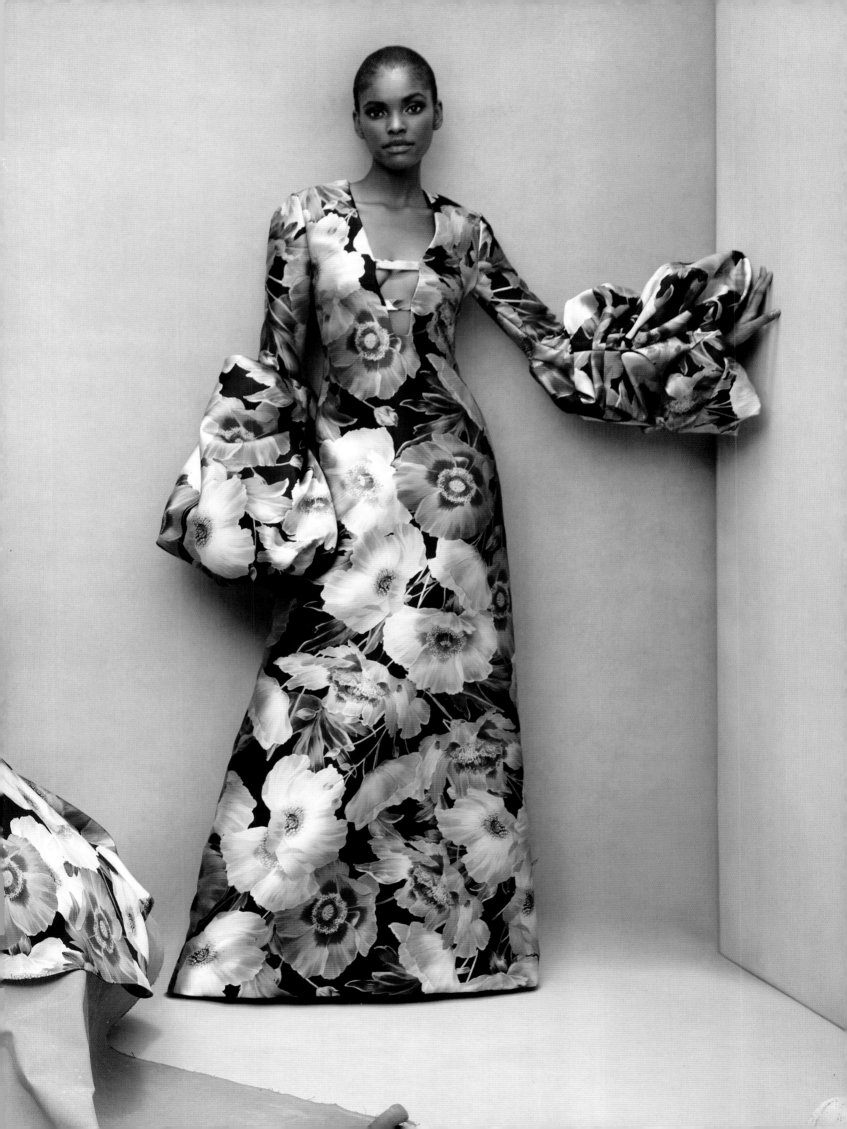

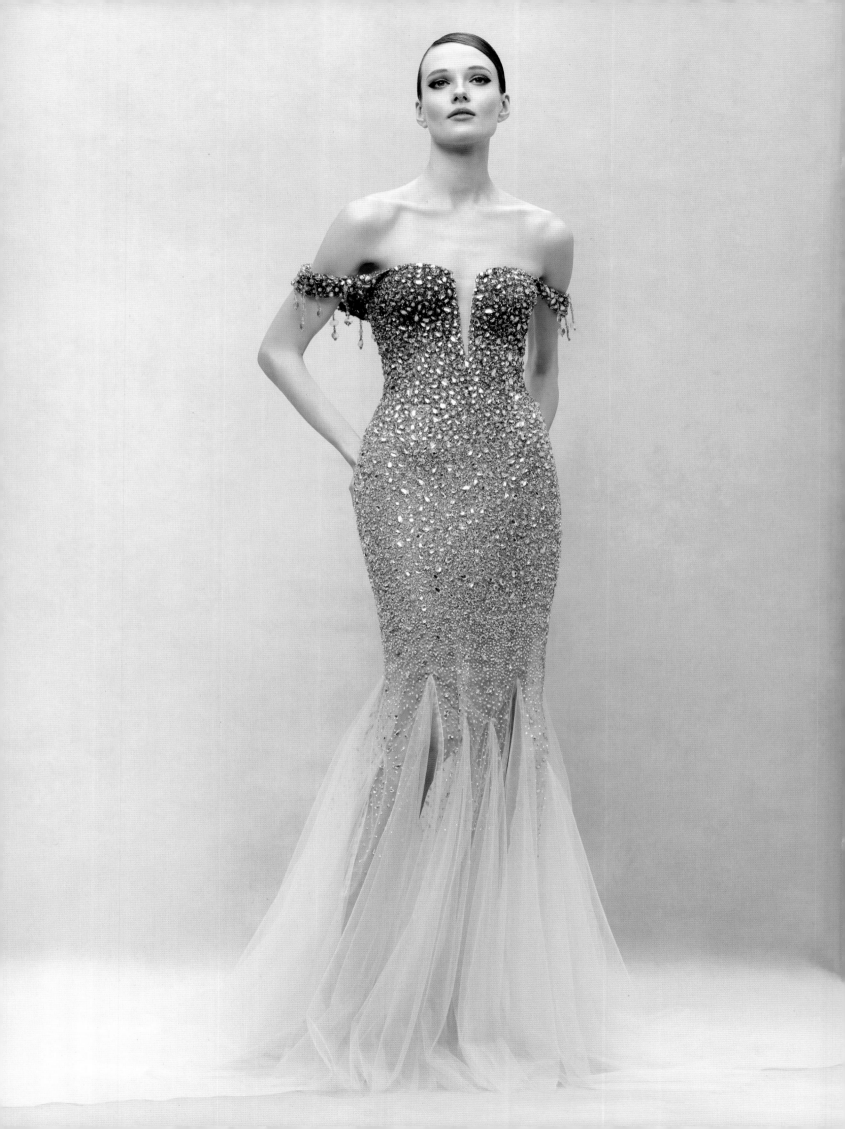

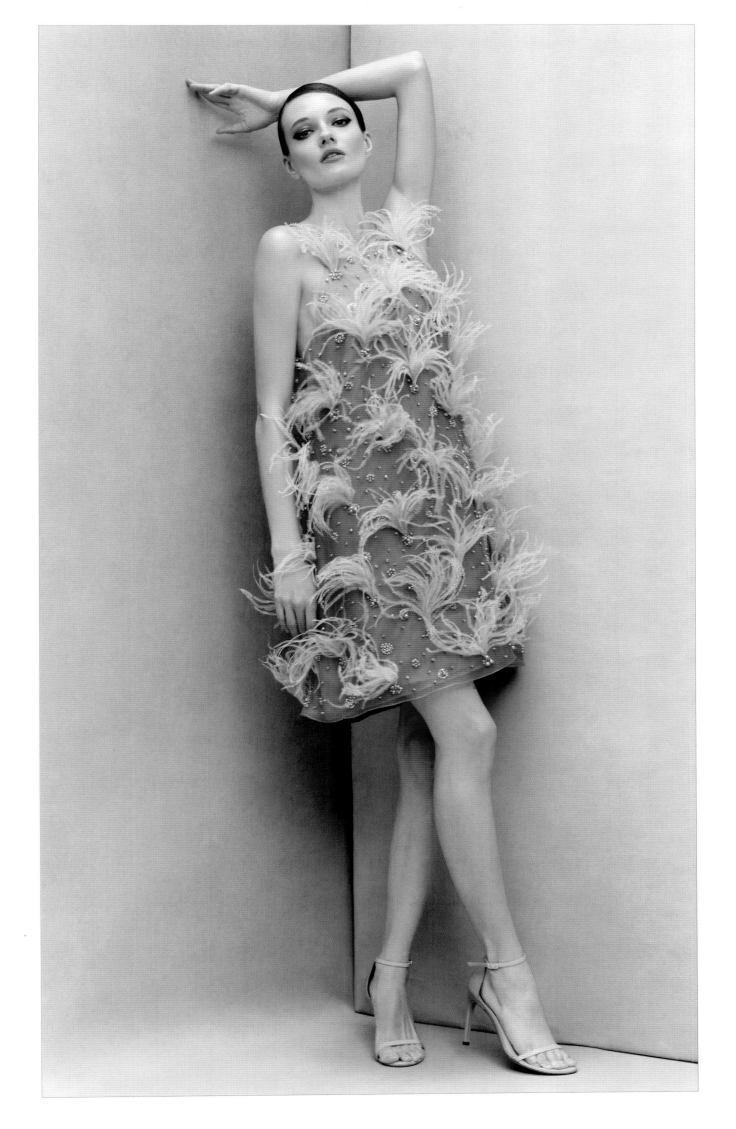

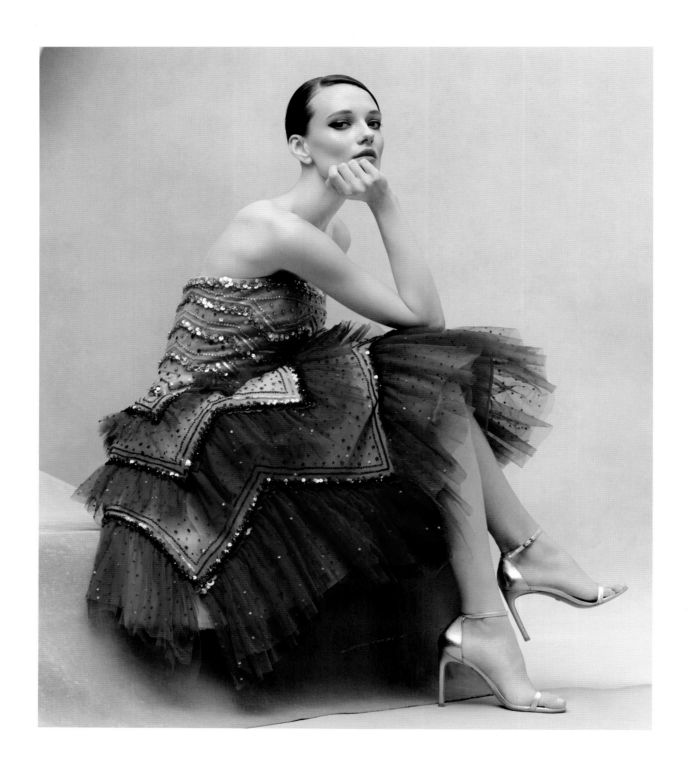

*Above and opposite:* I decided to let the looks speak for themselves in this simplistic shoot for the Pre-Fall 2023 collection. The colors, fabrics, and silhouette cuts take center stage.

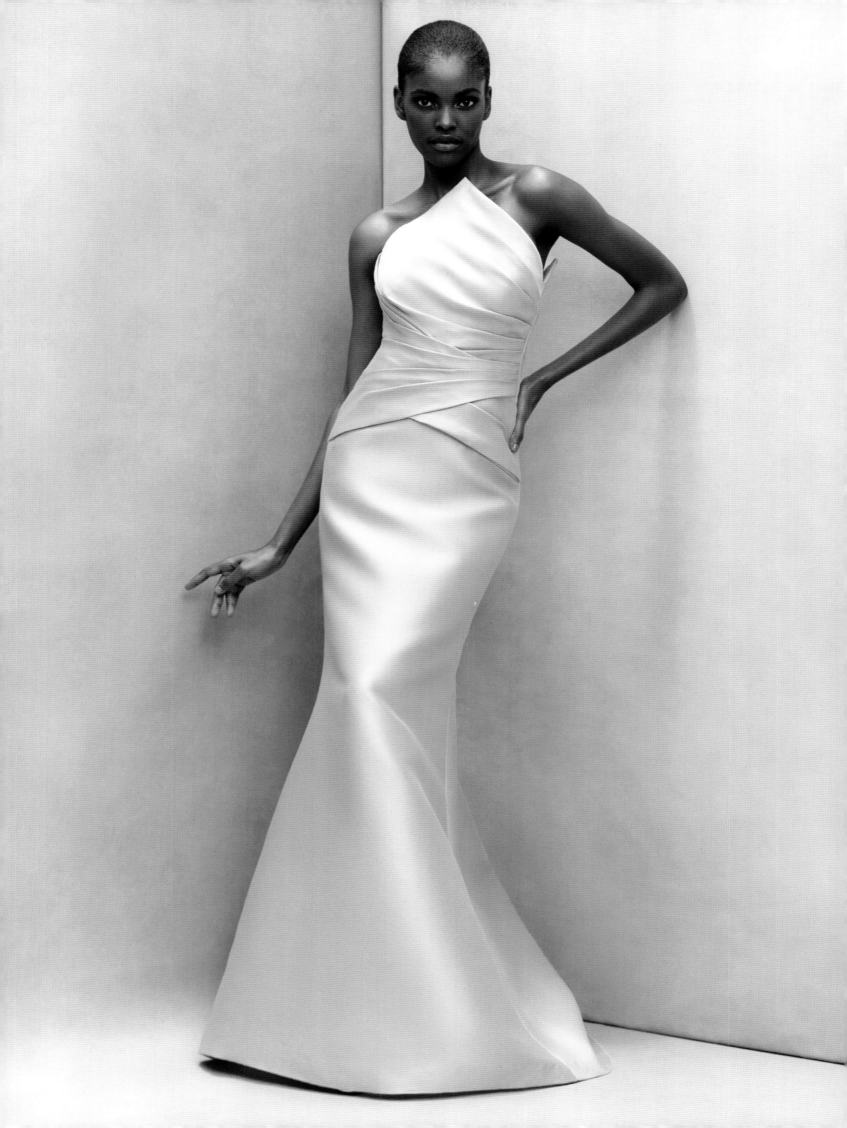

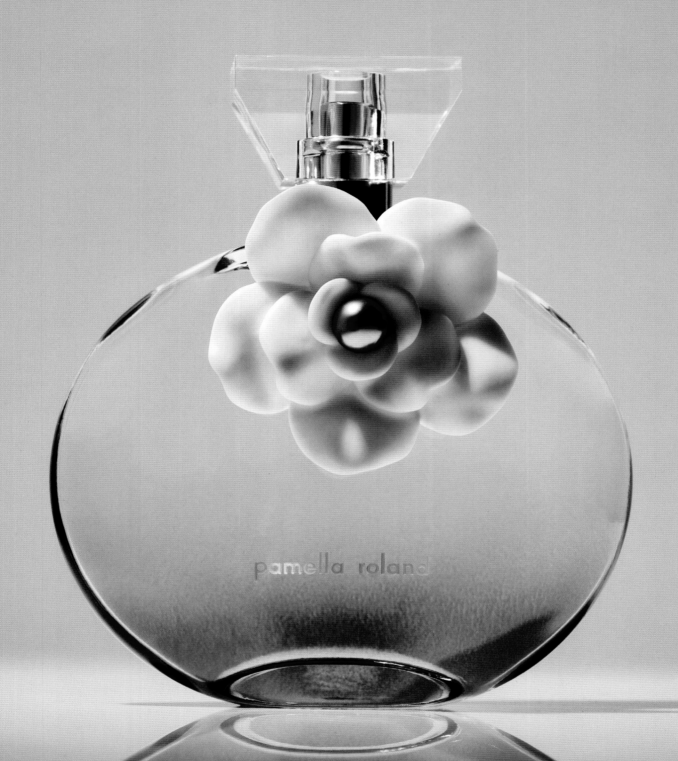

# a dream come true
## my fragrance

Every gown needs the perfect finishing touch: a fragrance that intrigues and makes the wearer truly stand out. I wanted to create a scent that complemented my sumptuous evening looks. The scent needed to be as sophisticated as my clients, and modern while nodding to the glamour of past decades. Because of production mishaps and a packed production schedule, it took me 10 years to bring the fragrance to life.

Developing the scent was the perfect opportunity to work with my daughters, Sydney and Cassandra, who were living in New Zealand and England, respectively, at the time. Family is so important to us, so we started sampling fragrances built around roses, which my mother and grandmother grew in their gardens. Rose-forward fragrances can easily feel a bit old-fashioned, so we added other notes to add brightness and surprise. The result was an opening swirl of bright, juicy fruits and subtle spice that then revealed three expressions of the rose—an ode to nuanced femininity. Over time, the florals give way to an afterglow of dark notes: velvet and amber woods, green moss, and tonka bean. The fragrance is as sophisticated and complex as my clientele.

When Pamella Roland Eau de Parfum launched in Spring 2021, many organizations still hesitated to put on events in the way they had in previous years because of the pandemic. Gowns and cocktail dresses waited in closets unworn but, thankfully, the fragrance still offered a little way to celebrate every day.

# lessons learned

Pamella Roland, the brand, has thrived over the last 20 years, but the seeds were planted much earlier. I always enjoyed watching my mother get dressed for fancy events. She was the most elegant woman to me. When I was 15 years old, I started working at a boutique in my Michigan town, where I learned to love fashion in a new way. I worked there for 7 years, but it would be decades before I launched my brand.

I have learned so much as the brand has grown and as the industry has changed over the last 20 years. My first and biggest lesson learned was that you do not have to be fresh out of design school to be successful. I did not start Pamella Roland until I was 42 years old. I had my three children and built a career in public relations first. My education was in business and art history, not fashion design. However, I had a clear vision of what I wanted to make and knew for whom I was making it: women who wanted to look good and get dressed easily. It took two years of hard work before I was ready to launch my first small collection in Fall 2002.

Although I was intimidated at first, being something of an outsider worked in my favor. I am not your typical fashion personality. I roll up my sleeves to work closely with the design team, touching every garment in the collection. People thought that, as a Midwesterner, I would not be tough enough to handle the New York fashion world. By

leading with kindness instead of toughness, I have made wonderful friends in the industry and kept some of the most talented people on my team for years. My uncommon background has also kept me focused on creating a good product. In the first few years, we did not advertise because I wanted to make sure the business was solid first. I watched many new designers focus on being seen at every party or in magazines before their businesses had a strong foundation, and they ran into trouble. My business background and frequent trips home to be with my family guided me, especially in the early days.

You cannot build a thriving business without knowing when to let go, and that was a difficult lesson to learn. At one point, I produced both a mid-range line and a bridal and diffusion line, in addition to the evening wear collection. My team and I were spread thin and, in the end, it was not the right move for the business. I made the difficult decision to move on. Thankfully, my primary clients, the ones who loved my gowns, appreciated my renewed focus.

*Above:* With my children **Cassandra**, **Sydney**, and **Cole** at the close of our Spring/Summer 2016 runway show.

# acknowledgments

I am so grateful to everyone who has supported Pamella Roland the brand and Pamella the woman over the last twenty years.

The team I have put together is my proudest achievement as a business owner. Scott, you have been my right hand leading this company, and I couldn't have asked for a better ally. Thank you so much! Thank you to Carolina for all you do; you manage our finances brilliantly so that the designs can flourish each season. I value our relationship. Michael, you have been with me since the very beginning. I don't know how Pamella Roland could have grown without you. Jeffrey, you have been finding homes for our garments for more than ten years. Thank you for being such a big part of our success. Andrew, your vision for our designs is its own work of art. It has been an honor to watch you grow. To Brandon and the public relations team: you have helped us dress some of the most talented artists of our times and tell the story of our designs. A million thanks! I am also so grateful to my friend Vanessa Williams for her contributions to this book and all our years of style and laughter. My dear friend Nigel Barker, I cherish all the knowledge, encouragement, and friendship you have shown me these 17 years.

Of course, my most heartfelt thanks goes to my family. I know there were times when it was hard to deal with my trips away from home and my long hours, but you knew I was working on a dream. I would not be the designer I am without your love and support. Dan, Cassandra, Sydney, and Cole: I love you more than I can say.

In memory of my mother Charlotte VanderLaan, whom I miss dearly. You inspired me every time you got dressed. Because of your style and elegance I have learned so much.

# photo credits

© AB + DM: p. 96 © Ruven Afanador: p. 109 (bottom right), 116 © Presley Ann/Getty Images for Baby2Baby: p. 69 © Jean-Paul Aussenard/WireImage: p. 18 (second row, far right) © Axelle/Bauer-Griffin/FilmMagic: p. 90 © Nigel Barker: p. 18 (bottom row, left), 19 (top row, middle), 102–103, 109 (bottom left), 115 © Neilson Barnard/Getty Image: p. 59 © Steven Bergman/AFF-USA.com: p. 93 (c) Normand Brouillette: p. 19 (bottom row, third from left) © Michael Buckner: p. 109 (top right) © Larry Busacca/WireImage: p. 34 © Dario Cantatore / Stringer: p. 19 (second row, far left) © Francesco Carrozzini: p. 112 (bottom left) © Dominique Charriau/WireImage: p. 28, 51 © MICHAL CIZEK/AFP via Getty Images: p. 82 © Mike Coppola/Getty Images: p. 84 © Andrew Cruz: p. 22, 26, 147, 166, 213 © Gregg DeGuire/WireImage: p. 30 © James Devaney/GC Images: p. 48, 60, 62 (left) © Dfree: p. 74 © Darian DiCianno/BFA.com: p. 148, 220–221, 224–225, 227, 234 © Miles Diggs/Shutterstock: p. 54 © Kevork Djansezian/Getty Images: p. 36–37 © Leonardo Donadel: p. 66 © Bernardo Doral: p. 65 © Francois G. Durand/WireImage: p. 19 (bottom row, far left) © Andrew Eccles: p. 98 © Rosemary Fanti: p. 19 (top row, far right) © BILLY FARRELL/Patrick McMullan via Getty Images: p. 18 (second row, far left) © Featureflash Archive / Alamy Stock Photo: p. 76 © Featureflash Photo Agency: p. 80 © Gilbert Flores/Variety via Getty Images: p. 113 © FOX via Getty Images: p. 40 © Gotham/GC Images: p. 63 (left) © Steve Granitz/WireImage: p. 71 © Jennifer Graylock: p. 18 (second row, second from left; third row, far left and far right; bottom row, right), 19 (top row, far left; bottom row, second from left), 150–158, 160–161, 163–165, 167–173 © Taylor Hill/FilmMagic: p. 87 © Randy Holmes/Disney General Entertainment Content via Getty Images: p. 68 © Nicholas Hunt/Getty Images: p. 9 (bottom right) © Kathy Hutchins: p. 46, 70, 75 (right), 81 © Image Press Agency / Alamy Stock Photo: p. 49, 56 © Arseny Jabiev: p. 15, 16, 19 (second row, far right), 236–238, 240–249 © Dimitrios Kambouris/Getty Images for Glamour: p. 50 © Dimitrios Kambouris/Getty Images for TIME: p. 77 © Dimitrios Kambouris/Getty Images for Whitney Museum of American Art: p. 9 (bottom left) © Brian Killian/WireImage: p. 18 (third row, second from left) © Rob Kim/WireImage: p. 162 © Jon Kopaloff/FilmMagic: p. 6 © Jon Kopaloff/Getty Images: p. 45 © IAN LANGSDON/EPA (top left): p. 9 © Jason LaVeris/FilmMagic: p. 95 © Jason LaVeris/Getty Images: p. 91 © Dan Lecca: p. 176, 182, 187–190, 193, 206–207, 210, 212, 214–215 © Fernando Leon / Stringer: p. 253 © David Livingston/WireImage: p. 94 (right) © Benjamin Lozovsky/BFA.com: p. 178–179, 181, 192, 196–198, 205, 209, 216–219 © Jerry Maestas: p. 112 (bottom right) © Elvis Maynard: p. 250 © Kevin Mazur/WireImage: p. 79, 88 © Jamie McCarthy/Getty Images: p. 75 (left) © Miller Mobley: p. 12, 106–107, 118–119 © Danny Moloshok REUTERS / Alamy Stock Photo: p. 72 © Paul Morigi/Getty Images for The Stronach Group: p. 9 (top right) © David Needleman: p. 114 © Lisa OConnor: p. 62 (right) © Lisa Paclet: p. 38–39 © Trae Patton/NBC/NBCU Photo Bank via Getty Images: p. 52–53 © Richard Phibbs: p. 110–111 © Ekaterina Pikalova: p. 67 © Rudy Popisil: p. 19 (second row, middle) © Lev Radin / Alamy Stock Photo: p. 57 © Rankin: p. 112 (top) © Courtesy of Pamella Roland: p. 18 (top left, top right; second row, third from left), 19 (bottom row, far right), 201–204, 208, 211 © Chrisean Rose: p. 109 (top left) © Norman Jean Roy: p. 105 © John Russo: p. 101 © s_bukley: p. 10 © Mark Sagliocco/Getty Images: p. 86 © Warwick Saint: p. 104 © Patrick Sawaya: p. 73 © SC Pool – Corbis/Corbis via Getty Images: p. 32–33 © Mark Seliger: p. 41 © Malorie Shmyr: p. 174–175, 183–185, 191, 194–195  © Francis Specker/CBS via Getty Images: p. 42 © Mark Squires: p. 108 © Jordan Strauss/Invision for the Television Academy/AP Images via Credit: Sipa USA/Alamy Live News: p. 94 (left) © Theo Wargo/Getty Images for NYFW: The Shows: p. 226 © ANGELA WEISS/AFP via Getty Images: p. 63 (right) © Matthias Wendzinski: p. 222, 228–229, 232–233  © James White: p. 99 © Steve Wilkie: p. 100 © Kevin Winter/Getty Images: p. 18 (top middle), 44 © Haifa Wohlers Olsen: p. 2, 4, 24, 25, 27, 120, 122–127, 129, 130, 132–134, 136–146 © Luca Zanoni/Launchmetrics: p. 230–231

first published in the united states of america in 2023 by **rizzoli** international publications, inc. 300 park avenue south new york, ny 10010 www.rizzoliusa.com **copyright © 2023 pamella roland art direction and design: burnside & seifer** publisher: charles miers associate publisher: anthony petrillose editor: gisela aguilar production manager: kaija markoe managing editor: lynn scrabis design coordinator: olivia russin all rights reserved. no part of this publication may be reproduced, stored in a retrieval system, or transmitted in any form or by any means, electronic, mechanical, photocopying, recording, or otherwise, without prior consent of the publishers. printed in china 2023 2024 2025 2026 2027 / 10 9 8 7 6 5 4 3 2 1 isbn: 978-0-8478-7317-3 library of congress control number: 2023904447 visit us online: facebook.com/rizzolinewyork twitter: @rizzoli_books instagram.com/rizzolibooks pinterest.com/rizzolibooks youtube.com/user/rizzoliny issuu.com/rizzoli

*Frontispiece:* A strapless white tulle ballgown with sequins and feathers from the Spring/Summer 2022 collection. *Opposite contents:* A peridot and gold tulle gown with 3D floral embroidery from the Spring/Summer 2022 collection.